performing
pedagogy

SUNY series, INTERRUPTIONS:
Border Testimony(ies) and Critical Discourse/s
Henry A. Giroux, Editor

and

SUNY series, Innovations in Curriculum
Kerry Freedman, Editor

performing pedagogy

Toward an Art of Politics

Charles R. Garoian

STATE UNIVERSITY OF NEW YORK PRESS

c o v e r p h o t o : Goat Island, *How dear to me the hour when daylight dies,* 1996. Photo by Nathan Mandell.

Published by
State University of New York Press, Albany

For information, address
State University of New York Press, State
University Plaza, Albany, N.Y., 12246

Production by Michael Haggett
Marketing by Anne M. Valentine

Library of Congress Cataloging-in-Publication Data

Garoian, Charles R., 1943–
 Performing pedagogy : toward an art of politics / Charles R.
Garoian.
 p. cm. — (SUNY series, interruptions — border
testimony(ies) and critical discourse/s and SUNY series, innovations in curriculum)
 Includes bibliographical references and index.
 ISBN 0-7914-4323-X (hc. : alk. paper). — ISBN 0-7914-4324-8 (pbk.
: alk. paper)
 1. Performance art—United States. 2. Artists—United States—
Psychology. 3. Arts—Study and teaching—Methodology.
4. Communication in education—United States. I. Title.
II. Series.
NX504.G37 1999
370´.1—dc21 98-54276
 CIP

10 9 8 7 6 5 4 3 2 1

Contents

List of Figures

Acknowledgments

In writing this manuscript, I received the generous support and assistance of many individuals whose contributions included personal encouragement, criticism of my text, and the organizational details that enabled its completion. Although it is impossible for me to acknowledge all who supported my writing, I nonetheless want to single out those who directly impacted its outcome. First and foremost, I humbly thank Bonnie MacDonald, whose critical reading of my text provided me with an objective means by which to clarify my ideas. A former student of mine, a friend, and a colleague, Bonnie was particularly important to this project as she had assisted me in organizing the Performance Art, Culture, Pedagogy Symposium at Penn State University in 1996. The first of its kind, the symposium examined the historical, theoretical, and experiential significance of performance art in order to distinguish its pedagogy as an emerging form of arts education.

I want to express my gratitude to Henry Giroux, my colleague at Penn State, who encouraged me to write a book about my perspective as an artist and educator who has used performance art strategies at the high school and university levels of teaching. Henry's writings on critical pedagogy are essential to the concept of performance art pedagogy developed in this manuscript. My appreciation also goes to Daniel L. Collins and Laurie Lundquist, directors of the Deep Creek School Summer Art Program in Telluride, Colorado. Dan and Laurie are dear friends and colleagues. Their gracious invitation for me to teach performance art at Deep Creek for the past six years furnished me with an exciting opportunity to explore the pedagogical relationships among the

body, technology, and ecology. The Cleveland Performance Art Festival, where I was invited to perform for the past five years, provided a professional venue for me to present my own performance art works and to interact with performance artists from around the nation and internationally. A special thank you to Thomas Mulready, the former director of the festival, for his continued support of my work as artist and educator.

There is a host of individuals who graciously indulged my curiosities about art and teaching and who provided me with an opportunity to pick their brains, to engage in dialogue, and to explore with them the interconnections between art and pedagogy. I am unable to mention them all here. However, John H. White, Chris Staley, Ray Langenbach, John Kissick, and Jerrold Maddox certainly stand out as friends and colleagues whose cogency and clarity provided such support throughout the writing of this manuscript. I am grateful to James Stephenson, former director of the School of Visual Arts, and Brent Wilson, former head of the Art Education Program at Penn State who encouraged me to pursue my research in performance art and art education. I am beholden to them for the opportunities that they gave me to explore these two areas of research, which enabled me to develop the subject of this manuscript. I am also grateful to the College of Arts and Architecture at Penn State University for granting me a sabbatical leave, which provided me with crucial time to concentrate on writing this manuscript.

A special acknowledgement goes to the featured performance artists, critics, historians, educators, and presenters who graciously accepted my invitation to participate in the Performance Art, Culture, Pedagogy Symposium and whose contributions greatly influenced the ideas found in this manuscript. They include Jacki Apple, Carol Becker, Thomas Borkovec, Dan Collins, Jonas dos Santos, Steve Durland, Mark Fearnow, Kenneth Foster, Joanna Frueh, Henry Giroux, Gerry Givnish, Guillermo Gómez-Peña, Matthew Goulish, Lin Hixson, Allan Kaprow, Suzanne Lacy, Ray Langenbach, James Luna, Anne Marsh, Robbie McCauley, Jeff McMahon, Tim Miller, Thomas Mulready, Jeanne Pearlman, Peggy Phelan, William Pope. L, Rachel Rosenthal, Moira Roth, Thomas Ruller, Mark Russell, Mariellen Sanford, Henry Sayre, Rober Shimomura, Roberto Sifuentes, Kristine Stiles, Ken Thompson, Marta Ulvaeus, John White, and Martha Wilson.

I also want to acknowledge Vartkess and Rita Balian of Washington, D.C., and Henrik S. Igitian, founder and director of the Children's Museum of Art and Aesthetic Education Centers of Armenia, who encouraged and supported my research trips to the Republic of Armenia in 1991 and 1992. Thanks also to Rafael Matevossian, Prorector for International Relations at Yerevan State University, and the Council for International Exchange of Scholars in Washington, D.C., who supported

my receiving a Fulbright Fellowship in 1994 to continue my work in Armenia. While in the Republic, I was able to see how Armenian children were taught to resist the oppressive cultural practices of the Soviet Union by performing their Armenian identities through the arts. Since art has served as the contentious space where I have long struggled to define myself as an Armenian-American and as an artist-teacher, the political and creative agency that Armenian children attained through their art-making practices touched my heart.

There are a number of funding agencies that financed the research and writing of this manuscript. Initial funding sources were the Institute for the Arts and Humanistic Studies and the College of Arts and Architecture at Penn State University. Their support sustained the majority of the costs for producing this manuscript. Parital funding from The Pennsylvania Council on the Arts enabled me to organize the Performance Art, Culture, Pedagogy Symposium as a research project to query the historical, theoretical, experiential, and pedagogical character of performance art.

The symposium would not have been possible, however, without a major grant from The Getty Education Institute for the Arts, an operating program of the J. Paul Getty Trust. The Education Institute provided the necessary funds to assemble the many symposium presenters at Penn State from around the nation and internationally. Significant financial and facilities support was also received from the Conferences and Institutes Division of Continuing and Distance Education at Penn State University. Sandra K. Edwards, director of development, and Roberta M. Moore, a conference planner for that program, were invaluable with their professional expertise and commitment to the outcome of the symposium program. Director Joe Jefcoat and facilities manager Lea Asbell-Swanger of the Center for the Performing Arts at Penn State must be mentioned for their generous technical support for the symposium. Additional funding was received from the Department of English, the Department of Theatre Arts, the Women's Studies Program, and the Paul Robeson Cultural Center at Penn State University. I am indebted to all the aforementioned agencies, departments, programs, and their representatives for the support and assistance that they afforded me to research performance art pedagogy, the topic of this manuscript.

Finally, my heartfelt gratitude goes to my family. I wish to express my love and admiration for my late father, Kurken, and my late mother, Satenig. It was their incredible stories of cultural persecution and their quaint emigrant sensibilities that charged my imagination as a young artist and teacher. My parents taught me never to forget the past. To this day, they continue to influence my desire to resist cultural domination through the performance of memory and cultural history work. I

extend my sincere appreciation to my brother, Gerard Garoian, and sisters, Miriam Vanderlaan and Claudette Hovsepian, with whom I shared my childhood experiences on our parents' raisin vineyard. The play of our daily lives, during those early years together, continues to provide a source of inspiration for my work.

In the end, however, I am left to thank those who were closest to my struggle to define my life through my work as an artist and teacher. To my loving wife Sherrie, and our dear children Jason and Stephanie, I dedicate this manuscript. Their unremitting faith in me as husband and father and their faith in God and family provided me with the courage and strength to continue with my cultural work even in the most difficult of times. They are a blessing in my life. Furthermore, I would be remiss if I overlooked thanking my academic family, the wonderful students and colleagues with whom I shared classroom experiences over the past thirty years. At the risk of sounding trite, I truly did learn more from them than they did from me. Their unique cultural perspectives, their vital creative production, and their relentless desire to resist cultural oppression challenged me to become the best teacher that I could possibly be.

Finally, I would like to thank the following individuals, agencies, and publications for permission to reprint materials in this manuscript. Jon Landau Management granted permission to reprint excerpted lyrics from *No Surrender* © 1984 Bruce Springsteen (ASCAP). Reprinted by permission. Exerpts from "Little Gidding" from *Four Quartets* © 1943 by T. S. Eliot and renewed 1971 by Esme Valerie Eliot, reprinted by permission of Harcourt Brace and Company in Orlando, Florida, and Faber and Faber Ltd. in London, England. Permission was granted to use excerpts from *The Roof Is on Fire* ©, a television documentary of KRON-NBC (Chronicle Broadcasting) in Oakland, California. An excerpt from "The Lonely Passion of Charles Garoian" © is reprinted by permission of ARARAT (A journal of the Armenian General Benevolent Union) in New York, New York. Chapter 2, "Performance Art: Repositioning the Body in Postmodern Art Education" © is reprinted by permission of the *Journal of Multicultural and Cross-cultural Research in Art Education* at Ohio State University. The image of Rachel Rosenthal performing FUTUR-FAX © is reprinted with permission from photographer Jan Deen in Sherman Oaks, California. And Kim Winck and Robert C. Meyhoefer, of the Penn State Center for Academic Computing, assisted me in digitizing and printing several of the videotaped performance images found in this manuscript.

1

Introduction

What we call the beginning is often the end
And to make an end is to make a beginning.
The end is where we start from.
 —T. S. Eliot (1943, p. 38)

At the end of *Little Gidding*, the poet T. S. Eliot portrays the performative relationship between the present and the past, between contemporary and historical experience. The beginning of this book is its end. Remembered, re-considered, re-presented, and re-viewed from the perspective of performance art pedagogy, the topic of this book, Eliot's poem reveals the tension between students' performances of personal knowledge and their performance of socially and historically determined curricula imparted through schooling. Whereas students' personal knowledge is comprised of their particular memories and cultural histories, socially and historically determined knowledge consists of the reified curriculum of academic culture. Thus, re-reading T. S. Eliot, "what we call the beginning" (the performance of personal knowledge) "is often the end" (of prescriptive curricula). To perform the end of curricula, students perform their personal knowledge in order to know it for the first time. The end of curricula is where they start from.

Therein lies the premise of this book: in providing a reflexive pedagogy, similar to the looping of time that T. S. Eliot suggests, performance art enables students to learn the curriculum of academic culture from the perspective of their personal memories and cultural histories. In doing so, performance art represents the praxis of postmodern theories in art and education. I will support this thesis as I query the pedagogical implications of performance art throughout this book. What would happen if school curricula, like the production of performance art, consisted of playful, performative contradictions? Would contrary ideas, images, and actions introduced in the classroom

1

"beg the question" of cultural familiarity as they do in performance art? Would they challenge the socially and historically determined assumptions of art and culture learned in school in contrast to those that students bring from their respective cultural backgrounds? If performance artists' cultural perspectives enable them to critique cultural inscription through performance art production, would students' performances of subjectivity provide them with similar opportunities in the classroom? Could a performance art pedagogy make personal/political agency attainable for students? How would classroom instruction based on performance art strategies affect the design and implementation of curriculum in schools?

Questions such as these marked the beginning of my development of a pedagogy of performance art over twenty-five years ago. In this book, I will characterize performance art as postmodern pedagogical discourse and practice. I will discuss the way in which performance artists use memory and cultural history to critique dominant cultural assumptions, to construct identity, and to attain political agency. In doing so, I will argue, performance artists engage in the practice of critical citizenship and radical forms of democracy that have significant implications for teaching in the schools. Finally, I will contextualize performance art pedagogy within my own cultural work to illustrate how my own memory and cultural history have informed my production of performance art works and my classroom teaching practices.

In 1969, after completing a master's degree in art, I took a job teaching in the art department of Los Altos High School in the San Francisco Bay Area. With no certification, and having only a limited experience of teaching, I entered the profession hoping to subsidize my studio production. The idea of teaching art while producing it appealed to me. Before too long, however, I realized that I had created a bifurcated life for myself, one split between the studio and the classroom. I might have quit teaching if it were not for the fact that I needed to make a living, but what is more significant, I found it to be an extremely rewarding experience. My interaction with my art students was intellectually stimulating. There was an intriguing connection between art making and art teaching, one that I wanted to explore further. Nonetheless, I continued to wonder about successfully maintaining two areas of cultural work, whether I could carry a double load.

I was caught between making art and teaching it. I refused to believe the myth that "those who can, do; those who can't, teach." Having experienced the effects of both oppressive and transformative pedagogies as a student, I refused to believe teaching to be an insignificant form of cultural production. What is more important, I refused to believe that knowledge and cultural production were limited to academic endeavors

disconnected from personal memory and history. A young and idealistic artist and teacher, I wanted to prove otherwise, that teaching is an art form just as art is a form of teaching. Could I do justice to both, or would I eventually experience burn-out and complacency and find myself unable to produce quality work in either area of production? To resolve the tension, I brought my art-making inquiries to the classroom where I could straddle the border between the art of pedagogy and the pedagogy of art.

Coincidental with my early teaching practices, in my studio, I was juxtaposing, mixing, and playing with disparate objects, materials, and processes on canvas, extending them off the vertical plane of the wall onto the floor. Once on the floor, I began exploring the spatial relationship of the canvas to the site of my body. As I played these various contexts against each other, I developed an embodied, performative practice of art making that I wanted to carry over to my teaching. Similar to my studio experiments, I wanted to create a way of teaching that would challenge the pedagogical assumptions that I had learned from my teachers. In my studio, I problematized aesthetic conventions by performing contradictory and conflicting ideas, images, and actions from my personal history. My goal was to expose and transform the conflicting discourses into a social praxis that would enable me to create new ideas, images, and actions based on my own cultural perspective. I wanted to experiment in a similar manner with my teaching, to see whether the polemical conditions that I created in my studio would produce a similar agency, curiosity, and desire for art praxis in my students. At that time it never crossed my mind that I would write this book. Nor was I aware of the diverse theories that eventually informed my pedagogy.

SPEECH-ACT THEORY: TEACHING IS PERFORMATIVE

The speech-act theory of linguistic philosopher J. L. Austin provides a lens through which to consider the performative dimensions of pedagogy. Talk, the principle practice through which teachers and students communicate, is performative. That is, the things teachers and students say in a classroom represent acts of doing and, conversely, what they do is something said. In *How to Do Things with Words* (1962), Austin provides a methodology for considering speech as performance. He distinguishes between two types of utterances: performatives and constatives. Performatives are words that carry out an action where saying something in the "first person singular present indicative active" is to do something (p. 5). "I approve," "I urge," "I criticize," "I agree," and "I disagree" represent examples of performatives. By expressing approval, urgency, criticism, agreement, and disagreement the speaker is engaged in

performative actions that are evaluated by the success or failure of their outcomes, what Austin refers to as felicitous or infelicitous (pp. 14–15). By comparison, constatives are comprised of true or false statements (p. 3). They carry out the traditionally assumed function of language where saying something is limited to description or the reporting of facts. "Pablo Picasso painted *Guernica*," "the ladder is leaning against the wall," and "one mile is equivalent to 5,280 feet" represent examples of constatives.

Austin further distinguishes performative utterances in three ways: as locutionary acts with a "certain sense and reference" that have a "meaning in the traditional sense"; as illocutionary acts that force a particular discursive interaction; and, as perlocutionary acts that achieve a particular response in a listener (p. 108). The following examples illustrate the differences between a constative and Austin's three characteristics of performative utterances in a teacher/student interaction:

> Constative: "The teacher assigned homework."
> Locutionary act: "The teacher *said to me*, 'complete your assignment.' "
> Illocutionary act: "The teacher *urged me* to complete my assignment."
> Perlocutionary art: "The teacher *made me* complete my assignment."

Austin's speech-act theory makes it possible to consider the performative dimensions of educational discourses and practices; how what teachers and students say and do in the classroom affects teaching and learning. Curriculum theorist Cleo H. Cherryholmes (1988) claims that Austin's theory challenges the passivity of descriptive language in education by materializing its active and evaluative properties (p. 138). Exposure of its performative dimensions enables a critique and re-consideration of language use in the classroom. Radical educator Peter Mc-Claren (1986) argues that the performative character of pedagogical speech, teachers' instructional language, plays "as much—if not more— than the actual informational content of instruction" (p. 107). In doing so, how teachers communicate plays a significant a role in what students learn. Unfortunately, teachers' speech acts function as abstract behaviors hidden from critical attention within a system of education where the expression of academic knowledge predominates subjective experience.

Cultural theorist Judith Butler (1995) argues that Austin's theory is not limited to word use alone but includes the actions that are performed as a consequence of word use (p. 197). Illocutionary force (the thing said) and perlocutionary effect (the thing done) represent the speaker's authority over an audience; a positionality that is not exclusive to the speaker but includes a "community and history of such speakers" (p. 203).

[A performative] *accumulates the force of authority through the repetition or citation of a prior and authoritative set of practices.* It is not simply that the speech act takes place *within* a practice, but that the act is itself a ritualized practice. What this means, then, is that a performative "works" to the extent that it *draws on and covers over* the constitutive conventions by which it is mobilized. In this sense, no term or statement can function performatively without the accumulating and dissimulating historicity of force.

When the injurious term injures . . . it works its injury precisely through the accumulation and dissimulation of its force. The speaker who utters the racial slur is thus citing that slur, making linguistic community with a history of speakers. (Butler, 1995, pp. 205–206)

Using Austin's theory of performativity as a rationale, I argue that a pedagogy of performance art challenges hegemonic and injurious speech acts by decentralizing the authority of the speaker. A multicentric art form, performance art repositions artists, teachers, and students to critique cultural discourses and practices that inhibit, restrict, or silence their identity formation, agency, and creative production. Within its aesthetic context, performance art deconstructs socially and historically determined speech and enables the expression of multiple subjectivities. A pragmatic form of cultural criticism, performance art serves as critical pedagogy whereby speech codes are taught, contested, and re-presented in the form of new ideologies, identities, and cultural myths.

The concept of 're-presentation' in performance art pedagogy assumes that identity and ideology are not fixed but in continual formation. As artists, teachers, and students invoke their personal memories and histories through performance, they engage in storytelling; a testimonial process that, according to performance theorist Elin Diamond (1996), is the doing of "certain embodied acts, in specific sites, witnessed by others" and "the thing done, the completed event framed in time and space and remembered, misremembered, interpreted, and passionately revisited across a pre-existing discursive field" (p. 1). Shifting between a doing and a thing done, "between present and past, presence and absence, consciousness and memory" (p. 1), invokes a continuum of past performances, a history, a "pre-existing discursive field" that, when juxtaposed with existential experiences, makes it possible to expose and interrogate cultural inscription and to re-consider and construct culture anew. Performance theorist Richard Schechner (1993, p. 1) describes this repetitive character of performance as "twice behaved behavior." Diamond (1996) defines it in terms of the prefix *re*. "[To] *re*embody, *re*inscribe, *re*configure, *re*signify [in performance] acknowledges the pre-existing discursive field, the repetition—and the desire to repeat—within the performative present, while 'embody,' 'configure,' 'inscribe,'

'signify,' assert the possibility of materializing something that exceeds our knowledge, that alters the shape of sites and imagines other as yet unsuspected modes of being" (p. 2).

Thus, according to Diamond, performance enables the critique and reevaluation of culture through subjectivity—a reflexive process of embodiment that enables the subject to turn history onto itself and to explore and interrogate its terrain. Learning history from a subjective vantage point in this way makes possible the construction of new historical ideas, images, and myths.

LEARNING TONGUE

In 1977, I produced a performance with the aid of my high school students that dealt directly with the hidden issues behind speech, cultural inscription, and personal history. Playing with the transliteration of "lezoo sorvir vor mart uhlas," an admonishment that my parents often communicated in Armenian, I created *Dialogue with an Object of Conversation* (Figure 1.1). Political refugees who had survived the Armenian

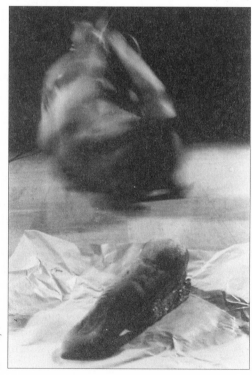

figure 1.1: Charles Garoian,
*Dialogue with an object of
conversation,* 1977.
Courtesy of the artist

genocide of 1915, and having had few opportunities for education, my parents believed knowledge to be a form of power. Having experienced and understood their otherness, they would continually remind my brother, sisters, and myself of the necessity to do well in school in order to survive socially, politically, and economically in America.

My parents' admonishment "lezoo sorvir vor mart uhlas" transliterates to "learn tongue so that you will be a man." In Armenian, 'lezoo' has multiple meanings. It literally means "tongue" and figuratively "language" or "education." 'Man' has two meanings: "man" in the sense of being male, and "man" as the universal representation of being human. Moreover, "lezoo sorvir vor mart uhlas" assumes John Locke's notion of *tabula raza*, that one is not human until inscribed with knowledge. Although I understood my parents' figurative use of this statement to be "the importance of education for becoming human," playing with its double and triple entendres began to suggest linguistic ideas, images, and actions for my performance art production and teaching practices. In particular, I wanted to explore the paradoxical character of language, its ability to say one thing and to mean several others, and, conversely, to be forced to say and mean only one thing. It was the ideological differences between "a free tongue" and a "sequestered tongue" that led to *Dialogue with an Object of Conversation*.

In *Dialogue*, a collaborative performance at the high school, my students gagged, hog-tied, and dragged my body before a white package tied with string, placed on the floor, and illuminated by a mechanic's "trouble light." Once I was situated with my head adjacent to the package, a student carefully untied its string, opened its wrapping to expose a large cow's tongue purchased from the local butcher. With my ability for speech and movement impeded, I began to twist and turn my body, to attempt freedom, to move toward the severed tongue. I repeated these actions while waxing philosophic about the paradox of art, its ability to liberate and obviate expression simultaneously. However, with my "tongue tied" and gagged, my commentary consisted of loud nonsense sounds and mumbles that were ironically juxtaposed with the severed tongue on the floor. Sounds such as "ah-ee-oo-a-mm-oh-oh" permeated the performance space. The tongue on the floor appeared distended and displaced from my body. My movements suggested attempts to retrieve my tongue, to rehabilitate my ability to speak coherently. Ironically, in lieu of my ability to speak discursively, my body's language was made explicit through movement and sound. My body's liberation from discursive presumptions notwithstanding, it was marred by censorship.

Dialogue with an Object of Conversation represents an example of a performance art work that evolved from my cultural background, research

that I then used to construct art lessons within the high school where my students and I could explore the paradox of language use, to expose and critique its hidden dimensions of public and private, past and present, presence and absence.

PERFORMANCE, PERFORMATIVITY, AND PERFORMANCE ART

There are three attributes of cultural production in which performance art pedagogy is founded: performance, performativity, and performance art. The first attribute, performance, represents an expanded, heterogeneous field of cultural work within which the body performs various aspects of production, socially and historically constructed behaviors that are learned and reproduced. Teaching, doctoring, farming, computing, cooking, learning, selling, buying, playing sports, putting out fires, writing, plumbing, building, designing, parenting, policing, and driving a vehicle constitute different examples of professional and domestic cultural performance. Within the arts, performance involves a process of making, doing, production in dance, music, and theatre, architecture, landscape architecture, and the various genres of the visual arts. Performance also includes audience members' embodiment of aesthetic experiences, their absorption while viewing, listening, and participating in works of art. Within the context of educational practice, performance represents the teacher's pedagogy, the students' interaction with that pedagogy, and their mutual involvement in school. Significant to cultural politics, however, is whether this expanded field of performance manifests the oppression of cultural workers or their political agency. Political agency assumes the performance of subjective desire within the expanded field of cultural performance.

The second attribute of cultural production, performativity, represents the performance of subjectivity, a means by which students can attain political agency as they learn to critique dominant cultural paradigms from the perspective of personal memories and cultural histories. However, political agency does not preclude cultural dominance; it enables it. Whereas the performance of subjectivity can re-position and emancipate students from hegemonic discourses and practices, it also distinguishes and establishes them in centralized positions of power. Emancipatory education, according to Paulo Freire (1993) and Henry Giroux (1993), is a paradox that requires both students' critique of pre-existing discourses and practices and a reflexive process through which they continually negotiate their positionality within the culture.

Performance art historian Amelia Jones (1998) refers to the reflexive nature of performance as the "culture of narcissism," a process whereby the "personal" became politically empowering for "the femi-

nists in the late 1960s and early 1970s." "The enacted body/self is explicitly political and social in that it opens out onto otherness and the world in general; in phenomenological terms, this body/self performs itself through its own particular social situation" (pp. 46–47). Thus, reflexivity, an important attribute of performance art pedagogy, represents a form of critical narcissism, a mode of production that flows cultural discourse and practice back onto itself. A decentralizing force, it checks the politics of cultural work and prevents ideological domination. The reflexive character of performance art pedagogy is a three-layered process. First, as a process of objectification, the critique of performance art enables students to see the culture that they embody and to expose and problematize its hidden circumstances. Second, as a process of subjectification, it enables them to see themselves within culture by critiquing it from the perspective of personal memory and cultural history. Third, it provides them an opportunity to see their performances within culture as they critique the positionality of their performances within the expanded field of cultural history. Political philosopher Chantal Mouffe (1993) argues the importance of positioning the subject in cultural history. She distinguishes among tradition, personal memory, cultural history, and traditionalism, the hegemony of cultural codes. "Tradition allows us to think our own insertion into historicity, the fact that we are constructed as subjects through a series of already existing discourses, and that it is through this tradition which forms us that the world is given to us and all political action made possible" (p. 16).

Performance art, the third attribute of cultural production, is the performance of subjectivity that originates from within the context of the arts. For the early modernists such as Alfred Jarry, F. T. Marinetti, Hugo Ball, Tristan Tzara, and others, performance art served as a liminal space, a virtual laboratory, where the body's preexisting modes of art production were challenged with the dynamic ideas, images, and processes of modern industrial culture. Having embodied the disjunctive character of the machine age—its new technologies, rapid modes of mass production, and consumer capitalism—artists developed the interdisciplinary strategies of performance art to deconstruct the western European canon and to create a new aesthetic for the twentieth century. In doing so, the subjectivity allowed by performance art provided the modernists' agency within the cultural mainstream, positions of power that they assumed to be the entitlement of artists.

As compared to the hegemonic discourses and practices of modernist art, the function of subjectivity and agency for postmodern performance artists is the production of critical citizenship, civic responsibility, and radical democracy. Postmodern performance artists such as Rachel Rosenthal, Suzanne Lacy, Guillermo Gómez-Peña, Tim Miller, Holly

Hughes, and others problematize the exclusionary practices of the modernists, combining their interdisciplinary practices with intercultural investigations in order to expose the hidden agendas of the cultural mainstream. The political project of postmodern performance artists is the decentralization of authority by aestheticizing ethnicity, sexual orientation, gender, race, and class distinctions. The project of postmodern subjectivity is based on liminal, contingent, and ephemeral practices through which culture, identity, and agency are continually critiqued and renegotiated, what performance art historian Amelia Jones (1998) refers to as "consciousness of the self as intersubjective (performed or enacted in relation to others), and of the self as particularized" (p. 86). Thus, as compared with reified cultural practices, postmodern performance art shifts from "authority to effect, from text to body, to the spectator's freedom to make and transform meanings" (Diamond, 1996, p. 3).

Performance art pedagogy, the central topic of this book, considers the aesthetic dimensions of performative subjectivity as an educational imperative, a practice of teaching that necessitates the critique of hegemonic cultural performances and the creation of new performative myths. Contrary to pedagogies that distinguish and establish subjectivity in a dominant ethnocentric position, performance art pedagogy resists cultural conformity and domination by creating discourses and practices that are multicentric, participatory, indeterminate, interdisciplinary, reflexive, and intercultural. In doing so, performance art pedagogy is the praxis of postmodern theory.

A self-conscious form, performance art pedagogy represents the possibility of creating new utopias. Predicated on inclusiveness, the utopia of postmodernism promises justice for all. A culturally democratic ideology, it invites cultural heterogeneity. Like postmodern theory, the praxis of performance art pedagogy assumes truth an elusive construction. Ideas, images, myths, and utopian visions are never absolute or attainable. Predicated on students' existential experiences and desires, they are continually negotiated and renegotiated. Accordingly, truth is not universal. It only applies to particular cultural conditions and circumstances.

An open form, performance art pedagogy represents a liminal space, an aesthetic dimension, wherein socially and historically constructed ideas, images, myths, and utopias can be contested and new ones constructed as they pertain to students' experiences of reality and their desires to transform that reality. Although students' interpretations of reality may not correspond with each other, they nonetheless can coexist and engage in a democratic debate within performance art peda-

gogy. As cultural signifiers, students' multicentric perspectives collide and bounce off of each other. They provide an opportunity for agreement and disagreement. Assuming that students agree to disagree, they debate their differences. Then, despite ideological differences, they choose whether and how they want to support each other's causes. It is in the struggle of that discourse that critical citizenship, civic responsibility, and the practice of radical democracy is made possible, according to Chantal Mouffe (1993, p. 6). Ultimately, however, democracy is a paradox. It is evolving but never a completed project. Contingent upon specific cultural circumstances to preclude domination, its possibility exists only within the circumstances of its impossibility (Mouffe, 1993, p. 8). Performance art pedagogy makes the paradoxical struggle of democracy visible. It is my fervent hope that educators and artists alike will find in these pages the desire to engage in that project.

OUTLINE OF CHAPTERS

In chapter 2, "Performance Art: Repositioning the Body in Postmodern Art Education," I introduce performance art teaching as a new pedagogy in art education. I argue that its radical critique enables students to experience, question, and respond to contemporary culture from interdisciplinary and intercultural perspectives. As I compare its pedagogy to six traditional models of art instruction, I explain how performance art facilitates students' awareness of cultural inscription and the reclaiming and repositioning of their bodies as instruments to create culture anew. A postmodern pedagogical practice, performance art is predicated on a history of critical resistance. Beginning with early twentieth-century performances that challenged traditional assumptions of art in order to accommodate the new myths of industrial technology, performance art history shifted to concerns about the politics of art, culture, and the body in the 1960s and 1970s. In addition to historical and theoretical discussions in this chapter, descriptions of high school and university students' performance art works provide examples of the implications of performance art for classroom instruction.

In chapter 3, "The Emancipatory Pedagogy of Performance Art," I argue that performance art pedagogy functions as the praxis of postmodern theories found in performance studies, anthropology, linguistics, and education. An interdisciplinary and intercultural pedagogy of the body, performance art enables students to expose and transform the circumscribed space of their bodies into a liminal space wherein the politics of domination can be contested. Within its liminal space, they learn to challenge dominant cultural discourses from the multiple contexts

that are contingent on their respective cultural backgrounds. The ephemeral condition of performance art pedagogy calls into question the immutability of socially and historically constructed discourses and proposes repositioning the body in existential experience as an oppositional strategy.

In this chapter, six strategies of performance art pedagogy are characterized that enable students to interrogate and intervene socially and historically embodied culture. The ethnographic strategy of performance art pedagogy examines the body's physical, historical, and cultural terrain. The linguistic strategy exposes and critiques the stereotypical cultural metaphors inscribed on the body to evolve a language of identity. The political strategy enables students to reclaim and reposition their bodies in their struggle for personal agency. The social strategy of performance art pedagogy teaches students to achieve critical citizenship and civility in their classrooms, neighborhoods, and communities through collaboration. The technological strategy enables students to use their bodies as cultural instruments to intervene and critique the mechanical and electronic instruments of technoculture and the mass media. Finally, the ecstatic strategy of performance art pedagogy exposes the aesthetic experiences of the body to call into question the dialectics of pleasure and desire.

In chapter 4, "Goat Island: Spectacle as Performance Art Pedagogy," I concentrate on how a Chicago-based performance art collective repositions itself within the spectacle of mass-mediated culture to create a spectacle of resistance. Goat Island's rendering the private body explicit within the public sphere of art represents a critique of the reified culture foreshadowed in the spectacle theories of Adorno and Horkeimer, Jean Baudrillard, Guy Debord, Edward S. Herman, and Noam Chomsky.

Goat Island's pedagogy is revealed in the juxtaposition of the collective's instructional strategies in a workshop at the Museum of Contemporary Art in Chicago with its performance strategies in *How Dear to Me the Hour When Daylight Dies*, also presented at the museum. The purpose of this juxtaposition is to identify the dialectical relationship between the collective's performance art-making and art-teaching practices, that is, how one informs the other.

To resist the embodiment of mass-mediated culture, Goat Island appropriates, critiques, and mimics its production methods and its stereotyping processes. The collective performs extreme and exaggerated movements to make the site of the body explicit. Collaged with narrative fragments that attest to the struggle for agency in contemporary culture, Goat Island's radical movements and gestures reveal the body's unequivocal function as cultural stage, on the one hand, and its

desire to break through the oppressive assumptions of that stage, on the other hand.

A performance art pedagogy based on Goat Island's practices enables students to challenge and resist the public spectacles of popular culture (TV, movies, radio, magazines, and the World Wide Web) inscribed on their bodies. By engaging the interdisciplinary and intercultural strategies of performance art, students learn to read and critique the codes of mass-mediated culture from their respective cultural perspectives. Moreover, they learn to employ their critical knowledge, like Goat Island, in the creation of performance spectacles that resist the spectacle of mass media culture.

Chapter 5, "Robbie McCauley's Talk-About Pedagogy," consists of two parts. First, the artist's performance strategies from the perspective of Shoshanna Felman's testimony theory demonstrate the pedagogical significance of McCauley's cultural work, namely her ability to engage audience members in fighting racism. Second, McCauley's workshop strategies identify implications for classroom instruction. I focus my inquiry on the pedagogical strategies that she used in a performance entitled *Fragments* and a follow-up workshop, both of which she presented at the Performance Art, Culture, Pedagogy Symposium at Penn State in November 1996.

Based on Freudian and Lacanian psychoanalytic pedagogy, Felman's theory identifies the dialogic relationship between analysand and analyst as a linguistic performance comprised of witnessing and testimony. With language serving as the basis for psychoanalytic pedagogy, the responsibility for identity construction is placed within the culture rather than the self. Language, a cultural construct, is performed as testimony is given. The reading and interpretation of language is performed as a witnessing process. Like performance art pedagogy, this reflexive process calls for a critical review of itself. Similar to psychoanalytic pedagogy, McCauley's autobiographical performances provide testimony as she recalls five generations of racism in her family. Constructed in collage form, similar to the fragmented testimony of an analysand, her images, actions, and narrative provide audience members with multiple points of reference for witnessing and interpretation.

What is more important, McCauley creates opportunities for audience members to return testimony to her. In doing so, she breaks through the "fourth wall" of theatre, the invisible border of the proscenium that separates audience from performer. As she crosses back and forth over that border, she creates a liminal space wherein audience members are repositioned from passive spectators to active participants. What McCauley achieves by this repositioning process is audience

members' testimonies about living in a racist culture, a discourse that seeks to transform their indifference and complicity in a racist society to antiracist activism.

In Chapter 6, "Understanding Performance Art as Curriculum Text: The Community-based Pedagogy of Suzanne Lacy," I examine the artist's collaboration with students, teachers, community citizens, and public policy makers to produce *The Roof Is on Fire*, a community-based art project in Oakland, California. I present the curricular implications of Lacy's community collaborations, a process whereby she and community citizens engage in an open discourse to co-create a public performance that challenges the oppressive codes of mass-mediated culture.

Lacy's intention is to use public art as a liminal space where citizens can openly critique, discuss, and debate those issues and concerns that are specific to their communities and to work collectively in fulfilling their desires. As performance artist, educator, cultural activist, and author, she brings particular skills to her projects. She invites community members to follow suit. In doing so, she is able to amass a community of experts who are able to coproduce broad-based public projects that are beyond the scope of a single individual.

Lacy's public projects demonstrate a participatory democracy wherein citizens are acknowledged as public intellectuals capable of taking responsibility for determining the quality of life in their families, neighborhoods, and communities. What is curriculum? What would curriculum look like if it were not circumscribed within the schools? How would students' learning be affected if its form and content were determined through a community discourse? What role does art play in the development of community-based curriculum? Is there an aesthetic dimension to curriculum production? How does curriculum function as performance art text? How does a performance art curriculum facilitate civic education? Questions such as these expose the curricular implications of Suzanne Lacy's community-based performance art works.

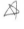 In chapter 7, "Constructing Identity: An Autobiographical Case Study of Performance Art," I contextualize my work as a performance artist within the framework of my memory and cultural history. Beginning with the relationship between my ethnic Armenian background and the oppressive circumstances that I experienced in school due to my cultural difference, I describe what it felt like to be inside the "melting pot." I was buffeted on one side by the pressure to assimilate dominant American values taught at school and on the other side with my parent's insistence that I maintain my Armenian identity. Finding myself on the border between two cultures, I found solace in the neutral zone of rock n' roll, where I was an Armenian dancing an American brand of music influenced by African American culture. Ironically, the hybridity of rock

'n' roll seemed to resonate with the ways my parents taught me to improvise a "playful" structure of work on the farm that was contrary to the fixed structure of schooling. My parents taught me how to intervene work with playful disruptions. Life on the farm was like a performance that enabled me to interconnect and validate the complex and contradictory parts of my life.

The performative aspects of art making, like rock 'n' roll and life on the farm, compelled me to become an artist. The study of art provided an aesthetic space within my college education, where I used interdisciplinary and intercultural strategies to improvise and construct my identity as a performance artist. Within the liminal space of art, I learned to perform subjectivity and to critique the dominant cultural ideas that I had learned in school.

In the second part of chapter 7, I provide examples of three performances that tell of my cultural background. In *History According Two Mental Blocks* (1995), an ironic tale, I drag two heavy blocks of concrete across a bed of bread crumbs while telling how I ingested holy communion in the Armenian Orthodox church, bits and pieces of Christ's body, at the same time that I developed the strange habit of biting and spitting the skin from my fingers. Ingesting God's body while expelling my own is the pretext for understanding the "gravity" of my religious upbringing in the Armenian church. In *Walking on Water* (1996), I submerge each foot in two large plastic bags, each filled with five gallons of water, which I tape to my legs. As I walk on water with a divining rod in my hands, I tell of an old man, a raisin farmer, who used to use his body as a water gauge. Finally, in *Raisin Debt* (1997), while grinding raisins, I tell my mother's story of surviving the Armenian genocide of 1915. My wife, Sherrie, spreads ground raisins onto slices of white American bread and then applies them to my bare back with medical tape, like bandages, while I recapitulate motions of survival.

Each of these performance examples is described in six stages to provide the reader with an idea of the process I use to construct a performance art work. My purpose in doing so is not to prescribe a methodology for others to follow but to expose the critical dimensions of my design process based on my cultural background. First, under the heading "concept, inquiry, and cultural commentary," I state the overall purpose of my performance. Second, in a list of materials and equipment, I identify the items necessary for the technical organization and production of my performance. Third, in a space plan, I illustrate the placement and proximity of objects, materials, and equipment that is required for me to perform. Fourth, in dimensional drawings to construct, I provide visual renderings complete with measurements for building special objects and equipment for my performance. Fifth, in

description of performance: actions, visuals, sound, and technical script, I assemble all the disjunctive components of my performance in order to provide a timed reading of its entire sequence. Sixth, in construction of signifiers, I identify the disjunctive concepts in my performance and the conjunctions I am attempting to create.

Finally, in chapter 8, "Constructing a Performance Art Pedagogy," I contextualize my cultural background and my work as a performance artist within my pedagogy. I describe nearly three decades of teaching art: seventeen years in a high school, five years in an art museum, and six years in university classrooms. It was during this time that I developed a pedagogy of performance art that provided me with the opportunity to develop and implement an aesthetic space for my students, one where they could perform their respective subjectivities and to challenge the "curricula" of learning institutions.

Throughout my professional career, I have maintained work in both the production and pedagogy of performance art because I believe that one informs the other. That is, the liminal, contingent, and ephemeral investigations that I undertook as a performance artist provided the impetus for similar production in my teaching. Likewise, the performative dimensions of my pedagogy provided an essential context where discussions about culture would emerge ideas and images, actions and gestures for performances. The performance art/education binary has provided me with fertile ground, a liminal zone to explore multiple possibilities between the two. Thus, in this final chapter, I provide examples of my pedagogical work, including performances by my students. In the process, I contextualize my performance art pedagogy within my cultural tradition. I discuss how particular memories and experiences fueled my desire to become an artist who teaches and creates pedagogy as an art of politics.

2

Performance Art

Repositioning the Body in Postmodern Art Education

On a chilly December morning in 1994, Dahn Hiuni performed *Art Imitates Life* (*Figure 2.1*) before a group of two hundred students, faculty, and community members gathered at the front entrance of the Palmer Museum of Art at Penn State University. A graduate student in painting and drawing enrolled in my performance art class in the university's School of Visual Arts, his performance marked a *Day without Art* dedicated to artists who have died of AIDS and those who are living with the HIV virus.

Art Imitates Life was performed in silence. Only the sounds of traffic passing by could be heard. Dressed in a hospital gown, Dahn emerged from behind the museum and slowly paced along the west sidewalk pushing a stainless steel armature, an IV pole from a local hospital, upon which a bag of red liquid was hanging, with its tube extended and attached to a vein in his wrist. As he approached an empty white canvas mounted on an easel before the front entrance, he slowly wove his way through the crowd, making eye contact with individuals along the way. Having arrived at the easel, he carefully removed the IV from his wrist and pierced the canvas with the needle. Releasing its flow through the tube, the red liquid slowly began to trickle from the needle and to soak the canvas. As saturation took place, Dahn slowly walked away, leaving everything behind, including the audience to ponder the impact of AIDS on the arts community.

Paper presented at the National Art Education Association Annual Conference in San Francisco, California, April 1996. Previously published in the *Journal of Multicultural and Cross-cultural Research in Art Education*, Vol. 14, Fall 1996.

figure 2.1: Dahn Hiuni,
Art imitates life, 1994.
Courtesy of Charles Garoian

How do performance art works like this one characterize a new pedagogy in art education? What is performance art? What are its theoretical and historical roots? How does it function as pedagogy? What are its implications for teaching in the visual arts classroom? Questions such as these will provide the focus for this chapter in order to establish the significance of this interdisciplinary and intercultural art form for the field of art education.

PERFORMANCE ART AS A RADICAL CRITIQUE

A radical form of art making, performance art has its roots in the experimental and interdisciplinary explorations of twentieth-century art movements such as futurism, constructivism, dadaism, surrealism, the bauhaus, pop, and postminimalism. In more recent times, it has been the genre of choice for artists of marginalized cultures who have found

the strategy of radical critique necessary to aestheticize issues surrounding ethnicity, sexual orientation, gender, race, and class distinctions.

Historically and theoretically, the political challenge of performance art has enabled artists to question the assumptions of traditional art and culture with respect to contemporary issues that are often considered "subversive," "controversial," or "difficult." In doing so, they have been able to reaffirm the significance of some of those assumptions while creating new ones relevant to contemporary cultural conditions. It is this critical-thinking dimension of performance art—the desire to experience, question, and respond to contemporary culture and to create culture anew from interdisciplinary and intercultural perspectives—that is significant to a pedagogy of postmodern art education.

A method of exploration and expression grounded in postmodern thought, performance art has enabled artists to critique traditional aesthetics, to challenge and blur the boundaries that exist between the arts and other disciplines and those that separate art and life. With regard to cultural identity, it has provided artists with a position from which to engage historical ideologies, to question the politics of art, and to challenge the complexities and contradictions of cultural domination in the modern and postmodern worlds.

The challenge of the postmodern artist is to "cognitively map our individual social relationship to local, national and international class realities," claims Jameson (1984, p. 91). This "social cartography" repositions the body from its marginalized status and reinstates its "capacity to act and struggle" (p. 92). Citing Jameson (1984, pp. 91–92) and Foster (1985, p. 152), Auslander (1992) considers this repositioning of the body in postmodern culture as the pedagogical function of performance art (p. 24). In the example of *Art Imitates Life*, Dahn Hiuni positioned himself within the dominant discourse of art as he performed "in the face of the museum" to resist the stigmatization and marginalization of AIDS affliction by the dominant culture.

The radical pedagogy of performance art is predicated on strategies of appropriation. Marcel Duchamp's "readymades," John Cage's "prepared piano," Merce Cunningham's "vernacular dance movements," and Allan Kaprow's "Happenings," represent examples where appropriational strategies were employed. McEvilley (1983) describes appropriation as the option of the performance artist "to choose to manipulate language and context, which in turn manipulate mental focus by rearrangement of the category network within which our experience is organized" (p. 63). Similar to collage, montage, and assemblage, performance art consists of "lifting" found ideas, images, materials, actions and sites from their respective contexts (Sayre, 1989, p. 20). The subsequent placement and

juxtaposition of these found phenomena within a live performance art work creates a semiotic play where signifiers are dislodged from their assumed functions (signifieds) in order to produce arbitrary, oppositional tensions between phenomena, between high and low art, between dominant and marginalized cultures, and between absolute and democratic pedagogies. Schechner (1993) refers to this linguistic action as "dark play." It "subverts order, dissolves frames, breaks its own rules, so that the playing itself is in danger of being destroyed, as in spying, con games, undercover actions, and double agentry" (p. 36). This disjunctive dynamic between signifiers can produce a critical discourse that seldom occurs when limited by their presumed functions and traditional strategies.

A graduate student in art education enrolled in my performance art class at Penn State University, Bonnie MacDonald (1996) engaged in a semantic argument about the use of the word *motherfucker* with three video representations of herself in *Dinner with Jocasta* (*Figure 2.2*).

The point of contention was "the intertextuality of contemporary American slang language, representations of the female and female sexuality, and the hegemony of phallocentric psychoanalytic and linguistic theories" (MacDonald, 1996, p. 1). A table set for four served as the site

figure 2.2: Bonnie MacDonald, *Dinner with Jocasta*, 1995. Courtesy of Charles Garoian

for a formal dinner around which were seated the actual Bonnie (Jocasta) and the three virtual Bonnies (Greek chorus) on video monitors. All four, including the video monitors, were draped with shawls pinned at the front with fancy brooches, Bonnie in red, and the chorus in black. While engaged in a conversation over dinner, the actual Bonnie and the virtual Bonnies found themselves deconstructing 'motherfucker.' The actual Bonnie argued the word to be offensive to women, while her three virtual selves provided historical, philosophical, psychological, and sociological rationales to justify its use (p. 1). The performance ends ironically with the actual Bonnie using 'motherfucker' to characterize everyone from God to Freud. As a "mother of two sons, middle-aged female, single sexual being, graduate student who 'problematizes' everything including herself" (p. 1) she told all of her "selves" to shut up and to cease using the word. Through performance art, Bonnie "played" with and deconstructed 'motherfucker' as an oppressive signification of women.

The practice of performance art is a form of shamanism, suggests McEvilley (1983), an ontological investigation that represents the desire to ritualize the fragmented and disjunctive nature of late-twentieth-century experience, "to reconstitute within Modern civilization something like an ancient or primitive sensibility of oneness with nature" (p. 65). Gorsen (1984) refers to performance art as an "aesthetics of existence" (p. 141). The performance artist experiences herself or himself taking the place of phenomena "that has previously been lived existentially, and for which [she or he], as a mimic, a magician . . . has taken on the job of midwife"(p. 139). Through the production of ontological metaphors, the performance artist provides "ways of viewing events, activities, emotions, ideas, etc., as entities and substances" (Lakoff & Johnson, 1980, p. 25).

What is the function of art in the twentieth century? What is the role of the artist? Questions such as these are the legacy of performance artists' interdisciplinary and intercultural explorations with modern industrial technology early in this century, with the mass media since mid-century, and with electronic imaging and telecommunications now at the end of the century. The aesthetics of performance art permeate all aspects of modern art and culture, bringing into question the dominant assumptions of traditional art making established in previous centuries. The assimilation of modern technologies into mainstream works of art embraces their ideologies, their procedures, and their cultural productions. Performance art provided a radical critique of these assumptions and the ideologies of contemporary culture.

Speaking in scientific metaphors, Kaprow (1993a) argues performance art provided laboratory conditions for basic research in the arts (p. 177). "It was in performance that [early performance artists] tested

their ideas, only later expressing them in objects," claims Goldberg (1979, p. 6). Performance art, conceptual art, and video art function as "laboratories for a new pedagogy," states Ulmer (1985). The "research and experiment" conducted through these genres have replaced object making with idea and process as the guiding force of art (p. 225). Kaprow's (1995) list of seven rules to break the barrier between art and life represent his experimental pedagogy for *Happenings*.

> (A) The line between art and life should be kept as fluid, and perhaps indistinct, as possible. (B) The source of themes, materials, actions, and the relationships between them [Happenings as well as other styles of art] are to be derived from any place or period except from the arts, their derivatives, and their milieu. (C) The performance of a Happening should take place over several widely spaced, sometimes moving and changing, locales. (D) Time, which follows closely on space considerations, should be variable and discontinuous. (E) [Due to chance encounters and ephemeral materials] Happenings should be performed once only. (F) [To eliminate theatrical convention, all elements including the audience are to be integrated. Thus] It follows that audiences should be eliminated entirely. (G) The composition of a Happening proceeds exactly as in Assemblages and Environments, that is, it is evolved as a collage of events in certain spans of time and in certain spaces. (pp. 235–241)

Kaprow's notion of performance art as laboratory, a site where experimentation can take place, corresponds with philosopher Robert P. Crease's (1993) analogy that the antinomic character of scientific experimentation, like performance, always results in something or someone being transformed. "They are at once utterly singular occurrences executed by a particular, fleeting context of materiel and personnel, and at the same time manifestations of a truth that transcends those special circumstances" (p. 98). Crease describes three interacting dimensions of performance that compare with this transformative character of scientific experimentation.

> Performance is first of all an execution of an action in the world which is a *presentation* of a phenomenon; that action is related to a *representation* (for example, a text, script, scenario, or book), using a semiotic system (such as a language, a scheme of rotation, a mathematical system); finally, a performance springs from and is presented to a suitably prepared local (historically and culturally bound) community which *recognizes* new phenomena in it. (p. 100)

In social and political terms, Kaprow's list of rules and Crease's dimensions of experimentation/performance correspond with Giroux's

(1994) "rupturing practice" (p. 135) and McLaren's (1993) "agonistic rituals" (pp. 82–83), oppositional pedagogies that enable the culturally disenfranchised to push "against the grain of traditional history, disciplinary structures, dominant readings, and existing relations of power" (Giroux, p. 135). An arena for cultural activism, the interdisciplinary critique of performance art has evolved new modes of representation and new voices heretofore ignored by mainstream western European culture. Herein lies the promise of its interdisciplinary and intercultural pedagogy, an ongoing critique of domination essential in a cultural democracy.

Unlike the traditional disciplines of visual art, dance, music, and theater, the advantage of performance art has been its free associative and improvisational strategies—a postmodern means by which to explore new and dynamic relationships among the body, technology, society, and art. At the Deep Creek School, an Arizona State University Summer Sessions Art Program in Telluride, Colorado, the student's body is considered a "contested site." "Various activities are engaged that seek to identify, give voice to, and develop the social body" (Collins & Garoian, 1994, p. 21). The following performance art work illustrates how students at the school explore and develop an understanding of themselves in relationship to the world through a pedagogy based on the body, technology, and ecology.

> Gene's [*Thunder Volt*, 1994] (*Figure 2.3*) involved an interface between electrical activity being recorded by the National Lightning Detection Network (NLDN) and the electrical activity of his body. He used his computer to process information coming from NLDN and to transmit that information via electrodes to different parts of his body. Small electrical shocks generated in response to remote lightning strikes stimulated Gene's muscles. The electrical activity of his own body was amplified in consort with the lightning strikes to produce an experience of the "geographical and atmospheric" characteristics of the body. (pp. 31, 69)

Borrowing Derrida's concept of 'undecidability,' Sayre (1989) describes the meanings elicited by performance art as "explosive, ricocheting and fragmenting throughout its audience. The work becomes a situation, full of suggestive potentialities, rather than a self-contained whole, determined and final" (p. 7). Such undecidable conditions eliminate boundaries. They enable members of the audience to conceptually, emotionally, and often physically penetrate the art work. Such possibilities present greater opportunities for individual interpretation. The traditional role of art spectator and audience is shifted to that of participant. The participation of individual members of the audience, in the reading of signifiers and the construction of meaning,

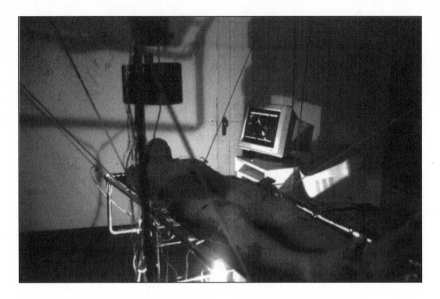

figure 2.3: Gene Cooper, *Thunder Volt*, 1994. Courtesy of the Deep Creek School

assumes a polyvocal condition whereby multiple cultural histories can come into play.

The improvisational strategies of performance art and the culture-bound strategies of traditional arts disciplines such as visual art, dance, music, and theater can be characterized in pedagogical terms as writing-on-the-body. To illustrate, Ulmer (1985) describes a semiotic pedagogy where "the professor is the faithful transmitter of a tradition and not the worker of a philosophy in the process of formation" (p. 163). As "faithful transmitter," the professor inscribes the signifiers of the culture upon the student body. Barbara Kruger's 1989 photomontage, *Untitled* (1990, p. 19), declares such action renders the body a "battleground" upon which the war of cultural politics is waged. In contrast, the professor as cultural worker initiates a process that enables students to evolve a philosophy and to inscribe it upon that of the cultural body. Ulmer suggests that this "latter notion—*the classroom as a place of invention rather than of reproduction*"—represents the attitude of Derrida's grammatology" (pp. 163–164).

A comparison of "nontheatrical" performance art strategies and those of the traditional arts, which Kaprow (1993c, p. 173) characterizes as "theatrical," serves to differentiate their inscriptions on the body. In the traditional arts, culture is written on the body of the performer and the audience as it is composed, choreographed, and staged according to

the script of the author—an autonomous discipline-based artist. Arguing against this Hegelian authoritative model, Ulmer calls for Derrida's post(e)-pedagogy based on performance art that does "away with the undesirable pedagogical effect of discipleship precisely because it generates disciplines and authorities" (p. 173). In performance art, the bodies of the performer and the audience are used as instruments by which to write upon the culture as they improvise and invent interpretations through diverse personal, cultural, and disciplinary perspectives (Battcock & Nickas, 1984, p. ix). Barthes (1980), refers to this indicative, "transparent form of speech" as "writing at the zero degree" (pp. 76), where "thought remains wholly responsible, without being overlaid by secondary commitment of form to a History not its own" (p. 77). Speech at the zero degree is described by Sontag (1969) as a silent aesthetic, one that "keeps things open" (pp. 19–20). The semiotic pedagogy of performance art functions at the zero degree, where the traditional arts and other cultural constructs are learned and critiqued, yet re-presented from diverse cultural perspectives (Ulmer, 1985, pp. 174–175).

PERFORMANCE ART: A HISTORY OF CRITICAL RESISTANCE

The sites wherein performance art works were first presented, circus, variety theater, and cabaret during the early part of the century by the futurists, constructivists, dadaists and surrealists, reflect its open methodology. Selected for their dynamic qualities, these sites provided artists with spontaneity, motion, parody, and "the twin tendency to make something new that was also in opposition to prevailing values"—all the characteristics of the machine age (Schechner, 1993, p. 7). Egalitarian in nature, they facilitated more rapid communications to a broader sector of society than the traditional galleries, museums, theaters, and concert halls, which remained the exclusive domains of the socially elite.

This early history of performance in the twentieth century begins in 1895 with Alfred Jarry's *Ubu Roi*, a bombastic denouncement of traditional theater that received violent reactions from the audience when the word *shit* was used repeatedly throughout the play. *The Art of Noises* (1913), Luigi Russolo's contribution to the futurist's theater of anarchy, introduced the sounds of machine technology as viable music. The Russian constructivist Nikolai Foregger's 1923 *Mechanical Dances* imitated a transmission and introduced a new system of dance based on machine technology. Zurich dadaist Hugo Ball's *Karawane* represents a free "verse without words," or "sound poem," to produce simultaneous, spontaneous, and improvised sounds. The 1924 absurd surrealist ballet *Relâche*, was a collaboration that included the visual artist Francis Picabia's wall of large silver disks inset with extremely bright lights, Erik Satie's "furniture

music," and a multimedia extravaganza that included a motion picture, dance, *tableau vivant*, and a miniature five-horsepower Citroën that was driven on stage. *Slat dance* (1927), one of Oskar Schlemmer's mechanical ballets at the Bauhaus, used a performer's body as a "real puppet" to indicate the relationship between the mechanics of the body and machine technology.

McCarthyism and the cold war in the 1950s, the civil rights movement, the women's liberation movement, and the Vietnam war in the 1960s and 1970s shifted the attention of performance artists away from machine technology to the politics of art and the body. During the pop art era in the 1960s, Happenings and Fluxus represented two groups of artists who took their cues from the concept-based readymades of Marcel Duchamp, the process-oriented work of abstract expressionist Jackson Pollock, and the aleatory music of composer John Cage to produce a wide range of activities that engaged the body in "live art" conditions. *Courtyard* (1962), for example, represents an early Allan Kaprow Happening comprised of a twenty-five-foot paper mountain in the middle of a run-down Greenwich Village hotel courtyard, a woman in an evening dress, and a cyclist to challenge a number of archetypical symbols including woman-as-goddess and nature versus culture. Postminimalist performance art in the 1970s included works such as Vito Acconci's *Seedbed* (1971) at the Sonnabend Gallery in New York City. As Acconci crawled and masturbated under a ramp over which people walked, he attempted to use his body as a power field to "interact with other people and objects in a particular physical space" (Goldberg, p. 100). This enactment of "power field" theory expounded by the psychologist Kurt Lewin enabled him to objectify his body as an instrument of culture in order to explore the body's function as sex object (Bourbon, 1984, p. 192).

The civil rights movement also laid groundwork for postmodern, postindustrial, and postcolonial movements about ethnicity, sexual orientation, gender, race, and class. Coupled with the ultraconservatism of the Reagan-Bush years in the 1980s and a collapsing economy in the 1990s, performance artists politicized their cultural identities in order to empower themselves and their respective communities. In her 1975 body performance *Interior Scroll*, Carolee Schneemann defined the contours of her naked body and face with broad strokes of paint and read from a scroll, which she unraveled from her vagina "inch by inch" to depict a relationship between a man and a woman from a "personal" and "diaristic" perspective (Sayre, 1989, pp. 90–92). In her 1984 ecofeminist performance, *The Others*, Rachel Rosenthal shared the stage with snakes, cats, dogs, squirrels, hamsters, rabbits, monkeys, and a number of other animals to portray the oppression of both women and animals (Lacy, p. 271). In *The Year of the White Bear (Two Undiscovered Amerindians Visit*

Madrid) (1992), Guillermo Gòmez-Peña and Coco Fusco occupied a gilded cage for a period of three days in a plaza in Madrid, Spain, on the occasion of the Colombian quincentennial. Dressed in stereotypical native American costumes and with a number of modern amenities such as a computer, a TV, and a kitchen table, they parodied "the way conquered peoples were brought back to Spain and put on display by the explorers" (Lacy, 1995, p. 222). John Malpede in *LAPD Inspects America* (Los Angeles Poverty Department) (1988–1990), recruited local homeless people in Los Angeles, conducted a workshop, and developed a performance that addressed issues directly related to conditions of living on the streets of the city. In addition, Tim Miller's politicized gay body and culture, Adrian Piper's gender and race projects, and Group Material's cultural empowerment projects represent performance art works like those of their predecessors early in the century who sought out and located their struggle against oppression in sites other than in the cultural mainstream. Unlike their predecessors, however, these artists located that struggle in their own bodies and in their respective neighborhoods in the form of community-based art works.

Performance artist Suzanne Lacy (1995) describes community-based art works as subverting the traditional autonomy of the artist, the art object, and art spaces. This "new genre public art" involves collaborations between artists and culturally diverse communities heretofore ignored by mainstream culture. The strategies are integral to performance art. Community-based art work is located in site-specific spaces outside the mainstream and in alternative spaces found in culturally diverse neighborhoods. Community members are not isolated as art spectators or audience. Instead, they are directly engaged as cultural workers. For her 1987 *Crystal Quilt,* Lacy worked for two and a half years in Minneapolis to develop a network of five hundred volunteers, twenty staff members, and a team of fifteen collaborating artists to produce a grand-scale performance honoring four hundred and thirty senior women whose ages ranged from sixty to one hundred. Arranged in a grid, their configuration of tables and chairs resembled the pattern of a quilt, and their conversations about their common problems and accomplishments, that of a quilting bee. At key points in their exchange, their choreographed hand movements suggested the process of quilting. In the end, those seated in the audience were also invited to take part in the quilt performance (Lacy, 1995, p. 252–253).

In a community-based performance art work like Lacy's, the artist functions as a mediator, soliciting ideas from community members and fostering their participation in the production of art works that serve the vital interests of their community. The democratic principles of this performance art strategy are further reflected by the documentation and

dissemination of these community-based art works through printed publications, videotape, and the World Wide Web, thus giving access to an even broader sector of the public.

The time has come to evaluate the radical strategies of performance art, argues Osborne (1980). He explains that unlike the creation of new forms in visual art, dance, music, and theater, whose critique of traditional aesthetics is discipline specific, the interdisciplinarity of performance art raises larger questions about the significance of art itself and, in doing so, confirms its cultural necessity (p. 10). Performance historian Anne Marsh (1993) agrees with Osborne's assessment that "performance art draws on many sources in and beyond the arts and often questions the structure of art itself by focusing on the relationship between art and society or between the artist and the spectator or both" (Marsh, 1993, p. 7). Accordingly, art works like Picasso's *Les Demoiselles d'Avignon* may have challenged the assumptions of traditional painting, but the painting's function as art and Picasso's role as artist were seldom questioned.

The interdisciplinarity and interculturality of performance art has functioned throughout this century as a complex delivery system, a pedagogical strategy by which to identify and connect disparate disciplines, technologies, and cultures. From the riotous actions of the dadaists during World War I, to the "Happenings" of Allan Kaprow in the 1960s, to Guillermo Gómez-Peña's current explorations of border issues, cross-cultural identity, and U.S.-Latino cultural relations, performance artists have worked to open the discourse on art and to expose its social and political underpinnings.

PERFORMANCE ART TEACHING AS A NEW PEDAGOGY

Six models of art teaching used in contemporary American classrooms provide a context from which to compare performance art teaching: the beaux arts tradition, vocational training, arts and crafts, the bauhaus, the child-centered approach, and discipline-based art education (DBAE). Each of these models represents western European art historical and cultural developments in art education pedagogy. The Beaux Arts tradition is patterned after Renaissance and baroque art academies that trained fine artists based on the tradition of the Old Masters to create art works to extol the virtues of the aristocracy (Boime, 1971). Curriculum content in this model is centered around the teacher. The students hold apprenticeship by learning the academic notions espoused by the teacher.

Originating as an industrial concept of art education in the nineteenth century, the vocational training model teaches technical skills intended to meet the needs of industry with an emphasis on the mass pro-

duction of commodity forms. The arts and crafts model centers around the production of utilitarian objects as well but differs from vocational training in that production is "hand-crafted." This model of teaching, stemming from the nineteenth-century arts and crafts movement, is a reaction against the impersonality of industrial forms. It provides students with a variety of materials and processes for making things with their own hands. The bauhaus model of art teaching represents an organized technical program balanced with personal inquiry and imagination. Its problem-centered curriculum enables students to develop a variety of solutions to visual problems related to the industrial environment.

The child-centered model of art teaching is grounded in art educational practices that evolved from the development of educational psychology and the child study movement in the early part of the twentieth century. This model of art teaching focuses on the individual needs of students, allowing them to develop their creative potentialities through art (Garoian, 1984, pp. 32–34). The sixth model of art teaching, DBAE, identifies four areas of inquiry that are necessary to art education: art making, criticism, history, and aesthetics. Although this model encourages some interdisciplinary and intercultural comparisons of art, its strategies for teaching are consistent with the media, object-based, and discipline specific pedagogies of the traditional models.

A radical form of pedagogy, performance art teaching takes its cues from the exploratory and experimental strategies employed by artists throughout this century (Apple, 1995, p. 121 and White, 1995, p. 133). The interdisciplinarity and interculturality of performance art represents a context for curriculum, instruction, and evaluation that is divergent, open, complex, and contradictory in character. Rather than universal absolutes, this pedagogical method seeks a diversity of images, ideas, perspectives, and interpretations. McMahon (1995) argues that performance art "cuts through the immobilizing effects of theory [and conventional schooling] with creative acts" (p. 127). As in Ulmer's discussion of grammatology above, it enables students to embody knowledge learned from across school disciplines. Through the interdisciplinary and intercultural strategies of performance art, students "'own' a text or cultural fact by re-working it through his [or her] own body and voice" (McMahon, 1995, p. 127).

Lesley's performance art work in my Los Altos High School art history class serves as an example of interdisciplinarity and "re-working" the text of culture through the body. To interpret the relationships among modern art, European existential literature, and her adolescent experience, Lesley chose to focus her performance on the writings of Kafka, Camus, and Sartre and the sculptures of Alberto Giacometti. The art history room was prepared with three slide projectors and a lectern

from which she would speak. On the day of her performance, she decided to use a treadmill as a visual and conceptual metaphor to represent "futility" in existentialism and in daily life. We telephoned Lydia's Health Spa located in our town and asked to borrow their treadmill exerciser. The request was granted, but the treadmill, weighing three hundred pounds, was too awkward to carry. To accommodate the task, ten husky students and I loaded it into my Dodge van and delivered it to the classroom a half hour before Lesley was to begin her performance. During her entire fifty-minute performance, she walked the treadmill without stopping. As she walked, she talked about the concept of 'futility' that is so often experienced in modern art, literature, and contemporary life. The visual image of her "going nowhere" and the monotonous sound of the treadmill's rollers provided a basis from which to experience futility directly. Within thirty minutes after her performance, the other students and I returned the treadmill to Lydia's Spa, and the art and English classes that had gathered to see and hear Lesley dispersed to their next classes (Garoian, 1993, pp. 159–162).

Lesley's performance serves to illustrate how the juxtaposition of text, image, speech, and action, the writing of performance art, enables students to construct meaning from their respective cultural perspectives that incorporate verbal images with visual images, with spoken words and other sounds of the body, and with actions of the body. In doing so, they learn how verbal, visual, auditory, and kinetic actions can be written, read, and interpreted like text.

Lamenting the traditional/avant-garde bifurcation of art, Goulish (1993) argues for an inclusive art education with value to be found throughout its history (p. B3). Performance art and its tradition of rebellion can be used to teach students how to channel their radical energies toward constructive outcomes (p. B3). The radicality of children's energies are most often found outside institutionalized contexts where they freely play and behave at will. From young children playing on a playground to adolescent experimental behaviors, learning outside of the home, the church, and the school represents improvisational and exploratory actions. Kaprow (1993b) writes about the significance of play in the education of "the un-artist" as the ability to create work that is not bound by the linguistic categories of art and culture. He argues that academic classroom rituals teach students strategies of competition in order to play the game of culture. As the historical and cultural assumptions espoused by the school are perpetuated and left unquestioned, children's perspectives are diminished.

[Ironically, gaming and playing] both involve free fantasy and apparent spontaneity, both may have clear structures, both may (but needn't) require

special skills that enhance the playing. Play, however, offers satisfaction, not in some stated practical outcome, some immediate accomplishment, but rather in continuous participation in its own end. Taking sides, victory, and defeat, all irrelevant in play, are the chief requisites of game. In play one is carefree; in a game one is anxious about winning. (Kaprow, p. 122)

According to Piaget (1971), the behavioral manifestations of play function as a natural part of children's cognitive development, their genetic epistemology (p. 13). At early stages, children learn as they absorb through their senses all that surrounds them. Cognition in this respect is concrete sensory perception. Piaget claims that during adolescent years, growth changes in the neurological structure of the brain enable a process called "thinking from thinking" (Flavell, 1963, p. 205). The mind continues to take in information from the environment through the senses but now has the ability to extrapolate abstract, independent propositions and interpretations. In doing so, sensory-perceptual information becomes the "raw-material" for the adolescent's abstract thinking (Flavell, p. 223). Piaget's cognitive and behavioral stages parallel Goulish's "radical energy and the [students'] desire to transform themselves and society" (Goulish, 1993, p. B3). These characteristics are usually stereotyped as cognitive dissonance and adolescent rebellion in traditional schooling contexts. Performance art teaching enables students to critique curricular and pedagogical stereotypes, to challenge the assumptions of the art world and those of the culture in general. This pedagogy recognizes and encourages the tradition of rebellion as a natural aspect of students' creative and mental development.

Unlike the traditional discursive models of dualistic and dialectical thinking, performance art cognition enables a nondiscursive complex of ideas and images to coexist simultaneously within the mind. Writing about creative cognition, Rothenberg (1979) refers to this mental process as "janusian thinking" after the Roman god Janus who was able to see in various directions simultaneously (p. 55). In addition, Rothenberg characterizes the singular spatial context wherein these simultaneous thoughts occur as "homospatial" (p. 69). Koestler's (1975) "bisociative thinking" parallels Rothenberg's notion. Like homospatiality, bisociation takes place when two or more ideas coexist within the same space of the mind (p. 352). In a significant chapter appropriately titled "Underground Games," Koestler identifies the use of puns, the phenomenon of displacement, double identities, and other conceptual bisociations as the "grammar and logic of dream-cognition" (p. 179). As in dreams, they are suspended in space and time. Koestler's underground strategies are not uncommon in the history of performance art. The dadaist Marcel Duchamp (Cabanne, 1971, p. 12) referred to his appropriational strategies as "underground,"

as did Allan Kaprow (1993c), for whom going underground meant "changing jobs" or changing his role as an artist (p. 104).

The mental operations to which Rothenberg, Koestler, Duchamp, and Kaprow refer represent the critical processes that occur during creative thinking. These processes preclude the objectification of values, attitudes, and beliefs that stifle interpretation. To avert such objectification, the presentation, experience, and interpretation of performance art depends on a "situational aesthetics"—one in which the relationships between the artist, the art-making process, and the community are considered part of the art work. Unlike traditional visual art, dance, music, and theater, performance art shifts the objective of art making from that which is culturally autonomous to that which is community based.

How are Janusian, homospatial, and bisociative thinking manifested in the structure and meaning of a performance art work? Paley (1995) identifies three "nonobjective" pedagogical strategies to resist "analytic objectification" during educational inquiry: bricolage, polyphonous voice, and rhizomatic. Bricolage is a strategy for radical juxtaposition, improvisation, and the nondiscursive analytic procedures employed by the dadaists and the surrealists. The term is also used by anthropologists to describe how "'primitive' cultures conceptualize and organize their environments" and "as a cultural term (to clarify practices, within certain youth subcultures, of appropriation/juxtaposition serving to disrupt/reorder systems of meaning and discourse)" (pp. 8–9).

Polyphonous voice is described by Paley as a strategy to challenge "systems of univocal discourse" and to affirm "multiple voices" and "multiple realities and experiences." This defines a pedagogy "in which no particular vocality can assure itself an absolutely authoritative status to the exclusion of others" (p. 10). This radical strategy, which reflects the educational politics of Paulo Freire's (1993) "pedagogy of the oppressed" (pp. 54–55), Maxine Greene's (1988) "dialectic of freedom" (p. 116), and Henry Giroux's (1993) "critical pedagogy" (p. 21), enables students to critique their oppression by dominant cultural values and to voice their diverse cultural identities.

The rhizomatic, Paley's third strategy, is adopted from Gilles Deleuze and Félix Guattari's study of Franz Kafka's writings. Similar to Eugenio Barba's "theater of roots" founded on the Asian ethos of mutability (Schechner, 1993, p. 14), it uses the virtually endless and multidirectional burrowing of the rhizome root as a structural metaphor. The weblike composition of the rhizomatic eludes absolute, authoritarian interpretations and opens the possibility for multiple experiences, identities, and cultural interpretations to exist.

Paley's strategies correspond to Clifford's (1988) "predicament of culture," an ethnographic surreal condition where "reality is no longer a

given, a natural, familiar environment. The self, cut loose from its attachments, must discover meaning where it may" (p. 119). Clifford claims the remedy to such detachment or marginalization is the theory and practice of juxtaposition, a hybrid of ethnography and surrealism that enables the repositioning of the body within the matrices of culture (p. 147).

The significance of juxtaposition in cultural predicaments is also acknowledged by Taussig (1987). He argues that manipulated, juxtaposed, and incongruent imagery, the montage aesthetic of surrealist art, represented a desire for exotic realities other than those prescribed by traditional western European culture. As such, surrealism functioned as the driving force of European colonialism: to escape the oppression of one's own culture and to take refuge in and assume the possession of another's. By comparison, "in the colonies and ex-colonies these [surreal] expressions are intrinsic to the form of life and at the service of its magicians, priests, and sorcerers" (p. 201). Through montage, shamanistic practitioners juxtaposed the ritual practices of both the colonizing and native cultures to create a hybrid, counterhegemonic condition whereby the voices of the oppressed were represented.

Ulmer (1985) identifies five characteristics of counterhegemonic "writing" in the ritual performances of Joseph Beuys that reflect Derrida's grammatology: teaching, creativity, models, mime, and autography. First, Beuys' teaching extended beyond his professorship in sculpture at the Academy of Art in Düsseldorf to include interdisciplinary theory, intermedia practice, and involvement in "organizations designed to intervene deconstructively in the educational system as a whole," such as the Free International University for Interdisciplinary Research (p. 228). Second, the artist's practice of sculpture "constitutes not only a self-reflexive theory of sculpture, but also a theory of the very notion of *creativity* as such in all human productivity, as indicated in his slogan, 'everyone an artist'" (p. 229). Third, Beuys' exploration of a broad range of vernacular objects, materials, and sites functioned as "*models*, employed in a kind of allegorical writing" (p. 229). Fourth, reflecting Derrida's notion of the "teaching body," the objects, materials, and sites used by Beuys function within "Actions, performance Events, or 'rituals,' in which he *mimes* both science and mythology in a didactic exploration of the creative process" (p. 229). Finally, Beuys' fifth characteristic of counterhegemonic writing, autography, represents the artist's use of shamanism as a means by which to write upon culture with one's own hand. Shamanism provided Beuys with "a way to de-monstrate the autographical character of poststructuralist, postmodernist knowing—idiomatic and impersonal at once—since the shaman draws on the most subjective, private areas of experience for his handling and treatment of public affairs and objective problems" (p. 229).

Goldberg's (1979) description of Beuys' 1974 performance *Coyote* at the René Block Gallery in New York City illustrates the counterhegemonic conditions of his pedagogical rituals.

> *Coyote* was an 'American' action in Beuys's terms, the 'coyote complex' reflecting the American Indians' history of persecution as much as 'the whole relationship between the United States and Europe.' [Beuys said] 'I wanted to concentrate only on the coyote. I wanted to isolate myself, insulate myself, see nothing of America other than the coyote . . . and exchange roles with it.' According to Beuys, this action also represented a transformation of ideology into the idea of freedom. (p. 97)

Three types of teaching as ritual performance are identified by McLaren (1993): teacher-as-liminal-servant, teacher-as-entertainer, and teacher-as-hegemonic-overlord. Like Beuys, the teacher-as-liminal-servant functions as a "convener of customs and a cultural provocateur—yet she (or he) transcends both roles" (p. 115). She or he knows "not merely [to] *present* knowledge to students; [but to] transform the consciousness of students by allowing them to embody or incarnate knowledge" (p. 116). McLaren argues that the "ontological status and personal characteristics" of the liminal servant and the teacher-as-entertainer appear relatively the same (p. 116). What distinguishes the latter from the former is that the entertainer, like Ulmer's "faithful transmitter" discussed above, performs the narrative of the dominant culture. Although the form of her or his teaching ritual appears like that of the liminal servant, her or his content is that of teacher-as-hegemonic-overlord, which inscribes dominant cultural values on the student body. By comparison, the liminal servant subverts this traditional pedagogy. Like Beuys, she or he enables students to improvise, invent, and "autograph" the dominant culture with their respective cultural identities.

The pedagogy of performance art represents a movement of aesthetic assumptions from cultural absolutes—from the familiar, known, seen, and marked—to those that can be characterized as strange, unknown, "unseen" (Berleant, 1977 pp. 14–15) and "unmarked" (Phelan, 1993). According to Phelan (1993), pedagogies of domination function as "dangerous propositions" because they invite "the belligerent refusal to learn or move at all" (p. 174). Instead she argues for the dynamic pedagogy of performance art.

> It is the attempt to walk (and live) on the rackety bridge between self and other—and not the attempt to arrive at one side or the other—that we discover real hope. That walk is our always suspended performance—in the classroom, in the political field, in relation to one another and to ourselves. The inevitability of our failure to remain walking *on* the bridge (when the storms come we keep

rushing for the deceptive "safety" of one side or the other) guarantees only
the necessity of hope. (p. 174)

Forsaking a cultural mainstream, a dominant center, and metaphors
that universalize experience, the interdisciplinary and intercultural
pedagogy of performance art calls for a repositioning of the marginal-
ized body. Walking Phelan's rackety bridge within Paley's rhizomatic
matrix, its ability to learn and move is multidirectional and ideologi-
cally polyphonous.

IMPLICATIONS OF PERFORMANCE ART PEDAGOGY FOR THE CLASSROOM

Between 1971 and 1973 Kaprow (1993c) wrote a series of three essays on
the "education of the un-artist" in which he identified four kinds of art
teaching: nonart, anti-art, art-art, and unart. "Non-art is whatever has not
yet been accepted as art but has caught an artist's attention with that
possibility in mind" (p. 98). Found objects, materials, sites, and actions
that are part of a student's home and cultural environment yet unfamil-
iar to the art context qualify as nonart. The following performance art
work by a student in my Los Altos High School art history class serves as
an example of nonart:

> In discussing the action paintings of Jackson Pollock, Brad set up a visual
> and conceptual analogy through performance art. Constructing a cloud
> chamber as it is used in a physics laboratory to track the movement of sub-
> atomic particles being released from small amounts of radioactive material,
> he placed an isotope (radium) upon the head of a pin. Imbedded in a cork,
> the pin was suspended in the cloud chamber below a small piece of alcohol-
> soaked cloth. Brad sealed the cloud chamber onto a metal plate, which was
> then placed on a block of dry ice. Next, the intensified light of a slide pro-
> jector was projected through the chamber. The alcohol condensed and
> formed a cloud layer over the cold metal plate. As subatomic particles dis-
> persed from the isotope and passed through the cloud, they created addi-
> tional condensation through their paths, thus making their movement
> visible. Brad's non-art gesture in the art history class provided a metaphor
> by which to understand Pollock's dynamic movement and drips of paint as
> an entropic process where matter is continually dispersed in nature.
> (Garoian, 1993, p. 161, 163–166)

"Non-art is often confused with anti-art which in Dada time and even
earlier was non-art aggressively (and wittily) intruded into the arts world
to jar conventional values and provoke positive esthetic and/or ethical re-
sponses" (Kaprow, 1993, p. 99). The intervention of students' nonart

findings in an art context can result in anti-art. Their familiar/strange juxtaposition produces questions, a critique about art's assumed functions. The following performance art work by a group of students in my Los Altos High School sculpture class serves as an example of anti-art:

> During the week of homecoming at the high school, the "jocks" celebrate their football games and pep rallies. A group of students regarded as "intellectual, art-type freaks," who were unable to relate to the purpose of the event requested my support to sabotage the homecoming parade with a prank. Realizing their feelings of exclusion to be very real, I suggested that they create a means of protest that would both serve to poke fun at the tradition of homecoming as well as present a new perspective. The students and I decided to organize an unconventional entry into the homecoming parade, a "walking float" based on a conceptual art work we had studied in class: Bruce Nauman's *Drill Team*, 1966–1970 (Meyer, 1972, p. 191). Nauman had drilled four drill bits into a 2˝ x 4˝ x 24˝ wooden board, to form a visual pun. The idea interested the students because of its obvious connection to the marching band. The school's traditional drill team was composed of forty girls dressed in short skirts and white gloves, each waving their hands in choreographed fashion and marching in step to the cadence of the marching band. Prior to the parade, the students and I organized our own drill team. We practiced marching and "drilling" late in the evening in order to preserve the element of surprise. On the day of the parade, We lined up four abreast in ten rows (forty participants). The two students on each end of the rows carried the 2˝ x 4˝ x 10´ wooden boards as the middle two students "drilled" into the boards with hand drills. Dressed in working clothes, we marched two miles from the school, down the main street of town and back again. Ironically, our drill team was radically juxtaposed behind the homecoming queen candidates riding in six new shiny Porsche sports cars. (Garoian, pp. 206–207)

As compared with nonart and anti-art, Kaprow argues "art-art takes art seriously . . . It is innovative, of course, but largely in terms of a tradition of professionalistic moves and references: art begets art" (Kaprow, 1993c, pp. 100–101). Art-art teaching follows the beaux arts, arts and crafts, vocational training, bauhaus, child-centered, and DBAE models discussed above. Since it represents the historical and cultural lineage of art making, both the form and content of work produced by students is based on traditional art-making materials and techniques such as painting, sculpture, ceramics, printmaking and photography.

Following Kaprow's three educational models, the education of the unartist, his fourth model, assumes providing a context that is playful rather than serious, interdisciplinary rather than discipline specific, intercultural rather than focused on the values of a single culture. A deconstructive process of stripping oneself of art-art, Kaprow argues "in

becoming un-artists we may exist only as fleetingly as the non-artist, for when the profession of art is discarded, the art category is meaningless, or at least antique (pp. 98–104).

The critique of performance art teaching assumes criteria that are unfamiliar to educational evaluation. Quantitative measures fall short because they attempt to classify behavior and learning in terms of discursive and taxonomic metaphors. Since the definition of quality varies from one culture to another, issues of "concept" originality, good "craftsmanship," balanced "composition," and level of "commitment"—the traditional criteria for grading children's art work—are suspect when assumed from a singular cultural perspective. Qualitative research in education, based on the ethnographic practices of anthropology, comes closest to understanding the complexities and contradictions of classroom instruction as ritual performance. If all teaching is political in that it represents cultural bias, as McLaren argues (1993, pp. 83–84), then it stands to reason that the evaluation of performance art teaching consists of counterhegemonic criteria. McLaren makes a value distinction between "bad" instructional rituals that "constrain the subjectivities of the students by placing limits on oppositional discourse, reflective dialogue and critique" (p. 84). In comparison, he characterizes "good" schooling rituals as those that "create an alternative to hegemony (counterhegemony) which will enable participants to critically reflect upon the way reality is perceived and understood" (pp. 84–85).

McLaren's counterhegemonic condition parallels Clifford's and Taussig's notions of a cultural hybrid and Ulmer's semiotic pedagogy, all of which call for performance art teaching strategies. The intervention of performance art pedagogy counters the rituals of traditional schooling by providing educational discourse that repositions students' cultural identities as new centers. The representation of identity through the interdisciplinary and intercultural strategies of performance art provides students with an opportunity to inscribe their voices upon the ritualized narratives of mainstream art instruction in the schools.

3

The Emancipatory Pedagogy of Performance Art

What is pedagogy? What is performance art? What do these seemingly incongruous forms of cultural work have in common? What are the possible consequences of a performance art pedagogy? To respond to these and other questions regarding the pedagogical character of performance art, I compare the critical strategies espoused by progressive educators and performance theorists with those rendered in performance art works. The praxis of postmodern theory, performance art espouses the critique of cultural codes and the development of political agency. A pedagogy founded on performance art represents the praxis of the postmodern ideals of progressive education, a process through which spectators/students learn to challenge the ideologies of institutionalized learning (schooled culture) in order to facilitate political agency and to develop critical citizenship. Throughout this chapter, I will refer to "artist/teacher" and "spectator/student" as parallel roles to convey the similarities between artists and teachers as cultural agents and spectators and students as cultural depositories. Moreover, my struggle to assign these roles an absolute position is due to their shifting, interchangeable characteristics. Under the circumstances of performance art pedagogy these roles frequently reverse, for example, when performing subjectivity students become artists/teachers.

In his 1972 performance *1,000´ Shadow,* artist Dennis Oppenheim presented a tribute to his recently deceased father in the dark of night

Paper presented at the National Art Education Association Annual Conference in New Orleans, Louisiana, April 1997.

by projecting the intense beam of a carbon-arc searchlight out and over the Atlantic Ocean from the edge of a cliff. Splitting the beam by standing in front of the lighting apparatus and facing out toward the sea, he created a dark, empty void with his body. Oppenheim then took a trumpet in hand and proceeded to blow long, sustained notes, filling the void with sound. The presence of the artist's body and the materiality of "sound" and "light" evoked mystical qualities that provided a spiritual testament to his dead father. Although Oppenheim's piece represents only one example of a wide range of works that constitute performance art, it illustrates the theme of this chapter: the liminality of performance art as transgressive pedagogy.

A limen (*Figure 3.1*) is a threshold, a border, a neutral zone between ideas, cultures, or territories that one must cross in order to get from one side to the other. According to performance theorist Richard Schechner (1982, p. 80), people anxiously want to negotiate the limen quickly, to take sides. Its condition is unstable, indeterminate, and prone to complexity and contradiction. For the anxious, the limen serves no purposes other than demarcating absolute value between conflicting opinions. For the artist, the limen is desireable.

Oppenheim's placement of his body in the beam of the searchlight represents the cultural work of performance artists in general who intentionally reposition themselves in liminal spaces between the codes of historically determined culture in order to evoke the existential conditions of the body, its memory, and its cultural history. The liminality of performance art pedagogy corresponds to artist/cultural critic Trinh T. Minh-ha's (1990, p. 96) notion of the "reflexive interval" where cultural workers challenge and resist cultural domination and where they "construct and participate in public life" (Conquergood, 1991, p. 189). It is in this realm that performance art makes possible a context for radical pedagogy. Problematizing the binary distinctions between the private and public spheres, between high and low culture, progressive educator Henry A. Giroux (1995) argues "it is within the tension between what might be called the

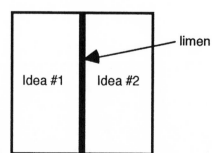

figure 3.1: A limen

trauma of identity formation and the demands of public life that cultural work is both theorized and made performative" (p. 5).

Positioned at the edge of a cliff overlooking the ocean, Oppenheim's *1,000′ Shadow* further embodies the performance artist standing at the precipice between modernism and postmodernism: two historically and theoretically distinct modes of cultural criticism. Modernist performances commenced with the conceptual investigations of the historical avant garde—the futurists, dadaists, constructivists, and surrealists—and culminated at the high point of modernism in the late 1960s and early 1970s with the body performances of Dennis Oppenheim, Bruce Nauman, Vito Acconci, and Chris Burden. Although interdisciplinary in its character, modernist performance art confined its critique to the aesthetic assumptions of western European culture. Interdisciplinarity in this instance assumed staying within the parameters of western European epistemology. Its mission to deconstruct the canon and to emerge an aesthetic relevant to twentieth-century life resulted in performance art works whose revolutionary concepts contributed to the evolution of the cultural mainstream.

The ideologies of modernism toppled, and by the late 1960s mainstream art reached a stage of minimality, a rarefied condition where content was relegated to pure form. It is within this modernist void that the critique of postmodern performance art emerged to include new areas of content in the arts during the 1970s. Performance artist Ellen Zweig (1997), suggests that performance art by the 1970s had become "an empty frame within which both the object (art) and the context (a socially constructed world) might be transformed" (p. 1). Thus, the interdisciplinary pedagogy of modernist performance art consisted of strategies to explore those domains of knowing that were exclusively based in the western European art canon. Although challenging the aesthetic assumptions of the canon, modernist performance art continued to privilege its epistemology. Its artists only ventured across its borders into other cultural domains in order to revitalize its tired aesthetic, to maintain its hegemony by appropriating and exploiting the cultural property of what were believed to be "naive and primitive" cultures.

By comparison, postmodern performance art effectuated two kinds of critique: the interdisciplinary strategies of modernism coupled with the plurality of intercultural work. This second kind of performance work originated in the 1970s with the autobiographical and highly political strategies of feminist artists such as Carolee Schneemann, Judy Chicago, Suzanne Lacy, Leslie Labowitz, Cherie Gaulke, and others. Performance theorist Rebecca Schneider (1997) argues that feminist's performance works rendered the body as "explicit," to expose it as the "stage" upon which the patriarchy acted out its cultural agenda. Renouncing the bifur-

cation of "modernism" and "postmodernism," Schneider claims that the latter is "more openly modern" (p. 138) in that it exposes the ideological underpinnings of modernism. As compared with the modernist's exploitation of primitive culture for aesthetic liberation, 1970s feminist performance artists embraced the concept of the "primitive" in order to "reclaim" their bodies and to challenge "the [patriarchal] terms of 'civilization' which marked [them] primitive" (p. 131).

Linked historically to the political theatre of Brecht and Meyerhold, the feminist's main purpose was to challenge the patriarchal epistemology of the western European canon by opening the discourse on art to include the voices of women (Lacy, 1996, pp. 4–5). Their efforts to subvert the gender bias of the canon soon were followed by those of other marginalized voices whose identities were defined by ethnicity, race, sexual orientation, and class. Thus, the critical pedagogy of postmodern performance art consists of interdisciplinary and intercultural work. While interdisciplinarity empowers spectators/students to explore and challenge the discipline-based ideas of institutionalized culture, interculturality enables them to cross borders, to challenge the biases of ethnocentricity, and to develop a world where a diversity of cultural perspectives can coexist.

This chapter examines performance art in terms of a pedagogy of intervention, the attainment of agency, and the multiplicity of its discourses in relationship to postmodern theories in anthropology, linguistics, the arts, and education. When borders separating the private sphere from the public and entertainment from politics are blurred, performance art pedagogy serves as a vigilant process to distinguish between domination and self-determination. A new genre of public art, performance art pedagogy emphasizes collaborative processes rather than the production of cultural objects. Instead of calling attention to itself or to the authorship of a single individual, it encourages citizens to work collectively, to discuss issues, and to affect change in their neighborhoods and communities (Brenson, 1995; Lacy, 1995). In doing so, citizens are positioned to create new cultural myths and new master narratives.

PERFORMANCE AS SITE OF INTERVENTION

Returning to progressive educator Peter McClaren's (1993) three types of ritual performance in education mentioned in the previous chapter, the hegemonic overlord represents the authoritarian teacher whose academic text serves as immutable law. The entertainer creates "academic amusement" in the classroom—curriculum and pedagogy that appeals to student's popular tastes. Yet in the guise of pleasure, the entertainer maintains absolute control over educational content at the expense of

any critical discourse that can ensue from student's identities and histories (pp. 113–121). By comparison, the teacher-as-liminal-servant functions as cultural provocateur, similar to performance artists, operating in the breach between schooled culture and the diverse content that students bring to the classroom from their respective cultural backgrounds at home, in their neighborhoods, and from popular culture.

In terms of McLaren's types, both the hegemonic overlord and the entertainer unquestionably choose the safety of the public sphere of schooling, rarely crossing over to that of students' private experiences. In contrast, the mission of the liminal-servant is to create thresholds, to expand the parameters of liminal space (*Figure 3.2*), and to dwell in its polemical space where "meaning is contested and struggled for in the interstices *in between* structures" (Conquergood, 1991, p. 184). Similar to Oppenheim and other performance artists whose works function at limens (Schechner, p. 80; George, p. 21), the pedagogy of the liminal-servant clearly represents a postmodern and poststructural approach to education, one that resists and challenges the normative instructional strategies founded on Cartesian-based subject-object binaries, the rationalism of the Enlightenment project, and the positivism of modern art and science. Instead, the liminal-servant works in a zone of contention, "moving between the private and the public, taking from the public to examine the private, taking from the private to examine the public" (Becker, 1995, p. 58). Contention is a desirable state. It is the principle means by which spectators/students become critical thinkers and participate in society as critical citizens.

By entering the contentious zone, the liminal-servant reclaims the self and the body as a political site. To privilege its memory and cultural history for the purpose of agency in this way, six strategies related to performance art pedagogy can be characterized. First, the performance of culture represents an ethnographic strategy to query and communicate the body's physical, cultural, and historical character. Conquergood (1991) argues that "doing [ethnographic] fieldwork—requires getting

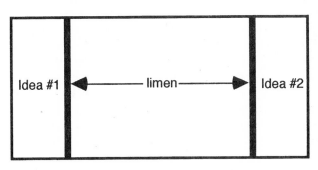

figure 3.2: An expanded limen

one's body immersed in the field for a period of time sufficient to enable one to participate inside the culture. Ethnography is an *embodied practice;* it is an intensely sensuous way of knowing" (p. 180). For the purposes of performance art pedagogy, "fieldwork" is not confined to cultural experience outside one's self and body, but is autobiographical in nature. It functions reflexively as spectators/students challenge schooled culture through their own memories and cultural histories. In addition to Conquergood, the anthropological theories of Victor Turner (1986) and James Clifford (1988), the performance theories of Richard Schechner (1982, 1988, 1993), and the study of play by Brian Sutton-Smith (1979) and Johan Huizinga (1950) are essential to ethnographic performance.

Second, the performance of language represents a linguistic strategy to critique those cultural metaphors that codify and stereotype the self and the body in order to emerge a language of identity. The body loses its identity and becomes text as it is inscribed with cultural codes. Performance art pedagogy enables spectators/students to play with language in order to deconstruct its authority. The Russian linguistic theorist Mikhail Bakhtin's (1996, 1965) notions of the dialogic imagination and carnival and the French critical theorist Julia Kristeva's (1967) connection of Bakhtin's semiotics to performance are key to understanding the critique of linguistic codes as performance.

Third, the resistance to cultural domination represents the performance of political strategy to challenge the body politic. The contested space of performance art pedagogy teaches spectators/students how cultural identity work functions politically to achieve agency within schooled culture. Here, the oppositional pedagogies of Ivan Illich (1971), Paulo Freire (1993), Henry A. Giroux (1993, 1995, 1996), and Stanley Aronowitz (1993) provide a theoretical background, while Goat Island's "spectacles of resistance," Robbie McCauley's antiracism "talkabouts," Tim Miller's antihomophobia work in *Fruit Cocktail,* the Guerrilla Girls' feminist urban interventions, and Guillermo Gómez-Peña's intercultural discourse in *Border Brujo* provide examples of a politics of resistance through performance art.

Fourth, the performance of community represents a social strategy to empower citizens to work collaboratively in restoring the cultural identities and civility of their neighborhoods. The theoretical writings of Suzanne Lacy, Patricia C. Phillips, and Suzi Gablik (In Lacy, 1995) describe the sociological character of community-based performance. Moreover, Lacy's performance *The Roof Is on Fire* (1992), where adolescent youth discussed critical social issues while sitting in new automobiles on the rooftop of a downtown Oakland, California garage; Merle Ukeles shaking the hand of every New York City garbage collector over

an eleven month period in *Touch Sanitation* (1979–80); and John Malpede's skidrow workshop *LAPD* (Los Angeles Poverty Department) for the homeless serve as examples of community-based performance art.

The fifth pedagogical strategy represents the body's intervention in technological culture through the performance of mechanical and electronic imaging devices. Notwithstanding a century of machine-body explorations, cultural theorist Donna Haraway's (1985) recent critique of modern science and technology and the Australian performance artist Stelarc's performative *Third Hand* and his other implantations of mechanical and electronic technologies within the liminal space of his body provide examples of cultural work currently dedicated to exploring the politics of body/technology interventions.

Finally, the ecstatic strategy of performance art pedagogy renders the phenomenon of the body explicit, as a site upon which culture inscribes its codes that, when reclaimed by the performance artist/teacher, serves as material for aesthetic experience and expression. Philosopher Drew Leder (1990) describes the ecstatic body as "a field of immediately lived sensation . . . Its presence fleshed out by a ceaseless stream of kinesthesias, cutaneous and visceral sensations, defining . . . [the] body's space and extension and yielding information about position, balance, state of tension, desire, and mood" (p. 23). Performance art pedagogy represents the embodied expression of culture as aesthetic experience— that is, pedagogy as performance art and performance art as pedagogy. In doing so, it calls attention to the forms through which they are performed. Leder claims that the body's experience of forms represents an "aesthetic absorption." He writes that "the world comes alive empathically within my body, even as I experience myself as part of the body of the world" (p. 166). Similarly, the appreciation and creation of performance art works is a fully embodied, ecstatic experience that takes place through aesthetic absorption.

Leder bases his concept of the 'ecstatic body' and its aesthetic absorption on phenomenologist Maurice Merleau-Ponty's (1968) "chiasm," an intertwining of subject and object, self and body, and body and world. Chiasm represents the body's experience of the world as "flesh" claims Merleau-Ponty.

The flesh is not matter, is not mind, is not substance. To designate it, we should need the old term "element," in the sense it was used to speak of water, air, earth, and fire, that is, in the sense of a *general thing*, midway between the spatio-temporal individual and the idea, a sort of incarnate principle that brings a style of being wherever there is a fragment of being. The flesh is in this sense an "element" of Being. (p. 139)

As the body in performance art serves as the principle means by which subjectivity is expressed, it intertwines with the "flesh" of the world through a process of "reversibility," argues Amelia Jones (1998). "The relation to the self, the relation to the world, the relation to the other: all are constituted through a reversibility of seeing and being seen, perceiving and being perceived, and this entails a reciprocity and contingency for the subject(s) in the world" (p. 41). Through performance art, the Cartesian binaries of subject and object are brought into a consanguineous, interconnected relationship whereby the body and world are experienced as one flesh.

The six pedagogical strategies of performance art are not mutually exclusive domains that function within a closed system. On the contrary, as seen in *Figure 3.3*, they provide interconnected possibilities for challenging cultural codes and re-presenting the body similar to the principles of rhizomatic structures described by cultural theorists Gilles Deleuze and Félix Guattari (1987). Accordingly, the ethnographic, linguistic, political, social, technological, and ecstatic strategies of performance art pedagogy are interconnected with the body. They represent a heteogeneous community. There are no fixed points; their interrelationships change in nature as their connections expand to new possibilities. In the event of a break in linkage, their interconnecting lines "tie back to one another." Like a map, their configuration is "open and connectable in all of its dimensions; it is detachable, reversible, susceptible to constant modification" (p. 12).

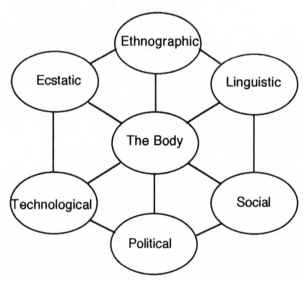

figure 3.3:
Pedagogical strategies
of performance art

For example, although Stelarc's linkage and exploration of his body with mechanical and electronic devices represents an actual intervention with technology, his performances do not preclude the metaphorical understanding of his body's technoculture as ethnography, changing the body's linguistic context through technologies; resisting the body politic which dictates the how, when, and where of body-technology interventions; and contributing to the social development of a cyber/cyborg community. In doing so, Stelarc's body functions technologically on two levels: first as a metaphorical instrument that probes and dismantles its own socially constructed identity; and second, as cyborg, a reconstructed hybrid identity that literally hosts technological devices within and without its physiological structure. The "cyborg myth," according to Haraway (1991), "is about transgressed boundaries, potent fusions, and dangerous possibilities which progressive people might explore as one part of needed political work" (p. 154).

Thus, performance art pedagogy provides spectators/students multiple strategies with which to critique cultural, linguistic, political, social, technological, and ecstatic codes and to re-present themselves with ideas, images, and actions from the vantage point of their respective subjectivities. Moreover, the performance artist/teacher functions as a liminal servant located in a zone of contention and inscribed within the postmodern condition like Dennis Oppenheim in *1,000′ Shadow*. To better understand this liminal space as a site of critical pedagogy let us examine the qualities of postmodernism that characterize this historical moment.

Schechner (1982) identifies ten qualities of postmodernism that are essential to the expanded interdisciplinary and intercultural field of performance art pedagogy: multicentricism, paradox, participation, indeterminacy, interdisciplinarity, reflexivity, dream logic, body intelligence, process, and interculturality (pp. 120–124).

1. *Multicentricism*: The critique of cultural codes, the attainment of agency, and the involvement in community through performance art pedagogy challenges the dominant center of culture and fosters the emergence of multiple centers, each working in collaboration with the other. The net effect is a redistribution of power relations.
2. *Paradox*: In opposition to rarefied forms of culture, there exists a delight in complex and contradictory propositions of performance art pedagogy. Conceptual, emotional, and physical variations are sought after and appreciated for their differences.
3. *Participation*: Distinctions between artist and spectator, teacher and student are blurred through performance art pedagogy. All who are engaged in its critical process are in the position to create new cultural representations and to participate as citizens in a cultural democracy.

4. *Indeterminacy*: Performance art pedagogy challenges cultural absolutes, the historically determined codes, assumptions, and ideologies of art and schooling. Interpretations are not fixed but determined by the changing circumstances and situations in which spectators/students find themselves.

5. *Interdisciplinarity*: All modes of communication are available in performance art pedagogy, including discursive and nondiscursive language. In addition, the consideration of multiple technologies, materials, and/or processes for communication represents possibilities for collaboration between disciplinary specialists working together to facilitate a community discourse.

6. *Reflexivity*: The flow of cultural discourse and production is directed back on itself as a self-critical process to distinguish its limits and impediments, to an open cultural discourse. Schechner suggests, "Sometimes we're in [the culture], sometimes we're out of it. Even when we're out of it; and even when we're in it, we're out of it watching ourselves in it" (1982, p. 122).

7. *Dream Logic*: The ebb and flow of images in the mind are not considered psychological aberrations or "secondary reflections of hidden primary process" in need of interpretation. Instead, dreams represent the revelation of the body's ideas, emotions, and desires. The coexistence of these images within the mind and their unpredictable patterns represent performance art cognition. Performance art pedagogy fosters thinking and production where interpretations are in continual flux like dream imagery.

8. *Body Intelligence*: Performance art pedagogy maintains that body knowledge is as significant to human expression as "cerebral cortex thinking." Culture affects the body as much as the mind. Both the body and the mind are connected contrary to Cartesian philosophy. Because cultural patterns inscribe the body and determine its participation, performance art pedagogy focuses on the body as a site for cultural resistance.

9. *Process*: Performance art pedagogy fosters a delight in process rather than object-oriented culture. In art and educational contexts, what is revealed in the process of discussion, production, or reflection is believed to be more significant than a work that exists in a finished state isolated on a pedestal, a stage, or a wall.

10. *Interculturality*: Cultural identity and the attainment of agency are essential to artists' and students' production of creative work. Performance art challenges the monocultural ideology of nationalism and recognizes intercultural discourse as essential to critical citizenship in a democracy.

The liminal-servant subverts and problematizes Western epistemologies by repositioning the student in the liminal zone that separates the public sphere of schooling from the private experiences of culture. By doing so, school curricula, which essentialize cultural binaries, codes,

and learning behaviors, are transformed into reflexive learning processes whereby students' subjective experiences and knowledge are recognized as critical content. The pedagogy of the liminal-servant teaches students to think and act critically in classrooms, to challenge the historical and cultural assumptions that they are taught in schools, at home, in the church, in the media, and in other sites where their identities and expressions are at risk.

Critical thinking is not intended merely to improve test scores; it is not task, discipline, nor culture specific. Instead, it enables students to cross historically and institutionally determined disciplinary and cultural boundaries in order to gain multiple perspectives and to participate in the discourse on educational content. Under such circumstances, classrooms are transformed into liminal spaces, sites of contestation where the struggle to learn takes place as the politics of learning is challenged with the interpersonal, interdisciplinary, and intercultural perspectives that students bring to school (Becker, 1996). These strategies correspond to those of the performance artist for whom no cultural site is beyond reproach nor impervious to critique. Instead, they foster dialogue, civility, and participation in a cultural democracy. If we are to understand the congruence of these performance artists' strategies as critical pedagogy, we must examine the postmodern theories that inform their work. In other words, what is the theoretical basis for performance art pedagogy? How does it work as cultural critique?

PERFORMANCE ART IS NOT THEATRE

Unlike conventional theatre, performance art does not dispense information to spectators through closed narrative conventions. Instead, it incites communication through intervention, a direct involvement of spectators in deliberating the binary oppositions contested by the artist. This transformative questioning process shifts the role of spectator to one of participant. For example, from 1983 through 1984 performance artists Linda Montano and Tehching Hsieh tethered themselves to one another with an eight-foot rope, vowing neither to touch each other nor to untie the rope for a year, thus creating a situation for themselves and their "bound" bodies where nothing could be left to assumptions nor old habits. All decisions for *Art/Life One Year Performance* had to be negotiated. Even the most prosaic aspects of tending to one's own bodily needs, working, exercising, sleeping, eating, defecating had to be accomplished by making continual adjustments, compromises, and relinquishing control to the other. According to Montano, the performance was "a chance for the mind to practice paying attention, a way to stay in the moment" (Carr, 1993, p. 5). Montano and Hsieh, by re-presenting

their bodies as binaries in the public sphere of performance, called attention to conflicting cultural representations particularly those based on gender, race, age, and size differences. For those spectators who publicly encountered the artists in these dialectical conditions, their physical, conceptual, and emotional negotiation of the year-long performance constituted a performative/participatory action as well.

Challenging the aestheticized monoculture of theatre, Schechner (1988) refers to performance events such as those of Montano and Hsieh, where the performers and spectators intervene a "genuine" cultural problem, as "actuals." His five qualities of actuals consist of "1) *process*, something happens *here and now;* 2) *consequential, irremediable,* and *irrevocable* acts, exchanges, or situations; 3) *contest,* something is *at stake* for the performers and often for the spectators; 4) *initiation, a change in status* for the participants; 5) space is used *concretely* and *organically*" (p. 51). These qualities make the attainment of agency possible as artists/teachers and spectators/students learn to "actually" intervene in the liminal spaces of codified culture through performance art. Let us look at another example of performance art and how and why it is not theatre.

Resisting the tendency to label his "actuals" as aestheticized theatre, Allan Kaprow has used terms such as *happenings, actions, events,* and *activities,* where disparate objects, materials, processes, and sites coexist within a "non-matrixed" space and represent themselves without intentionally contributing to any overall meaning. This "compartmentalized" nonreferential structure functions much like a "live" assemblage where each component coexists in an arbitrary relationship within a larger body of activity (Carlson, 1996, p. 96-97). The script for *Household* (1964), a happening that was performed at a "lonesome dump out in the country," attests to the nonreferential character of Kaprow's happenings. A portion reads as follows:

 I. 11 A.M. Men build wooden tower on a trash mound. Poles topped with tarpaper clusters are stuck around it. Women build nest of saplings and strings on another mound. Around the nest, on a clothesline, they hang old shirts.

 II. 2 P.M. Cars arrive, towing smoking wreck, park outside dump, people get out. Men and women work on tower and nest.

 III. People circle dump, out of sight among trees and behind tin wall, wait. Women go inside nest and screech. Men go for smoking wreck[ed car], roll it into dump, cover it with strawberry jam. (Kaprow, 1966, pp. 323–324)

From here, the happening continues as the participants engage the disparate "material culture" of the dump, carrying out actions that are

clearly delineated by Kaprow's open script. The happening ends when "everyone smokes silently and watches [the wrecked] car until it's burned up." Then all the participants leave quietly (Kaprow, 1966, pp. 323–324). The actors, props, and stage in the matrix of traditional theatre perform fictional characters who carry out fictional tasks with each leading toward the meaning of the play as structured by the script. Unlike theatre, where each action leads to an overall meaning, the disjunctive, nonreferential activities of *Household* present the possibility of multiple access points and multiple readings.

To better understand the nonmatrixed conditions of performance art, we must differentiate between 'place' and 'space.' 'Place' signifies schools, museums, religious institutions, the government, corporations, and other ideological institutions whose cultural agendas prescribe and codify the body's cultural performance. Performance theorist Vivian Patraka (1996) suggests that "performance place, then, is narrativized in advance, soliciting us to perform the script that is organized for and given to us" (p. 100). By comparison, 'space' signifies the spectator's/student's body itself, a site from which she/he resists cultural domination and achieves political agency. Each body represents a space in a complex of spaces that comprise the society. The memory and cultural history work of the collective represents multiple interpretations of culture "which situate/produce the spectator [and student] as historical subject" (p. 100).

The space, which Patraka suggests transforms the spectator/student from the object to the subject of performance, makes possible the construction and acting out of identity or what can be referred to as "performances of subjectivity." The public places where art and education are staged and performed are devoid of cultural neutrality. Museums, concert halls, theatres, schools, and higher education serve as institutions that inscribe the body politic on the spectator's/student's body. The interrogation and subsequent remonstrative actions that challenge the exclusionary dynamics of these cultural institutions constitute creating performative spaces, heretofore nonexistent, where the politics of inscription and representation can be debated and agency self-determined. According to performance theorist Daniel E. R. George (1996, p. 18), the potential for spatial critique through performance finds its complement in cognition in the form of liminal, contingent, and ephemeral epistemologies where knowledge is not "narrativized in advance" but determined by the coexistence of cultural experiences that each participant acts out through performance.

Returning to the question of why not theatre, Patraka's notion of performance space is not what we ordinarily associate with aestheticized activity. George (1996) claims, "Whereas in the past, performance was

seen as one example of the theatrical realization of a text, today theatre [and all aestheticized culture] is seen as one example of the category performance" (p. 24). Thus, performance art is not theatre, but theatre is performance art in the broader postmodern sense. The same can be said of any time-based art form such as dance or music. Even the definition of performance art has shifted and expanded since the 1970s. To assume when a performance artist is acting out, engaged in movement, or making sound that theatre, dance, or music is being invoked is a common misconception. The performance artist may borrow from each of these disciplines but is not limited by them nor any disciplinary convention. It is in the visual arts that performance art works, like those of Oppenheim, Montano and Tsieh, and Kaprow, seem to have escaped such confusion. This is largely due to the decontextualization of such works from static, representational to dynamic, real time and space circumstances.

The conflation of performance art by Rachel Rosenthal with theatre and Bill T. Jones with dance, for example, easily dismisses the postmodern, poststructuralist strategies employed in their work. It is their critique of cultural codes, their struggle for agency, and their resistance to conclusions, boundaries, definitions, and limits that clearly distinguishes their cultural work as performance art. Rosenthal's interdisciplinary "doing-by-doing (DbD)" strategies evolved from her work in Instant Theatre. Through "continual workshopping," she and her students resist improvisational outcomes that lack cohesion. Instead, they work toward a "spontaneous and collective ordering of chaos," which they assemble from their personal memories and cultural histories (Roth, 1997, p. 31). She describes her pedagogical process as a way of blurring the boundaries between the self and its cultural context and the self and other human beings "so that the whole body begins to come alive to awareness of energies coming in from other people" (Burnham, 1997, pp. 46–47).

Comprised of daily workshops, rehearsals, and improvisations, Rosenthal's DbD strategies enable her and her students to challenge contemporary cultural issues such as women's oppression, cruelty to animals, and the ecological devastation of the earth (Zurbrugg, 1994, pp. 37–43). Performances such as *file name: FUTURFAX (1992, Figure 3.4)*, where she performs in the present but receives a fax from the future foretelling of an ecological doomsday, are "set" in the theatrical sense when a unique structure evolves through improvisation and rehearsal. Once set, however, her script does not remain static. Rosenthal allows her script to stay open to new possibilities: information, ideas, feelings, and gestures that she may encounter during the day and deem appropriate for that evening's performance.

In *Still/Here*, Bill T. Jones examines the issues that threaten the body's health. Instigated by the loss of his partner Arne Zane to AIDS

figure 3.4: Rachel Rosenthal, *FUTURFAX*, 1992. Photo by Jan Deen

and his own positive HIV status, Jones's audio- and videotaped interviews and movement workshops with persons stricken with terminal illnesses structure his performance. His sensitive choreography was directly influenced by the personal stories, gestures, and movements that terminal patients shared orally and with their bodies in the workshops. For Jones, the patients' involvement represented a collaborative process. The stage set for *Still/Here* was sparse. In addition to theatrical lighting and music especially scored for the performance, it contained three large video screens upon which were projected patients' "talking heads," telling of living with illness and disease. These screens were technically constructed and "choreographed" to move upstage and downstage, thus creating a visual crescendo that corresponded with the movements of the music and the dancer's bodies. While dancers performed around the moving screens, they created a space that accomodated the virtual presence of the afflicted. Within the context of the performance, the patients' "testimonies of survival" challenged the punitive representations often associated with death and dying and, instead, re-presented the afflicted body with civil and compassionate metaphors.

New Yorker dance critic Arlene Croce's (1994) refusal to critique Jones's performance because of its transgression from traditional dance and theatre, its contingency on actual accounts of terminality which she

refered to as "victim art" (pp. 54–55), and its struggle for cultural iden-
tity underscores its performance art character. In her attempt to write
about *Still/Here*, Croce claimed being faced with four options: "(1) to see
and review; (2) to see and not review; (3) not to see"; and, (4) "to write
about what one has not seen" (p. 54). She chose the latter option be-
cause she felt "excluded by reason of [the performance's] express in-
tentions, which are unintelligible as theatre" (p. 54). Ironically, Croce's
refusal places Jones squarely in the liminal zone of traditional dance the-
atre that he is contesting.

Thus, cultural performance is not limited to an essentialized pro-
gram of aesthetics. Part of a complex cultural system, it represents the
"acting out" of spectator's/student's subjectivity, a metaphor that distin-
guishes theatre from the "social dramas" (Turner, 1986) found in every-
day life, the cultural and prosaic actions, rituals, and events that affect
responses in our bodies and our understanding of reality on a daily ba-
sis. By calling attention to and acting out the effects of culture on the
self through performance, the (artist's) body is transformed from being
the resigned object of culture to a reflexive subject, from mere con-
sumer to that of a critical producer.

> As an epistemology, performance offers a rediscovery of the now; relocation
> in the here; return to the primacy of experience, of the event; rediscovery
> that all knowledge exists on the threshold of and in the interaction between
> subject and object; a rediscovery of ambiguity, of contradiction, of differ-
> ence; a reassertion that things—and people—are what they do. (George,
> 1996, p. 25).

Once subjective awareness is acknowledged, any action that draws from
that awareness is reflexive, or "twice-behaved-behavior," according to
Schechner (1993, p. 1). It is this alterity of performance art that enables
the student/spectator to see one's self, body, and culture as an other
that further distinguishes it from theatre. In this state of autobiographi-
cal reflection, cultural identity and history are made available as content
for both self-expression and self-critique.

THE MULTIPLE DISCOURSES OF PERFORMANCE

The five strategies of performance art pedagogy outlined earlier repre-
sent ways in which to challenge historically determined codes and to fa-
cilitate multiple discourses in society. As spectators/students attain
agency through performance art pedagogy, their critical citizenship and
collective production will manifest democracy in action. What are the

theoretical bases for a multicentric pedagogy based in ethnographic, linguistic, social, political, technological, and ecstatic cultural performance?

Russian linguistic theorist Mikhail Bakhtin (1981) suggests multiple and coexistent circumstances in the performance of language to be "dialogical." He maintains that all forms of discourse, formal and colloquial "utterances," are determined by "heteroglossia," individual interpretations and cultural contexts that are in continual flux (p. 272). In his characterization of performance, Carlson (1996) cites three aspects in which all words exist for Bakhtin:

> [1] . . . as a neutral word of language, belonging to nobody; [2] as an *other's* word, which belongs to another person and is filled with echoes of the other's utterance; and, finally [3], as my word, for, since I am dealing with it in a particular situation, with a particular speech plan, it is already imbued with my expression. (p. 57)

Each utterance functions like a node in a nonmatrixed system of discourse. Similar to the reticular structures of Ivan Illich's "learning webs" (1971, p. 76), Nicolas Paley's rhizomatic system of learning (1995, pp. 8–9), and Richard Schechner's "performance web" (1988, pp. xii–xiii), utterances are not exclusive to any particular group, yet they always function as an appropriated phenomena—as the "other's" word. The multiple characteristics of utterances derived from their different cultural contexts, not their summation into a totalized language, contribute to a broader understanding of reality. Thus, "it is by appropriating, or populating, social languages and speech genres that utterances take on their meaning" (Wertsch, 1991, p. 86).

Ebonics, the controversial black English dialect approved by the Oakland School District in California in 1996, is an example of Bakhtin's language performance derived from utterances. Ebonics gives voice to the majority African American student body in Oakland. Like other dialects found in English literature, black English is part of American cultural life. The musical styles of jazz, blues, rock 'n' roll, rap and much of American fiction, poetry, and film embody the dialect. It is so pervasive that it is commonly accepted as an original American idiom. The Oakland decision resulted in public outrage by both blacks and whites, who assumed that teaching Ebonics precludes the study of formal English. If this were to be the case, they argue, black students would be held hostage by their dialect. By not learning the formal skills of English, they would be unable to enter the cultural mainstream and subsequently the job market.

What detractors have not understood is that the inclusion of Ebonics legitimizes African American culture; it is a means of assuring

agency for black students. As educator Jerome D. Williams (1997) has so effectively argued, "the aim is to have teachers learn the structure of Ebonics so they can be more effective in helping students see how the structures differ from structures constituting standard English" (p. 4A). Similar to Bakhtin's utterances that are context determined, educator Phillip Royster (1997) argues that language is evaluated linguistically and socially. When linguistically considered, the correctness of Ebonics is determined by its usage in the black community. When socially considered—for example when applying for a "managerial position at a major corporation"—the probability exists that it is inappropriate. In either case, Royster argues, neither usage is more correct nor more intelligent (pp. 7, 9).

As compared with the dialogical character of languages like Ebonics, Bakhtin refers to the pedantic performances of language as "monologisms," discourse that is not responsive to context. Instead, it is univocally determined by the content of dominant texts that represent the autonomous vision of a single author, director, or pedagogue. Bakhtin presents the possibility that performance in the arts, in education, or in any aspect of culture, can function as dialogical discourse, as a linguistic strategy to resist monologisms by giving voice to spectator's/student's multiple contexts of personal memory and cultural history.

To understand Bakhtin's monologisms as aesthetic or pedagogical "law," consider law professor Bernard J. Hibbitts's (1996) notion of "performatizing" as a means to re-consider legal texts "as instruments of performance rather than documentary ends in themselves" (p. 5). His five connections between law and performance, when examined from the perspective of schooling and artistic expression, provide some interesting insights about the necessity of performative action in negotiating the "monopoly" of cultural codes. First, Hibbitts argues that "performance makes law a part of our physical selves" (p. 3). All disciplines and cultures are expressed through our bodies. Contrary to Cartesianism, the thinking brain, with its ability to express experience in discursive language, does not preclude the comprehensive nondiscursive actions and reactions of the body in the interpretation and expression of cultural experience. Second, "law is memorialized in performance," according to Hibbitts. It is through the culturally determined rituals of schooling that the "memory" of academic and aesthetic assumptions, codes, and texts are "invented, and if necessary re-invented." Here Hibbitts reminds us that the recall of cultural history and memory does not assume a hegemonic act. The conditions of memorialization depend on the manner in which it is performed.

Third, "law is located in performance" because it "takes place both in space and time." Performance invokes academic and aestheticized

culture for the purpose of making it "accessible to human understanding" within the context of contemporary culture. In this way, performance "transforms the ordinary into the extraordinary, the self into the other, and the transient into the timeless." Fourth, Hibbitts claims "law is celebrated in performance." With regard to schooling and art making, the re-collection and re-presentation of cultural codes through performance "accentuates the ludic or playful quality of [their] law: law not merely in the sense of game, but in the sense of a restorative, literally re-creative improvisation that can be shared with other members of the community" (p. 4).

Finally, Hibbitts's fifth connection, "law is subverted in performance," represents actions that challenge and resist the "letter of the law" in order to elicit its "spirit" when applied to complex cultural experiences. Here, Hibbitts does not assume subversion to be limited to overt acts of social and political activism. The discreet, underground acts of resistance found in a teacher's critical pedagogy or in a student's challenge of academic assumptions and codes can also provide "structured opportunities for the expression of dissent" (p. 4). Hibbits's notions of "de-scribing" and "performatizing" the discipline-based practice of law (p. 5) suggests anthropological, linguistic, political, social, technological, and ecstatic strategies similar to those that distinguish performance art pedagogy. To "de-scribe" is to reclaim the body as the slate upon which cultural codes are *in-scribed* through schooling and other forms of institutionalized culture. To "performatize" is to re-consider cultural codes as instruments of cultural performance.

A THEORETICAL CONTEXT
FOR PERFORMANCE ART PEDAGOGY

According to performance theorists such as Antonin Artaud (1958), Augusto Boal (1979), and Richard Schechner (1988); anthropologist Victor Turner (1986); and progressive educators such as Paulo Freire (1993) and Henry A. Giroux (1992), the transformation of the artist/teacher or spectator/student from the object to the subject of cultural history requires liberatory forms of action. In such circumstances, historically determined "places" of art and schooling can be re-configured as "spaces," sites wherein their pre-scripted, discipline-specific, and monocultural objectives are challenged in the struggle to remain open to new areas of content. The postmodern pedagogy of performance art makes such circumstances entirely possible. Let us consider the performance theories of Artaud, Boal, and Schechner in terms of a critical pedagogy.

For Artaud, the theatre "doubles" when it bifurcates the role of the author's/director's script from that of the performer's/spectator's and

thus creates a condition where life imitates art in the form of reified culture. This doubling effect limits content to the subject of historical texts and places both performers and spectators as objects of its communiqué, resulting in "a culture which has never been coincident with life, which in fact has been devised to tyrannize over life" (1958, p. 7). To prevent the oppression of the script, Artaud calls for a "theatre of cruelty" to incite a "culture-in-action" through resistance, crisis, and contingency. Citing psychiatrist R. D. Laing's research on schizophrenia, critical theorists Gilles Deleuze and Félix Guattari (1977) characterize Artaud's critique of theatre as a form of madness where "breakthrough," as compared to "breakdown," is possible (p. 131). The manifesto of "The Theatre of Cruelty" reads much like the transgressive poststructuralist pedagogies of Freire, Giroux, and other progressive educators that I will discuss later.

Artaud declares: "choose subjects and themes corresponding to agitation and unrest characteristic of our epoch"; "renounce the theatrical superstition of the text and the dictatorship of the writer"; "base the theatre upon spectacle before everything else" (pp. 122–124). For Artaud, spectacle transforms the closed system of traditional Western theatre into an open site, one in which the proscenium's division is eliminated and the performer/spectator is no longer passive but is presented with the possibility of being directly involved in the creation of the performance. The proscenium metaphor can be applied to educational institutions as the invisible line that separates the objectives of schooling from those of teachers and likewise between teachers and their students. Students quickly learn about the unworthiness of their perspectives within the circumstances of academic culture.

Artaud's desire to transform the spectator into a participant finds its parallel in Augusto Boal's *Theatre of the Oppressed* (1985). Boal believes that knowledge of the body's actions and language is essential in its challenge and liberation from oppressive historically determined performance texts. "Knowing the body," "making the body," "theater as language," and "theater as discourse" represent the four strategies of his pedagogy (p. 126). Similar in spirit to Kaprow's experimental pedagogy of Happenings discussed previously, Boal's objectives seek the liberation of creative thought and action from the tyranny of oppressive culture.

According to philosopher Drew Leder (1990), although we inhabit and use our body throughout our lives, we take its presence for granted as we direct our attention out into the world. In other words, our natural tendency is to consign the presence of our body's phenomena to assumption, thus rendering it absent from our awareness. Mindful of this absence, Boal first recommends "knowing the body," a series of exercises for performers and spectators to gain awareness of the physical, con-

ceptual, and emotional characteristics of their bodies, knowledge that can be used as material or content in performance. Thus, for Boal knowledge of the body requires re-visiting its terrain in order to learn of its "limitations and possibilities, its social distortions and possibilities of rehabilitation" (pp. 126–130).

"Making the body expressive," Boal's second strategy, engages the body's re-discovered phenomena as performance material and content while it abandons other "more common and habitual forms of expression" (pp. 130–131). Here, emphasis is placed on exploring and playing with the body's resources, not their interpretation.

For his third strategy, "theater as language," Boal suggests the "practice" of the newly found phenomena and expressions of the "living and present" body. In doing so, he believes a language of performance will emerge predicated on the body's specific physical and cultural experiences, not on theatrical images and ideas from the past. Allan Kaprow refers to Boal's notion of practice as "basic research" which the artist must undergo to discover and experience hidden phenomena. Schechner (1988) underscores the significance of this strategy in his "rehearsal process," as a means of improvising, selecting, editing, and performing a variety of possible actions (p. 183). Thus, for Boal, practice is not the repetition of some prescribed text, but a process of improvisation that continually draws from the body, its phenomenological and cultural context, in order to create a language of performance. The development of this language occurs in three stages: in the first stage, simultaneous dramaturgy, "the spectators 'write' simultaneously with the acting of the actors"; in the second stage, image theater, "the spectators intervene directly, 'speaking' through images made with the actors' bodies"; and, in stage three, forum theater, "the spectators intervene directly in the dramatic action and act" (pp. 131–142).

Finally, Boal's fourth strategy for a liberatory theatre, "the theater as discourse," represents the culmination of his pedagogy. Here, after the body's awareness has been gained, its physical, conceptual, and emotional resources explored, and its language developed through practice, a discourse for performance emerges. Boal provides seven examples where this new discourse can be applied: newspaper theater, invisible theater, photo-romance theater, breaking of repression, myth theater, trial theater, and masks and rituals. For example, newspaper theater transforms news articles from the daily paper and other nontheater information into performances. Invisible theater is the unannounced site-specific performance of a scene in a nontheater location, in a crowd of people who are not spectators, yet whose intervention is included. In breaking of repression, participants are asked to recall, to reconstruct, and to tell the story of a time in their lives when they felt "specifically

repressed, accepted that repression, and began to act in a manner contrary to [their] desires" (p. 150).

The following performance art work by students in my Los Altos High School sculpture class serves as an example of Boal's invisible theater. *Breaking Bread* (1973) took place "unannounced" on the day before Thanksgiving as a ceremonial tribute to the American holiday. The performance began promptly at 7:30 A.M. in the front courtyard of the high school, allowing the arriving students to view and participate before morning classes began. Five art students, dressed in regular clothes and avoiding any attention of theatrical reference, set up the performance space. For the most effective use of the performance space, the art students alternated their positions, with two facing east direction while the other two faced west. Wielding sledge hammers, which were placed next to loaves of bread as place settings on a dinner table, each student carried his or her individual hammer to a bucket of water where it was washed by an attending fifth student. After their hammers were washed, the students returned to their stations, and a command to begin was given by the fifth student. The students with the sledge hammers began swinging their heavy "utensils" until all the loaves of bread were broken. Then they laid down their sledge hammers and carried the stretchers of broken bread, offering, sharing, and eating the broken bread with the large number of students who had gathered to witness the performance. Notwithstanding its correspondence with Boal's invisible theater, *Breaking Bread* functioned as a linguistic strategy where the cultural metaphors of the Thanksgiving holiday, the anxiety of family holiday dinners, the validity of performance art as pedagogy, and other culturally charged issues were brought into question. The performance engaged performers and spectators conceptually, emotionally, and physically as they literally "broke bread together" and metaphorically broke the stereotypes, the cultural text that binds their bodies and their identities.

Boal's *Theatre of the Oppressed* finds its complement in Freire's *Pedagogy of the Oppressed* (1993). For Freire, a prescriptive monocultural pedagogy creates a "culture of silence" where the subjective voices and actions of those who are marginalized in a society are restricted by their acquiescence to a dominant ideology. They lack opportunities for critical response, and they learn to confine themselves to the reproduction of the dominant culture's capital. Freire considers education under these circumstances as a form of "banking," "an act of depositing, in which the students are the depositories and the teacher is the depositor" (p. 53). Libertarian education requires performative strategies of resistance where the teacher-student contradiction is "reconciled" so that "both are simultaneously teachers and students" (p. 53).

Problematizing the teacher-student binary and other cultural codes in the classroom opens a space of liminality, a neutral zone where co-operation, acceptance, and trust in the interchangeability of teacher's and learner's roles enables a free exchange and debate of ideas. Similar to Bakhtin's dialogical performance of language, the polyvocal conditions of Freire's "problem-posing" education enables students to "develop their power to perceive critically *the way they exist* in the world *with which* and *in which* they find themselves; they come to see the world not as a static reality, but as a reality in process, in transformation" (p. 64). Learning to participate in this liminal, contingent, and ephemeral reality requires a pedagogy similar to that of performance art, where teachers and learners are critically engaged in the exploration, improvisation, and performance of their subjective understanding of reality.

Hearing-impaired students at the Fachhochschule Potsdam in Germany transformed their "culture of silence" through the "problem-posing" process of performance art introduced to them by performance educator Hanne Seitz (1998). Invited by one of her colleagues to intervene in his class on social work and social pedagogy, Seitz created an activity that "disrupted" the students' assumptions and academic understanding of social work as it related to the topic of youth identity in contemporary culture. She assigned the students a collaborative project: to invent a fictional person as a social/cultural myth. After researching the topic, which included delving into their own memories and cultural histories, the students used their findings to create "a case study of Thomas H." In constructing Thomas's identity, they exposed and examined the stereotypes of youth culture found in fashion, nutrition, religion, and sexuality, demographic knowledge that is important to social work.

Seitz claims that what seemed absurd to the students at first about the assignment developed a reality of its own. As word of his "presence" on campus spread, "Thomas H. lived through his 'absence,' he existed on the grounds of rumour, on things that were literally attributed to him" (p. 79). As time passed, the students' invented features of his identity became common knowledge throughout the campus. To end their project, they decided that Thomas would die either by accident, by suicide, or by AIDS. Dressed in black, they held a thirty-minute silent memorial service. Those who attended found memorabilia exhibited; letters from his friends, a partial container of Nutella, "a notebook, a package of condomes, a lost jacket, and lots of other things" (p. 79). Ironically, however, while the exhibition was supposed to bring an end to the mystery surrounding Thomas, his mythic identity established itself even further.

In addition to youth stereotypes, Seitz argues that the Thomas H. case study enabled the students to expose and critique the stereotypes

surrounding their deafness. Although a "silent" minority on campus, they used the power of their silence to create a "loud" presence for Thomas. The entire student body of the school, previously "deaf" to the presence of these students, unknowingly participated in their project. In doing so, they contributed to the creation of the Thomas H. myth, which enabled the political agency of students who are deaf within the school. Thus, through performance art, the deaf students learned to take responsibility for situations that can emerge in their lives by creating new social realities from their silent perspectives.

Turner's (1982) anthropology of ritual and theatre correspond with the performative pedagogies of Artaud, Boal, Schechner, and Freire. Defining humanity's basic instinct to perform as *homo performans*, he argues against academic approaches to ethnography in favor of those based on lived experience. To involve students and spectators in the sociocultural and psychological complexity of culture, he espouses the use of ethnographies for the writing of scripts that can be performed by both teachers and students. In doing so, Turner claims, students can revisit their ethnographic studies with "the understanding that comes from 'getting inside the skin' of members of other cultures, rather than merely 'taking the role of the other' [or speaking for the other] in one's own culture" (p. 90).

Turner cites Schechner's rehearsal process based upon a dialogical relationship among playscript, actors, director, stage, and props, as a suitable strategy for ethnographers because he "aims at poiesis, rather than mimesis: making, not faking" (p. 93). This process is appropriate for teaching anthropology according to Turner "because the 'mimetic' method will work only on familiar material (Western models of behavior), whereas the 'poietic,' since it creates behavior from within, can handle unfamiliar material" (p. 93). Thus, the three stages of Turner's process, ethnography into "playscript, script into performance, and performance into meta-ethnography" represent a radical form of anthropology. His process reveals the limitations of a singular disciplinary and cultural aesthetic and encourages teachers and students to look beyond such boundaries to other possibilities for understanding the complexities and contradictions of cultural performance.

Turner's pedagogy of ethnographic performance reverses the order of Artaud's notion of the theatre and its double. Rather than life imitating art, his "social dramas" originate from cultural performances and are later found in "aesthetic dramas," thus creating a situation where life precedes and influences art and culture (Turner, 1982, p. 90). Similar to Artaud's "theatre of cruelty," social dramas resist the inertia of a prescribed cultural aesthetic. Manifested in four phases, they consist of dramas that originate from everyday life. Social dramas first appear as a

breach of cultural authority when a transgressive action has been deliberately committed. This irrevocable action is followed by an escalating crisis, a situation that polarizes into factional groups. Third, a phase of redress follows where adjustive measures are introduced by group leaders who take into consideration the magnitude of the breach and its implications for social relations. Finally, in the fourth phase, two outcomes are possible according to Turner. Either the agitated group is reintegrated after compromises have been attained among factions, or the breach is decided by the culture to be "irreparable" thus resulting in "spatial separation" (pp. 69–71). Significant to this discussion of performance art pedagogy, these phases represent the transgressive actions of performance artists who intentionally agitate public opinion when they confront controversial cultural issues in their work with the intention of critiquing oppressive cultural binaries and creating agency. Although their desire may be to stir up and open debate on these opinions within the parameters of a cultural democracy, often the results are redressive measures that marginalize their voices and silence their work.

Turner's three-stage ethnography of social drama resembles Giroux's (1993) "border pedagogy," a critical process of education that

> offers the opportunity for students to engage the multiple references that constitute different cultural codes, experiences and language. This means educating students to both read these codes historically and critically while simultaneously learning the limits of such codes, including the ones they use to construct their own narratives and histories. (Giroux, 1993, p. 29)

What Giroux suggests here is a performative pedagogy where students learn to "negotiate" and "cross" disciplinary and cultural borders. The cultural codes to which he refers represent the codified assumptions that Turner, Boal, and other progressive public intellectuals challenge with their respective strategies in order to open the discourse on culture, to enable spectators/students to become critical producers of knowledge. As compared with "standardized pedagogies that codify experience and shape meaning production in predictable and in conventional ways," Giroux's critical pedagogy of representation "resist[s] such formalized production of meaning by offering new channels of communication, new codifications of experience, and new perspectives of reception which unmask the political linkage between images, their means of production and reception, and the social practices they legitimate" (p. 219).

Significant to the pedagogy of postmodern performance, Giroux's condition for self-reflexivity constitutes an oppositional strategy where students and teachers learn to "check" the codes of their own narratives.

Understanding the cooptive forces of the academy, corporate capitalism, and a history that cultivates the desire for fashion, wealth, and fame through the mass media, Giroux's imperative provides a means by which to redress desire based on three political and pedagogical principles. First, the expression of desire is an "important starting point for understanding the relations that students construct to popular and dominant forms." Second, the regulation of desire positions the body politically so that students can discriminate how it functions as the object and subject of popular culture. Third, the production of desire empowers students "so as to appropriate cultural forms on terms that dignify and extend their human possibilities" (1993, pp. 195–196). Similar to Schechner's twice-behaved behavior and Turner's performance as meta-ethnography, Giroux's self-reflexive checkpoint makes possible a kind of cultural work that is responsible for its actions. Without it, the oppositional politics of a performance art pedagogy is compromised as mere reification of the modernist cult of autonomy, individuality, and originality (Conquergood, 1991, p. 191).

Moreover, Giroux's critical writings serve as examples of a performance art pedagogy. In *Fugitive Cultures* (1996), he begins with a reflexive critique of his childhood experiences growing up in an oppressive Providence, Rhode Island, neighborhood where the cultural codes of racial and class violence were played out on a daily basis in the form of turf wars. From the vantage point of this egregious cultural history, Giroux characterizes violence in popular culture as "teaching machines" that influence racial prejudice and hatred among youth. By problematizing and positioning himself between these violent codes, Giroux "acts out" his transgression through writing. Like performance artists, his intentional "rupture" of these codes represents a critique of dominant markers that assign violence to disenfranchised black youth. Ironically, like most political performance art, Giroux's "in-your-face" syntax reads like a rant, calling as many readers to action as it does detractors who loathe confrontation and believe his ideas inaccessible and therefore oppressive in themselves. This irony characterizes the risk of cultural workers in the liminal space at the cultural borders.

Consistent with Giroux's border pedagogy is performance artist Guillermo Gómez-Peña's border aesthetics. Born in Mexico, educated in the United States, and a citizen of both countries, Gómez-Peña's series "Dangerous Border Game," represents the hybrid, multicentric musings of a performance artist caught between two cultures. In the opening scene of *Borderama* (*1995, Figure 3.5*), Gómez-Peña and his performance artist collaborators have invited the participation of the audience to "come to the show in costume, dressed as your favorite cultural other,

figure 3.5: Guillermo Gómez-Peña (with Roberto Sifuentes), *Borderama*, 1995. Courtesy of Guillermo Gómez-Peña

ready to express those interracial fantasies we all have inside of us" (Gómez-Peña, 1996, p. 127).

Gómez-Peña, "(wearing a straitjacket, a mariachi hat, boxer shorts, and snakeskin Norteño boots) is paraded around the stage in a wheelchair by a 'tourist' [played by Roberto Sifuentes] (wearing a tropical dress & a blond wig, carrying a camera)" (p. 129). The performance space is riddled with an assemblage of contradictory cultural images, icons, fetishes: a naked Zapatista (with black ski mask) playing European classical music; a Chicano group playing rap music; smoke from a fog machine; a crucified skeleton; dead and feathered chickens hanging from the ceiling; large-screen video projections of *Naftaztec TV*, one of Gómez-Peña's past performances. Throughout *Borderama*, "Spanglish" is spoken to critique the stereotyping of cultures. Spanglish is a hybrid language riddled with neologisms devised by the artist in order to resolve the tension between two cultures, the struggle of multiple identities in

the singular space of his body. A portion of the *Borderama* text reads as follows:

> Roberto Sifuentes: *Come on, Yiguermo, Guiliermou, be more specific & tell them how have you betrayed the indio in you.*
>
> Guillermo Gómez Peña: I . . . I have . . . I have been to McDonalds twice in the past six months. I had a McFajita with ketchup picante . . . & I didn't vomit. I tried but . . . it just didn't come out. I know, I'm a gringolatra, it's a disease raza!! I just can't control it. I even forgot the lyrics of "La Cucaracha" & worst of all, & worst of all . . .
>
> (RS): *Spit it out! They'll understand.*
>
> (GGP): I didn't attend the last Day of the Dead . . . Ay!! (Gómez Peña, 1996, p. 133)

In this short confession, we experience the irony of Gómez-Peña's border identity, his use of humor as a linguistic strategy. We experience his distress over alien culture invading his body on the one hand, and his growing delight in its experience on the other hand.

Thus, the border metaphor in Gómez-Peña's performances and Giroux's pedagogy represents the contested zone—the liminal, contingent, and ephemeral spaces of performance art—where cultural codes and binaries are intentionally challenged and reconstituted. This, in order to create a wider context, a limen, where multiple discourses can coexist and serve as multiple strategies for learning. Most important, the performance of border pedagogy provides students with agency, the ability to act on and take responsibility for their own education. It transforms students from being passive consumers of dominant cultural capital into "public intellectuals" who are capable of moving across cultural boundaries and various sites of learning in order to challenge the politics of their education (Giroux, 1996, p. 124). Giroux distinguishes educational politics in two ways: political education decenters power in the classroom so that dominant ideologies can be addressed, whereas politicized education is "pedagogical terrorism" that refuses to examine its own ideological constructs (p. 126). For students to gain agency, they must learn to challenge and get involved in the ideological politics that school culture represents.

Postmodernism's plurality of thought, diversity of cultures, and open systems of communication did not supplant modernism. Rather, argue Aronowitz and Giroux (1993), "it signals a shift toward a set of social conditions that are reconstituting the social, cultural, and geopolitical map of the world, while simultaneously producing new forms of

cultural criticism (p. 63). By comparison to the performances of early modernism, the reflexive nature of postmodern performance "provides resistance precisely not by offering 'messages,' positive or negative, that fit comfortably into popular representations of political thought, but by challenging the processes of representation itself, even though it must carry out this project by means of representation" (p. 142). With regard to pedagogy, Giroux distinguishes between the "representation of politics," a modernist strategy, and the politics of representation in postmodernity. "Resistance" in postmodern art and pedagogy is not about the achievement of cultural superiority but the creation of a contingent space wherein ideas and their means of representation are continually reconsidered.

The rationale for formulating a performance art pedagogy is predicated on the liminal, contingent, and ephemeral character of performance art. As a strategy to create critical sites of learning, performance art pedagogy makes it possible for all observers to become participants and all participants, creators of cultural meaning. In doing so, they learn about culture as well as ways in which to question its hegemonic authority. Its multicentric and dialogic processes recognize the cultural experiences, memories, and perspectives—participants' multiple voices—as viable content. It encourages participant discussions of complex and contradictory issues. Its strategies of inclusion involve the participation of the observer.

As an open system of discourse, performance art pedagogy includes all forms of communication, including those that are technology and media based. It serves as a site were participants learn to take conceptual and emotional risks as well as responsibility for what they imagine and what they create. Furthermore, it assures them of safety, of having a different point of view without the threat of being ostracized. Performance art pedagogy represents multiple strategies for learning and expression including the nondiscursive language of the body. It functions as a pedagogical site where brainstorming, improvisation, and experimental strategies for learning, creating, and critiquing are equally as significant as those that are academically determined. Finally, performance art pedagogy recognizes cultural difference as a vital resource to the development of a broader understanding of reality and where participants work toward the goals of critical citizenship and democracy. In doing so, it represents the praxis of postmodern educational theory where subjectivity is performed within the contentious zones of culture and where it confronts the face of cultural domination.

4

Goat Island

Spectacle as Performance
Art Pedagogy

The goal of providing students with a means to attain cultural identity and agency through the critical pedagogy of performance art is common to many artists who teach performance art. For them, the materialization and acknowledgment of the body and its performance of subjectivity facilitate cultural transgression and transformation. Their cultural work includes teaching in community centers, schools, museums, colleges, and universities. At these and other public sites, they lecture and conduct workshops, teaching students how to create performance art. They provide them with strategies to challenge the assumption of the body as depository, as the stage upon which the spectacle of public culture enacts its social, political, economic, and aesthetic agendas.

As in the production of their own performances, these artists who teach involve students in physical, emotional, and conceptual exercises to transform the body from a passive recipient of culture to one that takes a proactive role in challenging cultural categorization. The students' awareness and understanding of their own body's function as cultural stage is crucial to their desire to reclaim their bodies as sites of cultural resistance and production. The re-presentation of the body in performance art pedagogy enables students to mime the spectacle of culture, to make a spectacle of and with their bodies. They learn to challenge the moribund spectacle of the public with the spectacle of the private. By exposing their memories and cultural histories in this way, they contribute to school environments the content necessary to attain agency and critical citizenship.

With regard to performance art pedagogy, the cultural paradigm of the spectacle can be distinguished in two ways: as methodologies to reify culture and as strategies to resist reification. Spectacle methodologies consist of historically and socially constructed performances, reified, prescriptive procedures and techniques defined in advance that are closed to contextual circumstances. Counterspectacle strategies, like those of performance art pedagogy, are liminal, contingent, and ephemeral. Open to the multiple possibilities of any given context, they represent a plan of action to resist predetermined assumptions and methods. This duality of the spectacle of performance, its complicity and opposition to dominant ideologies, contains the possibility for pedagogical interventions.

Performance theorist Philip Auslander (1996) argues that the immediacy of performance art and the production of spectacle through mass mediation (mediatized culture) are mutually dependent (pp. 196–197), especially when considering the ubiquity of the mass media and the pervasive use of its technological apparatus (audio, video, computer, and other electronic delivery systems) in the production of performance. In this chapter, I will argue for the pedagogical significance of Auslander's notion of mutual dependency; namely, that performance art's spectacle of liveness, its ephemerality and immediacy, and the reified spectacle of mass-mediated culture functions "teach and learn" from each other. To illustrate this point, I will discuss a performance and a workshop by Goat Island, a Chicago-based interdisciplinary performance art collective, whose performative pedagogy employs both the spectacle and the technologies of mass-mediated culture to create a spectacle of resistance. However, before doing so, let us consider the theoretical basis of the spectacle paradigm in order to further distinguish the spectacle of reified culture from that of performance art.

THE PARADIGM OF THE SPECTACLE

The spectacle of reified culture can be defined as the monopoly and reproduction of historically and socially constructed codes, a system of signs that culminates in what performance theorist Antonin Artaud (1958) referred to as "petrified" society (p. 12). Cultural theorists Theodor Adorno and Max Horkheimer (1993) argue that the "industry" of reified culture coopts and commodifies all aspects of the private and makes them indistinguishable from its public system of signs (p. 4). When signs become interchangeable in this way, when the boundaries between cultural production and reproduction are blurred, the tension between opposite poles of representation and interpretation ceases, thus neutralizing oppositional discourse. Adorno's and Horkeimer's

theory of the culture industry finds its parallel in the writings of cultural theorists Jean Baudrillard, Guy Debord, Edward S. Herman, and Noam Chomsky.

Baudrillard (1984) characterizes the reified culture industry as a simulacrum, a hyperreal, simulated cultural condition that bears no relation to reality but functions as its own reality (p. 256). Debord (1995) refers to the hyperrreality of the culture industry as the "society of the spectacle," a condition where social relationships between people are mediated by commodified images (p. 12). The spectacle of mass-mediated images functions as insidious propaganda to "manufacture consent," claim Herman and Chomsky (1988). By virtue of its size, advertising, and expertise, the mass-media industry controls and influences public discourse. Unlike the overt tactics of totalitarian regimes, it encourages debate, criticism, and dissent as long as it conforms to an elite consensus, "a system so powerful as to be internalized largely without awareness" (p. 302).

Unlike the oppositional discourse of performance art pedagogy, the role of critique in the spectacle of reified culture is to regenerate its dominant ideology and power base by "scenarios of deterrence," claims Baudrillard (1984), "proving theater by anti-theater, proving art by anti-art, proving pedagogy by anti-pedagogy . . . Everything is metamorphosed into its inverse in order to be perpetuated in its purged form" (p. 266). Thus, the spectacle of reified culture stereotypes and marginalizes voices of difference and dissent. By dissuading students' memories and cultural histories as significant pedagogical content in schools, the antipedagogy of reified culture becomes self-evident as exclusionary pedagogy.

Artaud (1958) argued the contrary: culture is not self-evident but predicated on protest (p. 9). Using the totalizing crisis of the plague as a revolutionary metaphor, he called for the production of spectacle in performance to resist, expose, and transform the "*undersides (dans ses dessous)*" of petrified culture (p. 124). To accomplish this, he called for extending the historically and socially constructed space of the theater out and beyond the proscenium to include the spectator (p. 125). In doing so, Artaud anticipated the emancipatory pedagogy of postmodern performance art where the spectacle of resistance is multicentric, paradoxical, participatory, indeterminate, interdisciplinary, reflexive, and intercultural. Its critique, grounded in the individual bodies and experiences of spectators, interrogates dominant codes of historical performance. Rather than deterrence, it encourages an open discourse of ideas and interpretations.

In his critique of the spectacle paradigm, Debord (1995) argues "to analyze the [cultural] spectacle means talking its language to some degree—to the degree, in fact, that we are obliged to engage the methodology of the society to which the spectacle gives expression. For what the

spectacle expresses is the total practice of one particular economic and social formation; it is, so to speak that formation's *agenda*" (p. 15). Debord's theory calls for spectacles of resistance: strategies to "analyze" the reified spectacle of culture by engaging and miming its methodology. The spectacle of the private body in performance art does not narrativize a totalizing agenda in advance. Instead, it represents the ironic possibility to resist the spectacle of the public by way of the body's memory and cultural history.

How does the body of the performance artist relate to the body of the spectator to resist the spectacle of the public? Liminality, contingency, and ephemerality, the three main characteristics that challenge the ideological absolutes of reified culture, make possible the production of spectacle, rather than its reproduction, thus creating a space where spectators can situate their own identities and desires. The liminal space created by the performance artist exposes and re-presents the hidden codes of reified culture to enable their interrogation by spectators. A condition of contingency occurs as spectators interpret the cultural issues performed by the artist from the context of their subjectivities. Ephemeral conditions created by the performance artist as liminality and contingency take place in real time and space thus making possible spectators' witnessing an actual event and their participation a form of activism.

Similar to the way in which the spectacle of mass-mediated culture is constructed with jump cuts and sound bites to represent world events in films, television, and advertisements, Goat Island's spectacle of resistance is constructed as a collage. The artists' collective mimics and critiques mass-mediated culture by appropriating its production methods for use as strategies to research and develop performance art works. According to performer Bryan Saner, images, texts, sounds, and movements are appropriated and collected by Goat Island members to support the development of an idea. Saner describes the process:

> We find a text or movement that supports our idea. The quote or entire dialogue is copied word for word and inserted into the performance. These are never meant to be seen alone or on their own merit. It is meant to be a layer of a collage. Something happens over it, something happens under it. The physicalisation that we layer over the text often reveals new insights, or changes the meaning completely. (Goat Island, 1997, p. 72)

Goat Island performer/writer Matthew Goulish considers the way in which the collage of performance art changes the meanings of things essential to critical thinking. He argues that critical thought fulfills one or both of two interrelated purposes: to cause change and to understand how to understand (Goat Island, 1997, p. 86). Spectators and students

manifest changes in their perceptions, conceptions, and behaviors as a result of critical processes. These changes may narrow, or they may expand, according to Goulish. To understand understanding, he argues, spectators and students become aware of critical thought as a necessary process to deepen their understanding (p. 88). These two purposes of critical thought are essential to Goat Island's performance art works and teaching strategies, which I will discuss later in this chapter.

The six transgressive strategies of performance art pedagogy outlined in the previous chapter are here characterized in terms of a spectacle paradigm. Performance art pedagogy critiques the spectacle of culture through the vicissitudes of the students' bodies and cultural perspectives in order to unmask its hyperreality. Eugenio Barba (Barba & Savarese, 1991) refers to this unmasking as the "dilated body" where "the performer's presence and the spectator's perception" expose the "body-in-life" (pp. 54–55). By exposing and making explicit the body's private memory and cultural history as spectacle, it resists the cultural spectacle's oppressive system of public signs. Semiotician Umberto Eco (1977) claims the body in performance is made explicit through "ostension," a means of signification that consists in "de-realizing" the particular characteristics and circumstances of the body "in order to make it stand for an entire class" (p. 110). Through ostension, the body's private social, political, and aesthetic dimensions are spectacularized in order to challenge, critique, and resist the spectacle of the public. Building on Eco's notion, performance theorist Marvin Carlson (1996) makes an important distinction between framing and ostending the body. He argues that the operational difference between the two is that "the former emphasizes special qualities that surround the phenomenon [the body], the latter something about the phenomenon [the body] itself" (p. 40). Thus, to frame is to identify and critique the power structures that surround the body and, in doing so, to speak of the body's oppression. The ostended body speaks for itself. "Making any body explicit *as socially marked*, and foregrounding the historical, political, cultural, and economic issues involved in its marking, is a strategy at the base of many contemporary feminist explicit body works," writes performance theorist Rebecca Schneider (1997, p. 20). Thus, the inclusion of students' cultural identities as educational content in the schools through performance art pedagogy enables students to "de-realize" the social markings inscribed on their bodies by the body politic and to create new aesthetic and political codes significant to their lives.

The first strategy of performance art pedagogy is to engage students in the exploration of their body's cultural history and identity through ethnographic spectacle. This strategy enables students to query autobiographical information, which they can use as content in

the production of performance art works. The spectacle of the private is identified and performed in opposition to the prevailing binary code of the public, thus opening a liminal zone of contention between the two spheres. The second strategy engages students in linguistic spectacle to problematize the system of signs inscribed on the body by the dominant culture and to re-present the body by physically "acting out" and "miming" a linguistic critique of its social semiotics. This playing with the language of the body through the body enables students to create puns, paradoxes, conceptual bipolarities, and other contradictory configurations of ideas, images, and texts in order to free the body from its pedantic historically and socially constructed uses and to open new possibilities for its expression.

The spectacle of political resistance, the third strategy, teaches students how to become activists within their respective communities, to challenge the body politic in art, schooling, and society. Here students learn how to organize and produce public performances, demonstrations that call into question the civil rights of citizens in their struggle for agency within the dominant structures of institutionalized culture. The spectacle of social action, the fourth strategy, empowers students to work collaboratively and to develop a community of support in their struggle to solve the problems of contemporary culture in their neighborhoods and communities. At the heart of performance as social action is the student's learning to participate as part of a community where individual ideas, opinions, and ethics must be considered in relationship to the community as a whole.

The fifth strategy teaches students to engage the spectacle of mechanical and electronic devices, to explore and critique their somatic implications in order to evolve an ethics of technological intervention. Performance art pedagogy engages students in the dialectic of technology's intervention in the body and the body's intervention in technology. Students learn how technologies both reify the dominant codes of culture, those that we often take for granted as we sit disembodied before the spectacle of computer screens and television sets and as we click our keys and mouses and our remote controls. Inversely, students also learn that technologies can facilitate new modes of cultural representation essential to their attainment of agency. The body's intervention in technology serves as a "tool" for social and political resistance. Finally, the sixth strategy, ecstatic spectacle, renders the body explicit by presenting itself, its corporeal phemonenon, memory, and cultural history, as material for aesthetic production. In doing so, the ecstatic spectacle of performance art pedagogy enables students to understand their bodies as cultural artifacts whereupon culture constructs and reproduces its aesthetic codes. What is more important, ecstatic spectacle enables the

possibility for students to reclaim, critique, and produce culture from their respective cultural identities.

In what follows, I describe and discuss the instructional strategies of Goat Island, a collective of performance artists who teach in relationship to the six strategies I have outlined above. Goat Island's instructional strategies will be compared with a particular performance work in order to identify the dialectical relationship between the collective's performance art making and performance art teaching. For performance artists who engage in this dialectic, performance art making serves as a context to conduct research and to evolve their performance art teaching. Conversely, their performance art teaching serves to contextualize the research and development of their public performance works. It is the resonance between the two that is essential to Goat Island's performance art pedagogy.

HOW DEAR TO ME THE HOUR WHEN DAYLIGHT DIES

A narrow arena (*Figure 4.2*) accommodates audience members who sit in three tiers of chairs. Their close proximity to the performance space blurs the distinction between spectators and performers. Like ethnographers, the spectators seem poised, ready to witness some strange cultural

figure 4.1: Goat Island, *How dear to me the hour when daylight dies*, 1996. Photo by Nathan Mandell.

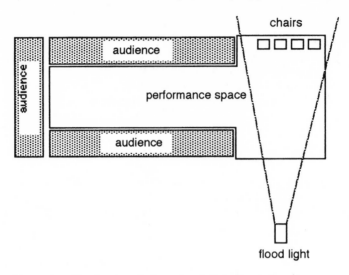

chairs

audience

audience

performance space

audience

flood light

figure 4.2: *How dear to me the hour when daylight dies*, performance layout

encounter. Like citizens in a jury box, their participation will soon be defined by attempts to conceptualize the complex poetics of Goat Island's *How dear to me the hour when daylight dies* (*1996, Figure 4.1*), a performance spectacle comprised of four stories that "investigates the themes of pilgrimage, human limitations, transformations, celebrities, and homage" (MCA Publicity Postcard, 1997).

In story one, four performers—Karen Christopher, Bryan Saner, Mark Jeffery, and Matthew Goulish—enter the space dressed in gray work uniforms, marching single file like in a military or prison yard drill. They come to a halt in the center of the performance space and in the beam of an intense flood light. Pivoting their bodies, they face the audience. Saner steps forward and delivers a speech that serves to encourage the group's morale while announcing its subjugation and oppression to the audience:

> We have surrendered.
> Not only us . . . but our country too.
> I don't know what will happen to us.
> I don't know if we'll be allowed to go on living.
>
> Our country has been bombed from one end to the other.
> Many people have been burned, or wounded, or are starving to death.
> Our homes . . . our homeland is in ruins.
> And we are here, prisoners, thousands of miles away.

All we have left is our faith in each other.
Up to now we have lived together.
We have faced sorrow and pain.
For all we know, we may die here.
If that time comes, let us die together.

There's a story.
The ghost of a dead sailor tied himself to an anchor,
wrapping the rope around his body nine times, and
threw himself backwards from a rock into the sea.
I don't recall the rest of the story.
And I don't know why this part of it came back to me this morning.
But now I can't forget it.

If we survive . . .
If the day ever comes that we go back home,
let us go back and work together to rebuild our country.

This is all I can say now. (Videotape transcription by author)

The predicament of these individuals, in relationship to the narrow configuration of the performance space and the close proximity of the audience, becomes poignant. Are these political prisoners on parade? Do the close quarters of the stage represent confinement in a cell, a prison yard, a parade route? Like Foucault's panopticon, the performers are situated in an ultimate position of visibility for spectators to survey, scrutinize, and interpret their disparate, erratic movements with an arresting gaze. Goulish considers this conceptual arrangement a means by which to introduce the audience as a performative element (Tsatsos, 1991, p. 70). The narrow performance space functions like a liminal zone where cultural issues can be interrogated. Under such confrontational circumstances, the oppositional positioning of the audience establishes their bodies as cultural binaries. Thus, audience members are directly implicated in two ways: as objective observers of the performance and as complicitous in the cultural issues of control that it explores (Bottoms, 1996, p. 173).

The other three performers leave, sit in chairs, as Goulish alone begins to rub the top of his right hand repeatedly as if attempting to massage a wound. Christopher enters the space, pauses, bends over, and then begins to leap in the air, twirling and contorting her body in the most strenuous manner. Soon Saner and Jeffery join her in the same movements, as does Goulish after ceasing his rubbing action. What is the meaning of this hyperactive, synchronous movement? Are these bodies exercising in a prison yard, convulsing in a sanitarium, dancing a crazed

jig? Is it a futile attempt to launch oneself Icaruslike and to fly away, to transcend some kind of confinement? Do these strained movements represent some form of self-torture? Are they intended to reclaim, transform, and liberate the body? For the audience, the process of hypothesis formation, understanding to understand, has begun.

All four performers continue to gyrate with tremendous force, often coming within inches of the audience. As their sounds of exhaustion increase, the physical exertion of their bodies seems to bear a psychological intensity. According to cultural critic Carol Becker, Goat Island's physical extremes represent a "fundamental metaphor and hidden premise" that "develops around the concept that the physical body can represent the psychic body and that the two are, in fact, one" (1996, p. 125). Christopher claims "the tremendous physicality makes it so that you're not just getting into the heads of people but you affect them completely, emotionally and physically" (Tsatsos, 1991, p. 67). In fact, Goulish states that the number of stories in a Goat Island performance is determined according to aesthetic reasons. "Lin [Hixson] tried to construct it so that by the end we were so tired we couldn't do . . . [another] repetition" (p. 67). The radical physicality of the body is experienced by the audience as a forced empathy. Spectators cannot watch the performance without feeling the body's tension.

A pop song, *Que Sera Sera*, plays loudly as the four continue to perform synchronously, repeatedly massaging the tops of their right hands, shaking their heads, and then turning their heads to the right, the left, and up. The song's lyrics diminish a young girl's/woman's existential questioning of sentimental fantasy. They acquiesce her desires, her self-expression to an undetermined destiny:

> When I was just a little girl, I asked my mother, what will I be . . . Que Sera Sera, what ever will be will be, the future's not ours to see . . . When I grew up and I fell in love, I asked my sweetheart . . . Now I have children of my own. They ask their mother, what will I be . . . Que Sera Sera, what ever will be will be, the future's not ours to see.

Meanwhile, the performers' peculiar movements seem like gestural fragments, the body's memory recalling its actions in past experiences. While these nondiscursive movements introduce ambiguity and abstraction, they contrast with the fragmented verbal narratives throughout the performance that provide the audience with access points to enter the work and to negotiate meaning (Becker, 1991, p. 64). The performance yields a logic of its own, similar to the surreal association of signifiers found in dreams. Here again, the audience is presented with the task of understanding how to understand.

Another tune, the music of a military marching band, humorously transforms the narrow space into a campaign parade route, and the performers' absurd gestures become like those of politicians who wave, appealing to crowds of people to garner votes. These strange juxtapositions seem to suggest a correspondence between political prisoners incarcerated for their activism and politicians who are imprisoned in their oppressive ideologies. Discussing the metaphor of the parade as a subtle method of social control, performance theorist Stephen J. Bottoms invokes Michel Foucault's influence on Goat Island: "One of Foucault's paradigmatic examples of this phenomenon is the emergence of the military parade, a device by which individual participants are trained into willing conformity" (1996, p. 170). This social control of parades relates directly to the characterization of reified cultural spectacle by Adorno and Horkheimer, Baudrillard, Debord, Herman, and Chomsky discussed previously.

Three historical characters are venerated as cultural heroes in *How dear to me the hour when daylight dies*. Their stories comprise the remainder of the performance. Story two is about Mr. Memory, a man who daily memorizes fifty new facts, whose character Goat Island has appropriated from the opening scene in Alfred Hitchcock's 1935 classic suspense film *The 39 Steps*. Story three concerns Amelia Earhart, the woman aviator who was the first to fly solo across the hazardous route from Hawaii to California in 1935, coincidentally the same year as Hitchcock's film, and whose plane was tragically lost in the South Pacific during an around-the-world flight. Finally, story four tells of Mike Walker, a Korean War veteran who became America's heaviest man at 1,187 pounds.

In story two, Goat Island references Hitchcock's opening dialogue between a music hall master of ceremonies who asks his erudite partner Mr. Memory to perform. Saner, as the master of ceremonies, leaps forward and proclaims: "Ladies and gentlemen, with your kind attention and permission, I have the honor of presenting to you one of the most remarkable men in the world." Goulish, who portrays Mr. Memory, is helped to his feet as he shakes convulsively. Shaking implies the toll of genius: privileging the mind and abandoning the body. Moreover, audience expectations that elevate the genius-as-cultural spectacle seem acutely destructive to the mind and body of the individual as well. Saner presents a pair of "spectacles" for the audience to "inspect" as evidence of genius and then places it on Goulish's face. "Test him please ladies and gentlemen, ask him your questions and he will answer you fully and freely . . . I'll also add ladies and gentlemen, before retiring that Mr. Memory has left his brain to the Museum of Science and Industry." With the latter declaration, the master of ceremonies reveals the character of Mr. Memory's encyclopedic mind: a veritable museum of collected facts

having no apparent relationship to each other like disparate signifiers dislodged from their signifieds floating around in his head. Is he genius, or is he mad? Similar to Hitchcock's character, Goat Island's Mr. Memory ironically represents the concealment of "secret codes" in a public body, a metaphorical representation of "celebrities" in whom the distinctions between the spectacle of the private and the public disappear. Addressing the obfuscation of the private by the public, Debord (1995) contends,

> The individual who is in the service of the spectacle is placed in stardom's spotlight is in fact the opposite of an individual, and as clearly the enemy of the individual in himself as of the individual in others. In entering the spectacle as a model to be identified with, he renounces all autonomy in order himself to identify with the general law of obedience to the course of things. (p. 39)

Mr. Memory walks forward in a deliberate fashion and enunciates into the microphone: "A-y-e, ques-tion p-lease." The master of ceremonies, who is lying on the floor, jumps to his feet and asks: "Who was the last British heavy weight champion of the world?" Jeffery moves into position backstage and begins to swing a punching bag tethered by a long rope, making violent punching sounds by pounding the bag onto the floor. Mr. Memory responds: "Bob Fitzsimmons, he defeated Jim Corbett, heavy weight champion of America in Carson City, Nevada in October 1897. Am I right sir?" To the next question, "How far is Winnipeg from Montreal?" Mr. Memory responds, "Mike Walker, he became America's fattest man when he reached the unreal weight of 1,187 pounds. Am I right sir?" As if concerned only with Mr. Memory's ability to spew facts, correct or incorrect, the master of ceremonies responds, "Quite right." He then announces a dance, music begins to play, and the four performers leap from their respective locations into a quadrangle formation where they gyrate a strange dance resembling a kind of military calisthenics, prison yard exercise, circus acrobatics. There is a recapitulation of body gestures in this tightly choreographed segment, references to prior movements. The performers' bodies seem physically and psychologically distressed. In this and other parts of the performance, they roll, convulse, thrust, and drag on the floor, shaking, twisting onto and around each other. Becker (1991) suggests that Goat Island's willingness to exhaust themselves physically "alleviate[s] the anxious urgency that appears to motivate the work, we become committed to their excessive action . . . we are willing to suspend analysis of its symbolic meaning while we give ourselves over to its unraveling" (p. 63). As the dance subsides, Mr. Memory rapidly fires a soliloquy of

disparate names, dates, places, events as if his mind is short circuiting. This aberration is embodied throughout the performance by convulsive movements suggesting the disfunctionality of genius. Moreover, the combination of Mr. Memory's disparate monologue and gestures functions as a microstructure within Goat Island's disjunctive plot in *How dear to me the hour when daylight dies*. The interruption of the performance with a microstructure serves as recapitulation, a formal strategy to emerge a structure for the audience to experience and interpret its disjunctive plot.

After his soliloquy, Mr. Memory remains standing absolutely still at the microphone where he finally elucidates facts about the solo cross-Atlantic flight of Amelia Earhart. Christopher lies on the floor as the aviatrix, donning a white flight cap. Saner places an antique electrical fan on her chest (the fan's design dates back to the time of Earhart's tragic flight). Goulish comes along and slowly pulls on a long string wrapped around its shaft. This rotates the fan blade like an airplane propeller, making Christopher's body planelike. Operating only on the force of Goulish's pull, the "propeller" gradually comes to a halt on Christopher's supine body.

Soon, Amelia is shouldered like the Pietá by Goulish, Saner, and Jeffery and then reclined on a makeshift hospital bed where she is attached to a portable microphone/speaker that resembles a crucifixlike, makeshift, artificial life support system. Ironically, the famous flying woman is transformed into Mike Walker, the incapacitated fat man. The paradox of the hero's transfiguration is signified: a Christlike, transcendent figure on the one hand, yet a cultural oddity on the other. Mike Walker, however, having come to terms with his malady, offers himself as a sacrifice. In his dying state, he places himself "on exhibit in an effort to discourage the public, especially teenagers, from destroying their lives the way I have wrecked mine." The tragedy of a hero's courage, daring, sacrifice, and transformation is revealed as lonely incarceration: the political prisoner confined in a foreign cell, the world's smartest man in a forgotten body, Amelia Earhart in her plane; and the world's fattest man trapped in an obese body.

Meanwhile, Jeffery repeatedly places his eye onto what appears to be an optical device covered with red dye. He stains his eye and then proceeds to wipe it on a clean white shirt hanging on a rack that resembles a body. Jeffery proclaims: "I saw 600 bloodshot eyes lying at memory's feet. And in the time when harm came to memory, I saw 600 bloodshot eyes fall like a great whale into the sea." With Jeffery's action and proclamation, the performance critiques the hero as the object of the gaze, as the spectacle of culture, as the victim of celebrity. A reflexive action, his "blood-shot" eye also serves as a symbolic sacrifice,

to vindicate the spectators' voyeurism, to forgive their complicity in gazing at the spectacle of Goat Island's performance.

Finally, as the performance comes to an end, Saner, the master of ceremonies, drags in a makeshift anchor made of plow shares and steel bars and attaches it to the microphone stand in the center of the narrow arena, thus making reference to his earlier story about the ghost of a dead sailor. The other three line up behind him and recapitulate earlier convulsive body movements. Goulish approaches the microphone and begins to speak with someone who is nowhere to be seen, perhaps the ghost of the dead sailor:

Goulish: Private Noguchi . . .

Saner: Yes commander.

Goulish: You.

Saner: Captain, is it true, was I really killed? I—I can't believe that I'm really dead. I went home. I ate the special cakes my mother made for me. I remember it well.

Goulish: You told me that before. You were shot. You fainted. Then you woke up. I was tending you, and you told me that story. It was a dream. You dreamed it while you were unconscious. It was so strong, I still remember it. But, after five minutes, you died. You really died.

Saner: I see. But, my parents . . . don't believe I am dead. That's my home. My mother and father are there . . . still waiting for me.

Goulish (yelling): But it's a fact. You died. I'm so sorry, but you died. You're really dead. You died in my arms. (Saner again walks in large strides making clanking sound off stage.)

Goulish: Noguchi (lays anchor/microphone on side and bows), I under-stand how you must all feel. Nevertheless, you were all annihilated. I'm sorry. I wasn't killed. I survived. I sent you out to die. I was to blame. I could place all the responsibility on the stupidity of war, but I can't blame that. I can't deny my thoughtlessness. My misconduct. I have only one more thing to say. It's important, but I'll try to be quick. As I look at you, I fear that the entire world is turning into stone. Now. Now is an unhappy time for the dead. But returning to the world like this proves nothing. A time will come. A time of wisdom, when the dead will be happy. Please, believe me. Go back. The day begins at dusk. (Videotape transcription by author)

Who is Noguchi? Is the ambiguity intended as an interruption to open interpretation? Is the narrative an apology for war, being a sur-vivor, a commander? Goulish stands in the flood light, glances toward

the other three as they count off and then begin to dance, to exercise the body's memory, this time without music. The sound of tools in Saner's pants clang like bones in a haunting ghost dance in the dark. Lights fade off Goulish. A side spot fades on the performers. Lights fade off completely. Only dancers' body sounds can be heard in the dark. First all three dance, then two, and then one body is left until it too becomes silent. The performance ends without any coherent sign of closure, other than silence and darkness. The audience is left to ponder the disparities of *How dear to me the hour when daylight dies.* Bottoms (1996) discusses this "incompleteness" of Goat Island's performance works as an intentional strategy

> to transfer the onus of responsibility [for interpretation] to its spectators . . . it defies the kind of interpretative closure (or at least coherent understanding) that traditional narrative drama offers. Built around principles of collage assembly, such work encourages spectators to make lateral associations and find their own meanings in the material, with the result that it is impossible to pin down exactly what is being said by the piece . . . Yet in a sense, this very openness of form is itself a political response to the kind of homogenizing pressures that the piece attempts to explore. (p. 182)

Becker (1996) agrees with Bottoms's assessment of Goat Island's incompleteness, referring to it as a "refusal to adhere to theatrical conventions . . . [that] allows for the speaking of the unspeakable in forms that can still unnerve, upset, confront, and, at times, release" (p. 131). It is this openness of form and the interpretational involvement of the spectator that is significant to the spectacle of resistance offered by Goat Island's performance. The collective's liminal, contingent, and ephemeral pedagogy represents the open praxis of postmodern theory discussed in chapter 2. In the next section, Goat Island's performance pedagogy will be compared with the curriculum that the collective uses when teaching performance art in workshops and classrooms.

GOAT ISLAND'S MCA WORKSHOP

When presenting workshops to students, director Lin Hixson and writer/performer Matthew Goulish collaborate with three other members of Goat Island ("goats") to create a dynamic learning environment with a sequential curriculum plan and a pedagogy of intervention, what the collective terms "interruptions" (Goat Island, 1997, p. 24). Their teaching strategies are similar to those that they use to develop their performance works. Goulish describes Goat Island workshops as a process with every goat participating in the ideas and details of each

figure 4.3: Goat Island workshop. Photo by Alan Crumlish

interruption and their responsibilities continually changing. Together they decide who should lead each interruption based on who wants to, who has done it before, who is good at it, and spreading the responsibilities equally. During each workshop, the interruption leader is only a "front person" enacting decisions that are made collectively. The role of each leader may change from one workshop to another. Goulish states, "In fact, we sometimes make a point of changing them to keep the workshops fresh; to avoid one person from becoming too identified with one interruption, and to make sure we continue to change and develop individually."[1]

In one particular workshop at the Museum of Contemporary Art in Chicago, a week prior to their performance *How dear to me the hour when daylight dies* in February 1997, the collective arrived at the museum's open studio space prepared to work with twelve students who had enrolled. As the students entered the space, they were greeted by their Goat Island facilitators and asked to make themselves comfortable while they waited for everyone to arrive. Meanwhile, the facilitators set up a table in one corner of the room where they would convene from time to

[1] Interview with Matthew Goulish, May 24, 1998.

time throughout the workshop in order to brainstorm and adjust the curriculum to the particular character of the students.

Goat Island's curriculum sequence at the MCA consisted of seven interventions, each of which was designed to break the continuity of the sequence, its linear time and space, and to place students in the liminal, contingent, and ephemeral circumstances of performance art pedagogy. The interventions were as follows:

- introducing the self and body to others,
- making the body explicit with an impossible task,
- remembering oppression,
- collaborating and assembling,
- recapitulating and structuring,
- the consequent performance, and
- a wrap-up discussion.

Like the fragments of image, text, sound, and movement in their performance *How dear to me the hour when daylight dies*, these interruptions represent the collage components of Goat Island's curriculum. The collective employs collage as a curricular structure in order to provide students with multiple possibilities for imagining and interpreting its disjunctive fragments in their creation of performances. In doing so, its pedagogy represents a praxis of postmodern theory, an open form of modernism that includes a concern for design principles. In what follows, I will discuss these interruptions in greater detail, revealing their parallels with the collective's performance collage.

Interruption 1: Introducing the Self and Body to Others

Hixson commenced the first of the seven-part performance curriculum by asking the students to stand and form a large circle in the room. Joining them in the circle, she informed the students that what they were about to experience for the next four hours was similar to the collaborative process that the members of Goat Island use to brainstorm, improvise, develop, and rehearse their work. After this initial bit of information, Hixson asked the students to carry out a simple task: to "tell" four bits of information about themselves.

- Your name,
- a truth,
- a lie,
- and point to a particular part of your body and name it.

The response of one student was, "My name is Amy; I have six children; I am 33 years old; this is my pelvic bone." This ethnographic exer-

cise represented one of many that had students querying their experiences, histories, and memories to elicit autobiographical content for their subsequent performances. As the students in the circle shared their responses to this preliminary exercise, Mark Jeffery, another Goat Island facilitator, made a rough pencil sketch of the human figure (*Figure 4.4*), a body map, whereupon he wrote each student's name corresponding to the body part that he or she identified. In doing so, Jeffery used the body as a device to arbitrarily divide students into groups, again a disjunctive strategy consistent with the collective's curriculum structure based in collage. Amy's name, for example, appeared in the location of the pelvis (12). Those students whose names appeared in proximity to one another on the map comprised a group. Later in the workshop, this body map served as an arbitrary means to divide the students into four small working groups.

Like in Goat Island's performance, this first interruption introduced the body as spectacle. By naming, the students identified them-

figure 4.4: Mark
Jeffery's body map

Group One: #1,7,11 Group Three: #4,10,12
Group Two: #6,5,9 Group Four: #2,3,8

selves. In telling a truth, they engaged their memories to reveal personal memories and histories. Telling a lie engaged their abilities to imagine, improvise, invent, and construct a story based on past experiences. By pointing to different parts of their anatomies students introduced the phenomena of the body, its physical, emotional, intellectual, and cultural functions as explicit content within performance. Together, the parts of this first interruption introduced students to disjunctive thought and action, the collage character of performance art that they would encounter as the workshop continued.

Interruption 2: Making the Body Explicit with an Impossible Task

The second part of the Goat Island workshop began as performer and workshop facilitator Karen Christopher invited students to sit and make themselves comfortable on the floor. Christopher then passed out sheets of paper and pencils and asked each student to "name and describe an impossible task." After a three-minute writing period, she asked them to pass their impossible task descriptions to the person on their right. After reading the impossible task just handed to them, Christopher asked the students to stand and find a place in the room, "to put this impossible task into motion, make it possible, in any way you can." She asked them to repeat, alter, develop, and rehearse the task and to make certain that it could be taught to someone else in the workshop.

Exchanging the tasks introduced the idea of "trading" as an element in collaborative performance (Tsatsos, 1991, p. 68). By performing another person's task, they were able to learn from each other, to observe and critique their own performances from a distance, and to develop camaraderie. Moreover, trading introduced the principle of collage where ideas, images, texts, and movements appropriated from various preexisting contexts are brought together in a new context. This juxtaposition of disparate ideas, images, texts, and movements provides spectators with multiple access points into an art work and multiple interpretations, accordingly. Thus, collage served both as a strategy to construct performances during the workshop and as a model for collaboration between students of different cultural identities and experiences.

The purpose of this exhausting exercise was to make the body's movements and gestures explicit, to become aware of its physical capabilities and limitations. Christopher claims that the physicality of the impossible task exercise and other such performative strategies functions as "body intelligence" to reveal the "body's response to thoughts and emotions" (Goat Island, 1997, p. 75). Although it was not apparent what the students were representing as impossible tasks in their performances, their complex gestures comprised dynamic abstract rhythms

and patterns of the body and presented the possibility for multiple read-
ings and interpretations. By rendering the "absent" body "present" in
this way, the students were able to effect a distancing from their body
and to engage it as an object, material, and process in the creation of
performance work. By not "naming" their impossible tasks, the focus of
communication was diverted from discursive uses of language to the
nondiscursive character of body language. For example, had the name
"lift the museum," one of the impossible tasks listed below, accompanied
its corresponding body performance, audience interpretations would
have been greatly influenced and limited, thus closing interpretation.
The following is a list of students' impossible tasks:

- build a skyscraper in a day,
- float on the ceiling for sixty seconds,
- think of an impossible task, as an impossible task,
- be born again physically,
- for a human to fly,
- dig my way to China,
- stand a suitcase on end and manage to sit on it,
- lift the museum,
- do an oil change;
- kill a dead man,
- touch the ceiling with my foot.

After three minutes of improvising and rehearsing, Christopher re-
quested students stand at one end of the room and begin performing
their respective impossible tasks simultaneously. This they accomplished
in silence as they walked, gestured, twisted, bent, rolled, tossed, and
stretched their bodies in a variety of patterns suggested by their impos-
sible task assignment for a period of sixty seconds. The purpose of
brevity in Goat Island exercises is for students to suspend their intellec-
tual analyses, rationalizations, judgments, and inhibitions about what
may initially feel to them an absurd activity. By acting on instinct and im-
pulse they are more readily able to produce actions emanating from the
body's memory and knowledge.

Christopher then divided the group in half. These two smaller
groups stood opposite each other in the room and performed their im-
possible tasks for another sixty seconds, moving toward and through the
other group. She further divided the two groups into smaller units of
three to four students and asked them to isolate a "fragment" of their
impossible task and to perform it repeatedly, synchronized with their
partners' actions until told to stop (after approximately sixty seconds).
Ironically, as both the groups and impossible tasks were fragmented by
Christopher, the students found themselves presented with opportuni-

ties to participate more fully. Having to adjust and readjust their performances to accommodate each new circumstance enabled them to continually collaborate, brainstorm, and re-present their ideas and actions. In doing so, they had begun to improvise and rehearse a variety of possible movements. First, Christopher's instructions to perform a no-name performance of an impossible task, and now, the isolation and compartmentalization of a fragment from the original task diverted the performances even further from any contextual reference and toward a decontextual, nonreferential space. Under these circumstances, the body's performance could be more readily experienced as nondiscursive language, abstract representations, whose interpretations were no longer dependent on some prescribed text, but on the experiential and gestural perspectives brought to bear by individual members of the audience (during the workshop those groups who were waiting their turn to perform served as the audience).

Christopher then directed each of the small groups to perform their impossible task fragments for another sixty seconds for the other groups to observe. This time, however, she complicated their performance by assigning each student a time-based problem to solve. By asking each of them to modify the rhythm of their movements according to the following instructions, she introduced the concept of syncopation.

Student 1: perform once at the beginning of a sixty-second time period and once at the end;
Student 2: perform ten times as quickly as before;
Student 3: perform five times as quickly as before;
Student 4: perform twice as quickly as before.

These ensemble performances were followed by instructions from Christopher for the students to perform their impossible task fragments in close proximity to the other groups. In doing so, students had to coordinate and maneuver their own bodies and their groups in and around and through one another to create a synchronous complex of abstract movement and gesture for sixty seconds. Through this exercise, the students became aware of the spatial conditions, the tension surrounding their bodies, as a performative element. As the students performed in their respective groups, they carefully considered their movements to respond and coexist in time and space with those in the other groups.

Finally, Christopher had all four groups perform in unison the following sequence:

Group 1: performed fragments three times, the whole impossible task once, fragments three times;

Group 2: performed fragments five times, the whole impossible task once, fragments five times;

Group 3: performed fragments three times, the whole impossible task once, fragments three times.

Here the concepts of repetition, rhythm, and variation were further emphasized. As group members syncopated their performance fragments and performance wholes, they learned how to vary their use of time and space and to create a complex choreography from the prosaic gestures of their impossible tasks. Moreover, for their collaborations to succeed, they learned to focus on their own movements without distraction while coordinating their movements with the others in their groups.

Christopher's strategies for activating the body's performative capabilities and solutions to problems of synchronous movement provided students with a means by which to begin working collaboratively in the sequence of the workshop. As the students brainstormed ideas and improvised various movements, a performance structure began to emerge. It was apparent that Goat Island's pedagogy was leading students toward the development of a comprehensive performance work. This structure was continually intervened and interwoven with a new set of physical and conceptual problems for students to solve as the workshop progressed. Matthew Goulish provided the next intervention.

Interruption 3: Remembering Oppression

Goulish, the Goat Island writer/performer, began the third part of the workshop with a twenty-minute writing assignment. After asking students to grab their pencils and papers, he asked them to sit comfortably on the floor, relax, breathe, forget everything, and close their eyes. In doing so, he wanted them to separate the previous exercise parts from the task he was about to assign. During this three- to four-minute period of closed-eye relaxation, Goulish instructed the students to "imagine your first encounter with failure, your own or someone else's you have experienced, the event, whatever comes to mind as I say this. This must be a true, factual event. Do not make one up." Goulish asked the students to picture in their mind's eye what occurred in the event and, when ready, to open their eyes and begin writing, describing it in detail, its sounds, smells, textures, temperature, and anything else that would describe its character. Essential to the achievement of agency, Goulish's assignment for students to write about their first experiences with failure is yet another means by which to materialize the body's cultural memory and history, to make students aware of its complex manifestations, to take control,

and to use their oppression as material for performance art. Just as Christopher's "impossible task" exercises expanded the body's physicality, Goulish's "first failure" writing exercise stretched the body's memory and history. Together, these experiences could "tell" a lot about the body's experience.

After an eight-minute period of intense writing, Goulish handed out blank envelopes containing small photocopied images with descriptive texts including a parachutist descending, a person swimming in the sea, a person watching an eclipse at Greenwich Observatory, and a close-up of a hand accompanied by the following text "the muscles and tendons pull on the bones and joints to which they are fixed and bend the hands inwards." Goulish asked students to open their envelopes when ready and to incorporate the contents in their writing. Fully aware of the possibility that the images and texts would "fictionalize" their actual encounters with failure, he encouraged the students to continue writing for another five minutes from the perspective found in their envelopes.

Then Goulish asked the students to focus on a single sound in their failure event, "Listen to it carefully, listen until you hear it, then write it down, describing its quality" (three minutes). Again, the naming of the sound was left until the discussion session in part seven of the workshop in order to focus on bodily response rather than on verbal text or sign. Goulish later commented that the process of "nonintellectual" decision making opens the way for decisions from the body. When asked during the final discussion to identify their sounds, the students conveyed the following:

- pushing down with my fists on leather car seats (the gesture of doing so was accompanied with loud hissing sounds),
- a garden hose spraying full force on a wooden porch,
- exaggerated flapping of bird's wings,
- annoyance from adults and fear from a child,
- blood flowing in my head (student likened the sound to the air conditioner in the room),
- honking of a gaggle of geese,
- distant lullaby,
- an oil change,
- writing frantically,
- whispers,
- popcorn machine popping popcorn, while a door opens and closes loudly.

After their events were effectively documented in writing, Goulish asked the students to take a separate sheet of paper and to write a concise

report of four elements (three minutes), distilling the longer version of
what they had just written into miniaturized form:

- the date of the event,
- the time of the event,
- the place of the event,
- a one-line sentence describing what happened.

Also on the separate sheet, Goulish asked everyone to write notes on
how to produce the sound they heard in their events using any object,
surface, or means available to them in the room (3 minutes). "Try to
think like a musician, director, how to create, perform the sound you de-
scribed in your writing," he suggested. Thus ended Goulish's segment of
the workshop where the students were able to develop the text for their
final performances. Christopher's notion of the impossible task frag-
ment and Goulish's miniaturized encounter with failure began to reveal
a performance structure that was developing through recapitulation and
collaboration. Rendering the body explicit through an impossible task
and performing subjectivity through an encounter with failure represent
lessons within the Goat Island curriculum that introduce students to the
six strategies of performance art pedagogy (ethnographic, linguistic, po-
litical, social, technological, and ecstatic).

Interruption 4: Collaborating and Assembling

In part four of the workshop, Goat Island performer and workshop fa-
cilitator Mark Jeffery divided the students into four groups to begin the
part of the workshop that underscored the collaborative process. The
new groupings were divided according to the proximity of names on Jef-
fery's body map. Jeffery directed each group to a different corner of the
room (*Figure 4.5*) and asked that they temporarily set aside all proceed-

figure 4.5: Group
locations in room

ings of the workshop except to "recall and share" with each other the impossible tasks they performed for Christopher and the sound for Goulish. Jeffery further qualified his instructions by asking them to "teach your group partners how to produce the task and sound." After a five-minute exchange, the groups were instructed to collaborate and combine their sounds and impossible tasks as an ensemble. "Decide how each combination will relate and evolve from the separate sounds and tasks," instructed Jeffery. In addition, he asked them to rehearse. After a twenty- to thirty minute period of rehearsal, the four groups performed their combinations for the other three. One group combined the following tasks and sounds:

- the impossible task of building a skyscraper in a day with the sound of pushing down with fists on leather car seats (the students' abstract movements indicated bricks and mortar being assembled in a frenzy, their bodies reaching, reaching exhaustively toward the sky while simultaneously pushing downward as if on a car seat and making a swishing sound with their mouths).
- the impossible task of floating on the ceiling for sixty seconds with the sound of a garden hose spraying full force on a wooden porch (some students stretched their bodies upward as if reaching and floating, while others banged the walls and floor with their hands and feet while making a swishing sound).
- thinking of an impossible task, as an impossible task with the sound of exaggerated flapping of bird's wings (students' subdued movements signified being lost, trapped in a mental state contrasted with their physically exhausting flapping gestures, their "flight" from reason).
- the impossible task of being born again physically with the sounds of annoyance from adults and fear from a child (students' movements suggested unfolding, peeling, climbing out of their bodies; while some group members made the rumbling sounds of adult conversation, others created whimpering, sighing, and gasping sounds of fear).

Interruption 5: Recapitulating and Structuring

Part five was presented by Goat Island performer and workshop facilitator Bryan Saner who provided each of the four groups with a nonobjective pencil sketch, a "diagram" (*Figure 4.6*), which he had prepared in advance while the other sessions were going on. An imposed choreography, the diagrams problematized the group's existing movements and reinforced the necessity to develop a structure for collaboration. Saner further instructed the groups to consider the placement and/or involvement of the audience within the space. Each of the groups brainstormed and rehearsed according to the diagram for five minutes. Saner interjected yet another directive. Each group was asked to isolate

Group #1 #2 #3 #4

figure 4.6: Bryan Saner's diagrammatic sketches

a section of their performance, to create a "miniaturized version" for a "micro stage" and then to add it to their final performance (five minutes). Each group was asked to create a "performance within a performance," thus introducing "recapitulation" as an essential element. Recapitulation and repetition provided the students' initially developed ideas, images, and gestures with a "history" and the means to emerge a "structure for collaboration," according to Goulish. Similar to linguistic theorist Mikhail Bakhtin's (1981) *dialogisms*, where a constant interaction exists between ideas, "all of which have the potential of conditioning others" (p. 426), recapitulation serves as a palimpsest to reflect the history of a performance. This process occurs on two levels in Goat Island's pedagogy: within the context of the performance itself and in the larger social-historical context from which the performance images and gestures are appropriated. That is, the miniaturized version recapitulates *How dear to me the hour when daylight dies*, just as the complete performance of *How dear to me the hour when daylight dies* recapitulates society.

Following the insertion and rehearsal of their miniaturized versions within their larger performance, the groups were finally instructed to add their "first encounter with failure" texts to the mix. This final rehearsal represented the culmination of workshop, the orchestration of its parts into a unified whole. Essential to the overall curriculum plan of their workshop, according to Hixson and Goulish, is that "each new stage serves as an intervention into the sequence [of the curriculum], thus compelling students to make adjustments to another level of commitment." (Audio tape transcription by author) As students stretch their imaginations and their physical endurance, they are able to suspend historical, cultural, and personal rationalizations to those which are somatically based in "body intelligence."

as an ethnographic representation of their research findings. The reca- pitulation of each stage of the workshop through repetition and re- hearsal enabled the students to consider and reconsider their body performances twice, thrice, and so on. This, in addition to the multiple strategies of the workshop and the multiple perspectives of the students, provided a dialectic condition from which evolved a structure of collab- oration. Through the workshop, this reflexive process contributed to stu- dents' evaluation of their decisions, their relinquishment of control to the group, and the development of self and community agency.

The performance art pedagogy of Goat Island represents an in- depth example of how the spectacle of performance art can critique the spectacle of reified culture. The collective's workshop interruptions pro- vide structure to the complex juxtapositions found in their performance art works. As in their MCA workshop, their performance *How dear to me the hour when daylight dies* introduced and rendered the body explicit through its exertion of "impossible tasks." Under the circumstances of the body's endurance, two limitations were revealed: its capacity for physical exhaustion and psychological oppression. Goat Island's perfor- mance and the workshop served to expose and liberate the body from these limitations. As seen through the characters of Mr. Memory, Amelia Earhart, and Mike Walker, these limitations signify the double coding of celebrity spectacle: exalted for their personal, private accomplishment yet isolated, confined as a public curiosity. This double coding repre- sents the allure of reified culture, the promise of a stable, sanitized world of ads, theme parks, and the fantasy of other virtual realities as an escape from personal and social responsibility. The tragedy of this escape is the abdication of one's personal identity, experience, and body to a histori- cally and socially constructed world, the surrender of critical citizenship to the commodified society of the spectacle.

As Goat Island's pedagogy critiques the society of the spectacle, it functions as the praxis of postmodern critical theory, rupturing, expos- ing, and interrogating the blurred realms of the private and the public. By introducing the self and body to others, making the body explicit with an impossible task, remembering oppression, collaborating and assembling, recapitulating and structuring, performing the body, and discussing, Goat Island's curriculum engages students in the liminal, contingent, and ephemeral conditions of performance art in order to explore, expose, and critique contemporary culture from their respec- tive, individual cultural experiences and from the position of their bod- ies. In doing so, students learn to make spectacles of and with their bodies, to challenge the normative and authoritarian spectacle of reified culture through the spectacle of their private experiences and knowl- edge. Herein lies the emancipatory promise of Goat Island's pedagogy.

5

Robbie McCauley's Talk-About Pedagogy

> In between absurdities is where I stand, and now there are
> trains again. Panic about identity, which Sigmund Freud said
> long ago is neurotic, has finally disoriented the white people.
> —Robbie McCauley, *Fragments* (1996)

In her performance at the Performance Art, Culture, Pedagogy Symposium entitled *Fragments (1996, Figure 5.1)*, Robbie McCauley walks onto the stage area of a quasiblack box arena dressed in black casual clothes, carrying a black net bag filled with assorted fresh fruit and a pair of black high heel shoes. The only prop situated in the center of the stage area is a low staircase with hand rails leading to a landing. McCauley proceeds to deliver a powerful monologue about the racism that she and her family have endured for more than four generations in America. The story that she tells is her own, her mother's and father's, grandparents', great-grandparents', and great-great-grandmother's experiences of living in a racist society.

> McCauley: *Uh* . . . (she grunts and grimaces in disgust, and with a slide of her ancestors projected in the background, she clenches her fists and thrusts her arms upwards in an act of defiance) . . . *Uh* (she grunts again and repeats the defiant gesture in front of a second slide of family). *She said* (McCauley tells of a conversation between herself and her mother), *"thing about white people, is that what they need to do is to get embarassed. They need to think about it 24 hours a day just like we do. They need to talk about it to each other all the time like we do." She said, "what's that man's name, what's that man's name, that one you talk about all the time, W. E. B. DuBois. Didn't he say that this was gonna be the thing about this century." I said, "yes, he said that the color line what this century was going to be about." She said, "he ain't got but three years"* (audience laughter). (Videotape transcription by author)

Although standing alone on a minimal stage, McCauley's "acting out" of her indignations, as well as those of her family members, functions like

figure 5.1: Robbie McCauley, *Fragments*, 1996. Courtesy Charles Garoian

a group conversation. As she fluctuates between monologue and dialogue, she speaks both to and with the audience. In monologue, she tells her narrative, which consists of the stories of family members. In one instance she tells her story and then her mother's, her father's, her grandmother's, her mother's again, her grandfather's, her great-great-grandmother's, and so on. At key points in her performance, she breaks from her monologue to ask questions of audience members, to solicit their input, their participation in a dialogue that deals with racism. She accomplishes this by presenting them with a challenge. "I want you to think about something," she says as she breaks from her monologue to engage them directly. "It will help this ritual," she continues. "*I want you to think of white people who have commited their lives to being antiracists* (emphasis added)."

With this challenge, McCauley repositions the audience in two ways: first, she blurs the traditional boundary, the "fourth wall" of the proscenium, and provides a space within which the audience can actually participate in the performance; second, she confronts the audience with the reality of racism in contemporary culture, their complicity with and/or struggle against racism. This engagement in discourse, among herself, the members of her family, and the audience, represents a significant cultural paradigm for performance art pedagogy: the "testi-

mony and witnessing" of history, a process grounded in the psychoanalytic pedagogies of Sigmund Freud and Jacques Lacan, two historical sources from which literary critic Shoshana Felman (1992) has developed a "theory of testimony."

This chapter characterizes the testimony and witnessing strategy of Robbie McCauley's performance art and teaching as a manifestation of psychoanalytic theory. The chapter consists of two parts: first, the artist's performance strategies are compared with psychoanalytic theory in order to identify their pedagogical correspondence; second, a workshop is described in order to demonstrate the application of McCauley's pedagogy in a teaching situation. It is important to understand that the purpose of invoking psychoanalytic theory is not to suggest McCauley's work, or performance art in general, as pathological inquiry or therapy. Rather, the theories of Freud, Lacan, and Felman constitute a pedagogy that has profoundly influenced the expression of subjectivity and the construction of identity through language in contemporary culture (Felman, 1987, p. 75). Psychoanalytic pedagogy acknowledges and enables the expression of subjective experience in ways that are similar to the pedagogy of performance art. Felman (1987) claims: "To learn something *from* psychoanalysis is a very different thing than to learn something *about* it: it means that psychoanalysis is not a simple object of the teaching, but its subject" (p. 74).

Moreover, basing McCauley's work in psychoanalytic theory does not preclude the significance of the antispectacle paradigm discussed in the previous chapter. On the contrary, these two paradigms complement each other. As the artist gives testimony, she conjures a representation of her cultural history that produces, rather than reproduces, a spectacle of testimony that challenges the spectacle of reified culture. Thus, a complement of creating the antispectacle of performance art can be based in psychoanalytic theory: exposing, challenging, and performing the repressed and suppressed experiences and knowledge of racism in order to imagine new myths that make cultural acceptance, understanding, and coexistence possible.

McCAULEY'S CRITIQUE OF MASTERNARRATIVES

Within the paradigm of psychoanalytic theory, McCauley actuates all six strategies of performance art pedagogy: the ethnographic, linguistic, political, social, technological, and ecstatic. Reversing the order and beginning with the ecstatic, she embodies the cultural stereotypes of racism in order to critique them. The spectators' aesthetic absorption and participation in her performances enables a visceral experience, one that raises their awareness regarding their position with racism. As

the ecstatic combines with the technological, she uses her body as an instrument with which to witness and give testimony about racism in contemporary culture. As an instrument of culture, McCauley claims her body resonates with "her experience and imagination" (McCauley, 1996, p. 274). Regarding her social strategies, she has gained international notoriety for her ability to work effectively with communities where racial tensions are at a crisis point. McCauley first selects an event in the community that "stirs" her. She then collaborates with members of the community to create a performance that "allows different points of view [about the event] to be talked about while retaining passion" for its charged issues (p. 270). Challenging the racist attitudes of contemporary culture, McCauley positions herself politically through performance art. Her rage being the source of her politics, she declares, "I will not rest until confessions of privilege come from all sides" (p. 275).

Regarding linguistic strategy, McCauley claims to be a student of stereotypes. She maintains that stereotypical metaphors function like scripts that people "consciously and unconsciously" act out on themselves and others (p. 279). Telling the stories of and about the various members of her family, and her dialogic relationship with the audience, represents a linguistic strategy to witness, give testimony, and critique the tendency to stereotype. As she shifts her storytelling from one family member to another, and her relation to the audience, her body functions as a cultural signifier engaged in a semiotic performance providing multiple perspectives on her African American experience and inviting multiple interpretations.

Finally, McCauley's ethnographic strategy represents the focus of her performance art pedagogy. In drawing inspiration and material from memory and cultural history, she argues that performance art teaches a history that aims "not 'to tell real stories from real people' but to create something that emerged from the process of the actor's examination of, and ability to give voice to, the essence of events" (p. 279). Herein lies the crux of McCauley's strategies, a pedagogy that epitomizes the liminal, contingent, and ephemeral praxis of postmodern theory. As she gives testimony about her cultural history and invites the audience to witness from their own cultural vantage points, she reclaims history and, in doing so, transforms herself and the audience from the objects of history to its subjects. McCauley's ethnographic strategy consists of performing a complex composition of her family's stories, what anthropologist Clifford Geertz (1973) characterizes as a "thick description . . . a multiplicity of complex conceptual structures, many of them superimposed upon or knotted into one another, which are at once strange, irregular, and inexplicit, and which he [the ethnographer] must contrive

somehow first to grasp and then to render" (p. 9). The veracity of McCauley's complex cultural collage lies in the sheer number of stories that she provides as testimony, her thick description.

Cultural theorist Michel Foucault (1977) refers to the subject's retrospective critique of history as a "genealogy," a search and telling of one's own cultural history, through memory work, that challenges and resists the dominant narrative of historical analysis. Performance theorist Rebecca Schneider (1993) argues that the Foucaultian geneological performance of subjectivity represents a praxis that exposes the inscribed history of the dominant culture on the body. It "finds 'something altogether different' from dominant practice . . . [and] it approaches bodies as landscapes of countermemory situated in and affected by that narrative" (p. 232). Foucault (1989) defines this genealogical performance of events for the purpose of critiquing historical regimes of power and knowledge as "eventalization" (p. 104).

The interrogation of historical knowledge, its position as absolute truth, represents "a breach of self-evidence," a political function of eventalization that Foucault argues makes "visible a *singularity* at places where there is a temptation to invoke a historical constant, an immediate anthropological trait, or an obviousness that imposes itself uniformly on all" (p. 104). This breach corresponds to the liminality of performance art pedagogy, a space within which the "singularity" of socially and historically constructed codes are challenged and liberation is desired. It is within this breach of self-evidence that Foucault presents a second political function of eventualization, namely "rediscovering the connections, encounters, supports, blockages, plays of forces, strategies, and so on that at a given moment establish what subsequently counts as being self-evident, universal, and necessary" (p. 104). This second function of eventualization is predicated upon contextual considerations, the contingent character of performance art pedagogy where a "multiplication or pluralization of causes" is brought into effect (p. 104). As McCauley constructs and performs a web of connections from the events in her life to those of her family, and those of audience members, she engages in a polymorphic process that deconstructs the racist codes of master narratives yet opens the possibility for rewriting history to include those voices whose stories have not been told, and those whose stories have only been told from an outsider's perspective. Cultural theorist Vivian Patraka (1993) refers to this telling of cultural history through performance art as dramatizations of "forgettable people," who in creating the past they "create the future by enlarging the circle of who one can associate with and the vision of what people can create and act upon" (p. 217). Pedagogically, such dramatizations are

significant in the attainment of agency within the context of the dominant culture.

Historical reform, for McCauley and Foucault, is not confined to a conceptual process that ascribes the object of history "to the most unitary, necessary, inevitable, and (ultimately) extrahistorical mechanism or structure available" (Foucault, 1989, p. 106). On the contrary, McCauley's subjective, intrahistorical perspective stands in opposition to the extrahistorical representations of mainstream cultural reformers. Her perspective manifests reform performatively as all who are involved in her testimony and witnessing process "come into collision with each other and with themselves, run into dead ends, problems, and impossibilities . . . [and have experienced] conflicts and confrontations; when critique has been played out in the real" (Foucault, p. 114).

The question of master narratives is also presented by cultural theorist Jean-François Lyotard (1989) who writes about the "'the loss of meaning' in postmodernity" because narrative knowledge based on subjective experience is no longer considered legitmate by the scientific mind-set (p. 80). With Lyotard we begin to understand the "master-narrative" metaphor as a contradiction of terms. He argues that narrative knowledge has no means by which to master or legitimize itself, to establish itself as historical truth. "[It] does not give priority to the question of its own legitimation and that it certifies itself in the pragmatics of its own transmission without having recourse to argumentation and proof" (p. 80). McCauley's performance of her family history certifies itself through a collage structure, a process that Patraka (1993) describes as a "collaborative composition" that uses the stories of others "to thicken and multiply the presentation" (p. 219).

These liminal, contingent, and ephemeral conditions of the narrative tradition, like those of performance art pedagogy, are unverifiable for the scientific mind. The scientist "classifies them as belonging to a different mentality: savage, primitive, underdeveloped, backward, alienated, composed of opinions, customs, authority, prejudice, ignorance, ideology. Narratives are fables, myths, legends, fit only for women and children" (Lyotard, 1989, p. 80). Similarly, conservative curriculum scholars believe its autobiographical character a form of "mystical alchemy," an "emancipation from research," and too "solopsistic and purely personal" (Pinar et al., 1995, p. 516). Lyotard goes on to discuss what he calls the "crisis of scientific knowledge," where the legitimacy principle has been eroded, providing the conditions for the paradigm shift to postmodernism. Due to the erosion of legitimacy, the "weave of the encyclopedic net," in which scientific disciplines are situated, has loosened, thus setting them free (p. 84). Lyotard asserts:

The classical dividing lines between the various fields of science are thus called into question—disciplines disappear, overlappings occur at the borders between sciences, and from these new territories are born [border identities and pedagogies]. The speculative hierarchy of learning gives way to an immanent and, as it were, "flat" network of areas of inquiry [a web], the respective frontiers of which are in constant flux. (1989, p. 84)

Once again, like McCauley's narrative web and Foucault's polymorphic connections, Lyotard describes the weblike matrix of narrative knowledge as "constant flux," characterizing the interdisciplinary and intercultural conditions of performance art pedagogy.

Lyotard's concept of narrative knowledge, as it relates to McCauley's dialogic narrative, is concurrent with Paul Ricoeur's (1981) notion of "discourse," the speech act as performance. Ricoeur describes discourse as the counterpart of "language-systems or linguistic codes" (p. 198). One cannot exist without the other. Four traits of discourse that, when "taken together [,] constitute speech as an event" [speech as performance], according to Ricoeur:

1. Discourse is always realised temporally and in the present, whereas the language system is virtual and outside of time. Emile Benveniste calls this the "instance of discourse."
2. Whereas language lacks a subject . . . discourse refers back to its speaker by means of a complex set of indicators such as the personal pronouns. We shall say that the "instance of discourse" is self-referential.
3. Whereas the signs in language only refer to other signs with the same system, and whereas language therefore lacks a world just as it lacks temporality and subjectivity, discourse is always about something. It refers to a world which it claims to describe, to express, or to represent. It is in discourse that the symbolic function of language is actualised.
4. Whereas language is only the condition for communication for which it provides the codes, it is in discourse that all messages are exchanged. In this sense, discourse alone has not only a world, but an other, another person, an interlocutor to whom it is addressed. (p. 198)

Thus for Ricoeur, the performance of discourse is temporal, subjective, experiential, and dialogic, characteristics that describe the pedagogy of performance art and, for the purposes of this chapter, the work of Robbie McCauley. These characteristics also describe the topic of the next section: the psychoanalytic pedagogies of Sigmund Freud and Jacques Lacan from whom Shoshana Felman has developed a theory of testimony and witnessing and in which McCauley's performance art pedagogy is grounded.

THE PARADIGM OF PSYCHOANALYTIC PEDAGOGY
AND TESTIMONY THEORY

Significant to psychoanalytic theory, Robbie McCauley's telling of her cultural history represents a performance of subjectivity, what she refers to as a "talk-about." A euphemism for the dialogic process of her discourse, one that finds its counterpart in the Australian aboriginal "walk-about," McCauley's talk-about functions in two ways: first, as a communal form that takes shape as the discourse "wanders" (in the aboriginal sense) from one person to the next ; and second, as content that emerges from the discourse as McCauley and her spectators/students "talk-about" their experiences, memories, and cultural histories regarding racism in the first person. As McCauley and spectators/students talk-about, they engage in a subjective discourse about charged cultural issues, a pedagogical process of intervention that challenges the phallo-centric gaze of the patriarchy.

> McCauley: (Spreading her feet apart to plant herself in place) *In between absurdities is where I stand, and now there are trains again. Panic about identity, which Sigmund Freud said long ago is neurotic, has finally disoriented the white people* (laughter). *And so we are all the same, but not in the ways that we've escaped into describing it. Once in Connecticut there was two men, one of them was one of my white husbands, no wait, wait a minute, no there were two, no the other guy was a friend of his* (laughter), *no men don't do that* (laughter), *no, that might be very interesting* (laughter), *but no, and I was drunk as a skunk, and here we were in this little café, and you know how white people borrow houses* (laughter), *so as usual I was drunk, I went into the bathroom to pick my Afro, and I was up there in the bathroom pickin' my Afro, and the hair was fallin' in the sink, and I would take towels out and wipe the sink, and there was this grey-haired white woman sittin' over there. She was lookin' at me and I'm pickin' my hair, and she came over to me. And you know how white people can be, tryin' to be subtle, like the Rock of Gibraltar?* (laughter). [The grey-haired white woman said] *"We're Republicans out here"* (laughter). *I flipped my hair over one time and I said, "Look, my family's been Republican ever since Lincoln"* (laughter). *So we are all the same: greedy, vengeful, bloody.* (Videotape transcription by author)

Felman (1992) likens performances of subjectivity, such as McCauley's, to the testimony and witnessing process of Freudian and Lacanian psychoanalytic theory. She characterizes Freud's psychoanalytic method as a pedagogy, "an unprecedented kind of dialogue in which the doctor's testimony does not substitute itself for the patient's testimony, but resonates with it, because, as Freud discovers, it takes two to witness the unconscious" (p. 15). A disciple of Freud, Lacan based his own teaching on Freudian psychoanalytic pedagogy by characterizing the dialogic process between analysand and analyst as a performance of lan-

guage, and, in doing so, he shifted the problem of identity formation from the self to the culture. As the analysand gives testimony, language is performed, witnessed, and interpreted as a cultural referent. In other words, psychoanalytic pedagogy serves as a critique of cultural pathology rather than that of the individual.

Figure 5.2 illustrates the way in which the testimony and witnessing process of psychoanalytic pedagogy works. The analyst functions as a *mirror* (Lacan, 1977, pp. 1–2) of the analysand's unconscious. In order to construct a theoretical interpretation that is specific to the knowledge learned from the analysand's disjunctive testimony, the analyst must suspend preconceived theories and interpretations in order to "free associate" its "latent meaning." In this respect, the analyst's responsibility as teacher is relinquished to the analysand, an antipedagogical strategy similar to the McLaren's (1993) teacher-as-liminal-servant. Felman claims that when Freud first wrote down his own free associative dream responses to his patient Irma's confessions, he unexpectedly discovered from the "dream's specific latent meaning" an unprecedented method of dream interpretation and a theory of dreams as psychical fulfillments of unconscious states" (p. 13). Thus, after witnessing the analysand's

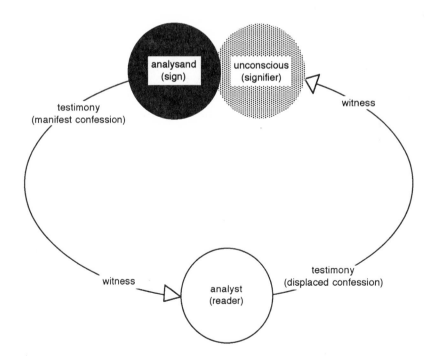

figure 5.2: The dialogic process of psychoanalytic pedagogy

testimony, the analyst constructs a collage, a narrative interpretation that, when returned (mirrored) back to the analysand, functions as testimony. Felman distinguishes the "manifest confession" of the analysand's testimony from the "displaced confession" of the analyst's testimony: "the *testimony* differentiates itself from the content of the *manifest confession* which it uses as its vehicle, the confession is *displaced*, precisely, at the very moment that we think we grasp it, and it is in this surprise, in this displacement, that our sense of testimony will be shifted once again" (1992, p. 14). As the analysand witnesses the analyst's displaced "shift" in testimony, she or he vicariously witnesses her or his own unconscious, a collage representation of the repressed and suppressed content that was heretofore hidden. Felman (1987) characterizes the learning process that takes place through psychoanalytic pedagogy as nonlinear. It proceeds "through breakthroughs, leaps, discontinuities, regressions, and deferred action, the analytic learning process puts into question the traditional pedagogical belief in intellectual perfectibility" (p. 76).

The disjunctive character of psychoanalytic pedagogy corresponds with McCauley's liminal, contingent, and ephemeral narrative. Critic/art historian Ann-Sargent Wooster (1985) describes the collagelike form of disjunctive narratives like McCauley's as a "stream of consciousness in which reality is ordered in strings of successive or interleafed images . . . where the point of view of the speaker constantly shifts and there are abrupt temporal leaps using flashbacks and flashforwards . . . [forms] in which time, action, and meaning, as well as the thoughts and actions of the characters, are treated as temporally fluid" (p. 205). Coincidently, the collage form of Freud's free associative interpretation of Irma's manifest testimony in the early twentieth century corresponds with the avant garde's use of collage in the same time period to represent the manifest testimony of modern industrial culture. What Freud and the modernist avant garde exclude from their complex and contradictory representations, however, Robbie McCauley confronts head-on. Namely, she appropriates and expands the collage motif of modernism to expose and interrogate its exclusionary content as a manifest testimony of racism.

> McCauley: *Everybody knows that my father was always in somebody's . . .* (With clenched fists, she thrusts her arms upwards. This gesture of defiance, along with the shouting out of branches of the armed forces, signals the changing of slide transparencies of her father and other black men dressed in the military uniforms) . . . *Army* (gesture/slide) . . . *Navy* (gesture/slide) . . . *Air Force* (gesture/slide). . . *National Guard* (gesture/slide). *He longed to be a policeman, he loved uniforms and other male mythology* (gesture/slide). *He liked his cigarettes raw and whiskey straight in a shot glass. He wanted a Cadillac more than anything else in the world* (gesture/slide). *Everybody knows my great-great-grandma Sally had children by masa' and that my*

mother got her name from one of 'em fine daughters who sit on the front porch with organdy dresses on. My mother loved pretty clothes. And the family was doing pretty well back in Georgia (Videotape transcription by author).

In her performance *Sally's Rape*, McCauley tells the story of her great-great-grandmother who was a slave in Georgia who bore two children by her slaveowner, "the Masa." She compares her grandmother Sally to Thomas Jefferson's Sally Hemmings who was a slave that bore him children.[1] In performance, she strips off her clothes and stands naked on a bench—a slave on an auction block—as her white female partner Jeannie Hutchins solicits bids from the audience to create a slave market climate. Performance theorist Raewyn Whyte (1993) describes audience members' responses to McCauley's scene as one of complicity and guilt. One the one hand, they were made aware of "being inescapably positioned as a potential buyer in the slave market [by McCauley], yet the urge to look away . . . [was] countered by the seductive intensity of the scene" (p. 278). By creating power relations similar to those in which Sally was caught at Monticello, McCauley enables audience members to experience being both the victims and perpetrators of racism.

McCauley's use of photographic images presents another dimension of her complex performance structure. The slide projections of her ancestors, in the midst of her narrative, interject iconic references that function in three ways: they augment the disjunctive structure of her performance collage; they verify, as evidence, the truth of her cultural history; and, they serve as "internal witnesses" to her testimony. Felman (1992), claims that photographs of deceased family members function as iconic references, images through which we create an internal dialogue to survive and compensate for our loss. This dialogue, which occurs through the icon, represents a testimony about our relationship with the deceased, a performative act "of establishing and maintaining an internal witness who substitutes for the lack of witnessing in real life" (p. 87). McCauley's backdrop of large slide images of family members represents the augmentation of a cohesive narrative about living in a racist culture that has long been shared as an oral tradition by her family, similar to the way in which family album photographs are often used to tell about deceased family members. There exists a long history of silent witnessing, suppressed and repressed, in McCauley's family that has been transformed through her performance art as critical pedagogy.

[1]During my interview with Robbie McCauley in June 1998, she clarified that her great-great grandmother was not Sally Hemings as Raewyn Whyte (1993) seems to imply. In *Sally's Rape*, Robbie, the character, states, "Shit, Thomas' Sally was just as much a slave as our grandma and it was just as much a rape. One Sally's rape by the master no gooder n' an nothern."

McCauley's performance narrative flashes back and forth from her present circumstances to those of her various ancestors, from her cultural history as an African American woman, to those cultural histories of her spectators. Describing McCauley's disjunctive narrative form as "fusion of politics, poetics, and music . . . [and her] African-American ways of speaking and telling," dance/theater commentator Raewyn Whyte (1993) writes:

> There's no beginning-middle-end to these stories, no narrative closure, no "once upon a time" or happy ending, no stereotyped familiar characters, no comforting moral messages. Fragments, individual incidents, are pieced together in the course of a performance, becoming part of a bigger picture through repeated images that extend the mininarratives and through repeated phrases that connect the underlying themes. (p. 285)

What Whyte is describing here is collage, a motif whose complex of co-existing images provides not a single, fixed perspective on the narrative of the performance, but multiple access points that lead to multiple interpretations. Closure is not what McCauley wants to achieve. After all, closure only assumes the attainment of an absolute, a fixed position. She continually re-positions herself, her audience, with regard to issues about racism and, in doing so, engenders a fluid, ongoing dialogue.

Similar to psychoanalytic pedagogy, Robbie McCauley's disjunctive testimony as performance art represents the signifiers of her cultural history. It serves as a "displaced" testimony of her ancestors' "manifest" testimony, a fluid process that she extends to her audience. As spectators see the gestures and hear the narrative of her monologue, they participate as analysts witnessing her testimony. Their reading and interpretation of McCauley's performance narrative as displaced testimony function as an internal dialogue similar to Felman's description of how photographs serve as silent witnesses. This silence should not be confused with suppression, however. Spectators' internal dialogue provides them with a sense of agency and responsibility. Unlike the spectacle of popular entertainment, the monologic pedagogy of the teacher-as-hegemonic overlord, and the teacher-as-entertainer, McCauley's narrative is open to interpretation, it requires that spectators read and interpret, "displace," her testimony from their respective cultural vantage points, to see themselves in relationship to racism. The following example represents my internal dialogue as I listened to and watched the aforementioned portion of McCauley's performance about her father's military service and her great-great-grandmother's "service" in the master's house.

Charles (internal dialogue): Is McCauley's defiance of her father's military service due to its patriarchal structure? Does she see her father's participation in the military, his love of uniforms and male mythology as acquiescing to a racist society? (In addition to her father, several black men in uniform are projected on the screen.) Why and how did black men in the military justify protecting the freedoms of a country that oppressed them? In doing so, were they not complicitous with its racist policies? Did black men believe they could escape oppression by joining the military? Do military induction, uniforms, male mythology, cigarettes, raw whiskey from a shot glass, and Cadillacs represent acceptance and power for black men rather than exclusion and domination by a racist culture? McCauley collages her father's military service with her great-great-grandma Sally having children by the master. Is McCauley asking viewers to conflate her father's military service with the service that Sally had to render as a slave/mistress? Was her father a "raped slave" like Sally? Are Sally's rape and slavery justified by the master as "duty" to his country? (In *Sally's Rape*, McCauley conflates Sally with rape and rape with racism. "All of 'em," she says, "who bin with the Massa, were Sallies" [Whyte, 1993, p. 292].)

The silent aesthetic of McCauley's monologic pedagogy is augmented when she shifts her performance from monologue to dialogue. In doing so, she enables spectators to participate directly in her performance, "to share" their own testimonies in response to hers. As before, spectators witness her performance testimony through an internal dialogue; however, now their silence is broken. They are positioned to respond, to return displaced testimony to McCauley about what they have witnessed (their readings and interpretations of her performance). As this dialogic proceeds, McCauley performs to the audience members who, in turn, perform to McCauley and to each other; an aesthetic undertaking that unfolds a community discourse.

McCauley's dialogic performance is metaphorically related to the psychoanalytic pedagogy of Lacan's mirror. Lacan (1977) characterizes the mirror stage of development, between the ages of six and eighteen months, when the child begins to fix her/his gaze on the "spectacle" reflected in the mirror and is able to imagine and identify the self in a symbolic way. This early developmental stage represents for Lacan the time in which the child first sees itself as itself (as the subject of her or his gaze) and begins to distinguish the world as other (as the object of her or his gaze). As the child (subject) assimilates this distinguishing process, it also learns to see itself as other (as an object among objects), whereupon it depends on language to restore its subjectivity. Lacan states that the self "is objectified in the dialectic of identification with the other, and . . . language restores to it, in the universal, its function as

subject " (1977, pp. 1–2). It is through the performance of language, the speech act, that the subject is able to express its identity, in the first person, to itself and others. In doing so, the self does not function as an entity unto itself but as a construction that is linked to all others in the society through language. Performance art pedagogy, which represents this work of subjectivity, facilitates agency through self expression and acknowledges identity work as significant content in arts education.

Thus, the performative pedagogy of the mirror functions in two ways, according to Lacanian theory: first, the mirror serves as a emancipatory reflexive action, one that enables the subject to gaze into one's self, to speak in the first person, to witness and create testimony about those cultural inscriptions that are repressed and suppressed within one's unconscious mind. Second, the phallocentric, outward gaze of the subject functions as a mirror that objectifies, surveys, and inscribes its desires on the other. As in Foucault's panopticon, by reflecting the gaze of the other back onto itself, it arrests the other in a state of perpetual otherness. In this state, the other is rendered the object of visuality, knowledge, and power, an oppressive condition where its subjectivity and its desires are suppressed.

Performance theorist Elin Diamond (1993) argues that re-positioning the subject through performance art represents a mimetic subversion of the Platonic ideal and the Aristotelian universal types of imitation. She invokes feminist psychoanalytic theorist Luce Irigaray's notion of an "imposed mimesis" as a strategy that politicizes Lacan's mirror by reflecting the phallocentric gaze of the patriarchy back at the male "*thereby demonstrating the truth of his centrality*—his own image, his Self-Same" (p. 364). In doing so, Diamond claims, this subversion of the patriarchal mimetic system results in "mimesis-mimicry [an intervention] in which the production of objects, shadows, and voices is excessive to the truth/illusion structure of mimesis, spilling into mimicry, multiple 'fake off-spring'" (p. 371).

An African American woman, whose family has experienced racism for several generations, Robbie McCauley's pedagogy testifies both to the oppressive and emancipatory power of the Lacanian mirror metaphor. On the one hand, she possesses an acute awareness of her gender and race, her oppression, because white patriarchal culture has held the mirror to her face as a marker of difference vis-à-vis its gaze. On the other hand, her performance work functions as reflexive strategy. By telling her version of history through the disjunctive narrative of performance art, McCauley turns the responsibility for the racist gaze of the patriarchy back on itself in the form of Irigaray's mimesis-mimicry. In doing so, Diamond argues, the Lacanian mirror is transformed "into a political tool: mimetic submission becomes destablizing mimicry" (1993,

p. 369). When subjectivity is performed, as it is in the case of McCauley, the subject is transformed from a submissive role to one that is politically proactive. By miming the racist expectations of the patriarchal gaze, Mc-Cauley exposes not only the ideological text of the dominant culture inscribed on her body, but, in a most effective way, she reflects the spectators'/students' complicity in racism, that is, their "whiteness."

To create this countermimicry, McCauley weaves together a testimony of racism that consists of comic and tragic elements. The audience members are drawn into her narrative with tragic elements, yet released from their emotional responses through comedy.

> *And then she went on to work at a little café that was attached to the Senate dinin' room, cause you know cookin' was already in the family, and she said, "Oh they would be up there and sendin' messengers and secretaries down to get little sandwiches and little quick-ups and things while the Senators would be up there beatin' on the table and talkin' about the 'the niggers this' and 'the niggers that,' and I'm goin' to do this and such with the niggers, especially that Storm Thurmon or whatever the hell his name was"* (laughter). *He ain' dead yet is he?* (laughter). *Don't wanta talk bad about the dead.* (Videotape transcription by author)

The push and pull of melancholy and laughter, audience members' reactions to McCauley's tragicomedy, enables a distancing effect similar to mimesis-mimicry, a means by which they can enter and experience the politically charged content of McCauley's narrative yet pull back in order to reflect and analyze its message. It is the pulling back of laughter that places audience members in a reflexive position, one that enables questioning of their insensitive reaction to the pathos of McCauley's testimony. As they consider making light of the tragedy of racism, they become aware of their complicity.

The following excerpts from McCauley's performance *Fragments* illustrate how the disjunctive form of her displaced testimony and spectators'/students' subsequent participation function as mimetic-mimicry:

> *In the elevator dreams* [a euphemism for delving into her unconscious], *sometimes it was a freight elevator and it was dangerous. Sometimes it was the back part of one of those department stores, or some other shopping place, where black people had to act dignified about not being able to try on clothes. At Curvins in Columbus, Georgia I didn't even know we couldn't try the clothes on. My auntie would say, "Well if it don't fit then take it back," and by then my grandmother had already made the pattern, but that's not enough. In the elevator dreams, they were sitting at counters I couldn't be at and the elevator would only stop at empty floors, and I couldn't get out of the building. Diabetes. Sugar. Pound cakes. I guess I should feed you* [Is she addressing the audience or talking to herself? McCauley is diabetic]. *Talkin' about food, the thing is, I tell you what* [she empties the black net bag filled with

fruit. Holds up an orange and looks towards the audience, places fruit on floor]. *We'll leave them here. I tell you what, why don't you think of times, you are mainly white* (audience nervous chuckle), *think of times, white people, when you were racist, stories about that. Raise your hands* [raises her hand to encourage audience participation]. *Go down in your elevator* [McCauley asks for audience to do memory work as she removes fruit from the bag and lines it up on the floor]. (Videotape transcription by author)

McCauley challenges her audience with three requests during her performance: at the beginning, in the middle, and at the end. In each case she tells of her family's history to establish a context for a discourse on racism. In the beginning, she says, "I want you to think of white people who have commited their lives to being antiracist." With this challenge, she shifts the role of the audience from silent witnessing to public testimony. Later, she uses the elevator metaphor to probe her memory of her family's past but then redirects the metaphor at the audience, for their avoval of racism. She says, "I tell you what, why don't you think of times, you are mainly white, think of times white people, when you were racist, stories about that." With this request, McCauley shifts the audiences members' testimony from others who are antiracists to themselves. In doing so, she asks the audience members to consider their own attitudes, their own complicity in racism.

In the end, McCauley returns to her first challenge for the audience to name names of white persons who have commited to being antiracists. "So this is the part, this is the time to call out the names," she says. As she sings *As Time Goes By*, the theme song from *Casablanca*, she interjects her white persons' names as well as soliciting those from the audience. Having been confronted with the responsibility to perform, the audience responds in a cautious, self-conscious manner. After several names have been shouted out, McCauley continues: "*You must remember this*, more names, *a kiss is still a kiss*, more names, you can at least name yourselves, everyone name yourselves, *a sigh is just a sigh*." This, McCauley's final effort to solicit names by asking the audience members to name themselves, empowers them with political agency. McCauley knows that the subject's claim of not being a racist is a denial of repressed racism. She solicits and interprets, in the tradition of psychoanalytic pedagogy, this denial. Bearing witness, like the analyst, she then constructs a displaced testimony through the naming process, allowing the subject to assume the political position of antiracism. Even if the subject claims not to be a racist, McCauley distinguishes antiracism as political activism and agency. The naming of the self as antiracist forces spectators to question their positions in terms of race and to make a commitment to fight racism even if they disavow racism.

Thus, the mimetic-mimicry of McCauley's testimony and witnessing process functions as the "antipedagogy" of psychoanalytic practice. Like the "teacher-as-liminal-servant," it stands in direct opposition to the academic rational approach of the "hegemonic overlord" and "entertainer." As McCauley and her spectators/students talk-about, their performance of subjectivity opens a liminal space wherein the dominant practice of historical analysis is mimed as displaced testimony, one that resists and destablizes that practice and its racist epistemology. However, warns Felman (1987), the antipedagogy of psychoanalytic theory should not be oversimplified as an "inverse pedagogy": "This one-sided negative interpretation fails to see that every true pedagogue is in effect an anti-pedagogue, not because every pedagogy has historically emerged as a critique of pedagogy . . . but because in one way or another every pedagogy stems from its confrontation with the impossibility of teaching" (p. 72). Rather than focusing on what Freud and Lacan taught, the theoretical and historical content of their psychoanalytic theories, Felman suggests we shift our attention to how they taught:

> [T]he illocutionary force, the didactic function, of the *utterance* as opposed to the mere content of . . . [their] statements . . . in other words, the pedagogical situation—the dynamic in which statements function not as simple truths but as performative speech acts . . . what can be learned about pedagogy not just from their theories . . . but from their way of teaching it, from their own practice as teachers, their own pedagogical performance. (pp. 72–73)

To illustrate McCauley's teaching practice as pedagogical performance, in the next section of this chapter, I describe one of her teaching workshops.

ROBBIE McCAULEY'S TALK-ABOUT WORKSHOP

Robbie McCauley's performance art teaching strategies are grounded in the performative speech acts of psychoanalytic theory. In stressing the importance of testimony and witnessing, she provides a pedagogical experience that enables hitherto subconscious ideas to surface and enter into discourse. In addition to this unveiling of hidden content, McCauley's pedagogy, like that of psychoanalytic pedagogy, "affords what might be called a lesson in cognition . . . an epistemological instruction" (Felman, 1987, p. 76) where not only what we think, but the way in which we think is challenged. Whereas some performance artists approach the problem of agency via the body's physical movement, McCauley begins with the body's ability to take action through speech, "talk-about" the charged issues of "race and class," raw emotions and concepts that she then directs toward body movement. The way that

spectators/students learn by McCauley's talk-abouts is contrary to conventional modes of learning, which are linear and cumulative in structure. Based on the disjunctive testimony of psychoanalytic pedagogy, her performance narrative and those of her spectators proceed "not through linear progression but through breakthroughs, leaps, discontinuities, regressions, and deferred action . . . [an] analytic learning process [that] puts in question the traditional pedagogical belief in intellectual perfectability, the progressist view of learning as a simple one-way road from ignorance to knowledge" (Felman, p. 76).

As stated previously, McCauley's talk-about workshop strategy has a double meaning. On the one hand, she uses it to divulge, confess opinions, feelings, and attitudes about racism and classism. On the other hand, talk-about, like the Australian aboriginal walkabout, functions as a wandering process that is used to interrupt the routine of daily life. Similarly, McCauley's talk-about serves as a process of intervention, a means by which discourse arbitrarily moves from one individual to the next and culminates in a public forum where charged cultural issues are openly discussed. Her minimal use of movement exercises serves to divert students' awareness from self-conscious and complacent attitudes and behaviors to those that are open and accepting. As students talk-about issues of race, their conversations link with others to develop a collective discourse, a group-talk performance.

Thus, in McCauley's workshops, body movement is used to uncover cultural narratives that are often hidden and unspoken and to bring their controversy to public discussion. The lack of physicality in her workshops should not be misunderstood as nonperformative. Performativity is relegated to the development of voice, both the individuals' and the group's. For McCauley, considering the circumstances of racism, it is not enough to make art. Rather than producing art for art's sake, she is concerned with the politics of representation. Her aim is to use performance as a political strategy to end racism.

"Teachable moments" occur, according to McCauley, when discussions about "charged issues" are contentious, when dialogue is polarized, and when there is a breakdown in communication. Felman (1992) refers to such moments in teaching as "crises" that are necessary for true learning to take place. Drawing a parallel between the testimonial process of crisis pedagogy and psychoanalysis, she argues that both "*live through crisis.* Both are called upon to be *performative,* and not just *cognitive,* insofar as they both strive to produce, and to enable, *change.* Both this kind of teaching and psychoanalysis are interested not merely in new information, but, primarily, in the capacity of their recipients to *transform themselves* in function of the newness of that information" (p. 53). In this respect, McCauley's discourse on racism, the charged issues

that she confronts in her workshops, represents a transformative peda-
gogy based in performance art.

The Robbie McCauley workshop (*Figure 5.3*) described below took
place at the Performance Art, Culture Pedagogy Symposium held at
Penn State University in November 1996 after a number of physically in-
tensive performances and workshops presented by other invited artists.

McCauley started her workshop by calling out the names of twelve
students in the audience who had previously volunteered to join her at
the front of the room. Although the remaining 150 persons in the audi-
ence stayed in their seats, she informed them that they too would be par-
ticipating. She introduced her "being here" exercises to focus students'
attentions to the time and space circumstances in the room. As students
spread out in the room, "where to stand?" "adjacent to whom?" emerged
as the first problems of the workshop. McCauley commented, "Already
space is an issue. How do we include everyone? Where will the teacher
go?" She recommended everyone consider his or her awareness of self
and discomfort in the space as material for the workshop.

Upon McCauley's request all began "moving in their bodies." She
called attention to the presence of others, that movement in the space

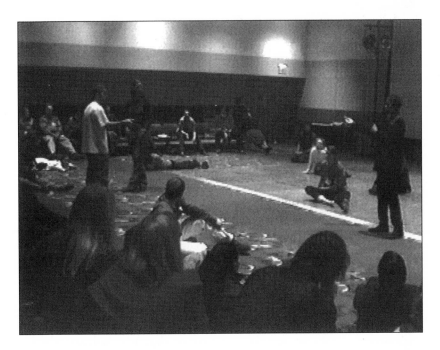

figure 5.3: Robbie McCauley, PACP workshop, 1996. Courtesy Charles
Garoian

and around other students' bodies was engaged. The students moved slowly and self-consciously around each other and throughout the room; some appeared anxious, and others appeared lethargic and complacent. McCauley asked the students to begin "talking-about" (in one, two words, or a sentence) their movements. While moving, the students responded:

- *What I say depends on how much I want to reveal. I'm trying to understand my relationship to you.*
- *My back is out, and I'm trying to move with that in mind.*
- *I'm aware of my nervousness.*
- *I've watched others stretch in other workshops, but I'm too nervous to do so myself. Now I want to go for it.*
- *I have a knot in my back; I really need a backrub.*
- *I feel comfortable, not physically stressed.*
- *I have to eat, I have a cold, and I have no more words.*
- *I have a fear of something in my heart. I want to shoot my heart to the audience. I do love you, and I want you to love me back. Will they be able to hear me?*
- *I'm pretending there is no audience. I've never performed before, and I don't think I want to perform ever, but I want to participate in some kind of antiracist work.*
- *I'm shy. I feel stiff.*
- *I want to close the circle. I feel exposed.*
- *I'm getting pissed off.* (Videotape transcription by author)

McCauley suggested that everyone "look around at each other. Look for textures, shapes, colors of the people around you." She asked that they "listen" to each other's movement, be aware of smells, the taste in their mouths, and the texture of people in the circle. McCauley then brought the discomfort of being observed by the audience to the students' attention. "What does it feel like being looked at? Is it more comfortable being the looker?" Students continued moving slowly around each other and through the room. She asked everyone to stop, to relax and notice that shape, texture, and color have become charged issues within the context of their exercise. She commented, "Race and class are difficult for people to talk-about."

While students sat on the floor, McCauley introduced her talk-about exercise. She declared herself the initial "listener and questioner," a responsibility that would eventually be "transferred" to someone else in the circle. Acknowledging that listening and observing were charged issues in the circle, she called for "subjective" responses to the charged issues. In her role as listener-questioner, McCauley asked a student to "talk-about being pissed off," a charged issue that came up in the first exercise. From that student's response, the question wandered around the circle. Here are some student responses:

- *I get pissed off when I'm afraid of something. I've an abandoment issue like why aren't my parents coming to feed me.*
- *I'm pissed off because I feel like a guinea pig, because people are staring at me.* (Videotape transcription by author)

To this last comment, McCauley explained that performance usually assumes an audience. She continued the talk-about:

McCauley: *Do you feel comfortable being watched?*

Student 1: *It's OK. I can feel uncomfortable and go with it and have trust about it.*

McCauley: *Do you feel uncomfortable being watched?*

Student 2: *Not when I'm teaching someone, only when I'm not in control.*

McCauley: *Do you feel in control?*

Student 3: *I have no problem being watched. I enjoy it because I assume only a small percentage in the audience will remember.* (Videotape transcription by author)

McCauley next opens the circle of students in the front of the room to include the audience.

McCauley (pointing to an audience member): *Do you feel uncomfortable watching?*

Audience member 1: *Yes, because I'm putting* [projecting] *my body out there with those being watched. I recognize that it takes work from both directions to form an equal relationship. So, if I think the person I'm watching is also watching me, I feel more comfortable.*

McCauley: *Is that a theory, or is that really happening?* (Points to another in the audience). *Do you feel uncomfortable watching?*

Audience member 2: *Yes, I wasn't expecting to say anything* [by sitting in the audience].

McCauley then turned to a student in the circle.

McCauley: *Do you feel pissed off?*

Student: *I don't think being pissed off is a bad thing. I'm more interested in finding out what happens next.* (Videotape transcription by author)

The students were then directed by McCauley to reposition themselves in the circle. As they moved around the room, she situated herself in the circle and initiated a talk-about on racism. "Listen, be subjective. What you hear is what you respond to. What is a charged issue for you [regarding race]?"

McCauley (points to a student): *What race are you?*

Student 1: *Caucasian, but I don't have any one geographical location to feel connected to any nationality.* (Videotape transcription by author)

Robbie passes the wireless microphone as the signifier of listener/questioner to someone else in the circle. Her relinquishing the mic in a talk-about finds its parallel in the Native American group dynamic refered to as the "talking circle," a tradition where a "talking stick" is passed around to provide each person in the group with a choice and an equal opportunity to speak without interruption. The significance of the talking circle is that it shifts all the power positions in the group to a level playing field where everyone is able to address their concerns.

Listener/questioner: *Why is race important for us to deal with if we are performing?*

Student 2: *Race is a charge issue in settings like this. Asking the question helps people get into their own hard feelings about it. It's hard to articulate.*

Student 3: *To become aware of automatic reactions about being racist.*

Listener/questioner: *What reactions about race are you uncomfortable with?*

Student 4: *I look at it and feel it politically. Then it goes through me emotionally; other times it's about personal history. It's a check and balance between the three.*

Listener/questioner: [directed at Robbie] *How did you feel last night in your performance when so few names were mentioned* [in response] *to your question* [In her performance the previous night, Robbie prompted:"*I want you to think of white people who have commited their lives to being antiracists . . . So this is the part, this is the time to call out the names.*]?

Robbie: *I felt challenged, whether or not it was a good thing to do. It's curious.*

Student 5: *I knew a whole list. I didn't say their names. They weren't names anyone else would've known. I'm not certain why I remained silent.* (Videotape transcription by author)

McCauley again directed the students to move around in the circle and brought them closer together and announced, "let's talk-about

class." "Who's middle class?" She counted five raised hands in the circle of students. "Who's working class?" Three hands went up. "Who's lower class?" One hand was raised. "Who's upper class?" Again one hand was up. Turning to the audience, she said, "I want to take some of this material and make it [materialize] into something that is graspable. Talking about race is one thing, but having a sense of who you are in relation to that word is something else. How many people feel that they are purely one race?" Two hands were raised.

Performance artist Rachel Rosenthal, who was in the audience, informed everyone that "science is now telling us that race means nothing anymore. It is a [culturally constructed] concept that is passé, no longer supported by scientific fact." Immediately, McCauley turned to the students in the circle and asked them to respond to Rosenthal's comment nonverbally, to do so through body movement. "Talk it out of your bodies," she said. Students began to move about the room twisting, bending over, standing, running in place. Some manifested nervousness, anxiety while others seem lethargic and complacent. McCauley then looked toward the audience members and asked them to talk-about the gestures of the students. Audience responses took their cues from students body gestures but directly addressed Rosenthal's "charged" comment.

Audience member 1: *Bullshit* [racism being passé because science says it is]. *I've experienced the hypocrisy. I was the only white faculty person in an all black University and saw it* [racism] *from the other side.*

Audience member 2: *Socially constructed aspects of race get acted out in real ways in the culture.*

Audience member 3: *I don't care what science says because there are racists. I feel at this conference that my worth is determined by my classification as a graduate student. That is a kind of "racism."*

Audience member 4: *We have to construct another construct.*

Audience member 5: *I once responded to my children when asked whether there were two races, that that was stupid. I told them that we are all one race. There is a lot of ambivalence about identity. Many of us would like to be one race.* (Videotape transcription by author)

The talk-about continued as the group attempted to come to terms with the notion that race, being a social and cultural construct, is passé. Students in the circle and audience members spoke out against that idea. One student expressed concern about the amount of faith entrusted to scientific truths. She explained that although we are all essen-

tially human with distinctly different physical attributes, there is the tendency to construct "false identities" around those attributes. "As long as we do that then, irrespective of our sameness, we are living with the effects of racism," she said.

The conversation continued for another few minutes until McCauley relinquished her listener-questioner role to the group. She instructed them to raise their hands when they wanted to discuss a charged issue, to wait until they were called on by someone to speak, anyone in the group. As the students wandered around the room, sat on the floor, stretched out, twisted their bodies, a young man sitting in the audience raised his hand. Another person from across the room stood and asked him to speak.

> The young man: *When I was a little boy, I was at a hardware, fishing store with my granddad. I took this pretty fishing box and put it into my mouth, and this elderly black man who worked there said to me, "Did you steal that? Do you have it in your mouth?" And I said, "Yes sir!" My granddad, an old southern gentleman, smacked me for saying "yes sir" to this man.* (Videotape transcription by author)

In response, a student talked about what she believed to be a "survival of the fittest" mentality. "It has to do with privilege, it is a matter of greed. Political boundaries and immigration laws are about people who are threatened by those who are different," she said. Another student commented that power and knowledge traditionally have been conflated. "Power is the problem; power is the accessibility to knowledge." A middle-aged woman stood in the audience and raised her hand. After one of the students called on her, she told of racism in her family.

> Middle-aged woman: *In the sixties, I came home from college. We were watching television when all of a sudden my father shouted, "Jesus Christ how do they expect to sell chewing gum with niggers chewing it?" I couldn't believe what he was saying. I'd never heard him say that before. Perhaps he did, and I was used to it. But when I went away to school and thought about it and came back I had no identity with my family. In the past four to five years, I've realized I'm a racist. On many levels, I'm not. I'm sure you know what I'm talking about. I think that [racial slurs and preconceived notions] just come into my head. I'm using performance art right now to do a performance on racism, and I'm embarrassed for being white and doing a performance on racism, but I'm doing it to sensitize myself first then everyone else.* (Videotape transcription by author)

As the woman completed her testimony, it became clear that McCauley's strategy was to use performance art as a context to engage a public discourse on race and class issues. Her appropriation and placement of the

workshop within the Performance Art, Culture, Pedagogy Symposium questioned the role of art in a racist and class structured society.

As the talk-about continued, a man in the audience raised his hand. When called upon, he expressed his contempt for what he believed to be reversed stereotyping. He declared:

> Man in the audience: *I want to say, I'm not ashamed of being white, being male, I'm not ashamed of being of rich ancestry, not ashamed of being from the South. When I grew up, I had a black nanny. She took care of me and taught me not to be prejudiced and to be loving, warm, and open. I was taken aback last night during Robbie's performance when it was insinuated that everyone from Mississippi was racist. I don't think I'm racist. I don't think about being prejudiced. I'm very conscious of how other people react because sometimes I may not know that I'm being prejudiced.* (Videotape transcription by author)

Another young man in the audience raised his hand. He expressed his fear and frustration with racial and class issues, the inappropriateness he felt in discussing them at all because, he said, "I'm the white man. I'm not a woman, not gay, not black or hispanic. I'm scared right now to talk about it." McCauley stepped forward and asked the young man to join her in the front of the room. "Look at me and say something about race. I realize that I am different than you." Someone from the audience shouted to her: "Why do you assume that you are different?" Responding to what appeared to be obvious, she said, "Because I was born into a situation [black body, black cultural identity] that makes me say that. It is difficult to talk about race between two white people. I didn't talk bad about people from Mississippi [last night]. That's what you heard [gesturing to the man in the audience who raised the issue] because you've heard that for a long time. We carry around stuff we hear."

McCauley then reflected on her talk-about strategy. She described how the discussions in the workshop represented "teachable moments," a time and space wherein the charged issues of race and class have materialized, have been brought out into the open so that their controversy and difficulty can be "talked through." She acknowledged her training in theatre, where she learned how to work with controversial issues and the necessity to use them as teachable moments. "Everyone in theatre knows [that] if you go on when you are nervous, you take that energy and work with it." McCauley asked the young man, "What are the things you don't say [because you are not black, a woman, or gay]?" He answered, "Why I can't talk about it [racism] is because when I was a kid, I attended a culturally diverse school. I wasn't aware of cultural differences. Then I moved away [to a new school] and learned what it was like

to be different because I was a stranger in a new school where I heard racist comments. Later, when I returned to my first school, I gained a different perspective. I saw how they saw me [as a white male]".

Having understood the impact of the student's awareness of what it means to be cast as ethnocentric, McCauley thanked the student. She then directed a rhetorical question to all in the room: "Is it enough in a given teachable moment, when it gets uncomfortable, if you stop, does it end, or when it gets uncomfortable do you get energized to continue?" There are no quick answers to these issues, according to McCauley. Their solutions can only take place through a process of engagement where the uncovered agendas about race and class function as material. "This material is rich. One enters it; one doesn't expect to end it overnight. It's messy; it's ugly; that's why I use theatre as material," she exclaims. Again, "theatre" references the performative nature of cultural identity and its potential for developing agency. For McCauley, peering into and mining the depths of one's cultural prejudice is essential to the production of compassionate and caring cultural work.

6 Understanding Performance Art as Curriculum Text

The Community-based Pedagogy of Suzanne Lacy

In June 1994, two hundred Oakland, California, teenagers, mainly African Americans and Latinos, gathered on the rooftop of the new downtown federal building parking lot to discuss a number of issues concerning their lives in the inner city: sex, violence, values, family, school, the future, and the mass media's stereotyping of youth as criminals. They were students from Oakland's inner-city high schools who collaborated with performance artist Suzanne Lacy and her colleagues Annice Jacoby and Chris Johnson to create a community-based public art project entitled *The Roof Is on Fire* (*Figure 6.1*). As they spoke out about these and other issues that affected their lives, they sat in new, rented, and loaned automobiles that filled the parking lot, private spaces of their choosing within the public context of the city. They sat and talked in parked cars with their windows rolled down and, in the case of convertibles, their tops open. As the students began their conversations, the audience walked up the ramps of the garage and approached the "sound installation" of parked cars in order to "listen in." Here are sound bites of a few conversations that took place in the different automobiles that evening.

In one car, a female student argued with the other students that, despite women's liberation, American culture is dominated by men. In a second car, four males discussed the media's stereotyping of black youth. One student declared, "If you're goin' to stereotype a person for a long time, they're goin' to start actin' how you stereotype them. Oh, he's black, he killed, he do this, he do that. Why, if everyone is going to focus that on my life, then I might as well do it!" In a third car, a female

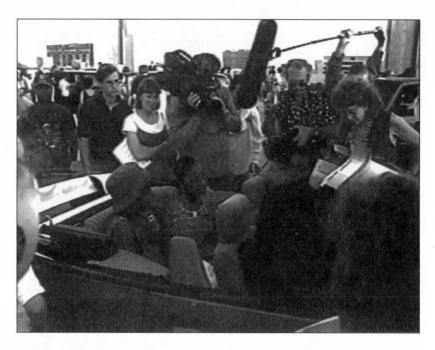

figure 6.1: Suzanne Lacy, Annice Jacoby, Chris Johnson, *The Roof Is on Fire*, Oakland, California, 1994. Courtesy of KRON-TV.

student flings her arms as she asserts, "I will stand up and shout it across the world. I'm so happy to be of African descent, that you don't know." In a fourth car, a female asks, "Who am I? Where do I stand in society?"

In a heated conversation between one male and three female black students in a Jeep convertible, the male and one of the females sustained a long debate about racism:

Female: So why are you sayin' things can't change?

Male: Things *can't* change. OK, let's say that we can sit in [the] front of the buses now . . . why is there still racism?

Female: Because racism is somethin' that's taught . . .

Male: Can we change it?

Female: . . . and until we change . . .

Male: Can we change it?

Female: [Y]es . . .

Male: Can we change it?

Female: Let me tell you. Until we change our train of thought and the way that we go about perceiving people and their differences, yeah, you're right we can't. But we can change it by educating people and letting them be aware that everyone has differences . . .

A second female in the car interrupts: Layers of difference . . .

First female: . . . and not to sit there, laugh, make fun of it and discriminate against that person because they don't have the same values, religion, or whatever else that you do. (Franklin, 1994)

That evening, San Francisco's KPIX, Channel 5 "Eyewitness News" (*Figure 6.2*) introduced its coverage of the event in this way: "A group of teenagers has a message for the Bay Area. 'Shut up and listen!'" CNN's on-site reporter, Mark Carter, summed up the purpose of *The Roof Is on Fire* as "to give voice to the feelings, rage and thoughts of inner city

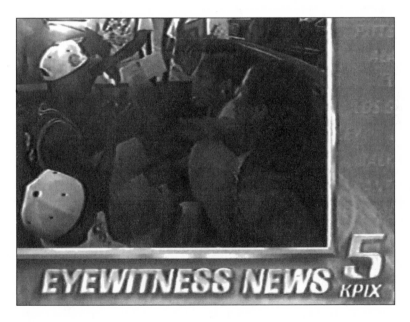

figure 6.2: KPIX Channel 5 "Eyewitness News." Courtesy KRON-TV

youth." Immediately following Carter's coverage, the Atlanta-based anchor added: "[T]hat's a great idea, I'd like to see what comes of that." Artist/media coordinator Annice Jacoby described the coverage of the students' performance on the 6:00 o'clock news as a major achievement. "It was, in essence, showing that they could get inside the [media] palace," said Jacoby (Franklin, 1994). For Suzanne Lacy, entering the palace is an essential step to challenging the mass media on its own turf. As Oakland's inner-city youth performed *The Roof Is on Fire*, they attracted the attention of local, state, and national media. What the mass media encountered and reported was a public spectacle that celebrated a positive representation of youth. In this chapter, I examine the community-based performance art of Suzanne Lacy as a curriculum text.

What is curriculum? How does it function as text? Is there an aesthetic dimension to curriculum texts? Are they performative? What are the relationships between curriculum texts and performance art pedagogy? What constitutes a curriculum based on ethnographic, linguistic, political, social, technological, and ecstatic considerations, the six strategies of performance art? How does the curriculum text of performance art affect critical citizenship and agency? These and other questions provide the focus of this chapter.

Recent works by Suzanne Lacy (performance artist, educator, cultural activist, and author) provide examples of performance art as curriculum text. Her art work is a performative curriculum because it opens a liminal space, within which a community can engage a critical discourse, a space wherein decisions are contingent upon the collective desires of its citizens, as well as an ephemeral space because it is applicable to the particular time and place for which it has been designed. Thus, for Lacy, communities are contested sites, and performance art is a function of community development. When working with community members, she takes the role of artist in residence. Unwilling to presume their concerns, she facilitates an aesthetic space where they can participate in a public discourse and express their desires. To research a community's issues, she reads its local newspapers, listens to its local radio, and views its local television news. To compare mass-media representations of a community to the lives of those who live there, she interviews citizens on the streets, in buses, in their homes, and in their places of work.

Lacy's community-based projects correspond to the six strategies of performance art pedagogy. They represent the praxis of postmodern theory. Like an ethnographer, she enables a community to represent itself, to define its own concerns, its own identity. She fosters a public discourse that exposes and challenges linguistic misconceptions and stereotypes. She inspires political activism to resist cultural oppression. She creates a climate of social awareness and collective involvement. Her

community performances attract and exploit the technological apparatus of the mass media to challenge its negative stereotyping with images that shed a positive light on a community's identity. Finally, by re-positioning community activism as art, she enables an ecstatic awareness of the body's cultural oppression and transformation.

To create a climate of collaboration, Lacy elicits the participation of community citizens and their willingness to contribute their personal knowledge and skills toward the creation of community awareness, identity, and agency through performance art. After successfully organizing citizens from diverse sectors of a community, she co-creates a public project with them, delegating responsibilities matching their individual areas of expertise. Some citizens are authorities on public policy, schooling, policing, health, social welfare, and the mass media. While others are "experts" by virtue of living in their families, their neighborhoods, or involvement with service organizations, schools, and agencies in the community.

Expertise is not exclusively defined by Lacy as professional, institutional knowledge. On the contrary, it includes citizens' memories and cultural histories. The artists' collaborations include youth, the elderly, parents, teachers, public policy makers, business leaders, and citizens of all walks of life as cultural co-workers. By working together, their collective voices address the complex and contradictory issues that affect their community. While Lacy solicits participants for their particular expertise, she directs their involvement in the project. Moreover, as an accomplished public artist, she assumes final authority over its imagery to insure artistic quality, a criterion that is essential to luring mass-media coverage and challenging its stereotypical representations of the community.

As a feminist artist with a working-class heritage, Lacy understands cultural oppression. She enters a community as an outsider, a political activist who facilitates a public discourse to engage citizens in a critique of their oppression. Her own identity in a community project is elusive. Although she manages, directs, and facilitates, she does so from the sidelines of a project, pulling it together. The purpose of her art is to make public the voices of those who are not heard. Unlike the performance artists who use their bodies as a site of cultural oppression and resistance, she locates her projects in the collective body of a community. Rather than calling attention to herself, to the politics of her own body, she directs attention to the body politic. She believes that the oppression of the private body can be overcome by challenging the public body.

As a cultural activist, Lacy has challenged two of the most difficult, controversial issues of our time, namely the cultural oppression of gender, age, and race and the intentional conflation of art and politics, which is a feminist art strategy. By juxtaposing art and politics, she

exposes the political dimensions of art as well as the aesthetic dimensions of politics, those aspects of both that are exclusionary on the one hand, yet transformative on the other hand. In the spirit of Lacy's activism, I will explicate the curricular implications of her community-based performances.

CURRICULUM AS PERFORMANCE ART TEXT

Curriculum can be defined in its most prosaic form as a course of study or a group of related courses that constitute specialized study. In either case, curriculum represents the way in which teaching and learning are structured in schools. As text, it functions much like a script for school administrators, a written plan with which to direct the overall course of their respective institutions. As scripts, curricula also define what and how teachers teach and students learn. In essence, they direct all aspects of educational performance. What and how students learn to perform in schools have a direct impact on their lives outside of schools, in how they perceive themselves and participate in their families, neighborhoods, and communities. A self-fulfilling prophecy, the value assigned by the culture to its citizens' identities, experiences, and knowledge inscribes them to contribute to their communities in either positive or negative ways. This monologic transfer of knowledge from the school into the community begs the question of why there is no reciprocity. If schools have an impact at all on communities, why have their curricula precluded a discourse that is culturally democratic? To answer this question, I will first consider the performative dimensions of curriculum, followed by a discussion of its implications for civic education.

According to curriculum theorists William F. Pinar and Madeleine R. Grumet, the term *curriculum* is derived from the Latin *currere* which translates:

> to run the course: Thus *currere* refers to an existential experience of institutional structures. The method of *currere* is a strategy devised to disclose experience, so that we may see more of it and see more clearly. With such seeing can come deepened understanding of the running, and with this, can come deepened agency. (Pinar et al., 1995, p. 518)

The existential experience of *currere*, like the liminal, contingent, and ephemeral conditions of performance art pedagogy, is predicated on embodied experience. Unlike conventional educational discourses and practices that define curricula as preexisting designs, courses of study, or master plans that limit students' experiences to cultural reproduc-

tion, the reflexive process of *currere* enables them to participate in its creation, to experience and critique its structural conditions from the perspective of their cultural backgrounds. An autobiographical/biographical process, "the course [of curriculum] becomes subsumed in, though not reduced to, the experience of the [student] runner" (Pinar, 1978, p. 318).

Pinar and Grumet's *Towards a Poor Curriculum* (1976), where the autobiographical and biographical theory of *currere* (See Pinar et al., 1995, pp. 515–566) first developed, was derived from performance theorist and practitioner Jerzy Grotowski's *Towards a Poor Theatre* (1968). Following Artaud's metaphor of cruelty as resistance to prescribed theater, Grotowski argued that the education of the actor is not an acquisition of skills, but *via negativa*, a process whereby actors eliminate perceptual, emotional, cultural, environmental, intellectual, and emotional blocks. Grotowski (1968) identifies two methods that comprise his "poor" theater.

1. Rather than an "accumulation" of cultural signs, poor theater seeks "the *distillation* of signs by eliminating those elements of 'natural' behavior which obscure pure impulse."
2. Poor theater further seeks to expose "the hidden structure of signs" through contradiction (between gesture and voice, voice and word, word and thought, will and action, etc.). (p. 18)

Thus, for Grotowski, the notion of "poverty" in performance represents an elimination of learned behaviors and a deconstruction of cultural codes that distract and inhibit the impulses of the body, its cultural experience, and its identity.

Emulating Grotowski's stripping away process through *currere*, Pinar and Grumet argue for students' autobiographical and biographical content to become part of the curriculum, to enable them to experience "running the course" of their learning. In doing so, the students' lives serve as curriculum texts. Grumet (1978) argues that the poor curriculum, like Grotowski's poor theater, enables students to experience curricula through critical engagement and, in doing so, to attain personal agency within the culture. "Rather than seeing the forms and habits of our culture as obligatory and imposed on us, Grotowski acknowledges our complicity in their creation and maintenance and demands that his actors turn back on themselves to work through the habits of movement, breathing, interaction, and thought to find and test the limits of their freedom" (p. 49).

Following Grotowski's pedagogy of poverty, Pinar and Grumet's *currere* emancipates students from the tyranny of socially and historically

determined knowledge. Arguing from the perspective of Artaud's the-
ater of cruelty, the psychoanalytic pedagogy of Freud and Lacan, Mar-
cuse's aesthetic dimension, Merleau-Ponty's phenomenology of the
body, and Grotowski's poor theater, Grumet describes the performative
implications of curriculum. "It is through our responses to our concrete
situations that we realize our freedom. This acting method is a blend of
engagement and estrangement, action and abstention, that reveals to
us the intentional threads that bind us to the world in which we live"
(1978, p. 44).

The disclosure of institutional experience for the purpose of per-
sonal agency through performance art is the principle aim of Lacy's
pedagogy. The structure of her community-based performance art par-
allels a number of contemporary curriculum theories reported by Pinar
and colleagues namely autobiographical/biographical curricula in
which *currere* is a major concept. Three "streams of scholarship" com-
prise this theory:

1. autobiographical theory and practice: major concepts include *currere*,
 collaboration, voice, dialogue journals, place, poststructualist portraits of
 self and experience, and myth, dreams, and the imagination.
2. feminist autobiography: major concepts include community, the middle
 passage, and reclaiming the self.
3. teachers' lives: the study of teachers' personal experiences in the class-
 room including their collaborative biographies, autobiographical praxis,
 their "personal practical knowledge, their lore. (Pinar et al., 1995, pp.
 516–517)

Each stream and its major concept corresponds to an aspect of Lacy's
performance projects, providing the rationale for inquires into the cur-
ricular possibilities of her work. The artist's performances are informed
by her identity as a woman and her feminist politics. They are created in
collaboration with teachers, students, and citizens who are enabled to
voice their concerns about issues in their communities from the per-
spectives of personal experience, memory, and cultural history. To foster
individual and community agency in this way represents the political po-
tential of curricular discourses and practices.

The institutionalized language of curriculum is not found in Lacy's
proceedings nor in descriptions of her community-based projects. The
connotations of curriculum as a master plan for classroom instruction
seem far removed from her emancipatory art-making practices. Never-
theless, by juxtaposing this pedagogical concept with "community," a
term that is usually associated with Lacy's activist art, I intend to expose
currere: the lived experience of her community-based performance art,

the running of its course, as curriculum. I believe that the performative curriculum of this artist-activist presents valued implications for educational reform.

PERFORMANCE ART AS CIVIC EDUCATION

Curriculum theorist Richard Pratte (1988) claims that lack of or indifference toward civic mindedness and critical citizenship in curricula demonstrates the isolation of schools from social life (p. 14). He calls for curricula that enunciate and explicate a "principle of vigilance," one that "captures the pervasive sense of social and political controversy that surrounds the topic of civic education" (p. 1). Pratte identifies three goals for a civic education curriculum, which he believes must be integrated into all school subjects in order for "civic virtue or virtuous citizenship" to develop. Goal one is the development of historical (and contemporary) perspectives that educate students about their own cultural heritage in relationship to other cultural traditions. Significant to this goal is that a "historical perspective can show that institutions shape public opinion and it demonstrates how educational as well as other social institutions, including the mass media, can usually be transformed into instruments of power and propaganda for the dominant regime" (p. 19). Pratte's second goal, the development of social-action skills, prepares students to "confer, discuss, debate, argue, plan, negotiate, compromise" (pp. 21–22). To participate in a cultural democracy, he suggests that all classrooms offer "an ideal free-speech situation—where students enter freely into discourse, recognize the need for inquiry in the pursuit of truth, and in the process are themselves free of constraint or manipulation" (p. 22). The reduction of ethnocentrism, Pratte's third goal, is necessary to a climate of cultural democracy and the development of critical citizenship. Understanding, appreciating, and respecting cultural difference develops from civic education as teachers and students learn how prejudice and discrimination are culturally conditioned, how they are learned behaviors that can be detected, critiqued, and transformed. Key to this third goal of civic education is a "flexible learning environment that allows for collective study, enriched learning centers, simulations and case studies, small- and large-group discussion, and peer and cross-age tutoring" (p. 25).

Like Lacy's community-based performances, Pratte's goals of civic education advocate teaching students civic mindedness that will presumably reach out into the neighborhoods and communities where students live. Moreover, civic education represents the potential for critical citizenship and social responsibility throughout students' lives. Pratte's

three goals, when considered from Lacy's aesthetic perspective, can extend the discourse on civic education across a school's disciplinary boundaries and out to the community, a collective process through which a design for community interaction can be created. Participating in educational experiences like Pratte's civic education and Lacy's community-based performances, students learn what philosopher John Dewey (1966) calls "a mode of associated living, of conjoint communicated experiences." Dewey describes democracy in action:

> The extension in space of the number of individuals who participate in an interest so that each has to refer his own action to that of others, and to consider the action of others to give point and direction to his own, is equivalent to the breaking down of those barriers of class, race, and national territory which kept men [and other disenfranchised groups] from perceiving the full import of their activity. (p. 87)

Based on Pratte's three goals, Lacy's community-based projects, and Dewey's "conjoint" discourses and "associated" interactions, the curriculum of civic education attains an authenticity that is often lacking in classroom instruction.

Significant to the discussion of performance art pedagogy is whether curriculum texts demonstrate Pratte's notion of vigilance, openness, and a willingness to engage community discourse or whether they "prescribe" learning conditions within schools that inevitably permeate communities as master narratives. Curriculum theorist Cleo H. Cherryholmes (1988) characterizes curricular texts that are concerned with "order, accountability, structure, systematization, rationalization, expertise, specialization, linear development, and control" as originating from the analytic philosophy of positivism, modernist notions, and structuralism (p. 9). Learning that is predicated on these concerns is circumscribed within the school with little or no bearing on students' civic responsibility and participation. Cherryholmes identifies as structuralist three curriculum texts that have had a pervasive influence on American education since the post–World War II era: Ralph Tyler's rationale (1949) for curriculum planning; Benjamin Bloom and colleagues' *Taxonomy of Educational Objectives* (1956) used to organize levels of critical thinking and cognition; and Joseph Schwab's "The Practical 4" (the teacher, student, what is taught, and milieu of teaching), a system of educational checks and balances to insure that learning objectives are being met (pp. 23–30).

What is problematic about the curricular principles of these three educators, and others like them, is that they function as fixed and separate rules, standards, and criteria by which to organize and evaluate ef-

fective teaching and learning, ones that are presumed applicable across all educational contexts. As curricular master narratives, they assume a sovereign, authoritarian status whose representations of educational truth and meaning supersede all others. They preclude a community discourse in curriculum where school administrators, teachers, students, parents, citizens, and public officials are able to discuss, critique, and construct curricula that are suited to the cultural issues of their respective schools, families, neighborhoods, and communities. Curricular master narratives forestall a postmodern, poststructuralist discourse that brings into question their structuralist assumptions, their displacement of a heterogeneous field of curricular possibilities, including the curricular potential of students' cultural traditions and histories.

The notion that one curriculum structure fits all is presumptuous. Like implicit, null, and hidden content, those who are excluded from representation by a structure are as important as those who are included. Whose issues and concerns are being considered when a curriculum is developed? Who is involved in its construction? Who is left out and why? The exclusionary practices of structuralism, its prescriptive language and its cultural homogeneity, have led to its critique by feminists Luce Irigaray, Hélène Cixous, and Judith Butler and by French poststructuralists such as Michel Foucault, Jacques Derrida, Jean-François Lyotard, Gilles Deleuze, and Félix Guattari. One result of their critiques has been to understand curriculum from interdisciplinary and intercultural perspectives. Contrary to structuralism, poststructural curricula "challenge and subvert not only the central themes, organizing metaphors, and discursive strategies constituting Western thought and informing the Enlightenment project, but all that is modernism itself, including those perspectives and cultural structures associated with modernism (Pinar, et al., 1995, p. 450).

Although poststructuralism critiques structuralist assumptions, it nonetheless proceeds by including and re-presenting those assumptions within a larger context of cultural discourse. Accordingly, poststructuralism functions as an open form of structuralism. This openness is evident in *Understanding Curriculum: An Introduction to the Study of Historical and Contemporary Curriculum Discourses* (1995), by William F. Pinar, William M. Reynolds, Patrick Slattery, and Peter M. Taubman. The authors survey, critique, and re-present the master narratives of curriculum to provide a greater understanding of their impact on the politics of education, as ideas and texts among several within a larger context, a "common ground" of curriculum discourse (p. 13). In doing so, the historical, political, racial, gender, phenomenological, poststructuralist, deconstructed, postmodern, autobiographical/biographical, aesthetic, theological, and institutionalized curricular texts that the authors identify are

not considered mutually exclusive. Instead, they represent multiple points of perspective, an open discourse on schooling similar to Lacy's community-based curriculum texts.

THE AESTHETIC DIMENSION
OF A COMMUNITY-BASED CURRICULUM

Significant to classroom instruction, teachers often work in communities similar to those where Lacy works. In addition to working with their students who represent various neighborhoods, communities, and cultural backgrounds, they are involved with professional organizations whose members comprise their teaching and administrative colleagues. They enroll and attend classes and workshops for professional growth at local colleges, universities, and community centers. They have access to and sometimes work with parents, local community members, and civic leaders in the development of school-related matters. Most important, they are themselves members of communities with rich cultural backgrounds and experiences. In other words, teachers potentially represent loci for extensive community outreach and collaboration. With this array of possible sources at their disposal, they have the potential to create curricula that extends beyond the academic structure of schools out into the neighborhoods and communities where their students live. Moreover, curricular collaboration serves as a community-based performance, one that involves students' memories and cultural histories in the classroom as content that can be openly discussed in relationship to the historically and academically determined content of school.

Unfortunately, such possibilities for community-based performance curriculum are often inconceivable and utopian, considering the extreme demands of teaching. Unlike Lacy, who is concerned with the aesthetic and performative dimensions of communities, teachers are often caught up in the institutional and instrumental dynamics of schooling, the prescribed text of its curriculum. The result of such isolation is that teachers, and the other constituencies that comprise a community, rather than working together, operate within fiefdoms where each wields power and claims superiority based on his or her conflicting curricular assumptions, goals, and objectives.

By comparison, Lacy works collaboratively with students, teachers, citizens, and local agencies to illuminate, explore, analyze, and critique the border politics that essentialize the issues and concerns of certain community agencies over others in order to create new possibilities, new curricular texts, new educational myths for living, learning, and creating together. As art, the curricular structures of her performances are created collaboratively by community participants from those issues and con-

cerns that they value intrinsically. Lacy's performances possess a quality with which community members can identify and about which they can feel deeply. Philosopher John Dewey (1958) claims structures that are immediately felt as art "possess internal integration and fulfillment reached through ordered and organized movement" (p. 38). He argues:

> What is even more important is that not only is this quality a significant motive in undertaking intellectual inquiry and in keeping it honest, but that no intellectual activity is an integral event (is *an* experience), unless it is rounded out with this quality. Without it, thinking is inconclusive. In short, esthetic cannot be sharply marked off from intellectual experience since the latter must bear an esthetic stamp to be itself complete. (p. 38)

Thus, community-based performance art enables teachers, students, and citizens to participate and experience their social and political issues and concerns from aesthetic perspectives. As a "felt" experience, art exposes the limitations of "intellectual" inquiry, assumption, and reproduction and enables the creation of those expressions that are valued intrinsically by the community.

By contextualizing the charged issues of neighborhoods and communities within art, Lacy exposes the cultural binaries that separate communities from one another. Art is a place for exploration and creation. It serves as a liminal space, a neutral zone within which to engage a discourse between binaries, to entertain differing points of view, to create new identities and myths about communities. Philosopher Herbert Marcuse (1977) claims this space of liminality an "aesthetic dimension" where cultural liberation is possible.

> [T]he radical qualities of art, that is to say, its indictment of the established reality and its invocation of the beautiful image (*schöner Schein*) of liberation are grounded precisely in the dimensions where art *transcends* its social determination and emancipates itself from the given universe of discourse and behavior while preserving its overwhelming presence. Thereby art creates the realm in which the subversion of experience proper to art becomes possible: the world formed by art is recognized as a reality which is suppressed and distorted in the given reality (p. 6).

Following Marcuse's notion that art represents an emancipatory space, cultural critic Carol Becker (1994) argues for the subversive function of art "not to be politely absorbed but rather to challenge and disrupt" (p. 127). In Lacy's performances, community issues are not allowed to rest. They are confronted head on within the aesthetic space of performance art in order to subvert the "given reality" of stereotypical assumptions and practices and to create new "realities."

Imagine how the learning process would change if teachers, like Lacy, considered the aesthetic possibilities of curriculum and pedagogy. Unaware of their suppressed reality and the potential to position themselves in an aesthetic dimension, teachers are locked in the routine of classroom instruction and management. They are too often preoccupied with fulfilling the requirements and expectations of the school's curriculum agenda, its preexisting epistemology and discursive practices. What they teach their students are curricular limitations in which they themselves are confined. What Lacy's community-based performance works offer classroom teachers is a process by which to attain agency within the context of schools by reaching out, beyond preexisting curricular practices, to create new possibilities for interaction, ones that involve teachers and their students as critical citizens with community issues and concerns. The consequence of such action is that teachers and students explore and discover new content from families, neighborhoods, and communities that contributes toward a contextual reciprocity. That is, learning from the perspective of their lives informs learning from the perspective of academic study.

The curriculum text of community-based performance art challenges the hegemony, the authoritarian assumptions and agendas, the traditional aesthetics of schooling. Its critical discourse enables teachers and students to re-claim their identities from the oppressive, institutionalized agendas of schools and to re-write and re-present curriculum that is contingent upon the expressive needs of their communities. Such educational reform is more likely to occur when communities consider their collaborations from the perspective of Marcuse's aesthetic dimension. Art has the potential to challenge dominant modes of performance and representation, to transform, and to create new ones. "The aesthetic transformation is achieved through a reshaping of language, perception, and understanding so that they reveal the essence of reality in its appearance: the repressed potentialities of man and nature. The work of art thus re-presents reality while accusing it" (Marcuse, 1977, p. 8). Curricular practices that consider the aesthetic dimensions of community-based education significant are more likely to foster personal agency, critical citizenship, and civic responsibility in students.

To consider community-based curricula as art is to provide teachers, students, and citizens with a context, an aesthetic space within which to evolve a critical discourse and from which to challenge historically and socially determined discourses and practices. In order to avoid the assumption that aesthetic considerations are beyond reproach, it is important to distinguish art as cultural reproduction from art as production. Notwithstanding art's subversive potential, Marcuse's aesthetic dimension applies to the reproduction of preexisting curricular dis-

courses as much as it does to the production of performance art curricula. That is, art preserves as much as it disturbs. It is precisely the contemporary desires and expressions of communities that make the liminal, contingent, and ephemeral conditions of performance art pedagogy necessary to curriculum decisions; to challenge and "disturb" the preserved aesthetics of cultural reproduction; to imagine and produce new curricular ideas, texts, and myths.

Unlike conventional educational practices that design and facilitate curricula within the institutional and disciplinary boundaries of schools, Lacy works collaboratively with community members, teachers, students, school administrators, citizens, public officials, and policy makers to organize and produce community projects that cross institutional and disciplinary boundaries. On a basic level, community outreach by classroom teachers is usually institutionally confined. That is, it originates from goals and objectives that are deeply embedded in the curriculum structure of the school and those that are mandated by local, state, and federal laws. By comparison, Lacy and her community collaborators create and perform within the liminal spaces that separate art and education, individual and community, the personal and the political. Locating their struggle in these binary spaces fosters critical citizenship through public discourse and agency through public action. Lacy works against the grain of preexisting structures, across institutional, disciplinary, and cultural boundaries to define a curriculum text for her community-based projects through an open discourse with local citizens, organizations, and agencies.

Essential to this process of re-thinking the public body and creating positive representations is a community's involvement in the construction of its own identity. A collective, critical discourse provides communities with a sense of ownership and agency. Questions such as, Who are we? How are we portrayed by the media? and What do we want to portray about ourselves? are necessary to the process of identity construction. Artists such as Lacy, whose performances facilitate identity representation, engage public discourses and practices that expose and critique stereotypical representations and create an aesthetic that is contingent upon the desires of communities.

Cherryholmes (1988) refers to this open form of engagement as the material practice of "critical pragmatism," "when criticism turns to action, when poststructural analysis is projected onto the world in what we say (discourse) and do (practice)" (p. 14). Similar to radical educator Henry A. Giroux's notion of critical pedagogy discussed in previous chapters, critical pragmatism "brings a sense of crisis to considerations of [educational] standards and structures" (Cherryholmes, 1988, p. 14). It calls for emancipatory discourses and practices where teachers and

their students are encouraged to serve as public intellectuals who are actively engaged in critical citizenship. As a critical pragmatist, Lacy is unhampered by institutional standards and structures. Her projects evolve from extensive collaborations across borders, working relationships, and a critical discourse with community members, organizations, public officials, and the mass media, to create aesthetic strategies for learning, participation, responsibility, and representation that serve the entire community by challenging normative culture.

A collective discourse on curriculum suggests a community aesthetic, one whose design is similar to Lacy's liminal, contingent, and ephemeral pedagogy. Having argued in previous chapters that performance art pedagogy is the praxis of postmodern theory, here I want to discuss how the disjunctive collage principle of performance art, namely the community-based performative strategies and structures of this artist, serve as a complex curricular structure. Within the context of Lacy's curricular collage, different discourses coexist not as separate master narratives, but as intertextual, linked conceptions that are open to theoretical and pragmatic differences. The text of such curricula is inclusive and determined by contextual considerations. It is contingent upon the voices of students, parents, and citizens in determining the content and form of education, interaction, and collaboration in their communities. This text is also ephemeral in that its form continually changes to accommodate factors that are likely to emerge and shift in community discourses. A curriculum based on Lacy's collage principle can be characterized as follows: the means by which schools and communities identify cultural diversity; how they create the cultural identity of the community; how they develop projects that involve community participation and collaboration; and the structure of a public forum that encourages critical discourse (Garoian, 1993, p. 84).

Using Lacy's collage process as a metaphor, discipline-based curricula of schools can be recast as community-based performance texts that challenge the normative assumptions of the general curriculum of the school and propose the possibility for collective engagement. In the spirit of collaboration, the experiences, knowledge, and expertise of each individual in the community—administrators, teachers, students, citizens, and so on—are significant. Within the context of the schools, for example, art teachers and students, whose expertise is most often marginalized as academically insignificant, can contribute knowledge about aesthetics, considerations, and practices that are necessary to the design of a community-based curriculum. That is, by bringing their knowledge and awareness of aesthetics to educational practices, an art of curriculum and pedagogy can be imagined and created. Interdiscipli-

nary and intercultural exchanges such as this can be encouraged and extended in all directions across school and community boundaries. Students who are involved in community-based performance art curricula learn to interconnect the various academic disciplines with memories, histories, and experiences outside of school. Within this aesthetic context, they learn to create knowledge and understanding that relates school to civic responsibility and critical citizenship.

Community-based curricular practices do not assume a cultural relativism where ideas and texts, functioning as objective truths, compete for an absolute position. Instead, they call for critical pragmatism, a "realistic" and "relativistic" struggle to resist curricular absolutes by engaging in discourses that are contingent upon the ideas, opinions, and lived expertise of those individuals who comprise a community (Cherryholmes, 1987, pp. 187–188). Like critical pragmatism, the curriculum texts of performance artists such as Lacy are "realistic" because they are sites of struggle, a place to resist the oppression of preexisting community discourses. They are "relativistic" because the subsequent decisions of a community pertain to and are intertextually linked with the curricular absolutes that they challenge.

UNDERSTANDING PERFORMANCE ART AS CURRICULUM TEXT

Understanding curriculum as a collective discourse is the project of curriculum theorists William F. Pinar, William M. Reynolds, Patrick Slattery, and Peter M. Taubman. In their critical survey on curriculum development mentioned above, the authors identify the major historical discourses of the field from the emergence of faculty psychology and classical curriculum theory in the 1820s and 1830s, to the progressive reform movement a century later, and to a reconceptualization of the field by the end of the 1970s. From 1980 to 1994, they recognize a contemporary field of autonomous discourses including political, racial, gender, phenomenological, poststructuralist/deconstructed/postmodern, autobiographical/biographical, aesthetic, theological, and institutionalized curricular texts. Significant to their concern for a collective discourse, the authors shift the historical emphasis of curriculum "development" from its structuralist concerns for rationales, taxonomies, and methodologies to a contemporary poststructualist "understanding" of "the curriculum field as discourse, as text, and most simply but profoundly, as words and ideas" (p. 7). In other words, structuralist curricula function as master narratives that assume autonomous goals and objectives, while poststructuralism links these disparate discourses into a curricular community of interpretations.

Pinar and colleagues' poststructuralism, their efforts to understand curricular structures, does not preclude new developments. On the contrary, their aim is to promote reflexive educational practices that ground and interconnect curricular structures to one another. In doing so, a collective discourse can occur that resists the pitfalls of structuralism, the possible hierarchy and domination of curricular master narratives. For example, in addition to their intertextual linkage, each of the curricular texts identified by the authors can be conjoined to the six strategies of performance art pedagogy. That is, the ethnographic, linguistic, political, social, technological, and ecstatic strategies connect symbiotically with Pinar and colleagues' identified curricular texts. The ethnographic strategy of performance art pedagogy, for example, can be intertextually linked to expose the impact of the authors' identified curricular texts on students' cultural performance in schools and in their neighborhoods. The linguistic strategy is concerned with whether they function as master narratives to inscribe their text on students and, in doing so, preclude critical issues related to cultural identity and community to enter the discourse. Thus, what is important to the discussion of performance art pedagogy, as well as our understanding of curriculum, is not whether one form of text supersedes or displaces the other, but to what degree they represent a collective discourse on education, a curricular collage that allows multiple performance possibilities for teaching, learning, working, and living together.

It is for the political project of inclusion that I open and extend the discourse on curriculum to the ethnographic, linguistic, political, social, technological, and ecstatic, the texts of the body in performance art pedagogy. Although private and public corporeality is implied by each of the discursive practices identified by Pinar and others, the curriculum text of performance art renders the pedagogical site of the body explicit. In particular, it exposes the implicit, null, and hidden curricular inscriptions on students' bodies. According to educational theorist Benjamin S. Bloom (1973), the implicit curriculum "teaches each student who he is in relation to others. [In contrast to the explicit curriculum of the school,] it may also teach each student his place in the world of people, ideas and activities" (p. 140). Curriculum theorist/art educator Elliot W. Eisner (1979) claims the null curriculum represents "what schools do not teach [which] may be as important as what they do teach" (p. 83). Eisner's concern about null content, although aimed at the lack of serious commitment to the arts in the schools, must be extended to include content introduced by students from their respective memories and cultural histories. Finally, Gordon's (1981) hidden curriculum is comprised of "unintended learning outcomes" (pp. 56–57). It represents implicit forms of discrimination, "hidden agenda," against

content in the guise of advocacy, a form of "lip service" given by schools to aesthetic considerations and to students' cultural experiences. Given the exclusionary inscriptions of implicit, null, and hidden discourses-practices of schooling, students are quick to learn the insignificance assigned to their cultural experiences. With their cultural perspectives superseded, their production of culture is consigned to perpetuation, to the reproduction of preexisting hegemonic values.

Progressive educator Peter McClaren (1986) refers to such cultural inscription as "enfleshment," a "suturing" of the body with "epistemic codes [that] freeze desire into social norms" (p. 274). He describes the body's simultaneous function as "instrument and victim of ideology, socially situated and incarnated (not to mention incarcerated) social practices that are semiotically alive" (p. 274). The curriculum text of performance art challenges socially and historically embodied curricula. It proposes an open, transformative text that enables "the dialectical re-initiation of desire and signification"; the body re-claiming itself, and re-writing and producing learning possibilities that are informed by memory and cultural history (McClaren, pp. 274–275). Lacy's community-based performance works enable teachers, students, and citizens to attain agency by re-claiming and re-presenting their bodies, their families, neighborhoods, and communities in order to challenge preexisting, stereotypical representations of the body politic by conventional schooling and the mass media. By exposing implicit, null, and hidden community-based issues and concerns within the frame of performance art, Lacy's curriculum text presents her speakers, listeners, and collaborators with the means to become politically and aesthetically engaged in the culture.

THE CURRICULUM TEXT OF SUZANNE LACY'S PERFORMANCE ART

Heeding Allan Kaprow's advice to create art that frames everyday life, performance artist Suzanne Lacy has dedicated her artistic career to defining the aesthetic dimensions of political and social life. Having studied with the creator of Happenings at the California Institute of the Arts (Cal Arts) in the early 1970s, she has emerged as a leader in community-based cultural work, a "new genre public art" whose structure "is not exclusively visual or political information, but rather an internal necessity perceived by the artist in collaboration with his or her audience" (Lacy, 1995, p. 19).

Kaprow's (1993) four qualities of Happenings, compared with the text-based orientation of theatrical scripts and school curricula, parallel those aspects that distinguish Lacy's performance art. First, unlike plays

that are enacted within the conventional spaces of theater, Happenings take place in everyday life, in contexts of "conception and enactment," where no separation exists between audience and play (p. 17). Similarly, unlike conventional educational practices, the "context of conception and enactment" of Lacy's performances is not fixed to a gallery, museum, theater, or school. Instead, they take place in community sites, such as classrooms, homes, community centers, churches, hotels, the street, buses, city hall, the police station, in the very spaces where community members are likely to be found and where they can speak, interact, and collaborate openly, without being intimidated or silenced by institutionalized discourse.

Second, unlike plays with written scripts that serve as fixed texts, Happenings have "no plot, no obvious philosophy." They are materialized in improvisational and impromptu fashion (pp. 18–19). Lacy's unconventional practices challenge preexisting curricula whose texts prescribe teaching and learning. Unlike curricular absolutes, her community-based performances evolve through improvisational interaction. She has no preconceived project, no text or agenda about what will result in a community performance, until she has engaged in a critical, collaborative discourse with community members.

Third, unlike theater, where time and space are fixed, chance plays an important part in Happenings. "Chance . . . rather than spontaneity, is a key term, for it implies risk and fear (thus reestablishing that fine nervousness so pleasant when something is about to occur)" (p. 19). Likewise, unlike the predictability of conventional curricula, Lacy opens community collaborations to spontaneous, chance occurrences, what she refers to as ambiguities and paradoxes that resonate within the art work (1995, p. 38). Her determination to collaborate with community citizens allows criticality to "happen," a risk-taking that is necessary for improvisation, interaction, and creative expression.

Fourth, unlike a play whose permanence is determined by the script, a Happening is predicated on the unforeseen; it cannot be reproduced. The contingent aspects of Happenings render them contextually and ephemerally specific to particular spaces and times (p. 20). Unlike the standardized practices of conventional curricula, Lacy's community-based projects are impermanent. Being contingent upon the discourses of specific communities, they are nontransferable and "cannot be reproduced." If they were, the ideas, images, and texts generated by one community would be used as a standard for others, a prospect that contradicts all that Lacy stands for. Like Happenings, the curricular texts of Lacy's community performances are "fresh, while they last." Unlike Happenings, which Kaprow created to challenge the assumptions of the art world, Lacy's projects use art to challenge the issues of contemporary culture.

An artist who experienced the turbulent 1960s while in high school and college, and whose career came of age during the 1970s, Lacy's feminist politics have shaped her identity as a woman and an artist. Just as the personal has always been political for Lacy, so has the social been aesthetic. From her involvement with the first feminist art program in Fresno, Calfornia, in 1969, and the Feminist Studio Workshop founded at the Woman's Building in Los Angeles in 1973, Lacy (1980) developed performance art into a "teaching structure [that] allowed women to encounter their perspective on reality and express it in a direct theatrical manner . . . These forms were seen as structures, educational in nature, which supported the audience in its confrontation with feminist perspectives" (Lacy, 1980, p. 6).

In the late 1970s, Lacy created two large-scaled public performances that were designed as pedagogical interventions to fuse politics with social activism as a means to ending violence toward women. *Three Weeks in May* (1977) was designed in collaboration with Leslie Labowitz, Barbara Cohen, Jill Soderholm, and Melissa Hoffman and cosponsored by the Studio Watts Workshop and the Woman's Building, to raise awareness about the pervasiveness of rape in Los Angeles, California. It was soon followed by *In Mourning and in Rage* (1977), a "media event" cocreated with Leslie Labowitz to intervene and challenge negative representations of women by the mass media.

For *Three Weeks in May*, Lacy worked with city hall, the Los Angeles Police Department, and other community agencies and citizens to educate the public about rape. For that purpose, she created a public mural by pinning up two large, identical maps of the City of Los Angeles on a wall in the City Mall, "a subterranean complex of fast-food outlets and retail businesses primarily intended to serve city and county employees who worked in the building above" (Kelley, 1995, p. 234). On the first map, she stamped in bold red letters "RAPE" in the specific sites where rapes were daily reported to the LAPD. Having exposed the high incidence of this violence toward women in such a graphic manner, she then listed on the second map the names, telephone numbers, and locations of rape intervention centers around the city. Although lacking in the kind of visibility that the project would have received in a more popular commercial mall,* Kelley (1995) reports that the underground City Mall ironically "positioned the artist and her project in the middle of a network of people, agencies, and funding sources that contributed to a greater degree of public visibility for the project—and for its subject—than otherwise could have been imagined" (p. 235).

*According to Lacy, the larger malls in Los Angeles refused to be associated with any project that dealt with the topic of rape.

Three Weeks in May consisted of a number of events, beginning with a press conference recommended by the city attorney, designed to make the project known to the public and continuing with a number of performances and events by various artists and activists throughout the project's duration. Sanctioned by city hall and sponsored by various local agencies, the project was publicized through the city's mass media. Women from a number of local organizations, including the Los Angeles City Commission on the Status of Women, the Sheriff's Department, the American Civil Liberties Union, Women against Violence against Women, and others, attended or created the various events of the project. One event in the project was *She Who Would Fly*, a three-part work by Lacy that included audience members telling about having been raped and then writing about having been raped on maps of the United States that covered the walls of the Garage Gallery, in part one. In part two, Lacy created a private ritual with four other performers, "all of whom had experience with sexual violence . . . they prepared the space, talked, ate food, and anointed each other's bodies with red grease paint" (Kelley, 1995, p. 237). In part three, the public was invited into the space, three or four at a time, to witness and read the stories of rape inscribed on the maps. Having entered the space, they were confronted with an eviscerated lamb adorned with wings and suspended from the ceiling as if in flight. As viewers looked up at the lamb, they were shocked to discover the four nude women covered in red grease paint perched above the entire scene. Lacy's description of the viewers' shock at having their "watching being watched" suggests a return of the gaze that exposes their complicity in a society that allows violence toward women.

Having experienced the media success and potential of *Three Weeks in May*, Lacy and Labowitz followed the project with an event that was designed to take place on the steps of city hall in Los Angeles, to challenge the sex-violent stereotypes of women proliferating the mass media around the Hillside Strangler murders. Responding to the media's sensationalized reports of ten suburban Los Angeles women being murdered by the Hillside Strangler, the two artists and their collaborators performed *In Mourning and in Rage* on the morning of December 13, 1977. Kelley (1995) describes the event:

> A funeral motorcade of twenty-two cars filled with women followed a hearse from the Woman's Building to City Hall, at which point nine seven-foot-tall veiled women, their veils draped around their heads in the angular shapes of coffins, emerged from the hearse and took up positions on the steps facing the street. Women from the motorcade filled in behind them and unfurled a banner that read, "In Memory of Our Sisters, Women Fight Back." Then, with City Hall behind them and the assembled local press in front,

the first mourner walked to the microphone and said, "I am here for the ten women who have been raped and strangled between October 18 and November 29," after which she was echoed by the chorus of mourners who chanted, "In memory of our sisters, women fight back." In succession, each of the nine veiled women made statements that connected the Hillside Strangler murders with the larger social and political issues of violence against women, and each, in turn, was echoed by the chorus in the performance of what Lacy called "a modern tragedy." (p. 241)

In Mourning and in Rage provided images that countered the sensationalized reports of the mass media that depict women as victims. The artists presented a deconstruction of such media, and an exhortation to reporters, within the context of the performance, all of which was duly reported by all major media. For Lacy, the spectacle of the mass media, namely its stereotyping of women, had been successfully met with a challenge. Having discovered the impact of art intervention in mass-media representations, the artist used *Three Weeks in May* and *In Mourning and in Rage* as prototypes for the community-based performance art that would follow.

Lacy's illustration (*1996, Figure 6.3*) describes how she extends her pedagogy from the art context, and the purview of the artist, out to the audience, to communities where patriarchal representations and treatment

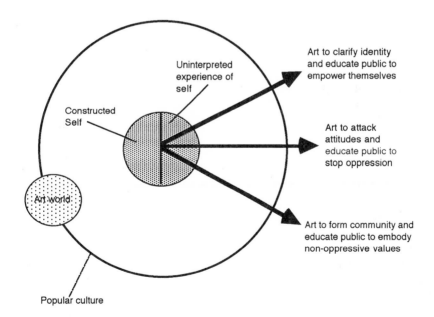

figure 6.3: Suzanne Lacy's "curriculum structure"

of women are codified and ingrained, where it is necessary to aestheticize and politicize the issues and concerns of the culturally oppressed. The aesthetic participation of audiences and communities evolved a performative structure for Lacy, a curriculum that "supported the audience in its confrontation with feminist perspectives. [In doing so,] the artist's role was enriched to include skills as educator and guide" (p. 6).

Kaprow originated this transformation of the spectator to that of participant, of high art to that of everyday life, by requiring the "audience to do something," claims art critic Jeff Kelley (1995). For Kaprow, participation meant the body's ability to engage aesthetic experience, to determine meaning, to attain awareness and agency. By engaging in the pedestrian activities that were scripted like musical scores, ordinary tasks that included multisensory experiences and random actions, the participant was able to embody artistic metaphor. Kelley (1995) describes Kaprow's transformation of the spectator to participant:

> By composing with actions and events as well as with materials and spaces, [Kaprow] learned to envelop the "viewer" in ways that invited a fuller play of the body and its senses in the experiencing of a work, whether by eating apples, moving furniture, calling to a partner in the woods (and listening for a response), or pushing one's way through a roomful of crumpled newspaper and chicken wire . . . [In doing so] the participant will have "embodied" the artist's metaphor, reinterpreting it according to his or her own experience . . . which results in "emergent content," that is, meaning that arises through an experience of participation. (p. 226)

Essential to Lacy's public projects, Kaprow's "participation performance" shifts the responsibility of interpretation and representation from the privileged position of the artist, art critic, teacher, school, to the cultural experiences of participants, those teachers, students, and community citizens who are involved in Lacy's community-based performances. To participate is to collaborate in Lacy's projects, to "emerge content" from one's cultural experiences, content that enables civic mindedness and critical citizenship.

To articulate a position of participation whereby the audience is able to "form and inform" a performance, Lacy describes a pedagogical structure comprised of a series of concentric circles, ripples of engagement, beginning with a core of individuals who develop a discourse with her about local issues that then evolves into a collaborative project that involves other citizens in the community (Lacy, 1994, p. 178). In this structure of interaction, the closer one gets to the core, the more intensive and involved the process of leadership and authorship. To avoid a hierarchical construct, and to encourage input from all levels, the concentric divisions are permeable so that participants can "reach

from core persons, to part time production workers, to volunteers, to audience, to performers, to people who see the performance on the media, and back again" (Interview with the artist, March 1997). Lacy (1994) suggests that these permeable, concentric levels of audience engagement are "useful only if they encourage appropriate complexity when considering the notion of interaction. But through such scrutiny an important implication is revealed: the educative function of [this] new genre public art" (p. 180).

For Lacy, community collaboration and critical awareness is accomplished through an empathic process. Empathy is essential to aesthetic experience because it provides an embodied connection between the artist and the world. This ability to project oneself outward, to better understand the aesthetics of the self in relation to that of the world, is "consciousness seeking to know itself," claims Sontag (1969, p. 4). Writer/ philosopher Arthur Koestler (1975) argues that empathy is a primary psychological means of projecting into the self, the world, and art.

> The fluid boundaries of the self as represented in the unconscious mind, confer on it the gift of empathy—*Einfuehling*—of entering into a kind of mental symbiosis with other selves. Empathy is a nicely sober, noncommittal term for designating the rather mysterious processes which enable one to transcend [her] his boundaries, to step out of [her] his skin as it were, and put [her] himself into the place of another. (pp. 187–188)

Thus, according to Koestler, the primary function of empathy is to discover aesthetic similarities between oneself and the world. Aesthetic experience illustrates the workings of empathy because it represents the ability to project oneself in the place of cultural forms, to absorb oneself in their dynamic content.

Philosopher Martin Buber (1926) addresses the relationship between empathy, aesthetic experience, and the body. "Empathy means to glide with one's own feelings into the dynamic structure of an object . . . as it were to trace it from within, understanding the formation and motorality—*Bewegtheit*—of the object with perceptions of one's own muscles; it means to "transpose" oneself over there and in there" (p. 34). This aesthetic absorption represents the body's ecstatic experience of itself and the world, what philosopher Drew Leder calls "bidirectional incorporation." He argues aesthetic absorption, or empathy, a symbiotic function that allows the body and the world to penetrate each other (p. 165).

With a premed background and an interest in psychosomatic illness, Lacy's bidirectional incorporation is comprised of

> networking, medicine, and social design . . . healing processes in which the dismembered members of the social corpus are rejoined . . . [Hers is] a view

of the [ecstatic] body in which the inside and outside are in constant, some-
times deceptive, play. For her, the body exists at a juncture between one's in-
ner and outer lives—the place where psychological and social phenomena
meet in a physiological embrace—and is an instrument that measures the
exchanges between the self and others. (Kelley, 1995, pp. 226–227)

Thus, for Lacy, subjectivity is made possible through empathic absorp-
tion. Artists and communities who work collaboratively reach out and
experience each other's aesthetic dimensions in actual ways. Finding
themselves in the memory, cultural history, of the other, is their first step
toward advocating the position of the other. Having made an empathic
link, they embody "an underlying dynamic of feeling that becomes the
source of their activism" (Lacy, 1995, p. 36).

For this cultural interaction to take place, according to Lacy (1995),
a continuum of aesthetic positions are necessary for the artist, strategies
that range from art making as a private enterprise to one that takes place
and includes the public. For example, the artist as experiencer, similar
to the ethnographic strategy of performance art pedagogy, becomes a
"conduit for expression of a whole social group" (p. 174). Like the artist
as reporter, Lacy relates to Roland Barthes' notion of "aesthetic fram-
ing," a process where the intentional framing of certain experiences is
"inherently political" (p. 175). Her artist as analyst position represents a
critique, a visual or textual challenge to aesthetic conventions (p. 176).
Finally, the artist as activist specifies the collaborative practices of com-
munity-based performance art, namely the artist's willingness to "take a
position with respect to the public agenda . . . [to] act in collaboration
with people, and with an understanding of social systems and institu-
tions" (p. 177). Each of these positions represents a pedagogical strategy
whose curricular outcomes are contingent upon the cultural profile of
the communities wherein a performance takes place. That is, actual "ex-
periences" of students' cultural identities teach a respect for cultural dif-
ference, "framing" students' cultural concerns teaches critique and
advocacy. "Collaboration" with students on community-based issues
teaches civic responsibility and critical citizenship.

Each of Lacy's community-based performances has a markedly dif-
ferent organizing strategy, aesthetic issue, and organizing technology. Al-
though her work is issues-based, she avoids "subject-oriented art," a
topical model centered around social issues that have attained political
visibility such as "homeless people," "abused women," and "teen preg-
nancy." Not that these topics are insignificant, but when extrinsically mo-
tivated, they elicit an artificial and presumptuous discourse. Concerned
about these developments, Lacy comments:

In the past twenty years we've developed a form of "subject-oriented art" that started in the seventies with political people who defined subject areas, brought together constituencies like abused women and did pieces about them. In the nineties that kind of work has influenced the education of art students, and you can find many such examples. While this may be a viable starting point, there's an inherent problem with defining people by a type of socially prescribed identity which frames and fixes them in time. It's still a viable technique, but I think we can work for a level of greater sophistication in political art. (Interview with the artist, March 1997)

As a critical pragmatist, Lacy works toward a level of sophistication, a different kind of model, that is determined by those discourses that are critical and intrinsic to the communities from which they originate. She believes that a project's authenticity is predicated on a grassroots, one-on-one nurturing process. The community informs her about its issues and concerns. The problem with the subject-oriented model is that the "artistic" ends justify and presuppose the means. In doing so, those issues and concerns that are intrinsic to communities are avoided in order to produce a public spectacle that amounts to artistic one-liners.

John Dewey's (1966) characterization of subject matter in the schools as "unreal" supports Lacy's concerns about subject-oriented community performances. Dewey writes: "There can be no doubt that a peculiar artificiality attaches to much of what is learned in schools. It can hardly be said that many students consciously think of the subject matter as unreal; but it assuredly does not possess for them the kind of reality which the subject matter of their vital experiences possess" (p. 161). Similarly, subject-oriented performance curricula disjoin art from life and produce political indifference in citizens because they precede and often preclude a community's intrinsic "vital experiences" and discourses. Arguing against extrinsic models of civic education, Pratte (1988) claims that unless schools and communities collaborate, "the recourse of professional knowledge [which a subject-oriented model represents] and judgment against polymorphous community power" will nullify political vigilance (p. 18).

Ironically, subject-oriented art was influenced by artists such as Lacy who, for the last twenty years, produced public projects that dealt with critical social issues. As Marcuse has eloquently stated, however, what was once art is now reified culture. To continue producing art, Lacy looks for ways to break through and to reframe the very conventions that she established with her cultural work. Rather than assuming the discipline of art, or a preconceived social issue a model for community activism, she questions community citizens, public policy makers, and community service providers to evolve a performance that represents

their concerns. Lacy asks: "How does art move within this arena of community, city, county, and state politics?"

In advance, Lacy informs her collaborators that they represent significant generative forces in the performance. They have approval on everything about the content of the work. Depending on the extent of their participation, they have access to editing of film and video, to all designing of the performance. They have full charge of training their community peers to produce the performance. Nevertheless, in terms of the imagery, the participants must agree that Lacy retain full authority. Lacy claims the problem of authority always comes up in one form or another, and she honestly tries to engage it. "These are not workshops for teaching public art per se. [Instead] we are going to do a professional work together, collaboratively" (Interview with the artist, March 1997).

The give-and-take process that Lacy implements is not devoid of disagreements. Willing to participate in her performances because they agree with Lacy that they and their community are being stereotyped with punitive metaphors, participants' ideas and images often conflict with each other and with the artist's vision. What is explicitly understood by participants from the beginning of a community project is their engagement in a process of deliberation with the artist and each other that is open to disagreement. For Lacy, "Openness is what distinguishes participation from manipulation . . . [and] participation . . . [is] an ongoing process of negotiation *without a hidden agenda*," claims Kelley (1995, p. 232). The art critic continues:

> Participation is [not] simply a matter of agreeing with the artist at the outset of a project or of her agreeing with her participants. Rather, participation is a dialogical process that changes both the participant and the artist. Like the art, it is not fixed, but unfolds over time and in relation to the interests brought to bear upon it. For the artist, those interests represent perspectives and values previously unconsidered or overlooked. They add to her as she adds them to her art. (pp. 232–233)

In the case of *The Roof Is on Fire*, a recent example of Lacy's work that I discuss in the next section, some community organizers proposed the use of buses as a central image since youth were more likely to take public transportation in Oakland. The youth had a variety of ideas. Lacy responded to the deadlock by counseling that she could not imagine that the media would cover the event nor would an audience attend "if it doesn't have the quality of a performance" (Interview with the artist, March 1997). So aesthetic issues dictated the final image. The content, or improvisational dialogue, was completely determined by the youth involved.

For Lacy, it is the art context and a poignant visual metaphor that create the necessary spectacle to attract the media and audiences to community-based performances. She "insists upon the symbolic integrity of the visual images in her work" (p. 228), writes Kelley (1995). Media coverage is important to her because it represents a public arena where the stereotypes of youth violence are communicated to mass audiences, where positive images of youth must present a public challenge. As a professional artist who has worked with communities and with the media for the last twenty years, Lacy retains authority of the image in order to create a spectacle that resists punitive cultural representations, but the opinions, perspectives, and contents of the events are completely designed and owned by the participants.

What participants learn from Lacy's performance projects is not a set method, a template, or a recipe for community-based performance art. Instead, they learn new strategies for interaction by doing what they know best how to do and working in collaboration with others who do the same. Such a curricular model finds all participants linked intertextually with the possibility of learning from multiple perspectives rather than a single person. Philosopher and cultural historian Ivan Illich (1971) refers to such multiple access links to educational resources as "opportunity webs" (p. 76). To circumvent the predetermined curriculum of schooling, and to provide students with resources to achieve their own learning goals, he proposes four strategies: "reference services to educational objects" in the form of information and experiences that can be found in libraries, museums, laboratories, showrooms, theaters, factories, airports, farms, and other cultural sites made accessible to students; "skill exchanges" that allow students, teachers, and community citizens to identify their skills and their willingness to share them as models with others; "peer matching," collaborating with partners; and "reference services to educators-at-large" to link students with community "professionals, paraprofessionals, and free-lancers" (pp. 78–79). Like Illich's web, Lacy's performance projects provide teachers, students, and citizens with references to a range of community sites and objects; they depend on a sharing of skills including that of Lacy herself as resident artist; collaboration is the principle means of interaction and intervention; and they represent a potential network of skilled citizens that can serve as "educators-at-large" long after the project has ended.

THE ROOF IS ON FIRE

The Roof Is on Fire, represents a public performance through which the teenagers of Oakland, California, could challenge the mass media's punitive portrayals of youth and to "speak and be heard without interference."

Artists Suzanne Lacy, Annice Jacoby, and Chris Johnson collaborated with 200 students from Oakland's inner-city public high schools, and with community citizens and public officials, to create the performance. Surrounded by an audience of 1,000 persons, the students questioned the mass media's stereotyping of youth as cultural misfits while they sat in parked cars on the rooftop of the downtown federal building parking lot. The audience was not allowed to intervene in the conversations, to allow students' uninterrupted speech. The students agreed as performers to disregard the audience, to focus on their own discussions. By separating these two tasks, Lacy claims, "the audience performed the *act of listening* while the teenagers performed the *act of self-revelation:* a model for us to listen to teenagers" (Franklin, 1994). In their conversations, the students expressed dissatisfaction with the fact that as teenagers they are rarely given a voice in society, yet they are represented as suspect on the evening news whenever violence is reported.

To accomplish the overwhelming task of coordinating this community-based performance project with Oakland youth, Lacy and Johnson teamed up with teachers and students from Oakland's inner-city schools. While Lacy took on the responsibility for designing *The Roof Is on Fire* performance, Jacoby arranged for media coverage, and Johnson collaborated with teachers to create a curriculum in "media literacy." Johnson describes the pervasive and insidious nature of mass-media images and the importance of students learning how to read and interpret media representations of youth.

> I think of media literacy as trying to teach a fish about wetness. It's everywhere, it shapes your whole way of being. When all those images are negative, when they tell you constantly that you are less idealistic, less intelligent, less motivated, [and] have fewer opportunities than the generations that came before you, you feel bad and frustrated. (Franklin, 1994)

The Roof Is on Fire did not have a conventional script. Instead, each car of teens was presented with a list of issues that evolved from a discussion of the student planners that was facilitated by Lacy and Johnson. Within the framework of the list, and while seated in the cars, the students expressed, discussed, and debated a wide range of concerns including the following:

- The mass media's stereotyping of black Americans as "drug dealers."
- The powerlessness of women and the contradictions of American democracy.
- Ideological conflicts within black communities.
- The control of government by "middle class white men."

Shortly after these comments, Lacy showed *Youth, Cops, and Video-tape*, a documentary of a youth police project that has been adopted by the Office of Police Services as a training video. "We need to talk about assumptions, background ideas, to get to know each other," she said. One woman acknowledged the value of such projects but questioned their long-term effects. Lacy assured her that by creating new social and aesthetic ways to communicate among youth, police, and the community, the process would have staying power. She pointed to the year-long process of discussions on the Oakland Youth Police Initiative that culminated in *No Blood, No Foul*, another performance project that brought cops and youth together on the basketball court. As the meeting proceeded, Lacy invited all who were in attendance to participate as members of an advisory group, to help continue and shape the project with her and the youth of Oakland.

7

Constructing Identity

An Autobiographical Case Study
of Performance Art

Well, we busted out of class had to get away from those fools
We learned more from a three minute record than we ever learned in school
Tonight I hear the neighborhood drummer sound
I can feel my heart begin to pound you say you're tired and you just want to close your
eyes and follow your dreams down
Chorus
Well, we made a promise we swore we'd always remember
no retreat baby, no surrender
Like soldiers in the winter's night with a vow to defend, no retreat baby, no surrender.
— Bruce Springsteen (*No Surrender,* 1984)

There I was, standing in front of a class of thirty adolescents. It was the first day of classes, just after Labor Day 1969, at Los Altos High School, and I was about to begin a pedagogy that had to be sustained for 188 days, the duration of the entire school year. In those beginning moments, my life seemed to pass rapidly before my mind. A first generation Armenian American, I came from an emigrant family. I was raised on a raisin farm where I worked and played throughout my childhood. The first in my family to complete a college education, I found my new role as teacher somewhat ironic. It seemed just yesterday that I was a student myself, on the receiving end of oppressive pedagogies. Had I become a teacher to challenge that oppression? What could I do to make a difference, to change the hegemonic discourses and practices that I had experienced in my school years? In what way could the subject matter of art play a part in transforming the hegemony of education into an emancipatory practice?

As a child, I had attended public schools, like the one in which I was now standing. Like many of my ethnic classmates, I had a learning handicap. English was my second language. My parents, political refugees who had emigrated to France where they grew up, then to the United States just a few years before I entered school, spoke only Armenian at home. In my first year of school, I was placed in a "special room" with other ethnic students who, like myself, lacked any reading, writing, or speaking skills in English. It was the first of many times to come that I experienced being marked as culturally different. Throughout my grade school years, my friends and I experienced ethnic and racial slurs from classmates, not to mention clear indications from our teachers that our cultural identity did not matter in the larger scheme of American society. Having yet to assimilate the English language, we sounded different. Our ethnic and racial difference was detected by our difference in skin, hair, and eye color. We were noted for the difference in our cultural customs. Coming from emigrant families who did not possess material wealth, we were known for our class differences by the homemade, second-hand, outdated, or off-labeled clothes we wore; the older houses and neighborhoods we lived in; and the used cars that our parents drove.

To be "a good American," we learned from our third-grade teacher, meant that we had to eat a "healthy breakfast" before coming to school. A healthy meal seemed the sensible thing to do, considering the energy required in school study. However, what constituted healthy eating we discovered was culturally biased. Every morning for the entire school year, after the pledge of allegiance and the singing of the national anthem, the teacher flipped the shiny pages of a large chart that contained the dietary codes of American identity. As she pointed to illustrations and read the accompanying texts on each page, she informed us that a good American ate a breakfast of two eggs, two pieces of bacon, toast with butter, potatoes, oatmeal, orange juice, and milk. Never mind that my Mexican friends dined on frijoles, tortillas, chorizos and other nutritious Mexican foods for breakfast, that at our home breakfast consisted of Armenian delights like soojouk and basturma (meats cured in special spices), chourag (a pastrylike bread), tell banir (string cheeze), peda hatz (a round bread topped with sesame seeds), and zeitouns (Armenian olives). What appeared as an innocuous chart clearly defined our cultural disparity.

My ethnic friends and I waited to hear, to no avail, our teachers mention or acknowledge our traditional breakfast foods or any of our cultural practices. In time, we learned that cultural difference was something to be abhorred. We learned that to assimilate was the quickest means to social acceptance and academic survival in school. We learned that to express ourselves appropriately, to interpret the contents of our

lessons, required that we first silence our cultural identities; veil the mark of otherness inscribed on our bodies due to race, ethnicity, and class; and adopt the dominant cultural values, beliefs, and attitudes promoted by the school. Some of my Armenian friends, for example, refused to talk about their Armenianness and would not associate with anyone except for Anglos.

Those of us whose families resisted assimilation found our cultural struggles compounded as we grew into the existential conditions of our teenage years. No longer was school the only challenge to our identities. As we grew from childhood to adolescence, we were allured by the spectacle of the mass media. Innocent, on the one hand, impetuous on the other, we were easily seduced by stereotypical representations of rebellious youth. Ideas and images from television, radio, magazines, and the movies captured our hearts and stirred our imaginations. Not only did we lack an arena in which to challenge the dominant discourse of schooling, but we also had no means to resist the mass media's spectacle of teenage life in America.

I clearly recall my Armenian, Japanese, Mexican, Italian, Jewish, and Hungarian friends and myself going to great lengths to look and behave like Elvis in the late 1950s, like the Beatles in the 1960s, trying to sing and dance like Martha and Vandellas, Ike and Tina Turner, or the Supremes. Somehow Elvis, Jerry Lee Lewis, Little Richard, James Brown, Chuck Berry, the Beatles, and the other pop idols of our youth appealed to our rebellious streak, our desire to challenge the values, attitudes, and beliefs imposed on us by school and by our parents. Rock 'n' roll appeared to erase the stigma of cultural difference. As our heads and hearts filled with the defiant sounds of rock n' roll, our bodies packed the nation's dance floors where we danced tirelessly. In the neutral, liminal space of rock 'n' roll we reinvented ourselves, hybrid identities that mixed one's own culture with those of others. Dancing to rock 'n' roll music was like paying homage to jazz, the blues, and gospel, idioms of African American music and dance. To my friends and me, it seemed that those Americans who were persecuted for their cultural difference had "arrived." They were the kings and queens of rock 'n' roll. For once in our lives, we had persons whom we could look up to, whom we could identify with. Through their achievements, the pressure to assimilate dominant American cultural values seemed to abate.

As Bruce Springsteen suggests in "No Surrender" (1984), the epigraph at the beginning of this chapter, high school was an irrelevant blur by comparison. It lacked the physical and emotional immediacy of rock 'n' roll. Wanting was a context for self-expression, a place to create personal value, to fulfill one's desires. School was a conditional environment where information was dispensed for the purpose of passing

exams, where we learned reading, writing, and math to advance to the next grade level, to get ready for college, for the future. Who we were, where we came from, and what we wanted seemed to be of the least importance to our teachers. My parents always instilled in me the necessity of doing my best in school. To succeed academically was a means of attaining agency, overcoming the social, political, and economic hardships they faced as refugees and emigrants in a newly adopted country. School represented the salvation from cultural oppression. Knowledge was power. Michel Foucault would have loved my parents in that respect. They understood about power and knew what it meant for the body.

Being an adolescent, I challenged my parents' values. Dropping out of school was not an option in my family, yet I questioned my purpose for being there. I studied hard, yet I wondered about the relevance of school in my life. I asked my geometry teacher why it was necessary for me to stay enrolled in geometry. Why study axioms and postulates? I asked the typical teenage question: What purpose does it have in my life? He informed me that its purpose was to help me advance to Algebra II. Unsatisfied with his answer, I approached my guidance counselor with the same question. He said geometry was necessary to get into college. Although I stuck it out in that class, it was not until graduate school, in an art history seminar dedicated to the study of existentialism in art, that I realized the irony of my high school mentors' responses to my question about the purpose of geometry.

While discussing the writings of Nietzsche, Heidegger, Sartre, and other existentialists, someone in the seminar invoked Euclid's use of plane geometry as a means to measure himself to his physical environment, to calculate who he was in relationship to the world. Was this possible? All of a sudden my mind leapt back to my query in high school. There I was, confused about the necessity of school and my purpose in life asking my geometry teacher and guidance counselor perhaps the same existential question that Euclid had asked himself centuries earlier. I wonder whether my attitude about school would have been different had they considered my question from an aesthetic perspective, one that took into consideration my adolescent bewilderment about my place in school, the culture, the world. As I reflect, it seems that an opportunity was lost by my teacher and counselor, one that could have enabled me to understand how geometry functioned as a mathematical means to define my life at a time when it really counted.

As the age of rock 'n' roll unfolded in synchronicity with the civil rights movement, we listened to and watched Martin Luther King and Caesar Chavez proclaim the beauty of being ethnically and racially different. For my Armenian American friends and I, the slogan Black Is Beautiful became I Love Being Armenian. Although life in American

culture began to change during the turbulent 1960s, we discovered that slogans were not enough to overcome our oppression. They merely gave the appearance of liberation. To challenge the hidden, insidious forms of discrimination required political action. For me, political action was necessary within the context of the schools. The classroom was the necessary site of resistance where I believed the artist/educator had to work as a double agent to teach yet critique existing curricular discourses and practices.

Inspired by performance art and by Marcel Duchamp's notion that the artist must go underground to challenge the historical assumptions of art, I constructed a pedagogy that provided my students with the historical, social, and aesthetic foundations of art, on the one hand, and a means to rupture that pedagogy with their issues and concerns of contemporary culture on the other hand. My students learned to challenge preexisting discourses and practices of art and culture through the ethnographic, linguistic, political, social, technological, and ecstatic strategies of performance art. In doing so, they were able to better understand the relationship between art and contemporary culture, the place of art in their lives, and the purpose of art within the context of schools.

Thus, considering the circumstances of being ethnically or racially different, my friends and I had three choices: first, to assimilate the dominant culture portrayed by school and the mass media in order that our ethnic identities be cleansed and legitimized; second, to resist assimilation and risk being cast off as a cultural other, forever perceived as suspect or illegitimate; or third, to reside on the border between two cultures, having to continually struggle with problems of identity. As Armenian Elvises, Little Richards, Chuck Berrys, Tina Turners, and Beatles, we chose the latter. The twisting, shouting, gyrating, eccentric gesticulations of rock 'n' roll represented for us the physical manifestations of our struggle for liberation and equality. Although I regularly attended and graduated from the Saturday Armenian language school offered at the Armenian church and served as an acolyte on Sundays, I learned to assimilate American values in order to do well in school. Caught between two cultures, I found myself in a dilemma similar to the one Guillermo Gómez-Peña has described as his bifurcated border identity as Mexican and American.

My early art education took place on the farm, while working and playing in and about my father's vineyard and in my mother's kitchen. Since ours was a low-income, working-class family, my father had to work as a laborer in a fig-packing plant to make ends meet. Under our financial circumstances, necessity was truly the mother of invention, whether at work or play. What farm implements we could not afford, Father

would build himself. Like a bricoleur, he would forage junk piles and secondhand shops for broken or used tools. He would salvage parts from several implements and improvise their assembly to create a unique hybrid. He took pleasure in being able to create his own tools and his way of agriculture.

Like Father, Mother seemed to possess and apply the same ingenuity inside our home. While Father's responsibilities consisted of the vineyard and the packing house, hers was that of housewife and seamstress. To bring in extra money, she sewed wedding gowns and dresses for women, suits and sports coats for men. Her skills at the Singer sewing machine were paralleled by her terrific cooking. My brother and I raised chickens for meat and eggs to be used in the delicious Armenian meals that she prepared. We took great pleasure in knowing that Mother used what we had produced. We fancied the beautiful table that she prepared. The smells, the taste, the visual experiences of her meals left indelible sensory marks on our minds, memories, and bodies. Her responsibilities as a housewife and mother, although diverse, appeared curiously interconnected. Mother wasted nothing. Even empty chicken feed sacks had a purpose. She would have my brother and I collect them from the chicken house and bring them to her sewing machine. Photographs taken during our grade school years reveal my brother and I wearing shirts that she had sewn from the patterned sackcloth. Our wonderment of Mother's ingenuity, however, was quickly dispelled at school as we discovered the cultural stigma assigned to the way we dressed. Unlike "store-bought" clothes that purchased social acceptance into American middle-class culture, our clothes were marked as economically deprived and socially depraved.

The life that my parents created for my brother and me, and later for our two sisters, was filled with ritual. Ceremonies of work and play created meaning in our lives. Like a living assemblage, each of us children had an essential part to play in defining our family. Play and ironic, humorous speech acts often intervened our work. Creative disjunctions, they subverted the daily routine of farm life. A biographical essay about my cultural history written by author-historian Paul A. Blaum (1991) contains an example of my father's playful disruptions.

Garoian recollects with a chuckle how he and his younger brother, Gerard, had to dig six-foot garbage pits, a sweaty task which they hated. One day he and Gerard were digging a pit and, as usual, grumbling. Charles was ten, Gerard eight. Three hours went by. Their father listened patiently to their muttering. They reached a depth of about four feet, then Charles found a quarter in the dirt. Excited by the find, Gerard uncovered a dime. Charles found a few pennies, Gerard found a nickel. "We were digging like mad,

and we got down, not to six feet, but seven feet that day," Garoian says. "At
the end of that hole, my dad is leaning back, and he's got the biggest smile
on his face. You know what the guy was doing? As we were working furiously,
he was taking coins out of his pocket and dropping them in that hole.
That's creative discipline." (p. 48)

Unable to afford commercially produced toys and games, my
brother, sisters, and I transferred the creative sensibility that we learned
from our parents to the construction and production of play. The
county dump, a heap of cultural signifiers, was located near our farm. As
children, we foraged the refuse, found and salvaged objects and materi-
als that we assembled in some kind of playful construction. Once, I re-
call asking Mr. Lindsay the dump tender permission to use his
compressor to inflate inner tubes that we found in a pile of used tires.
After doing so, we tossed the tubes into the irrigation ditch that flowed
along one side of the dump and continued toward our home a mile
away. As if embarking on an expedition, we climbed inside the tubes and
paddled downstream using long, flat pieces of lumber that doubled as
machetes, implements that we used to hack a clearing through the
thicket of grasses that lined the ditch. After reaching home, we realized
what a wonderful adventure we had had. The residual outcome of our
playful adventure was that the ditch had been cleared of grass to allow a
better flow of irrigation waters to farms downstream. We relished such
multiple outcomes, play and work accomplished in a single effort.

It was not until a number of years had passed that I realized the sig-
nificance of our parents' playful interventions, their intentional intro-
duction of pleasure and joy in a life that, for them, had begun as a
tragedy. My brother, Gerard, my sisters, Miriam and Claudette, and I
learned to assign work and play symbolic value. Metaphorically, the farm
was Armenia. It represented the "old country," the place lost in the grim
circumstances of the genocide. On the farm, activities were accom-
plished with passion. The purpose of our cultural struggle was to sym-
bolically avenge the loss of loved ones. Nothing was wasted. Even
watermelon rinds had symbolic value.

During summer months, after dinner, my mother would often serve a
watermelon from our garden for dessert. While we ate, my father would
share his recollections of Armenia, his childhood experiences of the geno-
cide. He would tell personal stories amidst those that he would weave as
he went along. Some were funny, while others were sad. While telling
them, he would take a dinner knife in hand and begin to carve the water-
melon rinds. As he told his story, he constructed sculptural forms like a
train fashioned and fastened together with toothpicks complete with
engine, box cars, and caboose. What did the train represent? Perhaps a

signifier of his exodus, it represented the force that helped to drive away his childhood pain. Or perhaps making the train from what amounted to garbage represented a form of cultural empowerment, one that enabled him to re-think and re-define himself through play and to challenge the odds of his ability to survive as a political refugee, an emigrant in a foreign land. Ironically, the watermelon rind was only a watermelon rind, and the image of the train was merely an image. In the space between fantasy and reality, father created an experience that was mysterious and magical, on the one hand, contemplative and critical, on the other hand.

It was not until my sophomore year at California State University at Fresno that I began to understand the aesthetic dimensions of my youth, the relationship between my American education and my Armenian identity, how my childhood experiences could inform my work as an artist and how the pleasure of creative work and play on the farm served as the figure against a ground that contained the painful memories and recollections of my parents. The push and pull of these experiences from my past served as the impetus for my future cultural work as an artist and teacher.

A student in Professor Wes Williams's introductory art course, I had just stretched my first canvas. The gesso had dried, and I was about to apply my first strokes of oil paint to create an image. Unfortunately, the surface was too intimidating. The work of preparing the canvas seemed like such a significant ritual, the surface so taut and pristine, that I could not proceed. This being our first experience with oil paints and canvas, Professor Williams wanted us to experiment, to explore the medium, and to paint whatever image might evolve in the process. There I was stuck, frozen in place, not only because the surface was intimidating, but because I could not imagine what to paint.

Two class sessions later, still unable to make a breakthrough, Professor Williams approached me and struck up a casual conversation. What we discussed in those twenty minutes changed my life forever. Having observed my difficulties in starting, he gently persuaded me to talk about myself, about my cultural background. He asked me if my surname was Armenian, to which I responded in the affirmative. He asked me if I was aware of the history of my people, to which I again responded yes. I sensed he was asking about the massacre of the Armenian people by the government of Turkey, the first and forgotten genocide of this century. I informed him that my parents experienced those atrocities firsthand. They were genocide survivors. They spoke incessantly about the brutalities they witnessed, about the murders of family members, friends, and neighbors right before their eyes.

As I told him of my parents' daily testimony to my brother, sisters, and myself, to surviving family members, to friends and acquaintances, I

realized that Professor Williams had opened a door in my consciousness that had been forced shut long ago. I could tell that he sensed a nerve had been struck. When I finished responding to his question, he looked at me and asked me to paint from my parents' recollections, to create images that represented what I had witnessed about their testimony. In the next few class sessions, as I awkwardly attempted to apply paint to canvas and to represent those vivid images told to me by my parents, I became increasingly aware of the significance of my memory and cultural history within the context of school. I began to understand how it served as part of a dialectic, the oppositional content necessary to intervene and subvert the dominant cultural codes of schooling.

- From that point on, I realized that everything I learned in school could define my life but only if understood from the perspective of my cultural experiences outside of school—my family history, my farming experiences, my life in the Armenian American community where I was raised.
- From that point on, I realized that the aesthetic dimension of art was the site of inquiry where that contention could occur, where I could construct my own identity and attain political agency within school, within American culture.
- From that point on, I was no longer resistant and indifferent to what I had to learn in school because I understood the role it would play in my life.
- From that point on, I was able to understand the role that my memory and cultural history would play in defining the fullness of who I was, where I came from, and where I would inevitably choose to go. It is also possible that at that moment I was destined to become an art educator. And although I was beginning in the medium of oil paint, it was the content of my life that compelled me to create performance art.

PERFORMANCE ART AS IDENTITY CONSTRUCTION

Presented in the form of live collage/montage/assemblage or live semiotic constructions, my performance art works are autobiographical. They serve as a site where my ethnicity, cultural history, and contemporary cultural experiences collide. A first-generation Armenian American whose emigrant parents survived the genocide of 1915, I grew up in a family environment hearing about the atrocities experienced by my parents and relatives, about the persecution of family members, their friends, and their people due to their cultural difference. My parents' continual lamentations helped purge them of their pain and anguish. Directed outward, their expressions fed my imagination and stirred my emotions. In today's world, these kinds of horrifying images and ideas borne of cultural injustices continue to exist, and, in doing so, they

influence the cultural identity issues in my work. Through performance art, I explore and play with the language of my body and the cultural body to question and transgress the assumptions that have been ingrained in me. The politics of culture and cultural diversity are at the heart of my performance art works.

To create my performances, I use interdisciplinary strategies that I acquired through my education in the visual arts, mixed-media painting and sculpture, and from semiprofessional experiences in dance, theater, and opera early in my life. This formal education in the arts finds its complement in having grown up on my family's raisin vineyard, a place where play and work were intertwined, where prosaic objects, materials, images, sounds, actions, and structures were used for other than they were intended. Like my father the *bricoleur,* I learned to improvise farm tools out of found objects and materials, to do farm labor that was animated with storytelling and playful action, and to make childhood toys and games that transformed life on the farm into a hopeful reality. These experiences, joined with the religious rituals in which I routinely participated as an acolyte in the Armenian Apostolic church, prepared the ground for my work as a performance artist.

In what follows, I describe three of my own performance art works to illustrate how my personal memory and cultural history inform my work as an artist. In chapter 8, I augment this process with examples of my performance art pedagogy, exposing the conjunctions of my life, my performance investigations, and my teaching practices. To conceptualize a performance, I undergo an intensive multilayered process of research, experimentation, and rehearsal. I begin by searching, finding, and gathering disparate elements of information—objects, materials, images, sounds, ideas, and actions—that relate to my cultural background. One or two key concepts begin to take shape. I then juxtapose these disparate elements to brainstorm, improvise, negotiate, and rehearse a collage structure of disjunctive associations. Wanting to create an open work that contains the possibility for multiple readings, I then read and critique the structure in order to learn the meanings that result from its conjunctions. Finally, I manipulate the conjunctions by adding, subtracting, or reworking the disjunctive elements until I have achieved a desired result. Through this process of construction, I am able to experiment and rehearse a number of possible outcomes.

In the following portion of this chapter, I provide in-depth descriptions of three performances, *History According Two Mental Blocks* (1995), *Walking on Water* (1996), and *Raisin Debt* (1997), to reveal my iterative process of conceptualizing, creating, revising, and performing. My purpose in presenting these documents is not to have them taken up as scripts, but rather to reveal my design process in all of its phases. The vi-

sual, aural, and gestural components of a performance are planned and worked out through a process of trial and error.

Presented here are my final scripts, stage plans, and monologues with descriptions of what the audience or viewer witnessed at the actual performance. I describe each of my three performances according to six stages of production: 1) in concept, inquiry, and cultural commentary, I characterize my general intent for the performance; 2) in list of materials and equipment, I identify the items that I assembled for the production of the performance; 3) in space plan, I illustrate the placement of performance objects, materials, and equipment within the performance arena; 4) in dimensional drawings to construct, I provide my working plans with precise measurements and instructions for constructing special objects and props; 5) in description of performance: actions, visuals, sound, and tech script, I provide a timed sequence of the entire performance; and, 6) in construction of signifiers, I describe the metaphoric meanings I am working to evoke with the conjunction of ideas, images, objects, materials, and actions in the performance.

Each of the aforementioned stages comprises an in-depth, comprehensive research, brainstorming, improvisation, rehearsal, and editing process that I use to construct and compose my performances. Moreover, my aim in adjoining the disjunctive ideas, images, objects, materials, and actions in each performance is to provide audience members with multiple conjunctions and entry points that invite multiple readings and interpretations based on their respective cultural experiences.

HISTORY ACCORDING TWO MENTAL BLOCKS (1995)

Concept, Inquiry, and Cultural Commentary

An autobiographical parable, *History According Two Mental Blocks* ironically contrasts my lifelong experience with holy communion as a bit-by-bit intake of Christ's "body" with that of obsessively "biting" and "spitting" my own finger nails and skin. How many Christs have I ingested? How many of my own bodies have I spat? The burden of cultural expectations, the weight of personal responsibility, the impediment of mental blocks drive a desire to "shed" skin, to "negate" the hands, to "erase" the body. A confession in the public ear, it tells of a history of oppression that begins vicariously through the ritual of communion and culminates in the colonization of my body and my culture.

History According Two Mental Blocks was performed in 1995 at the Penn State University School of Visual Arts Faculty Exhibition, the Pittsburgh Center for the Arts, and the Eighth Annual Cleveland Perfor-

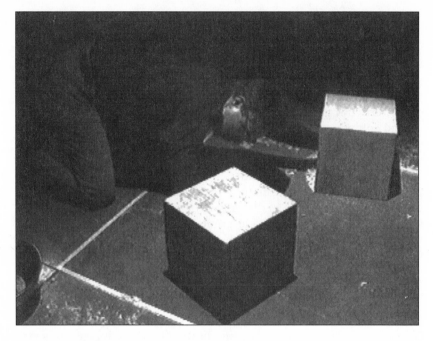

figure 7.1: Charles Garoian, *History according two mental blocks*, 1995. Courtesy of the artist

mance Art Festival. I was accompanied by my wife Sherrie Garoian, who sang an Armenian prayer, and five students, four of whom assisted me by carrying two heavy concrete blocks in a procession in the first part of the performance. The fifth student provided technical assistance.

List of Materials and Equipment

- six pounds of dry bread crumbs
- pair of white gloves
- large stainless steel bowl
- two heavy concrete blocks weighing 113 lbs. each
- 2 video monitors, VCR, and cables
- slide projector
- audio system with speakers
- VHS tape of body scan
- Slide of Andrea Mantegna's *Dead Christ* (after 1466)
- 10 slides of fingerprints showing bite marks on skin
- four Fresnel light fixtures fixed to the ceiling controlled by a variac (to vary the AC voltage).

SPACE PLAN

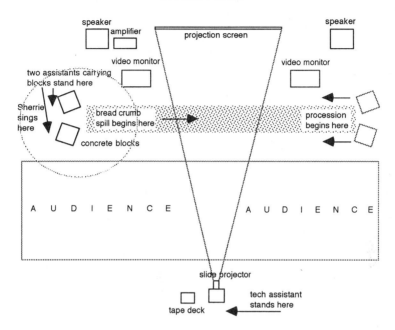

f i g u r e 7.2: *History according two mental blocks,* space plan

Dimensional Drawings to Construct the Two Concrete Blocks

- Construct two plywood forms to pour concrete for heavy performance blocks. Weight: 113 lbs. each. (*Figure 7.3*)
- Prior to pouring concrete, insert two plastic tubes inside forms to accommodate hands. (*Figure 7.4*)
- Both tubes should contain a handle for gripping and pulling.
- Anchor handle in concrete with nails.

Description of Performance: Actions, Visuals, Sound, and Technical Script

Andrea Mantegna's *Dead Christ* (after 1466) slide projected—Video monitors on blank screen—Charles takes microphone and introduces performance and crew—LIGHTS DIM—Everyone takes their places.

(Time indicates hours:minutes:seconds)
00:00:00
Fresnel lights gradually turned on to #7 setting on variac dial. Sherrie, standing stage right, begins to sing *Soorp, Soorp* ("Holy, Holy," a sacred Armenian prayer).

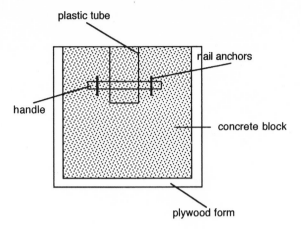

figure 7.3: Form to pour concrete

Soo-oo-oo-oo-oo-oo-oorp, soo-oo-oo-oo-oo-oo-oorp, soo-oo-oorp de-r zo-roo-tiantz, li yen yer-gink, yev ye-r-gir pa-rrok ko, orh-noo-tioon ee par-tzoons, o-o-o-orh-nial vor ye-gir yev ka-lotz, yes a-nooa-mp diarn, ov-sa-na ee, par-tzoon-ns. A-me-n.

A procession of four assistants picks up and slowly carries two heavy concrete blocks from stage left toward Sherrie. Charles, wearing white gloves, follows behind the procession carrying a stainless steel bowl filled with bread crumbs.

00:01:05
Four assistants reach the area where Sherrie is standing, place heavy concrete blocks on floor with a thud, and stand at one side of each block. Charles follows slowly until he reaches the concrete blocks. He pauses until Sherrie finishes song.

00:01:47
Song ends—Sherrie pauses and then walks off in a procession with the four assistants.

00:01:55
Charles begins to walk backward slowly, toward stage left, while carefully sowing bread crumbs from the stainless steel bowl onto the floor. Bread crumbs make a pattering sound on floor.

00:05:11
Charles reaches stage left, carefully places stainless steel bowl on floor, comes to his knees, pauses for ten seconds, and then bends over and begins to blow bread crumbs, cleaning a path in which to crawl—30 seconds after Charles begins, tape recorder turned on to start whispering monologue.

[Monologue in a whispering voice heard from two speakers] "*For in the night in which he was betrayed, he took bread; and when he had given thanks, he brake it and gave it to his disciples, saying, Take, eat, this is my Body, which is given for you. Do this in remembrance of me.*"

The priest anchored the wine-soaked wafer with the thumb and index fingers of both his hands. Balancing the chalice between his palms, he ripped a piece of the sacred flesh and placed it on my extended tongue. As I pulled the sacred morsel into my mouth, he invoked the trinity. "In the name of the Father, the Son and the Holy Ghost, Amen."

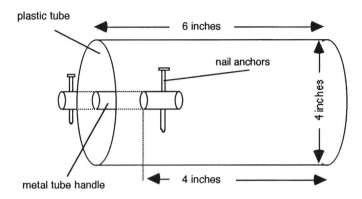

figure 7.4: Plastic tube insert

It was the first of anything I had eaten in twenty-four hours, yet this was not breakfast, lunch, nor dinner. "The body is a sacred temple," my mother said. "You must not indulge it with the food of this world in order to prepare it for the feast of the other."

Now, with the fragment of Christ's body sandwiched between my tongue and the roof of my mouth, I wasn't permitted to chew nor to bite down. "Allow it to dissolve in your mouth," I was told. "If unable, then swallow it whole." A rush of anxiety shot through my spine as I realized the responsibility of behaving properly.

Can you imagine doing the Heimlich maneuver on someone choking on God? At the least, the firm upward thrust just below the rib cage to force air from the lungs would simulate genuflection.

After the previous day's fast, it was only now that I was permitted to dine on my mother's cooking. Ample amounts of shish kebab, rice pilaf, kufta, soubourag, and other delights awaited as my father pulled the '49 Plymouth into the driveway. All these on the condition that whatever went into my mouth had to stay there.

I was warned not to gnaw nor to suck marrow out of any bones. What about the fork? No toothpicks. How about a spoon? No spitting and no foul language. My body had been sanctified by the Eucharist, and it had to remain that way for several days.

"For in the night in which he was betrayed, he took bread; and when he had given thanks, he brake it and gave it to his disciples, saying, 'Take, eat, this is my Body, which is given for you. Do this in remembrance of me.'"

What a set-up. I wasn't absolutely certain of my sins, yet there I was in a group confession with fifty other people asking for absolution. What a pathetic sight we must have been to the others seated in the pews. Were they not sinners, or were they merely in denial? Was my confession a lie? If not, the restrictions placed upon me would almost certainly lead me to do so.

God, how could I stop from spitting, chewing, sucking on bones, or cussing? How could I prevent anything that went into my body from coming out?

Yet, every Sunday morning, it became routine. Early to rise, no breakfast, white shirt and a tie, black slacks, black shiny shoes, and Brylcreem gripping my hair to my scalp.

The five-mile ride in the back seat of the Plymouth followed by genuflection with a chorus of sinners, swallowing Communion, then no spitting, gnawing, or cussing.

Charles is still blowing bread crumbs.

00:09:32

[Whispering monologue continues]*What a coincidence . . .* Video monitors begin to "PLAY." They reveal closeup images of Charles's body. As the camera scans his head, hair, face, neck, shoulders, arms, arm pits, torso, waist, hips, genitals, buttocks, thighs, knees, calves, ankles, feet, toes, and slowly back up again, the audience witnesses the terrain of his body, the source of his skin, as if asking its relationship to God's body.

Slide projection of Mantegna's *Dead Christ* changes to the first of ten finger prints that show bite marks on skin. White, empty spaces have been left behind where skin was bitten and torn away from the finger. These images change every 45 seconds until the last finger is reached. The sequence is as follows: left thumb, index finger, middle finger, ring finger, and pinkie followed by the right pinkie, ring finger, middle finger, index finger, and thumb. This last image, the right thumb, stays up for the remainder of the performance.

Slide image of left thumb showing bite marks on skin. Video image scans left side of Charles's head, face, and ears. *It was during these same years that I formed a strange bodily habit that I've continued to this day, a private ritual that I would carry on during the week in between my holy weekends.*

I found distinct pleasure in biting the hand that fed me by chewing my skin, the skin around my fingernails, my cuticles, and in the area of my finger tips.

"For in the night in which he was betrayed, he took bread; and when he had given thanks, he brake it and gave it to his disciples, saying, 'Take, eat, this is my Body, which is given for you. Do this in remembrance of me.' "

Charles is still blowing bread crumbs.

00:10:17

Slide image of left index finger showing bite marks on skin. Video image scans left side of Charles's jaw and neck.

[Whispering monologue continues] *It enabled me to escape the intensity of my own thoughts, to suspend any expectations, and to slow the passage of time. Or was I merely accelerating my chronological age by overwhelming the natural process of generating and eliminating body cells? In doing so, was I losing time?*

Some nights I dreamt I was flying with my hands flapping like the wings of a bird; other nights my hands were heavy as concrete blocks dragging on the floor.

After biting and ripping away, I would chew the tiny morsel obsessively. Then I would spit, its landing random—unpredictable.

Charles is still blowing bread crumbs.

00:11:02

Slide image of left middle finger showing bite marks on skin. Video image scans Charles's forehead and features of his face.

[Whispering monologue continues] *A divine reciprocity, on Sundays I took in bits of Christ's body, and during the week I expelled my own.*

According to Newton's third law of motion, for every action force, there is an equal and opposite reaction force.

Entropy in action, my body dispersed, scraps of skin flying from my mouth in all directions. My actions were discreet; that is, I assumed they were.

The only time that I could've been found out was if someone had aimed their gaze directly at me.

Charles is still blowing bread crumbs.

00:11:47
Slide image of left ring finger showing bite marks on skin. Video image scans Charles's left shoulder, body hair, and underarm.

[Whispering monologue continues] *If caught in the act, I would pretend contemplation— with my fingers gently tapping my lips then sliding down to hold my chin as if on the verge of some profound thought like Socrates or Rodin's Thinker.*

Meanwhile, the surface of the chair upon which I was seated and the floor around me would begin to resemble an early snow or an acute dandruff problem.

Bartholomew became my patron saint, and Michelangelo flayed on the Sistine Wall, my idol.

Charles is still blowing bread crumbs.

00:12:32
Slide image of left pinkie showing bite marks on skin. Video image scans Charles's chest, body hair, over to right shoulder and underarm.

[Whispering monologue continues] *My habit followed me to all parts of the house, to school, to the movies. Only on weekends, at church, would I work hard to consciously re- strain myself. To college, to my job, in the car, in airplanes, on the trains—I would surren- der myself. I've often wondered if, in all these years, anyone detected the presence of my skin after I had walked away.*

I always hoped for a more obvious interpretation: crumbs left by a sloppy eater or sand from the cuffs of a beach bum.

In my home town, in the cities that I have visited, in the countries where I have traveled, skin, ripped from my fingers, chewed with a sense of delight befitting a nineteenth-cen- tury dandy, hurled through my teeth and landed wherever gravity would force.

Charles is still blowing bread crumbs.

00:13:17
Slide image of right pinkie showing bite marks on skin. Video image scans Charles's right nipple and rib cage area.

[Whispering monologue continues] *The pleasure of my habit, coupled with the possibility of such dangers as transferring germs from my fingers to my mouth, being caught in an act of folly, causing skin cancer made the experience sublime.*

What an embarrassment the first time that I was actually found out. It was by a policeman no less. I was sixteen. I had just passed my driving test when a cop working the DMV asked me to step forward to his desk.

Charles is still blowing bread crumbs.

00:14:02
Slide image of right ring finger showing bite marks on skin. Video image scans Charles's abdominal area, body hair, and navel.

[Whispering monologue continues] *He took my hand and pressed my fingers against a black stamp pad, "fingerprints for your license," he said. This was before they used photographs. Upon examining the results, he looked puzzled. He examined my finger tips and asked me if they were diseased.*

Rattled by his suggestion, I responded with the truth to which he then declared, "Well, you won't be too hard to track down, will you?" If that wasn't admonition for staying within the law, I don't know what else could have been. I then realized the burden of my craving—I had branded myself with marks of anxiety, I could be easily detected.

00:14:42
Charles reaches the concrete blocks at end of bread crumb path through which he has blown a clearing. He is visibly out of breath and perspiring. With heavy chest, he takes off his white gloves, pauses for 15 seconds, inserts hands in concrete blocks, and begins to tug them backward along the bread crumb corridor.

[Whispering monologue continues] *"For in the night in which he was betrayed, he took bread; and when he had given thanks, he brake it and gave it to his disciples, saying, 'Take, eat, this is my Body, which is given for you. Do this in remembrance of me.' "*

00:14:47
Slide image of right middle finger showing bite marks on skin. Video image scans Charles's groin, around the left side of the hip, and the area of the buttocks.

[Whispering monologue continues] *In fifty years time, only two months have I refrained from this corporeal indulgence—it happened last March and April in the Republic of Armenia.*

Signs of despair and hopelessness were everywhere; buildings were in a state of disrepair, streets filled with pot holes and garbage, people without food or water, soldiers being carried in procession to the cemetery of heroes.

Charles is still tugging concrete blocks backward along the bread crumb corridor.

00:15:32
Slide image of right index finger showing bite marks on skin. Video image scans Charles's right thigh, genitals, and over to the left thigh area.

[Whispering monologue continues] *Thousands of wild dogs roamed helter skelter through the streets posing a wide ranging threat, so the government gave permission to shoot. Gun shots rang out all through the night; dogs fell as did people in the Kharabagh just on the other side of the border.*

Was the horror merely another example of the second law of thermodynamics? I kept trying to remain objective but failed. "Are death and dying merely realms of the aesthetic, or are they real?" I wondered as I realized the finiteness of my own life.

In a state of panic, I telephoned Sherrie in Los Angeles. She asked if someone was holding a gun to my head. I didn't understand the question, but I replied "no" anyway.

Charles is still tugging concrete blocks backward along the bread crumb corridor.

00:16:17
Slide image of right thumb showing bite marks on skin. Video image scans Charles's left thigh down to his left knee, ankle, foot and crossing over to his right foot.

[Whispering monologue continues] *To keep me from losing my senses, she reminded me that I was an American. Believing this a remedy, I wrote it down and repeated it like a mantra every morning for a week.*

Anahid asked if I wanted to see the architectural monuments of Yerevan. I reluctantly replied "yes" and went along.

All I could do during her tour was to look at the ground. Only briefly did I look up to catch a glimpse of the site to which she was referring.

Having lost my bearings in what appeared a God-forsaken land, I thrust my gaze downward if only to feel safe and secure.

There, on the ground all around me, I noticed what appeared to be black, shiny fragments of broken glass.

Precious in their appearance, they captivated my attention, they took me far from Anahid's monologue about the city.

"What are all these black rocks everywhere?" I asked. To which she condescended, "Oh, those; don't pay any attention to them. They're a nuisance. They're the Devil's fingernails." These people believe that their land is cursed.

Rocky, mountainous, and jagged is the character of their landscape and the harsh realities they have endured over the past centuries.

Particularly devastating: the genocide of 1915, 75 years of Soviet socialism, the earthquake of 1989 that claimed 25,000 lives, the current economic blockade imposed by Azerbaijan, leaving them without the basic necessities of life.

The conditions of their history and their land are intertwined. They believe as God portioned land to all the peoples of the world, he did so with disregard for them. While others received beautiful and bountiful settings, they themselves were left with the remains, the worthless scraps.

What appeared to me as shiny black fragments of broken glass turned out to be obsidian, a stone found everywhere in this country. Geologically, it is a form of glass produced through volcanic action during past millennia.

Charles is still tugging concrete blocks backward along the bread crumb corridor.

00:18:48
Video of Charles's body scan ends, having traversed back up his body from his right foot to the top of his head. PAUSE on image of hair on head.

Despite its rich black color and its quasi-precious appearance, here it is perceived as a nuisance.

The black, shiny, brittle, razorlike properties of this ubiquitous stone, and its origins from the fiery bowels of the earth, have earned it the title of "the Devil's fingernail."

"After chewing his fingernails in Hades, the Devil spat them out of a volcano and scattered them everywhere in this God-forsaken land. Be careful where you step!"

Upon returning from Armenia, I resumed flaying my fingers, chewing skin, and spitting. Why? I am not certain.

Perhaps it's a physical manifestation of survivor's guilt, a form of penance for living the good life.

In all the years of Communion, how many Christ bodies have I ingested? In all the years of ripping and chewing my skin, how many of my own bodies have I spat?

Where are my finger prints? What is my identity? Who will remember me?

00:20:04
[Whispering monologue ends] turn tape recorder "OFF" after *Who will remember me?* Heavy breathing and sounds of exertion can be heard from Charles as he continues to tug concrete blocks for remainder of time in silence back to where bread crumb path began. He pauses, breathes heavily; his body is exhausted.

00:21:15
Charles finishes tugging. He removes his hands from inside the concrete blocks, sits up in kneeling position, pauses while continuing to breathe heavily. The performance ends when he stands and walks away from the performance space. Lights dim.

Construction of Signifiers

As large projections of fingerprints provide testimony to my repulsive habit, I sow bread crumbs across the floor, which I proceed to blow away in order to create a path. I then imbed my hands in two heavy solid blocks of concrete, dragging them over the path and across the floor in order to "slow the passage of time" and to "ponder the possibility that the deepest truths may only be found "in the concrete." A video camera surveys the terrain of my body, exposing its vulnerability to cultural inscription on video monitors. While this surveillance continues, a monologue is whispered over a public address system. The following intentions further describe my construction of signs and the readings I worked to communicate.

- Andrea Mantegna's *Dead Christ* (after 1466) is projected at the beginning of the performance to contrast the sacred body with the profane actions of my own body. Christ's body, lying on a table as a corpse/specimen, is juxtaposed with my scanning my own body on video, the slides of my bitten fingers, as if specimens.
- The four assistants carrying the concrete blocks across the audience members path of vision provides visual testimony about the burden of their weight.
- The procession, along with Sherrie's singing of an Armenian prayer, introduces the concept of sacred religious ritual, one that I critique, re-configure, and re-present throughout the performance.

- The bread crumbs signify both the dispersal of my body as spat skin and the dispersal of God's body as bits of holy communion.
- The white gloves cover my "profane" hands. They prevent my body from soiling the bread crumbs, "the communion," the "body of Christ."
- The sowing of bread crumbs provides two possible readings. On the one hand, Christ is debased as bits and pieces of His body are thrown onto the floor. On the other hand, the presence of His body sanctifies the floor as hallowed ground. The floor is also where I most often spat my skin.
- The whispering of the monologue suggests a confession monologue prior to receiving communion. The role of the audience is similar to that of a priest who witnesses a confession from a sinner.
- The projected finger prints provide evidence of my indiscretion, the biting and spitting of my skin as debasement of my body. The numerous spaces where skin has been removed from each finger shown in the slide projections correspond to the dispersed bread crumbs on the floor.
- The heavy concrete blocks signify both physical and psychological weight. I bury my hands in the concrete blocks to conceal the bite marks on my fingers. Tugging the blocks across the performance space is a form of penance. As it reaches physical exhaustion, the corporeality of my body is exposed. Psychologically, laboring to move the concrete blocks signifies the burden and struggle of oppression.

WALKING ON WATER (1996)

Concept, Inquiry, and Cultural Commentary

In *Walking on Water* (*1996, Figure 7.5*) I reference and re-present historical water myths: divining for water, water bodies, bathing, irrigation, and baptism from the perspective of my body, memory, and cultural history. Water comprises 80% of my body. My body quenches its thirst as it consumes a body of water. Baptized in the Armenian church in my youth, I was immersed in water to sanctify my body. St. John the Baptist baptized Christ, who walked on water. Having been baptized myself, can I walk on water? What does it mean to bathe, irrigate, and baptize in effluent and polluted waters? Water, having lost its mythic purity, flows impurities into my body, the food I eat, and my soul. What does it mean to search for water with a divining rod when water is always at my feet?

An old man that I once knew used his body as a water gauge to alert him when the irrigation of his vineyard was completed. During irrigation, he would lie in the furrows of his vineyard waiting for the waters to approach, to alert his attention. The strangeness of his farming practice always fascinated me. His wisdom seemed "Christ-like." In my performance, I attempt to conjoin the old man's method with Christ's. I walk on water, but my attempts to mimic Christ are futile and absurd. At best, my body seems closer to the old man's. As I clumsily walk with plastic bags

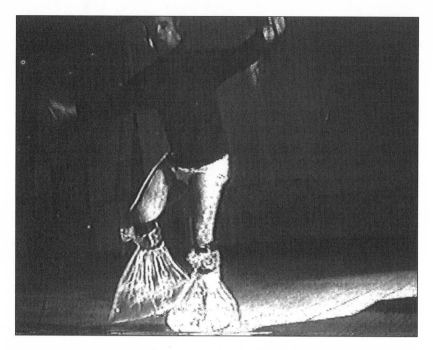

figure 7.5: Charles Garoian, *Walking on water*, 1996. Courtesy of the artist.

containing water and tied around my feet and legs, I feel the pull of gravity. Due to its relentless force, my legs can bearly manage lifting the weight of the water, let alone walking on its surface. Except for the water sounds that I produce as I pace back and forth in the performance space, my efforts seem ridiculous. The sounds are agitated yet soothing, unsettled yet peaceful. My body is a divining rod, one that I use in this performance to search and explore the confluence of water myths and my own experiences of water. *Walking on Water* was performed in 1996 as a work in progress at the Art Department of the University of California Irvine Campus and the Deep Creek School in Telluride, Colorado, and as a completed work at the Ninth Annual Cleveland Performance Art Festival.

List of Materials and Equipment

- stepped altar
- roll of black duct tape
- glass bowl 15˝ diameter
- two stainless steel bowls 15˝ diameter
- v-shaped tree branch (8´ 8˝) for an "over-sized," "over-weight" divining rod

- video camera, batteries, charger
- 5´ RCA cable
- 10 clear plastic bags for water approximately 24´´ x 36´´
- Ultrasound video image (VHS) of a fetus moving in amniotic fluid
- human water gauge audio cassette
- three 25´ extension chords
- two 5-gallon buckets filled with water
- towels or mop to clean up water after performance
- four Fresnel light fixtures fixed to the ceiling controlled by a variac (to vary the AC voltage).

SPACE PLAN

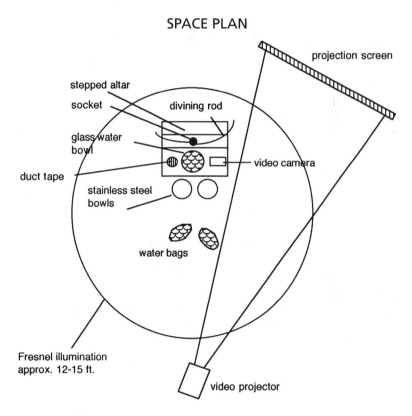

figure 7.6: *Walking on water,* space plan

Dimensional Drawing to Construct the Stepped Altar

- Construct stepped altar using $\frac{1}{2}$´´ plywood. (*Figure 7.7*)
- After construction, paint all visible areas flat black.
- Cut $3\frac{1}{2}$´´ diameter hole to accomodate v-shaped branch.

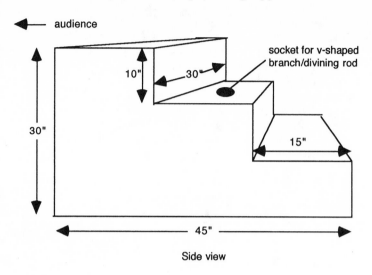

figure 7.7: Stepped altar construction

Description of Performance:
Actions, Visuals, Sound, and Technical Script

In advance of the performance, fill two five-gallon buckets to measure water for clear plastic bags and glass bowl. Place glass bowl in center of stepped altar and fill with water to approximately 1" from top. Place live video camera on the top, right side of stepped altar and aimed at the bowl of water. Connect video camera with RCA chord to video projector. Place roll of duct tape on opposite side from camera on stepped altar. Fill the two large clear plastic bags with the remaining water in equal portions. Knot the top of each bag, and place both on floor in front of the stepped altar to refract light like prisms. Stand v-shaped branch/divining rod upright, like a pruned tree or vine, in stepped altar socket. Stage light consists of one Fresnel light fixture illuminating a circular area approximately 12' to 15' in diameter.

(Time indicates hours:minutes:seconds)
00:00:00
Charles walks in from stage right, removes shoes, socks, and pants and places in front of stepped altar (leaves on his shirt and underwear).

00:01:00
Charles bends over, unties knots from clear plastic bags, gently places feet into water, tapes tops of bags around legs with duct tape, making certain that bags bulge with air. He folds over the flaps of the bags above the taped areas and also tapes down. During this process, sounds of water sloshing, plastic crinkling, and the ripping and sticking of tape fill the space.

00:04:30
Charles picks up the video camera. While holding it firmly in his left hand, he begins to walk in semicircular path in front of the stepped altar. Struggling to negotiate the weight of the plastic bags filled with water taped to his legs, he flails his arms so that the live video image mimics his body movement, making its idosyncratic gestures explicit. He begins to speak in tongues, a nonsense monologue that sounds like a cross between a strange foreign language and talking under water. He makes four passes from stage left to right in front of the audience (back and forth twice). The sound of water sloshing in the bags, the fluid sound of speaking in tongues as if under water, and the wavering video images are joined as contiguous water concepts.

[Fragment of speaking in tongues transcribed] *Alubula-blushala-blubula-claubli-hublau-dubalu-ebalubau-ebalubau-glaubuli-glaubuli-bulahaila-bulahailabalabu-bulbiladedede-bulbiladedede-bulbiladedede-elubalabulu-elubalabulutabati-mulubalabauili-mlandabama bah-hilibulum-bilibulubah-taubulibuluf-bushalabasa-bulasabuliba-baloobalabu-baloobal-abulibu-rulatubaslabala-rulatubastlarantaribi . . .*

00:06:50
Charles stops and places video camera back on stepped altar and aims its lens at the bowl of water. He turns around and stands stage left facing audience, veils his eyes with his left hand, raises his right hand in testimony, and begins a dream monologue:

In my dream, I heard the river speak to me.

Its message was garbled, I couldn't understand. I listened attentively but couldn't make it out.

I thought about the puddles I used to play in that have long since dried up. About the rivers that I used to fish that have long since been dammed. The oceans I used to surf that are now polluted. The river's message was still unclear.

00:08:02
Charles lowers his hands and walks on water away from the audience to the bowl of water on the stepped altar.

I awakened from the dream and I approached the river's edge.

I took off my shoes and pants and stepped into the water. I felt its coolness as it rushed across my feet. I bent over and cupped my hands. I filled them with water and brought them to my lips. I drank.

00:08:33
Charles cups his hands, bends over, and fills them with water from the glass bowl. In doing so, the video projects large-scale disturbance patterns from the water's surface onto the wall facing the audience. Charles brings the water to his lips and takes it into his mouth. He stretches his arms outward in a crucifix pattern, cocks his head backward, and begins to gargle aloud. As he gargles, water shoots from his mouth and drips from his hands.

[A sustained gargle] *I thought if I could lend the river my vocal chords I could then understand its message.*

I decided to try again. [Another sustained gargle]. *One more time.* [After this third sustained gargle, Charles turns and looks directly at the audience, shrugs his shoulders.]: *I still don't understand.*

00:10:02
Transition to next part of performance: Charles slowly walks around and away from the front of the stepped altar to stage left, where he pauses just at the edge of the lighted area.

00:10:23
Assistants remove glass bowl of water and video camera, taking them off stage.

00:10:50
Charles walks around to the rear of the stepped altar to access the v-shaped tree branch/divining rod. Audio tape of Charles's *Old Man* monologue and the video projection of an ultrasound image of a fetus moving in amniotic fluid begin to play simultaneously.

It was dawn, and he hadn't slept for days. The sun was rising, flooding each row with the light of morning. The old man pulled his faded blue pants up and over his naked legs.

00:11:12
Charles lifts the preposterous divining rod from its socket in the stepped altar. To manage its awkward shape, its weight, and its 8′ 8″ span, he cantilevers the divining rod out from his body toward the audience. Using his hands and arms as a fulcrum, he thrusts his shoulders back and his pelvis forward to balance the weight of the divining rod. With this phallic posture, he turns and begins to walk full circle around the stepped altar. The divining rod vibrates as Charles attempts to balance the weight and span of the divining rod against his body.

He had just finished irrigating his vineyard. During the day, he worked at Gallo. At night he tended his vines. He had no family, only a few friends. He lived alone. I heard about the incident a week after it occurred. After a day's work at the winery, he drove home in his '52 Chevrolet flatbed. By the time he approached his destination, the afternoon sun had set. No time for dinner, no sleep, no drink—only work. The quarter-mile rows of his forty-acre vineyard were parched—in need of water. With his Ford tractor, he had double furrowed each row a couple of evenings before. Having had no sleep, he was exhausted. Drowsy-eyed, he pulled the old Chevy up to the pump house. Illuminated by its headlights, he unlocked the weathered wooden doors and entered the darkness inside. Feeling his way around, he flipped the lever on the fuse box. Then he pushed the lowest button to start the twenty-horsepower motor. Cool water began to pump out the aquifer. It flowed underground along a concrete pipeline and then spilled out of watergates into each furrow at the west end of the vineyard.

00:13:25
Having reached the upstage side of the stepped altar, Charles uses the divining rod as a crutch to support himself while he carefully lifts his "heavy" legs onto each step until he reaches the top (to lift the bags up each step safely without slipping, sliding, or falling, he cannot bend his knee. He must lift the weight of the bag by keeping his leg straight and pulling up from his hip and then place bag and foot down on the step. Once one leg has been lifted in place and secured, he lifts the second leg. He repeats this motion until he is standing at the top of the stepped altar).

Wearing his irrigation boots and wielding a shovel, he set out to disperse the waters evenly by adjusting each gate and to mend any broken furrows along the way. The entire forty acres of Thompson Seedless grape vines were now under irrigation.

00:14:00
Charles, having ascended the stepped altar, allows for a portion of the water bags to sag over the edge of the stepped altar. He pauses.

00:14:10
Charles raises the divining rod straight up into the air at arms' length, pauses, and then punctures each bag five times to spill water onto the floor. Then he raises the divining rod high in the air so that his body appears crucified. Exhausted from carrying the weight of the water bags, Charles breathes heavily and loudly in order for the audience to hear the sounds of his body against the streams of water.

The musical trickle of water could be heard along the frontage road—Valentine Avenue.
Inhaling a deep breath as if to yawn, he gazed up at the clear night's sky lit by a full moon
and stars. The smell of newly wet soil permeated his nostrils. In his weary state, he slowly
walked the quarter-mile to the opposite end of the vineyard where the furrows ended.
There, he stuck his shovel into the ground and hung his khaki fedora on the handle.

00:14:28
Assistants place stainless steel bowls on the floor to catch trickling streams of water whose
sounds are amplified as they hit the inside of each bowl.

He slipped off his irrigation boots and stuffed his socks. Gently, he sat on the ground, took
off his pants, rolled them into a pillow, laid back, and wedged his head. Adjusting his body
like a gauge, he lifted each of his naked legs into the air and plopped them down into the
dry earth of the two adjacent furrows. Within minutes, he dozed off. He slept peacefully
into the night. At dawn he was awakened with a startle. The cold irrigation waters, hav-
ing flowed all night, finally reached his feet and soaked his legs at the end of the vineyard
row—a signal that it was time to turn off the pump and to repeat the cycle of labor. I'm
not certain why, but the old man's strange ways always kept me stirring and awake at
night and my mind wandering, dreaming during the day at school. The classroom was
empty by comparison. It was merely a site from which to experience the confluence.

00:15:58
Monologue ends. Charles continues holding divining rod in air in crucified position. Lights
stay on for audience to concentrate on the sound of trickling water

00:16:28
Lights dim.

Construction of Signifiers

- The water-filled plastic bags, duct taped to my feet and legs suggest a
 number possible readings: walking on water; walking in furrows while ir-
 rigating a vineyard; playing in puddles; swimming in rivers, lakes, and the
 sea. My body is a water vessel. It contains 80% water. I cup my hands to
 drink. The water flows down my esophagus to fill the cavities of my body.
 I drink to irrigate my body. I urinate to eliminate water. When I was bap-
 tized as a child, my "body-of-water" was immersed in the body of water in
 the baptismal font. Since my body contains water like the plastic bags, am
 I always walking on water? My memory is fluid. It flows like water.
- The stepped altar serves both a technical function and a symbolic one.
 Technically, it allows me to elevate my body in order to stream water
 down from my feet into the bowls on the floor. Whereas the struggle of
 my body is taking place on the horizontal plane of the floor, the stepped
 altar allows me to shift my movement vertically as I struggle to ascend its
 steps. Symbolically, the stepped altar alludes to the structure whereupon
 the religious rites of the Armenian church were performed and where I
 served as an acolyte in my youth.
- The tree branch/divining rod also has a double function. Technically, it
 serves as a support for ascending the stepped altar. Symbolically, it suggests
 three possible concepts: first, it alludes to the vineyard and orchards that I
 played and worked in during my entire youth; second, it functions as a

divining rod that is used to find water for the irrigation of vineyards and orchards; and third, its crosslike form suggests a divining rod to find God.

- Water spilling from my feet into the stainless steel bowls suggests my body being drained of water. It also puts forth the sacramental blood of the Lamb of God, pouring into the sacred chalice.
- The ultrasound image of a fetus moving in amniotic fluid and the old man lying like a fetus in the furrow of his vineyard waiting for the waters to reach his body suggest similar yet different ideas and images. My body being contained in the womblike water-filled bags also resonates with the idea and image of the fetus and the old man.

RAISIN DEBT (1997)

Concept, Inquiry, and Cultural Commentary

Raisin Debt was a requiem performance dedicated to my mother, Suzanne, who died at the end of October 1996. To produce this work, I drew heavily from my own memory of my mother, namely her struggle to survive the Armenian genocide of 1915 as a child and the difficulties

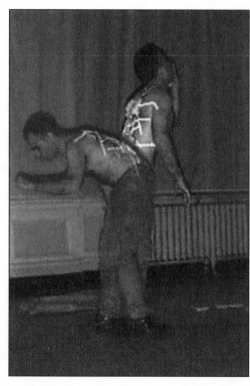

figure 7.8: Charles Garoian, *Raisin debt*, 1997. Courtesy of the Cleveland Performance Art Festival (Digital image manipulation by Mark E. Andersen)

she endured as a political refugee while in exodus from her homeland. In the performance, I re-member my Mother and her struggle to re-position and re-define herself as an emigrant in "the new world." Throughout the monologue, the refrain *working in the dark to pay our raisin debt; working in the dark to define our raison d'être, working in the dark to raise the dead* refers to working on my parents' raisin farm as a metaphor of the struggle to survive, to define our lives, to remember and never forget loved ones lost in the genocide. Mother, together with Father, instilled a work ethic that toiled my body, that made my body's corporeality explict, that constantly reminded me that I was alive, to thank God that we had survived. *Raisin Debt* was performed at the Tenth Annual Cleveland Performance Art Festival in 1997 where I was invited as a featured artist. My wife, Sherrie Garoian, accompanied me in the performance, and an assistant provided technical help.

List of Materials and Equipment

- four 5 lb. packs of raisins
- three 24″ x 36″ brown paper trays
- large silver meat grinder mounted on a pedestal (9″ x 15″ x 29.5″) constructed from ½″ plywood and varnished to seal surface of wood.
- meat grinder handle
- 2 black pedestals 18″ x 18″ x 30″
- brown wrapping paper (36″ wide, 8′ long)
- 3 loaves of white American sliced bread
- Johnson & Johnson adhesive tape ½″ or ¾″ wide
- video tape (Mom's monologue)
- audio tape (my monologue)
- video projector.

Dimensional Drawings to Construct Pedestal and Mount Meat Grinder

- Pedestal constructed from ½″ plywood sheet.
- Varnish pedestal to seal wood and then bolt grinder on its top surface (*Figure 7.10*).

Description of Performance: Actions, Visuals, Sound, and Technical Script

(Time indicates hours:minutes:seconds)
00:00:00
Audience members enter the performance arena as Sherrie and Charles begin a syncopated wailing in falsetto heralding them to the performance. Charles begins in a falsetto voice; Sherrie follows in her soprano voice. In alternating rhythm, each inhales a deep breath, expands his/her diaphram, yells while slowly emitting air from his/her lungs

SPACE PLAN

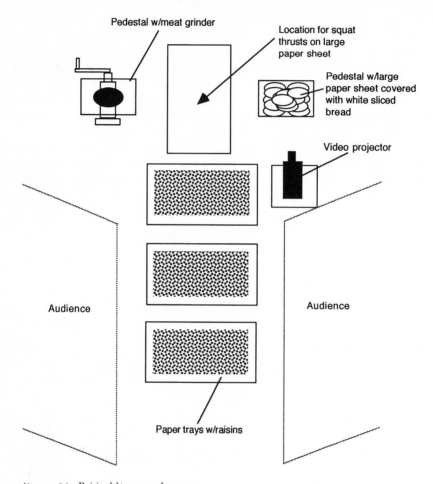

figure 7.9: *Raisin debt,* space plan

(approximately 15-20 seconds), listens for resonance in room, and then begins again. They repeat for five minutes and until audience is seated.

Charles: *Yoo-oo-oo-oo-oo-oo-oo-oo-oo-oo-Hoo-oo-oo-oo-oo-oo-oo-oo-oo-oo-*

Sherrie: *Yoo-oo-oo-oo-oo-oo-oo-oo-oo-oo-Hoo-oo-oo-oo-oo-oo-oo-oo-oo-oo-*

Charles: *Yoo-oo-oo-oo-oo-oo-oo-oo-oo-oo-Hoo-oo-oo-oo-oo-oo-oo-oo-oo-oo-*

Sherrie: *Yoo-oo-oo-oo-oo-oo-oo-oo-oo-oo-Hoo-oo-oo-oo-oo-oo-oo-oo-oo-oo-*

Charles: *Yoo-oo-oo-oo-oo-oo-oo-oo-oo-oo-Hoo-oo-oo-oo-oo-oo-oo-oo-oo-oo-*

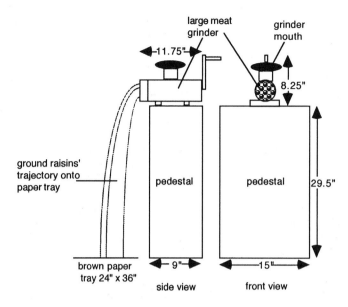

figure 7.10: Grinder pedestal construction

Sherrie: *Yoo-oo-oo-oo-oo-oo-oo-oo-oo-oo-Hoo-oo-oo-oo-oo-oo-oo-oo-oo-oo-oo-*

Charles: *Yoo-oo-oo-oo-oo-oo-oo-oo-oo-oo-Hoo-oo-oo-oo-oo-oo-oo-oo-oo-oo-oo-*

Sherrie: *Yoo-oo-oo-oo-oo-oo-oo-oo-oo-oo-Hoo-oo-oo-oo-oo-oo-oo-oo-oo-oo-oo-*

For five minutes, their yelling resonates loudly within the room. Sherrie stands at stage left behind a three-foot pedestal draped with brown wrapping paper and piled high with 78 slices (three loaves) of white American bread. Charles stands stage right behind a pedestal mounted with a large shiny meat grinder. On the floor down stage, there are three brown paper trays (24″ x 36″) each covered with a single layer of raisins (approximately five pounds on each tray).

00:05:00
After audience members are seated, Charles and Sherrie stop their yelling and begin tending to individual tasks. Charles turns the crank on the meat grinder, making a loud metal scraping sound while Sherrie sings "Der voghormia" (Lord have mercy), Mother's favorite Armenian prayer, which the Armenian priest sang for her while administering her last rites.

Der-vo-ghor-mia, Der-vo-ghor-mia
Der-vo-ghor-mia, Der-vo-ghor-mia
Der-vo-ghor-mia, Der-vo-ghor-mia
Der-vo-ghor-mia, Der-vo-ghor-mia
A-me-na-soorp, Yer-ror-too-tiun
Door-ash-khar-hees, Kha-gha-ghoo-tiun
Has-hok-noo-tiun, Za-ra-hi-kotz
Nun-che-tze-lotz, Ar-ka-yoo-tiun
Shor-heev-a-voors, Mez-vo-ghor-mia
Un-gal-der, yev-vo-ghor-mia

00:09:07
The serenity of the song is offset by the unnerving repetitive sounds of the grinder. After completing her song, Sherrie trades places with Charles. She relieves him at the grinder, while he walks over to the pedestal of bread where she was standing. He leans over, takes two corners of the wrapping paper in his hands, pauses, and then yanks them upward, catapulting the pile of white American bread toward the audience. With sliced bread scattered all over the floor, Charles holds up the brown wrapping paper like a screen to conceal his body.

00:10:27
As the lights in the space are dimmed, a video segment is projected on the brown paper screen of Charles's mother, Suzanne, telling about a childhood experience while in exodus from the Armenian genocide. Sherrie continues to make the metal scraping sound by turning the meat grinder handle. The following transcription represents Suzanne's testimony (5:22 min.).

Satenig (Charles's mother's Armenian name): *So, we went to this Smyrna big, big park, in the forest, for the vacationers, they used to come from England, they used to come from France, all those big, wealthy people used to come for vacationing, and golfing, or things like that, or some kind of a game that they push the ball in the hole. It wasn't, it wasn't the golf, no, it was . . . looked like a hammer.*

So the American photographers, they was specially sent from the United States, to take our picture while they throwing a bread to those crowd, refugees. And, we didn't have the bread; we had cracked wheat. My mother used to boil that crack over the, the big stumps, burning the stumps and cook the pilaf, feeding us just the boiled pilaf.

So, during that time, from Smyrna to Marseilles, well this happening, you know, it doesn't, it doesn't go a month, maybe a month, month after the age I gave you. Six, did I say six or seven? Six, six years old I told you. And during that time, I was very small, not a big built child. I was a small.

Charles: (off camera) *Now, this is where?*

Satenig: *This is in Smyrna, I went back again.*

Charles: *OK, OK.*

Satenig: *And when, when I saw that the people gathered front of the stage, because on that stage there were actors coming to act for the rich people. And everybody gathered, because they told everybody they going to have a picture taken by grabbing the, the bread. Well people they are hungry, they don't care if they take a picture. You know, it's a matter of surviving. So what they did is . . . the Armenian people are very honorable people. They don't want to be sexually abused, they don't want to be a verbally abused. And, they are very quiet people. And, there wasn't any fear of that, in that park. They went and gather, front of the big stage, and while they were going, I was going with them. My mother screamed, she says, "Don't go, you are too little, they won't see you, they will step all over you, you die." "No, no," I says, "Mom I'll watch." So, I went, I went, I was low anyway, very, very small, and I was pushing their legs, to go through. When I went right in front of the altar [stage], I was watching how I am going to grab that bread. It was about this big . . . of a bread. About this big of a bread. And I stand, I stand right over there, and I had my hands up like this, up to grab that bread. And, somehow I, I catch one, I didn't leave my place. I wanted another one because we are so many people . . . there is, there were our friends.*

Charles: *Why were they throwing bread?*

Satenig: *Just to take our pictures to bring it here and show it. They, they brought those pictures in the United States and show it.*

Charles: *So these were American photographers . . .*

Satenig: *Yeah . . .*

Charles: *. . . That had come to the park . . .*

Satenig: *Right.*

Charles: *And . . .*

Satenig: *. . . and then gather those people . . .*

Charles: *. . . gather these people . . .*

Satenig: *. . . and then throw the bread. While they were throwing the bread, one person throw the bread, the other person take the pictures, there was, there were about three or four photographers for that crowd.*

Charles: *What were they trying to communicate?*

Satenig: *Well, the communicate is, in other words, they are doing good deed for the Armenians, feeding them. But it's not the way to do the good deed. The good way is, all this refugees are settled in one corner, in that, in that, in that park. They could have go and give them one by one. They still could take a picture. You know how many people they were, they were under their feet, injured . . .*

Charles: *. . . in order to get the bread.*

Satenig: *. . . in order to get the bread because they were hungry. Why torture people while you feed them? That is what I don't understand.*

00:15:49
After the video segments ends, the lights are brought up. In silence, Charles gently places the brown wrapping paper screen onto the floor, kneels on its surface, and begins an aggressive series of squat thrusts. As the paper snaps, crackles, and crinkles from his exercise, its surface creates a loud, anxious, lightninglike sound. The sequence of this exercise is as follows: 25 squat thrusts and then kneel and expose heavy breathing for 20 seconds; 25 squat thrusts and then kneel and expose heavy breathing for 20 seconds; 25 squat thrusts and then kneel and expose heavy breathing for 20 seconds; this continues for approximately four minutes.

00:19:52
The audio system begins to play Charles' *Raisin Debt* monologue. Still breathing hard, he stands, walks over to the three paper trays covered with raisins and begins to "cigarette roll" them.

Working in the dark to pay our raisin debt; working in the dark to define our raison d'être; working in the dark to raise the dead.

We were fast asleep. That is, until the thunder rumbled outside the house and lightning flashed through our bedroom window. I was 11, and my brother was 9. We awakened scared shitless of the dark and the violent strikes of light. Although 3:00 in the morning, we were both wide awake. Afraid of darkness, we tried to bury our faces deep in our pillows.

Working in the dark to pay our raisin debt; working in the dark to define our raison d'être; working in the dark to raise the dead.

00:20:42
Charles walks back and relieves Sherrie at the meat grinder, turning its handle to continue the background sound of grinding metal. Sherrie walks to the cigarette-rolled trays of raisins, picks them up one at a time, carries them to where Charles is working, and pours their contents into the mouth of the meat grinder. The monologue continues as Sherrie pours and Charles struggles to grind the raisins. The ground raisins that extrude from the grinder are a gooey mass that falls onto the brown wrapping paper still on the floor.

After mustering some courage, I peeked out the window and couldn't see a thing until suddenly a flash of lightning illuminated our back yard. For a split second, I saw my father's white '49 Plymouth parked in the driveway next to the vineyard. Then it went dark again. Another flash, and I could see the pump house near the irrigation ditch. Dark again. Flash. The basketball pole stood leaning to one side with its shiny black hoop. Darkness. Flash, flash, flash. There was the large mulberry tree under which we would eat our evening meals on the adjacent patio. Flash. Flash. The persimmon tree. More darkness. Flash, our vineyard where we worked to grow grapes and dry raisins. Just then, as I dug my face in the pillow again, our father walked into the room.

Working in the dark to pay our raisin debt; working in the dark to define our raison d'être; working in the dark to raise the dead.

Flash. Darkness. It was early September, the high point of the raisin harvest. The grapes had been picked and were drying on paper trays spread on the ground. The crop was in danger of rotting should it begin to rain. Flash, flash. Dark again. We grew Thompson seedless grapes, which make the best raisins. After picking, the grapes were spread onto paper trays on the ground where they would dry over a two-week period under the sun. As if calibrated scientifically, the vineyard rows were oriented in an east/west direction to maximize exposure to the sun's rays between dawn and dusk, to prevent any shadows from the vines being cast on the drying grapes. Flash. The success of the raisin harvest was essential to our survival. It was our principle means to put bread on the table.

00:23:07
The meat grinder jams from the gooey consistency of the ground raisins. Charles strains to turn the handle, the raisins no longer extruding from the grinder. In a frenzy, he walks around to the front of the grinder, quickly unlocks its end nut, and removes its extrusion plate and cutter in order to prevent any further obstructions. Only the auger remains, which now allows him to continue grinding with less resistence.

Working in the dark to pay our raisin debt; working in the dark to define our raison d'être; working in the dark to raise the dead.

Flash. Father told us to get up immediately and get dressed. As we jumped into our Penney's jeans and pulled up our Redwing high top work shoes, Father listened to the weather report on the radio. Flash. Rain was on its way. Knowing what this meant, we didn't say a word. While dressing, our hearts were pounding in our chests nonetheless. Having previously experienced what we were about to do in the dark of night, we knew what to expect. Flash, flash. Lightning and thunder continued as we prepared to "cigarette roll," a euphemism for rolling semidried grapes/raisins in their paper trays as if tobacco in cigarette paper. Question was, could we accomplish the task? Among the three of us, there were 20 thousand trays to roll before the rains came.

Working in the dark to pay our raisin debt; working in the dark to define our raison d'être; working in the dark to raise the dead.

00:24:27
After Charles completes grinding the raisins, Sherrie drags the gooey heap over to the pedestal and begins applying the ground raisins to the slices of bread that she collected from the floor where they were previously scattered. The monologue continues as Charles removes his shirt, walks over to the pedestal, and drapes his body over its top.

Both our parents survived the genocide. Flash. They were political refugees who came to America having narrowly escaped persecution. My brother and I, and later our two younger sisters, grew up hearing of the horrors of family members, friends, and neighbors being slaughtered for their cultural difference. Our parents never once considered psychological help, counseling to purge them of their pain, to soften their anger. Such therapies were looked down upon in those days. So they talked about it openly at home around my brother and me, later with our sisters, with neighbors, friends, and other family members. Only at church, in prayers, and during communion was the subject handled with any degree of subtlety. Flash, flash, flash. We grew up amidst their lamentations. The raisin farm was where we learned to search for lost loved ones, where we searched for our lost souls. It was the homeland where we worked to avenge such losses.

Working in the dark to pay our raisin debt; working in the dark to define our raison d'être; working in the dark to raise the dead.

00:25:56
Sherrie applies the bread slices covered with ground raisins to Charles's exposed back. She then tapes them in place with adhesive tape to signify bandaging his wounds.

Flash, flash. Father turned off the radio and signaled with his baseball cap it was time to leave. As we walked out the back door of the house, my brother and I stayed close behind him. The power of lightning flashes and thunder now intensified. We had to move quickly to save as many raisins as possible. The only available light to work by was lightning that would flash intermittently. The rest we accomplished by feeling our way in the dark. Flashlights were of no use since both hands were needed to cigarette roll the raisins. Flash, flash. Father gave us instructions. He would take a middle row, and my brother and I would flank him on the side rows. We didn't speak, yet he knew we were afraid of the dark, of the lightning, of the thunder, of the responsibility. He knew our hearts were pounding in our chests.

Working in the dark to pay our raisin debt; working in the dark to define our raison d'être, working in the dark to raise the dead.

I was alone. Flash. I looked down the quarter-mile row and couldn't see a thing. Flash. The wind began to rustle the leaves of the vines, creating sounds and suspicions in my mind. Separated by two rows, I could only imagine what was going through my brother's mind. Flash. At my father's command, we began to work at a feverish pace. Wanting to save as much of the crop as possible, he kept getting ahead of us. For fear of being left behind, we tried to keep up, not necessarily to save the raisins, but to save our hides. Flash, flash. The faster he worked, the faster we worked, only to keep up with him, to be near him, for fear of the dark, of the violent lightning strikes. From time to time, my brother and I would call out to him, to hear his voice, to measure our distance, our proximity to his body. He would respond immediately to assure us that he was there, that he had not deserted us.

Working in the dark to pay our raisin debt; working in the dark to define our raison d'être; working in the dark to raise the dead.

Suddenly, in the midst of our frenzy, the chaos of our fear, I began to hear the sounds of a soothing melody. At first, I could barely make it out. But then, as the lightning flashed and thunder exploded around us with increased frequency, the sound increased in volume. He was singing. Father was singing a song. He was singing a passionate Armenian love song at the top of his lungs . . .

00:28:33
Sherrie stands to the side, bows head, and says prayer in silence as Charles raises his head and sings along with the love song in the monologue.

heravor oo amahi dzoveroo mechdegh
yes oonenal goozeii balad mu puregh
yev yertaink kez hed miasin siragan
taghel mer sern ait pooinin metch arantznootian/mer shoortcha keech pajzanman yergnee yev dzovoon
katch horizon . . . he was singing an Armenian love song—to mark his place, to dispel our fears, to instill hope.

00:29:57
After the song ends, Charles slowly rises from the pedestal where his body was on "display." He recapitulates the grinding motions, the shouting motions, and the cigarette-rolling motions in silence as if they were inscribed on his body. He repeats this process during the entire final part of the monologue. He continues his body movements as the lights slowly begin to dim.

[Pace of monologue is slowed] *Working in the dark to pay our raisin debt; working in the dark to define our raison d'être; working in the dark to raise the dead.*

We were unable to save the entire crop that night. The rains eventually fell as we worked, filling our nostrils with the smell of newly wetted soil, washing our bodies of sweat, and filling our hearts with calm. It was dawn. As the early morning sun began to rise in the east, we heard a familiar yoo-oo-oo, hoo-oo-oo coming clear from the other end of the vineyard. Again, yoo-oo-oo, hoo-oo-oo. It was Mother calling us. She was signaling that it was time to come in from the rain, to dry off and change clothes, to eat our morning meal, to thank God, she said, for all that we were able to save, she said. After all, there are people who have nothing in this world, she said. There are people who go hungry, she said. People who go hungry. Hungry. Enough is enough, she said.

00:31:45
Lights dim to darkness.

Construction of Signifiers

- Sherrie and I yelling "*yoo-oo-oo-Hoo-oo-oo*" remembers Mother's method of calling Father, my brother, and myself to come in from the vineyard at the end of a work day. Like Mother, Sherrie and I use her call to summons the audience into the performance space.
- The meat grinder that we use in the performance belonged to Mother. She used it to grind raw, lean meat for *khema*, a favorite Armenia dish. She would grind the meat three times, season it with salt and pepper, and knead it with fine bulghur and water. After the bulghur had softened by absorbing the water and the juices from the meat, she stopped her kneading, shaped the ball of meat into a flat round cake, furrowed

the sign of the cross along its surface with her hand as a blessing, and fill a garnish of chopped green onions and parsely in its cavity. For the performance, unlike Mother, we first use the empty meat grinder to establish a rhythm of scrapping metal, to call attention to it, and to produce an irritating sound that will nag the audience throughout the first part of the performance. The nagging sensation signifies the anxiety, guilt, and frustration of growing up in a household of genocide survivors. Later in the performance, when Sherrie pours raisins into the grinder's mouth, the pattern is broken, the sound subsides, and the grinding action changes its meaning.

- The slices of American bread tossed on the floor represent the bread that was tossed to the starving Armenians by the American press photographers as told by Mother. Bread also represents the body of Christ received as Holy Communion. Its initial placement on the pedestal suggests a veneration of Christ's body, of American ideals; its dispersement on the floor, a debasement of those ideals.

- The video projection of Mother telling her story signifies her virtual presence in the performance. She tells of an incident in Smyrna, Turkey, where she and hundreds of starving Armenian refugees were gathered and taken to a public park by members of the American press with the understanding that food would be supplied. In the park, she and the others were assembled on an outdoor theatrical stage where they were surrounded by newspaper reporters and photographers. From their strategic vantage points, the reporters began tossing bread into the starving crowd. As a "feeding frenzy" ensued, the photographers flashed their cameras in rapid succession to document the event. My mother talked about her disappointment, how the food was tainted by the dishonesty of the press, about being exploited for the purpose of creating a photo opportunity to sell newspapers.

- As I repeat the squat-thrust exercise on the paper tray where my mother's video image was projected, my breathing becomes heavy, rapid, and loud. My body pushing itself to exhaustion suggests my inheritance of pain, my struggle with Mother's history of oppression.

- The repeated use of the word *flash* throughout the monologue corresponds the lightning strikes we experienced while "cigarette rolling" the raisins with the American journalistic photographers' camera flashes in Mother's story of Smyrna.

- The juxtaposition of dispersed American bread slices and raisins on paper trays signifies the irony of Mother's experiences with "grounded" food: first, the humiliation of having her food thrown on the ground by the Americans when she was a child in Smyrna; and second, making a living from a vineyard where grapes were dried into raisins on the ground after she arrived in America.

- As the raisins are ground in the grinder, they are conflated with meat. Meat, being the flesh of the body, is conflated with the bread lying on the floor. Raisins, meat, and bread signify the oppressed body.

- As I lie with my shirt off on the pedestal waiting for Sherrie to apply the bread/raisin bandages to my back, my body's function as a cultural slate and sacrificial altar is made apparent.
- The application of bread/raisin bandages on my back represents my taking on Mother's "wounds of oppression." In the end, I recapitulate motions of survival to heal the wounds of her testimony "inscribed" on my back.

8

Constructing a
Performance Art Pedagogy

There I was, standing in front of a class of thirty adolescents. It was the first day of classes at Los Altos High School and my first teaching job. I was extremely nervous. My legs were shaking, my hands balmy, and my voice crackling when I introduced myself to the students. Having had years of experience reciting poetry, singing folk songs, and performing folk comedy in the Armenian community of Fresno, California, and having performed opera, musical comedy, dance, and theater during my college years, the anxiety I felt standing before my students seemed familiar. It felt as though I were standing before an expecting audience. Just as I began addressing the students for the first time, I vividly recalled the experience of performing, namely the symbiotic relationship between actor and audience, the ways in which they can inspire one another during a performance.

A young and idealistic teacher, I wanted to communicate with my students in an open and honest manner. I imagined them to be my peers, a group of human beings gathered together to make some sense of this wonderful yet crazy world through art. I wanted to share my knowledge, experiences, and passion about art in such a way as to stir their interest, their comprehension of the ideas that I would teach, and their interpretation of those ideas. I wanted them to create art works that explored and challenged the assumptions they learned in school, at home, in their neighborhoods, and from the mass media. I wanted them to create art works that expressed their personal perspectives and desires.

On that first day, I told the students my name and a bit about my cultural background. I asked them to reciprocate, to tell me something

about themselves. Having just returned to school from summer vacation to find this strange person standing before them, they were a bit apprehensive. They responded in a cursory manner. After finishing with introductions, I told them about the various art-making exercises and projects upon which they would be working. I would show and discuss art historical works that were relevant to the assignments and those that particularly related to their own creations. My rationale was to show how historical artists have interpreted similar issues and concerns such as theirs and, more important, for the students to see themselves within a context of history. We would have critique sessions, discussions following each project to interpret and discuss the meanings of the images and ideas communicated in their work. My rationale for the critique was to deconstruct an art work in order to understand its expressive characteristics and its meanings, to edit and recompose an art work in order to explore different possible interpretations, and to learn from its experience in order to proceed toward the creation of new work.

I believed then, as I do now, that my students had as much to contribute to the learning process as I did. What distinguished me from them was age, experience, and authority. I proposed the idea of conducting the class as a collaboration. To make this happen, we would have to alter the traditional teacher/student dynamic. Together, we would create a classroom environment where we could learn from each other, a place where we could explore and debate ideas, where the images we created would be informed by our conversations about the relationships among art, culture, and our desires. After several years of study, I brought to the classroom knowledge and skills in art production, art history, and criticism. However, these skills in and of themselves, were not sufficient to artistic thought and creation. To produce art, I believed my students needed the vital content of their lives that only they could provide. While my contribution to our collaborative process would consist of my art-making expertise, theirs would consist of their life's experiences, what they had learned from their families, from their communities, as well as from other classes in school. By inviting a diversity of knowledge, the classroom could become the site of convergence, a confluence of cultural ideas, images, and skills.

Although I could teach them historical assumptions about *form* in art, I had to rely on their contribution, the *content* of their cultural experiences to interpret, challenge, and transform art history into new cultural metaphors. Aesthetician Ernst Fischer (1963) explains the dialectical relationship between form and content. He argues that "content changes incessantly, at times imperceptibly, at other times in violent action; it enters into conflict with the form, explodes form, and creates new forms in which the changed content becomes, for a while, stabilized

once more (pp. 124–125). Through art making, my students could learn to challenge the preexisting cultural codes of art by bringing their cultural perspectives to bear in their art works. Thus, to create images that expressed their conceptions of reality and their desires, I had to evoke somehow a critical imperative in my students based on their cultural perspectives.

To facilitate collaboration, I placed my students and their cultural perspectives before all else. As far as I was concerned, nothing preceded their experiences, not art nor any other subject matter in the school. Unless I positioned the students' knowledge, experiences, and desires first, what I had to teach them about art would amount to a perfunctory exercise that would, once again, inscribe their bodies with socially and historically determined ideas, images, and metaphors. I did not want my pedagogy to preclude their cultural production. It was incumbent upon me to construct an art curriculum that would enable my students to learn and critique preexisting metaphors, myths, and utopias and to create new ones relevant to their lives. By creating a context for my students to perform their subjectivities, I found myself on the other side of the teacher/student divide. My recent experiences as art student informed my pedagogy.

I knew from being an art student that the creation of art was predicated on memory, cultural history, and my experience of contemporary culture. My experiences growing up on the farm and my parents' use of play, storytelling, and humor to disrupt the routine of farm and house work were significant content that I brought to my art-making process. Moreover, as a young art student in the historical moment of the 1960s, during the civil rights movement, the feminist movement, the sexual liberation movement, worldwide resistance to the Vietnam war, protests against nuclear armaments, and the movement to save the environment, I had developed the impulse to question socially and historically determined values, attitudes, and beliefs. I was highly aware of the anti-establishment *zeitgeist* that permeated American society at that time. It disrupted academic life on college and university campuses. Sit-ins, protest marches, and riots were commonplace. These contemporary cultural events occupied my thoughts and influenced my actions.

At California State University at Fresno, student unrest may not have been as spectacular and newsworthy as it was on other campuses, but the sense that times were changing did stir our hearts and minds. It was time for new possibilities. My art classmates and I experimented with a variety of materials and processes to invent new forms. Nationwide dissent provided us with inspiration and the license to resist the cultural establishment and to challenge the historical assumptions of art. Some of our professors invited experimentation, while others held on firmly to their

academic notions of art. As classmates, we challenged and influenced each other. We were ambivalent about entering the job market after graduation. What mattered most was our utopian struggle to achieve moral and ethical justice through art.

Inspired by Marcel Duchamp's readymades, John Cage's and Merce Cunningham's use of aleatory music and dance, Allan Kaprow's Happenings, and Robert Rauchenberg's and Jasper Johns's collages and assemblages, we appropriated found objects, materials, and processes to construct our projects. The construction of new work by these artists seemed to resonate with my farming experiences, the creative ways of my parents, the way in which we mixed work and play, and my desire to construct identity through art. I learned that no idea or process was sacrosanct. To create art that responded to the circumstances of contemporary culture meant that I had to challenge assumptions in all genres of art making, all academic disciplines, and all aspects of my life.

A mixed media painter at the time, I delayed taking a required crafts class until my junior year. Having learned from my drawing, painting, and sculpture professors to discriminate between high and low forms of art, I loathed the idea of wasting my time making pots, mosaics, baskets, and other hand-crafted items. Half way through the semester, after reluctantly registering for the class, my suspicions were confirmed. We were assigned a mosaic project that had to be completed in two weeks. I spent the entire time gathering materials, researching medieval images of mosaics, and constructing a still-life image on a piece of masonite. Due to my lack of enthusiasm and commitment, I constructed a mediocre mosaic, a disinterested reproduction of a historical art form.

Despite my indifference, however, the day of the critique yielded an eye-opening experience for me. A mosaic was presented by a classmate that further challenged my assumptions about art and changed the way that I thought about crafts from then on. As we all assembled around a large table with our mosaics in hand, Ted Greer entered the room carrying two grocery bags and a 4´ x 8´ sheet of plywood. It was curious that Ted, being one of the most prolific and inventive artists in the school, seemed unprepared for the critique session. Having come to class with his materials in hand, it appeared that his project was incomplete. I thought that perhaps he too was disinterested in the assignment.

When it was Ted's turn to present his mosaic, he asked us all to remove our projects from the table so that he could set up. He carefully placed the large plywood sheet on the table, opened the grocery bags, and took out four boxes of a variety of donuts and two cans of cake frosting. In a matter of five minutes, he applied the frosting to each donut and arranged them in an abstract pattern on the board, taking into consideration the formal elements of art and the principles of design.

We all sat astonished as Ted wielded his spatula to construct his "donut mosaic." When he finished, he asked us to do something we had never experienced in an art class. He invited us to eat his mosaic, his art work. As we ripped apart his project and ate its component parts, we laughed and discussed his use of parody to critique the language of art, his use of time to introduce the concept of ephemerality, and the strategy he used to transform our role as spectators to participants in the creation of his art work. At Cal State Fresno in the late 1960s, such disruptions were commonplace. My classmates and I "played" with our assignments. We critiqued and challenged their assumptions with a number of possible strategies and solutions. Our challenge affected the conception of art and the pedagogy that I would eventually create for my own students.

A DISRUPTIVE PEDAGOGY

From the beginning, I wanted to teach in a way that invited the creative disruptions I found so valuable from my days growing up on my parents' farm and in my art education. To accommodate these disruptions within the linear time/space sequence of the school semester, I developed a curriculum plan where both could coexist, complement, and challenge each other. Figure 8.1 illustrates the structure for performative disruptions that I implemented within the curriculum sequence of my classes at Los Altos High School. I taught my students the historical codes of art and culture using a sequential curriculum plan, one that provided an overlap between one lesson and the next. Sequence provided my

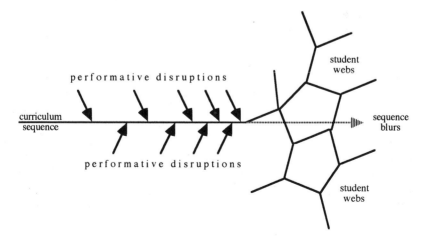

figure 8.1: Disruptive pedagogy

students with a familiar structure that was aligned with the linearity of
the school day, week, month, and academic year. Through a sequential
layout, they could readily comprehend the logic of my disruptive peda-
gogy and to eschew any possible confusion that I might cause by being
disorganized or unintentionally abstruse.

However, my concern for cogency and clarity did not preclude my
desire to introduce complexity and contradiction in my art lessons.
What I was after was a classroom experience where ideas and images,
historical and contemporary, private and public could be openly prob-
lematized, interrogated, and expressed without the threat of absolute,
universal, or reductive limitations. The art classroom seemed the most
sensible place for such discourse since there was nothing to lose. A mar-
ginalized discipline within the school curriculum to begin with, art was
perceived as academically insignificant, a frill. Difficult for administra-
tors to evaluate, and assumed catering to a minority of students with
talent, its place in the school curriculum was determined by its enter-
tainment value, to provide "serious" students with "fun experiences"
and a "dumping ground" for those who were academically suspect.
Considering such condescension, it was the perfect site to explore the
aesthetics of cultural identity, diversity, and justice, three essential ele-
ments in creative self-expression and my pedagogy.

To resist ideological prejudice, I implemented interdisciplinary and
intercultural disruptions within the structure of my curriculum in the
form of performance art. The conjunctions between these disruptions
and my curriculum sequence, like colliding signifiers, yielded provoca-
tive conversations, debates, and art works by my students. Similar to my
parents' creative disruptions on the farm, and those that challenged my
assumptions in art school, I wanted to create a reflexive pedagogy that
would transform my classroom into a space where my students could dis-
cuss openly the cultural issues that mattered to them most, to play with
ideas, metaphors, and images, and to create art that represented their
cultural struggles. Thus, my intentional use of the interdisciplinary and
intercultural content of performance art to disrupt my pedagogical dis-
course and practice, my epistemology, and that of the school's, com-
prised the scope of my curriculum.

In addition to the scope of art historical ideas, images, materials,
and processes that I taught my students, I invited them to bring their
vital experiences, the knowledge that they had acquired from their
respective cultural backgrounds. The myriad of shared cultural perspec-
tives stimulated discussions, raised questions, and resulted in performa-
tive actions that were ethnographically, linguistically, politically, socially,
technologically, and ecstatically stirring. Their performance art disrup-
tions enabled them to play with and to challenge the historically and so-

cially constructed codes that I taught them and to invent new ones that related to their contemporary cultural circumstances.

As Figure 8.1 illustrates, my students' influence on the curriculum sequence increased with the frequency of their disruptions. Science historian and theorist Thomas Kuhn (1962) argues that, within the history of scientific revolutions, such disruptions challenge the normative practices of science. Art critic Philip Leider (1978) has written about similar occurrences in art history. Kuhn describes a paradigm shift according to four stages: normal-science, anomaly, crisis, and paradigm-conflict. Normal science is "an attempt to force nature into the preformed and relatively inflexible box that the paradigm supplies. No part of the aim of normal science is to call forth new sorts of phenomena; indeed those that will not fit the box are often not seen at all." Scientific anomalies challenge the preexisting paradigm and, as they increase in frequency, they throw the paradigm into a state of crisis and transformation (p. 24).

Within the context of my curriculum sequence, Kuhn's structuralist model makes sense. Having invited my students to disrupt the normative cultural codes that I was teaching them, anomalies surfaced that challenged those codes. As my students' performances of subjectivity increased in frequency, my curriculum sequence was thrown into a state of crisis. No longer able to sustain the challenge presented by my students' cultural perspectives, both the form and content of my curriculum were transformed. Unlike Kuhn's linear structure, the form changed to a poststructuralist system similar to Nicolas Paley's reticulated rhizomatic, which I have discussed in chapter 1. The content of my curriculum also changed from a predominance of historically determined ideas, images, and processes to accommodate the subjective positions of my students. My students found agency as they disrupted and displaced the centrality of my curriculum sequence with what I label in Figure 8.1 as *student webs;* a multicentric system that allowed them to work both independently and collaboratively.

Whenever questioned about the purpose of their disruptions, my students would meet the challenge first by invoking Duchamp's declaration that "art is life," Walter DeMaria's "art is a matter of life and death," or other such pronouncements by controversial artists about whom they learned from their readings and our conversations during and after class. They would continue these conversations with their friends, teachers, and family members with the conviction that art could make a difference in an indifferent world.

To sustain the tedium of school, some students would attend their classes "stoned." Their goal for the school day was to maintain an "act" of sobriety in order to avoid being detected by their teachers. Understanding their quest for agency, I wanted to divert the defiance of their

drug-induced behavior to radical expressions and performances in art. I told them the story of Salvador Dali, the surrealist painter whose dream-like images my students regarded with great awe. Prompted by their hallucinatory character, an interviewer once asked Dali if he ingested drugs. The artist immediately responded with: "I don't need drugs. I am drugs." I recall my students being amused by the artist's declaration. However, I sensed that what mattered most was that I sincerely cared about them and wanted them to realize their creative potential through radical art rather than drugs.

My painting students learned about the political ramifications of a radical act the hard way. Within a sequence of assignments that included painting on various conventional, flat surfaces such as paper and canvas, I asked them to stretch shaped and formed canvases, to introduce collage and assemblage into their paintings. Provocative discoveries in modern and contemporary painting at the time, these techniques and processes challenged the way artists historically thought about pictorial space. Within the context of their pictorial explorations, I asked my students to apply paint to their faces, to allow the contours of the face and the surface of qualities of its skin to suggest the kind of image that they would create. Never having experienced anything like this in an art class, let alone school, the students jumped at the opportunity to defy appropriate school behavior. Discussions about cosmetics, tattoos, piercings, and other such body markings took place as they applied paints to each other's faces. Issues regarding body politics, encroachment on another persons' space, touching their bodies, intimacy, sex, and love were also discussed by the students.

After completing their projects in a single period, the passing bell rang, and they departed for their next classes with their faces painted. Not realizing the potential reaction that their appearance might cause, my students walked to their next classes, which were located in various parts of the campus. As they passed through the hallways, they attracted the attention of students, faculty, and administrators. News of the students' painted faces spread like wildfire. By the time the tardy bell rang, practically everyone on campus knew about the activity. I was immediately summoned by the principal to come to his office and explain the disruption we had caused. Fearful of chaos, he asked me to explain myself.

Without assuming a defensive posture, I provided the principal with an honest rationale for the assignment. I informed him about the context of images, surfaces, materials, and ideas that the students were exploring in the painting class. I explained the relationship between the body and identity in the making of art. I wanted my students to challenge stereotypical or clichéd notions of art. This, in order that they

think critically and express themselves from their own perspectives. The principal's demeanor gradually shifted from confrontation and reprimand to understanding and appreciation. We discussed the importance of students learning to construct connections through art among the various disciplines in school and life at home, in their neighborhoods, and their experiences of culture learned from the mass media. As I left his office, he offered a handshake and a congratulatory remark about teaching my students to think. He also felt obligated to admonish me to be careful about disrupting the order of the school.

While walking back to my class, I realized the significance of our meeting. Why should I assume that my principal, my teaching colleagues, parents, or the student body would categorically accept any challenge that my curriculum or my students' art works would present to the status quo of the school? An effective critique engenders public discourse and critical art, and pedagogy makes such discourse possible. To continue my disruptive pedagogy, I would have to be prepared to meet any resistance with dialogue, to create a forum where a debate could ensue, to take responsibility for the public discussions that would result. In doing so, I could educate my colleagues, my administrators, the students, and their parents about the cultural agency that art enables. Advocacy was necessary to making my curriculum politically viable within the general curriculum of the school. Within the context of such advocacy, I taught my students to take responsibility for their own education, to challenge my curriculum sequence and that of the school's, and to become critical citizens.

I implemented my disruptive pedagogy throughout my seventeen years of teaching at the high school. In drawing, painting, ceramics, sculpture, and photography classes I taught my students to think critically about visual representation in historical and contemporary art and culture, to create art works that responded to these issues from the perspective of their lives. Of all my classes, however, the most provocative and controversial challenge to conventional art pedagogies was in art history. Art historical content was fertile ground for performance art disruptions. The moral and ethical codes that the students were being asked to abide by, those that they had learned throughout their schooling, were visually represented in art history. Ancient Greek artists' attempts to define beauty and truth in a world of strife, the Romans' use of art as a symbol of political domination, medieval Christian art and its representation of spiritual transcendence, the Renaissance synthesis of sacred and profane themes, the ostentatious grandeur of baroque and rococo art, the utopian rebellion of romantic art, the perceptual inquiries of impressionism and postimpressionism, the machine metaphors of cubism and dada, surrealism's machinations of the mind, the

gestural subjectivity of the abstract expressionists, pop artists' representations of mass media culture, and the postmodern critiques of feminist artists such as Judy Chicago, Suzanne Lacy, and Miriam Shapiro, the struggles of artists throughout history to define their lives through art resonated strongly with my students' questions about the purpose of school and life in general. Moreover, my students learned that no master narrative in art history is beyond reproach. By reading, interpreting, and performing they learned of the ideological significance of art historical works and the importance of critiquing and creating new narratives, new myths.

I taught art history in an unorthodox way, from the artist's perspective about art history, questioning its experiential character and relating historical myth to contemporary life and culture. In doing so, I aimed to bring history to life for my students. To begin, I presented few lectures in the class, only to introduce historical and stylistic themes. Although I was responsible for designing the curriculum, my students lectured the majority of the semester addressing specific historical periods and artists' *oeuvres*. To prepare for their lectures, they read, took notes, and wrote papers using at least three art historical texts, sources that were included in an extensive bibliography which I provided. I oriented them to the high school library, the public library in town, and the libraries of a nearby college and university. There, they found not only the readings on my list, but those that they discovered on their own.

While preparing their lecture notes, the students identified at least ten to fifteen slides to use as illustrations. Unable to afford to purchase slides from museums and commercial vendors, at my personal expense I used a close-up lens on my 35 mm Nikomat to photograph their lecture images from the pages of books, magazines, journals, postcards, wherever I could find the highest quality reproduction. Over the course of fourteen years teaching the class, I was able to amass approximately 10,000 slides in my personal teaching collection and an extensive bibliography. Anticipating their lectures, the student/lecturer and I met at least once or twice during one of my breaks so that I could listen to her/his presentation and to provide helpful tips and critical feedback. Our dialogue, during those sessions was invaluable. Not only were the main historical points of the lecture confirmed, but the students' personal interpretations of historical themes, ideas, and images were also integrated.

Within the limitations of a fifty-minute class period, the students lectured for a total of thirty minutes to allow time for the other students and me to raise questions and to intervene with our interpretations. In this manner, the students' lectures provided a pedagogical basis to experience art and a stage upon which we all could speak figuratively

about our personal experiences of culture and thereby disrupt the hegemony of historical assumptions. An essential ingredient in my art history curriculum was the intervention of performance art, strategies that interrogated historical assumptions from the students' perspectives. Similar to my studio curriculum, I introduced frequent performance art disruptions within the sequence of art historical lessons. In addition to their slide-illustrated lectures, I asked my students to prepare and perform a live conundrum, an enigmatic activity, happening, task, event, or exercise that represented the theme of their lecture topic metaphorically. The juxtaposition of these miniperformances with art historical content evoked complex and contradictory interpretations. It opened a liminal space wherein historical texts could be experienced, examined, and interpreted from a contemporary cultural perspective.

Brad's use of a cloud chamber from the physics laboratory to reveal particle dispersion as a metaphor of Jackson Pollock's action painting and Lesley's walking a treadmill while she lectured to represent the futility in Albert Giacometti's sculptures (See chapter 2), represent examples of live conundrums, performances in my art history class. Another took place during the week we were studying the influence of Etruscan death masks on Roman portraiture. A segment of an essay that I wrote in 1991 entitled "Art in Crisis: An Attack on Recent Body Metaphors," previously published in the *Penn State Journal of Contemporary Criticism 4,* describes that performance and its pedagogical implications. I quote it here in its entirety:

> During a unit on Roman Art, the concept of 'art for the dead' was introduced specifically as it related to the ancestor worship tradition of the ancient Etruscans; the culture whose death masks greatly influenced the honorific portraits of the Romans. In this context, the exercise provided students with opportunities to explore modern counterparts to the Etruscan practice and to identify forms of "death masks" in our century.
>
> The Etruscan masks consisted of impressions taken from the faces of the recently deceased family members. Usually made of terra cotta and placed in a shrine within the home, on the occasion of funerals these masks were worn by living family members. As they followed the newly deceased, and a procession of mourners to the burial site, the movements of their bodies animated these masks, and in doing so, brought the spirit of the dead back to life. The special status assigned to these masks and their naturalistic depiction of the human face would later influence the honorific portraits of senators and noblemen sculpted by ancient Roman artists.
>
> To investigate the relationships between this Etruscan ritual and ways of dealing with mortality in the modern world, the exercise in the art history class began with the making of a "death mask." On the day prior to the lecture on Roman portraits, my students and I poured wet plaster onto the face of a student volunteer. With a dim light illuminating our work area, we

prepared the student's face with petroleum jelly, blocked his nasal passages with cotton, and placed two drinking straws into his mouth for breathing.

The ritual like atmosphere of the dimly lit room helped mystify the activity. After the plaster had hardened, we carefully lifted the mold from the student's face and subsequently pressed wet clay into its cavity. By the next day, the clay had dried and shrunken away from the mold, enough that on the day of the Roman portraits lecture I was able to remove the clay impression and to draw parallels with the death masks of the Etruscans.

On the day following the lecture, a second activity was presented to link the modern practice of collecting family portraits in photographic albums with the ancestral worship rituals of the Etruscans. Slides, that were taken from students' photographs of recently deceased family members (a grandfather, grandmother, mother, father, uncle or aunt) were projected onto an eight foot screen in the classroom. Standing between the large scale projected image of their loved ones, these students read a prepared monologue describing the character of the relative depicted in the slide and the significant role that they played in their lives. With heartfelt affection and tenderness the students shared their joys and sorrows with their classmates.

In doing so, they achieved three important purposes. First, they developed a closer bond among themselves. Their willingness to be emotionally open contributed to a greater sense of trust. The sharing of feelings, ideas and experiences contributed to an exciting learning dynamic in the classroom. Second, the experiences of the monologues, juxtaposed with a lecture on Etruscan and Roman art for the dead, brought the concept of ancestor worship to their contemporary lives.

Metaphorically, the students learned to link the photographs in their family albums with the honorific death masks and portraits of the ancients. They also drew parallels between the historical forms of ancestor worship and the contemporary practice of using old photographs to remember loved ones. Through their stories and recollections, like in past civilizations, they brought the spirit of their dead loved ones back to life.

Finally, the third purpose of this activity. Rather than repressing the all-important lessons about death and dying, as we often do in our culture, these students faced the inevitability of their own mortality. By openly discussing questions about their own dying, they were better able to understand the purpose of art for the dead. More importantly, they were able to create a bond with history. (Garoian, 1991)

Returning to Figure 8.1, the sequence of my art history curriculum contained the ideas and images of prehistoric, ancient, medieval and Renaissance, modern and postmodern cultures and civilizations. I introduced a series of performative disruptions in the form of physical exercises to make students aware of the ecstatic experiences of the body when making and interpreting art. Based on early twentieth-century explorations of body mechanics and aesthetics, like Emile Jacques-Dalcroze's eurhythmics, Nikolai Foregger's *tafiatrenage*, Meyerhold's biome-

chanics, and Rudolf von Laban's eukinetics, I introduced preliminary performance exercises to prepare my students to absorb, to feel the aesthetic experiences of art. The performance techniques of these modern artists/educators focused on the body's kinesthetic experiences. By exercising the skeletal, muscular, and nervous systems of the body, its machinations, they enabled aesthetic absorption of the dynamic qualities and characteristics of life and culture in the modern industrial environment, a knowledge of the body that was essential to the understanding and representation of modern art forms.

To engage the body knowledge of my students early in the art history course, I introduced a three-part exercise: to use the body as an object; to use the body as a kinetic device; to use the body as a sound-producing instrument. They performed these body functions as part of an ensemble group, in collaboration, to interpret three historical paintings that I had projected on the classroom wall. Before starting the exercise, I randomly divided the class into four small groups comprised of approximately five to eight students each. After a five- to ten-minute breathing and visualization exercise while lying on the floor with their eyes closed, I asked them to sit up slowly, open their eyes, and study the image in the first slide: Theodore Gericault's *Raft of the Medusa*. In this first part of the exercise, I asked them to explore the visual composition of the painting, to find its directional forces, and to discuss their findings with the other students in their group. I asked them to brainstorm, construct, rehearse, and perform a *tableau vivant* (a posed living picture) with their bodies that mimed the directional lines in Gericault's work. After each group performed its *tableau* in the center of the classroom, the audience applauded to provide support for having taken a risk and trying something unusual in a classroom situation.

For the second part of the exercise, I changed the slide image on the wall to Claude Monet's *Gare St. Lazar.* Building on the premise of their *tableaus,* I asked the students to study the painting's directional forces and to construct, rehearse, and perform a composition constructed with their bodies as before but with an added dimension. For this second performance, after studying the directional forces in the painting, I asked them to consider their choreographic possibilities, to interpret their implied movements with their bodies. First, the students composed their bodies according to Monet's directional forces and held their positions for thirty seconds for the rest of us to examine. Next, at someone's command, they began to move, spin, crawl, jump, and weave around one another the way in which the painting suggested. The static composition of their *tableau* was transformed into a kinetic form that continued for thirty seconds, until the rest of us had the opportunity to examine its multifaceted and ever-changing character.

Finally, the third part of the exercise was in response to a slide of Vincent Van Gogh's painting *Starry Night*. Like before, each of the groups prepared a *tableau*, then a kinetic interpretation of the painting's directional forces. Then I introduced the third and final dimension for them to consider: sound. I asked them to look at Van Gogh's painting and to imagine sounds. What kinds of sounds do the directional forces in the painting suggest? After collaborating on their three-part performance, each group took its turn in the center of the classroom. First, they assembled their *tableaus*. Next, at someone's signal, the group members began to move as the painting's directional forces suggested. Then, at another signal, they created a chorus of sounds with their bodies to complement their movements. After the exercise ended, several of the students likened their experience to modern dance, to sports, to movements at work and play. We discussed ways in which our cultural environment influences our behaviors, how we reflect cultural ideas and images, or how we challenge them by creating culture anew through art. In this three-part exercise, the students were able to familiarize themselves with one another through personal interaction, to develop a sense of community through collaboration, to experience building a performance composition using body knowledge, and to interpret cultural ideas and images through the body.

Exercises such as this introduced my students to the body's ability to contain and express ideas, images, and actions. Combined with performance art activities to metaphorically represent their art historical topics, they introduced ideas, images, and actions to ponder in the study of art history. These performative exercises enabled them to query the historically and socially constructed truths of art history and to understand them from their contemporary cultural perspectives. In doing so, my students learned that art could enable their agency in spite of the codes that predominate their cultural experiences.

PERFORMANCE ART AS MUSEUM PEDAGOGY

In 1986, two years after completing a Ph.D. in education at Stanford University, I was appointed education director of the Palmer Museum of Art at Penn State University. When I received a telephone call from the director, asking me to apply for the position, I was curious about his interest in me. Having exhibited my art work in museums, given workshops and lectures, but never in the capacity of professional staff, I questioned his motives. The director expressed his desire to have me implement my performance art teaching strategies, the one that I had performed during my tenure at the high school and about which I had

written my doctoral dissertation at Stanford entitled *Performance Art Teaching as New Pedagogy* (Garoian, 1984).

My curiosity piqued as I began considering the possibility of using a museum, its collections and exhibitions to develop interdisciplinary and intercultural programs similar to the way I taught high school art history and the way my students and I created performance art works. I imagined using my performance art pedagogy to make the museum more accessible to students and community members who would not otherwise visit its galleries, view its exhibitions, attend its lectures and workshops. Could I possibly rupture the privileged institutional character of the museum to attract audiences who were not art historians, patrons, and benefactors? Was it possible to open the museum to intercultural and interdisciplinary programs, to attract students and community citizens to bring their diverse cultural interests to bear on the museum's exhibitions?

I was fortunate in that I entered the museum education profession just after a watershed report by the Commission on Museums for a New Century entitled *Museums for a New Century*. The report called for rethinking the relationship of museums to the public. In particular, it emphasized the necessity for researching, developing, and implementing education programs to respond to cultural diversity in America. With my primary responsibilities as program developer and community outreach liaison, I set out to establish an advocacy network throughout the university as well as the Centre County Region of Pennsylvania wherein the Palmer was the major art museum.

I was interested in attracting audiences who were not predisposed toward art museums. There were thousands of students who would pass by the Palmer on the way to classes each day, never once entering its galleries. There were university faculty with no proclivity to include the museum in their research and teaching. Then there were teachers in the schools, and other community citizens, who had little understanding of the educational significance of art museums. The public's perception of the museum was that it served the interests of connoisseurs and collectors. As education director, my interest was not only to get community members to visit the museum for their viewing pleasure but also to use its collections and exhibitions as a resource for knowledge the way that we use libraries (Garoian, 1992, p. 65).

During my five years at the Palmer, I spent most of my time building a community of interested participants in the museum's education programs. While the director, curators, registrar, and exhibition designer worked to produce exhibitions, I queried the public's interests and attempted to link them to the art works. I served as a board member for

the Central Pennsylvania Festival of the Arts and the Pennsylvania Dance Theatre Company. I attended meetings of the Downtown Business Association and participated in public forums to discuss the issues and concerns of the community. I volunteered my services to a number of local organizations to make the Museum's presence known throughout the University and the community. As exhibitions opened, I gave related talks and workshops in classrooms across the university's disciplines. I presented workshops for K through 12 teachers to incorporate the museum's exhibitions in their curricula.

In all my endeavors I operated on the premise that the museum and its exhibitions represented cultural ideas that could be explored from the various disciplines of the university and from the different cultural interests of the community. In doing so, I was able to expose interdisciplinary and intercultural connections to the museum. These connections were pedagogically significant because they represented disruptions that were similar to those that I had put in place in my high school teaching. As in my curriculum sequence, inviting nonart academic and cultural perspectives to the museum opened the possibility for disrupting its assumed purpose in the university, in the community, and in the culture. The many students, faculty, and community members who participated in the museum's events transformed its space from a repository of art objects to that of aesthetic contemplation and contestation.

There were several interdisciplinary and intercultural programs that I instituted with the assistance and participation of faculty, students, and community members in this way. To solicit their participation, I would engage them in a conversation about aesthetics. Assuming that aesthetics is not exclusive to the arts, what are the aesthetic dimensions of engineering, mathematics, nuclear science, geography, business, agriculture, and so on? Having studied the formal and ideological characteristics of art works in a forthcoming exhibition, I approached colleagues in other disciplines to query their perspective on the very issues with which the artists in the exhibition were dealing. Always ready to meet my challenge, they provided me with important insights to design and construct educational programs that complemented their curricula. These programs enabled students to cross disciplinary boundaries and to experience their studies from the perspective of the museum's exhibitions and collections.

The Business and Politics of Collecting Art, for example, was a symposium that brought together contemporary artists; collectors; museum workers; and business, political science, and art history scholars to discuss the unprecedented art market boom of the late 1980s. What impact will this current phenomenon have on the future of the art world? How will artists, collectors, and museums who do not have access to this mar-

ketplace be affected? The symposium entertained these and other questions, discussions from students, faculty, and community members.

Today's Leonardos Symposium and accompanying educational programs were a collaboration between the museum, the College of Arts and Architecture, and the College of Engineering. Inspired by *The Machines of Leonardo da Vinci,* an exhibition sponsored by IBM of working models constructed from the drawings of this Renaissance artist, the symposium was designed to engage a discourse between faculty and students about the common impulse to create in engineering and art. In addition to four keynote speakers, artists who had distinguished themselves as "Today's Leonardos" with their creative applications of computer technology to art making, over 450 undergraduate engineering students participated in workshops over a week's time. As the facilitator of those workshops, I asked the students to bring their engineering knowledge to bear on the exhibition by critiquing Leonardo's machines in order to explain why and how they worked, how their form served their function. The students not only explained the functionality of each of Leonardo's mechanical devices but also they were able to identify modern and contemporary machines that served analogous functions.

The Art and Land Symposium was designed around an exhibition of sixteenth-century paintings entitled *Dutch Masterworks from the Bredius Museum: A Connoisseur's Collection.* The symposium program was prompted by the landscape paintings in the exhibition, namely their symbolic preoccupation with land use and its relationship to human survival. The Dutch historical representations of the land seemed to resonate with the concerns being voiced in Pennsylvania's Centre Region. Should farmers in Centre County sell out to land developers? Should local zoning boards be more cautious about decisions that affect the historical and rural integrity of the region? What ecological outcomes are we faced with as local farms and open spaces are taken over by real estate developers? Scholars and students from the College of Agriculture, the Department of Architecture, the School of Visual Arts, the Department of Landscape Architecture, the Department of Geography, the Department of Geology, local farmers, land developers, and community residents participated in the symposium, bringing their perspectives on land politics, economics, and aesthetics.

In addition to local artists, scholars, and citizens, the symposium program also included invited art historians and artists who lectured on the symbolism and history of Dutch landscape art, images of farmers in nineteenth-century American art, eccentric spaces in the American landscape, local art and land issues, and the social responsibility of public land art. Happenings artist Allan Kaprow facilitated an activity with students from the College of Agriculture and the College of Arts and

Architecture. Scheduled for the vernal equinox, the first day of spring and a significant day in the history of agriculture, he paired students from both colleges and asked them to assist each other in carrying a twenty-five-pound bag of fresh manure around town for an entire day as a performative metaphor of bearing responsibility for the waste that we produce, the solid waste problem in Centre County, the nation's toxic waste problem, and ecological concerns internationally. Land artist Alan Sonfist presented a week-long workshop for students that resulted in planting a grouping of indigenous oak trees on the campus entitled "Oaks Rising." Sonfist's goal to reintroduce native flora in regions where they have been destroyed around the world was realized at Penn State. From a single vantage point, the life cycle of a red oak could be observed in nine stages from seedling to mature tree. Although this public forum did not solve the problems of land use in the region, it nonetheless demonstrated the museum's ability to facilitate a community discourse within its aesthetic space. Using its exhibitions and collections as symbolic historical texts, community citizens were able to discuss and debate their political and economic considerations of land use from multiple perspectives.

The Nuclear Energy Symposium brought together students, faculty, community citizens, environmentalists, scientists, and artists concerned about the ecological impact of nuclear energy. The premise of the two-day symposium was based on Esther Grillo's *Meltdown,* the artist's installation in the museum that was inspired by the crises at Three Mile Island and Chernobyl. The walls of Grillo's installation were lined with rusted lithography plates. The center "core," an altar, contained a dismembered and melted ceramic human figure covered with glass and metal lying in repose. Fired at a temperature far exceeding normal kiln conditions, the melted mass of the body suggested the effects of nuclear meltdown, the downfall of civilization. Illuminated with a heavy industrial lighting assembly, the installation provided a grim testimony about the dangers of modern technology.

The educational programming for the symposium consisted of a unique collaboration that included the museum, the Department of Nuclear Engineering, and the Breazeale Nuclear Reactor facility at Penn State. The purpose of the symposium was to debate the advantages and disadvantages of nuclear energy. On the first day, artist Esther Grillo addressed her "nuclear reactions"; Peter Gould, professor of geography at Penn State, presented his recent findings on the affects of the Chernobyl disaster in Sweden, entitled "Fire in the Rain"; and Edward H. Klevans, professor and head of the Department of Nuclear Engineering, spoke on "Demystifing Nuclear Energy." On the second day of the Nuclear Energy Symposium, a public forum was held in the museum that

involved nuclear engineers, artists, and community citizens debating their concerns about nuclear power. Following the forum, an unconventional event took place. The forum participants and audience were given a discussion tour of *Esther Grillo's Meldown* installation by the museum's docents, followed by informational tours of the Breazeale Nuclear Reactor conducted by specialists from the Department of Nuclear Engineering. Like the previous events of the symposium, the conjunction of these experiences gave the participants and audience both an aesthetic and scientific perspective to interpret the significance of nuclear energy.

The most provocative event of the symposium was performance artist Jay Critchley's political parody of nuclear energy. As self-appointed president of the NRC (Nuclear Recycling Consultants), an acronym he had appropriated from the Nuclear Regulatory Commission, he challenged the federal agency's politics of nuclear disaster. Following the symposium lectures and discussions, Critchley performed *Homage to the Atomic Age,* aimed in particular to Three Mile Island, located just two hours driving distance from the university; the Breazeale Nuclear Reactor on campus; and the ecological vulnerability of the Centre Region. Having used bales of hay from a local farm as building blocks, the artist had previously erected a cylindrical "cooling tower" 25 feet high and 15 feet in diameter in an open field adjacent to the university's football stadium. After dark, with an audience of approximately 100 standing in subzero weather, Critchley delivered a monologue illuminated by a single spotlight and torches while standing before his tower. After reading his own rendition of the Book of Genesis and leading the audience in a parodied verse of "Oh Beautiful," he ended with a recitation of the Ten Commandments handed down from "Atom, the Lord thy God." Finally, with the town and campus police present to control the crowd, and the local fire department prepared in the case of an emergency, Critchley ignited the inside of the hay structure from an open hole at its base. Functioning like a chimney damper, the hole allowed air to rush into the tower, carrying the fire and smoke upwards through its cylindrical chamber. At first, a plume of smoke came billowing out from atop the tower followed by a blast of intense fire. For two hours, the tower burned in effigy. The performance ended after it finally consumed itself in fire.

My five years at the museum provided me with an opportunity to experiment and expand upon the interdisciplinary and intercultural strategies developed as a high school teacher. Unwilling to compromise the cultural experiences of museum audiences for the sake of art, I worked to transform the museum into a context for public discourse. My purpose was to intervene the socially and historically determined codes of art with interdisciplinary and intercultural interpretations. I wanted

to rupture the codes of art history, to challenge its assumptions, from the contemporary cultural perspectives of the students, faculty, and community citizens who participated in the museum's exhibitions and programs. To achieve that end, I shifted my attention to the knowledge and experiences that museum participants brought from their daily lives. Just as I had privileged the student rather than art when teaching high school, I applied the same strategy in museum participants. To assume that art history precludes their existential experiences denies them their voice, their interpretations, their understanding of the significance of art history in their lives and their agency within the culture.

PERFORMING A CRITICAL PEDAGOGY IN THE UNIVERSITY

After five years at the Palmer Museum of Art, I decided to return to academic work, where I could concentrate on researching, developing, and teaching performance art pedagogy. To rekindle the interplay between my art-making and pedagogical practices, I wanted to dedicate more time to creating my own performance art. As an associate professor of art education at Penn State University, I have been teaching in three areas: Performance Art studio class where students create their own performances in addition to learning about performance art history; Concepts and Creation in the Visual Arts, a topical lecture/studio course for undergraduate art majors and nonart majors that looks at art from the vantage point of contemporary cultural issues such as representation, otherness, technology, ecology, health, censorship, and the business and politics of collecting art; and Studio Practices in the Classroom, an undergraduate preservice course on art teaching strategies for upper-level art education students who are about to begin their student teaching experiences.

The final part of this chapter presents my curriculum for the performance art course. As in my previous teaching experiences, the curriculum consists of a sequential structure that begins with preliminary exercises to render the body explicit, storytelling exercises to enable my students to construct stories and actions that represent their respective cultural experiences, followed by exercises where my students construct and perform live manifestos and rants that challenge the politics of domination. Throughout the semester, the students learn to construct and represent their respective cultural identities according to the six strategies of performance art pedagogy: ethnographically through autobiographical performances; linguistically as they construct and perform a live collage of ideas and images; politically as they critique and intervene the socially and historically determined codes; socially as they collaborate in small and large group performances and perform in and with the public; technologically as they use sound, video, computers to

counter the spectacle of the mass media; and, ecstatically as they empathize, absorb, and express with their bodies the aesthetic conditions of contemporary culture through their performances. These strategies are not intended as formulas for teaching, but serve as illustrations of my performance art pedagogy.

I attribute much of the success of the performance art course to the broad range of students that it attracts across the university. Students from English, engineering, psychology, anthropology, visual arts, theatre, business, communications, film and video represent the mix that I encounter each semester. Coming from the university's various programs, departments, schools, and colleges, they bring with them "ready-made" interdisciplinary perspectives that I ask them to consider as content for class assignments. My students also represent a diversity of cultures based on race, ethnicity, gender, and sexual orientation. They come from different neighborhoods, communities, and regions from around the nation and internationally. I encourage them to tap their cultural backgrounds for performance art material. Thus, before getting underway, the class composition contains multiple possibilities to disrupt the structure of my sequential curriculum. Whether they "happen" or not is predicated on the liminality, contingency, and ephemerality of my pedagogy.

Preliminary Activities to Render the Body Explicit

A C T I V I T Y 1

Exercising the body internally in order to actuate and expose its sensory, imaginative, conceptual, emotional, and visceral processes. Clear the classroom of furniture, making room on the floor for students to lie down comfortably without interfering with each other's concentration. An open body position is most desirable in this activity. Folded arms, clasped hands, and crossed legs tend to guard the body rather than expose its vulnerability to new experiences.

The activity begins: *close your eyes, relax, listen, and keep your minds open and alert. Become aware of your breathing, imagine the air passing through your nostrils like invisible cylinders. Take a deep breath, hold it, hold it, and let it out with a sound. Now continue to breathe normally.*

Try to achieve as much silence as possible. If you hear ambient sounds inside or outside the room, listen and meditate on them. Mime the sounds with your bodies. Take a deep breath in and hold it, hold it, and let it out with a sound. Allow your body to relax, to breathe, to hear the ambient sounds.

Now, concentrate and imagine a sound gently entering your body through your nose as you inhale and exiting your body as you exhale. Allow the sound to run through your body. Take a deep breath, hold it, hold it, and let it out with the sound. Now continue to breathe normally.

Next, imagine that you are able to move out of your body as if it were clothing and to see it as an object. Begin to inspect that body in your mind's eye as if it were an object, site, territory, or place. Notice the various features of that body, the character of its nose, what its eyelids look like when shut, its lips. Imagine moving around to the side of its head and looking inside its ear. What does it look like in there? Run your hands through its hair and feel its texture. Take a deep breath, hold it, hold it, and let it out with a sound. Now continue to breathe normally.

Continue this visualization activity down your entire body to your feet and look back across its topography from a "worm's-eye" perspective. Take a deep breath, hold it, hold it, and let it out with a sound. Now continue to breathe normally. Slowly, open your eyes. Let us talk about your felt sensations, the ideas and images you experienced in your minds.

ACTIVITY 2

Exercising the body externally in order to actuate and expose its corporeal properties, its identity, its objectness, its materiality, its movement in space and time. Again, move classroom furniture aside and clear the floor so that there is plenty of room to move around. To explore and exercise the body's various performative properties, brainstorm with students and create a list of verbs. Students again lie on their backs, on the floor, in an open body position, situating themselves far enough apart to prevent colliding with each other during the activity.

(The activity begins) *Close your eyes, relax, breathe, listen, and keep your minds open and alert. Concentrate your attention on your body. I am going to call out a verb from our list. With your eyes closed, listen to the verb and imagine your body performing its action. The verb is "to roll." Perform its action in your imagination several times. Perform the action in slow motion. With your eyes closed, study the slow motion movements of your body and imagine how it feels to produce them. Now imagine repeating your action ten times faster than before. Return to a comfortable speed, repeat, and stop. Open your eyes and actualize the action in the room. Look around the room to see how other students are interpreting the verb action. Repeat the action until I ask you to stop* (20 seconds).

The list of verbs might include the following: *to roll, to twist, to crumple, to drop, to remove, to simplify, to open, to knot, to spill, to rotate, to smear, to lift, to support, to tighten, to loosen, to enclose, to hinge, to stretch, to bounce, to erase.* In addition to exposing the body's external properties, these verb forms serve as a repertoire of body metaphors that students can draw from to construct future performances.

ACTIVITY 3

Exercising the body as object and site in order to expose its function as a culturally inscribed artifact in the environment. This two-part exercise was designed and implemented at the Deep Creek School in Telluride,

Colorado, in collaboration with faculty members Dan Collins, Laurie Lundquist, Jim Linker, Ray Langenbach, Jason Sanford, and Angela Ellsworth. In the exercise, students expand their awareness beyond the visual sense to include touch, smell, and hearing. By exploring the relationships among their sensate bodies, objects, and sites, they learn to render the body as an object, material, and process for creating performance art works.

In the classroom, pair the students randomly. Blindfold one partner and assign the other partner the task of serving as a "safety slave"[1] and "scribe." The safety slave protects the blindfolded partner from self-injury and she/he does so in silence to preserve the blindfolded partner's responsibility for the exercise. In addition, the safety slave serves as a scribe to record the blindfolded partner's experience. The blindfolded partner *leads* this exercise with the safety slave/scribe walking within arms' length in case of an emergency. The partners reverse roles and repeat the activity.

Part 1 (The exercise begins): *Blindfolded partners, you are to exit the classroom and explore the environment attended by your safety slave/scribe.*

While blindfolded, using your other senses, find a site where you feel comfortable and an object within that site that is in some way meaningful to you that you can manage to carry away.

Analyze the site and give a point-by-point description of the site to the safety slave/scribe who will write it down. Your description should be a catalogue of available nonvisual sensory data and any conclusions that you have drawn from the data.

Blindfolded partners carefully remove the object from the site and transport it back to the classroom. Safety slave/scribe lead your blindfolded partner back to the classroom to deposit her/his object.

After the object has been deposited in the classroom, partners reverse roles and repeat the exercise so that the other partner is blindfolded and has an opportunity to find a site and bring an object back to the classroom.

Part 2 (The exercise continues): *Back in the classroom, after having returned with their objects, each partner finds a place that suits you and where you will have some room to work.*

Consider your body a metaphor of your site, position it accordingly in the space of the classroom where you have chosen to work, and place your object in a relationship to your body in that space.

After you have placed the object in a relationship to your body, hold your position while your partner (safety slave/scribe) performs body movements that interpret the written description of your site. (One pair presents to the group at a time.)

[1]Ray Langenbach suggested using "safety slave" to clarify power relations in an unequivocal manner and to inject humor in what can be an intimidating exercise for some students.

After having completed your part of the exercise, trade places with your partner and repeat the above instructions.

After each of you has completed your performancs, decide who will go first and then return, lead your partner back to her/his site with object in hand and without a blindfold. Take note of the terrain you traversed when you were previously blindfolded.

After arriving at the site, carefully imbed your body in the place where the object was originally located. Hold that position for a period of time that you believe to be appropriate and imagine experiencing the site from the perspective of the object.

After having finished, carefully return the object to its exact, original location. Then return to the classroom in order to lead your partner to her/his site and repeat the process above.

ACTIVITY 4

Telling a story while doing and showing something in order to introduce complexity and contradiction in the construction and performance of a "live" collage (between 5 and 10 minutes in duration). In this exercise, students learn to engage their personal memories and cultural histories to create an autobiographical performance.

(The activity begins) *Tell a story of an unforgettable experience that you know from memory.*

Perform a task that you are familiar with, that you perform on a regular basis, and that is unrelated to your story.

Project a slide transparency, video, or film footage or amplify a sound that is unrelated to your story or task.

Using the above three components, construct a live collage.

Refrain from using components that illustrate and explain each other; otherwise you restrict the experience of your audience to that of spectatorship. For audience members to experience the disjunctive structure of your collage, and for them to create their own conjunctions, find a task that is unrelated to your story and an image or sound that is unrelated to both. Collaging these disparate elements in your performance provides the audience with multiple access points, readings, and interpretations. Left with collage fragments, they are positioned to create the metaphorical links for themselves based on their respective cultural experiences.

ACTIVITY 5

Collaging time, space, and actions in order to introduce composition in the construction of a live performance. This exercise was designed after a Goat Island workshop (see chapter 3) strategy to teach students how to develop performance art compositions. Although there are multiple possibilities for composition, the following provides students with an example to consider as they construct their story/task/image or sound performances.

(The activity begins with the entire group of students doing breathing exercises and stretching their bodies in order to prepare for physical activity) *While lying on the floor with eyes closed, visualize yourself engaged in the task that you have identified for your performance. In your imagination, see yourself performing the task repeatedly until told when to stop.*

Open your eyes, stand, and begin performing the task using only your body without any objects, materials, or equipment (all the students perform in unison).

(Divide the class into groups of 4 or 5 students) *Now reduce your task to its most significant fragment and perform simultaneously with your small group mates* (this activity demonstrates syncopation; how to modify space, time, and action to create variation:

Student 1: *perform fragment, stop for ten seconds, start again, repeat for 60 seconds.*

Student 2: *perform fragment ten times faster than you previously performed your complete task, repeat for 60 seconds.*

Student 3: *perform fragment in slow motion; repeat for 60 seconds.*

Student 4: *perform fragment twice as fast as your previously performed complete task; repeat for 60 seconds.*

Student 5: *perform fragment five times faster than you previously performed your complete task; repeat for 60 seconds.*

(Students return to a lying position on the floor) *With eyes closed, imagine your unforgettable story. What happened? Where did it occur? Who was involved? What time of day was it? What kinds of sounds were happening at the same time? What kinds of smells?*

Reduce your story to a single phrase and a sound you can make with your body. Collaborate with your group mates and coordinate your task, story, and sound fragments.

Brainstorm and rehearse the various parts of your group composition. Decide how you will begin your performance and how you will end it. After you have finished rehearsing, and before you perform, decide how you want to arrange the audience in relationship to your performance.

Group 1: *everyone in the group perform, simultaneously, your task fragments three times while repeating your body sounds, your entire tasks once while repeating your phrases, your task fragments three times while repeating your body sounds.*

Group 2: *everyone in the group perform, simultaneously, your task fragments five times while repeating your phrase, your entire tasks once while repeating your body sounds, your task fragments five times in silence.*

Group 3: *everyone in the group perform, simultaneously, your task fragments three times while repeating your phrases, your entire tasks once while repeatedly whispering your phrases, your task fragments three times in silence.*

Group 4: *everyone in the group perform, simultaneously, your task fragments three times in silence, your entire tasks once while repeatedly whispering your phrase, your task fragments three times in silence.*

After instructing the audience where to sit or stand in the room, each small group takes its turn to perform. Following the performances, a critique session is held so that students can discuss their impressions and reactions to the exercise. The groups are asked to consider questions such as the following: What affect did the brainstorming and rehearsal have on the final outcome of your performance? How did the tasks, phrases, and sounds affect each other? What did you learn by performing simultaneously in a group? What ideas, images, and feelings did you associate with each group's variation?

An example of a student story/task/image or sound performance, Jennifer Dowlin-Kelly's *La Bocca della Verita* represents an example of a story/task, image, and sound performance from my class. She begins her performance by collecting audience members' shoes and stuffing them into a large backpack. The dark room where she is performing is illuminated by the reflected light of a single overhead projector.

Jennifer dons the backpack filled with shoes and begins to run in circles around the overhead projector and through the audience. Her magnified shadow moves across the wall and then disappears, across the wall and then disappears, repeatedly, each time she crosses the beam of the projector. As the performance proceeds, Jennifer's breathing becomes increasingly apparent. While running at an exhausting pace, she delivers a monologue about her relationship with Geraldine, a woman she met in Italy who confided that she believes she will die young. The performance ends when Jennifer stops her running, dumps the shoes on the floor, and writes on the overhead transparency a transcription of an answering machine message left by Geraldine's father, informing her that Geraldine had been killed by a drunk driver.

According to Jennifer, "This performance memorializes Geraldine, and it represents a *memento mori* for the audience. I take the audience members' shoes to draw them into the performance so that they can identify with the narrative, to realize that death can happen at any time. The title, *La Bocca della Verita* (the mouth of truth), refers to the name of an architectural monument in Rome where Geraldine and I were making a pilgrimage. The 'mouth of truth' is a metaphor for Geraldine who foretells her own early demise while admonishing me to seize the day."

Performative Manifestos, Rants that Challenge the Politics of Domination

In chapter 2, I describe two student performances, Dahn Hiuni's *Art Imitates Life* and Bonnie MacDonald's *Dinner with Jocasta,* both of which were produced in response to the final assignment in my performance art class.

For the assignment, I asked students to go to the library, to read and take notes from recent journal, magazine, and newspaper articles that discuss a contemporary cultural problem. They selected a topic that was significant to them personally in order to develop and perform a live critique of its issues. Essential to this final project is the assumption that performance artists are informed about the social injustices that they critique and re-present. In addition to their note taking, the students brainstormed and discussed with each other and/or with me the politics of their topic in relationship to the body. This brainstorming process enabled the students to interrogate and expose the critical issues of their topic.

From their research sources and discussions, the students compiled two lists: first, a series of words, actions, phrases, images, and ideas that described the cultural oppression of the body; and second, a series of words, actions, phrases, images, and ideas that constituted the body's critique of that oppression. Having compiled these two lists, the students explored their binary oppositions and, in their interstices, opening an aesthetic space within which to conceptualize and construct a political performance. To accomplish this task, the students improvised strategies to interconnect the binary oppositions so that both could coexist in a political performance. The students used these strategies as notations to experiment, rehearse, and produce dynamic tensions in their performances.

To provide continuity and recapitulation in the curriculum, I ask the students to appropriate elements and strategies from their previous projects. The deconstruction and re-presentation of their former words, actions, phrases, images, and ideas in a new, political performance allow them to critique their own cultural production. This reflexive process serves the students in three ways: to recapitulate their overall production in the class; to find new meanings as they compared one assignment with the other; and to critique their own political positions within the culture. It was in response to this assignment that Hiuni presented *Art Imitates Life* (*Figure 2.1*), a compassionate and caring performance about living and dying with AIDS that challenged the punitive stereotypes of those who are afflicted with the disease. MacDonald's response (*Figure 2.2*) was a performance deconstruction of the gendered signifier *motherfucker* in *Dinner with Jocasta*. In another example, Dana Ziegler presented a parody of technoculture and its impact on the female body in an *Untitled* (1995) performance (*Figure 8.2*).

Three hooded figures dragged Dana in a body bag to the center of the room where her naked body was deposited, like raw material, at one end of a triangular floor installation of metallic tubes that she had constructed for her performance. At each apex of the triangle, there stood metallic monuments towering above the tubes. The entire installation resembled a strange factory assembly line. Dana crawled through the first

figure 8.2: Dana Ziegler, *Untitled*, 1995. Courtesy of Charles Garoian

tube. Although invisible to the audience, her body movements were made apparent by the sounds of crinkling foil and her collisions with pieces of metal, tools, bolts, and other industrial scrap that she had placed inside the tube. Ironically, as she crawled, the machinelike tube undulated organically similar to peristalsis, the actions of the esophagus and intestinal system as they work to digest food. Her body, a raw material to be forged by an industrial system of production, appeared to subvert that system. As Dana crawled toward the end of the first tube, she tore through various places along its metallic foil skin to toss out a rusted pipe, a bolt, nails, and other hunks of industrial scrap. Set against the continual sounds of the foil, and the peristaltic actions of the tube, the audience laughed nervously at the machinelike system's inability to digest its intake.

At the end of the tube, Dana crawled inside the first monument, a tall, vertical box frame with a glass box affixed to its top. As she stood, her naked body filled the frame, and her head inserted into the glass box through which she scoped the audience as if from some kind of factory observation tower. After exiting the tower, Dana entered the second metallic tube, through which she crawled, breaking through its skin and expelling component parts from various machines. Reaching the second tower, a tall conical monument, she sat in a swinging wire basket suspended above a circular metallic pan on the floor. As she swung, she excreted machine fragments from between her legs. Like "industrial/ technological shit,"

they made loud clanking sounds as they dropped inside the pan. The audience burst into laughter as Dana presented an interesting dialectic: being consumed by technological culture as well as being the consumer.

Dana climbed down from the tower and entered the third metallic tube in the triangle, where, once again, she spewed metallic parts through its skin. As she approached the end, however, her movements were impeded by a large, cumbersome piece of technology: an automobile muffler. Instead of small tears in the metallic skin, this time she burst through with her entire body. Heaving the muffler aside, she produced a loud thud on the floor. She rose and climbed onto the third monument, a curved piece of sheet metal suspended horizontally above the floor on a vertical steel shaft bolted to a cart. Lying on the cold metal above the ground, her body appeared like a levitated eviscerated cadaver. As Dana's hooded assistants re-entered the space and pushed the cart and her body away, the audience was left with references to medieval torture, disembodiment, the technological exploitation of the body, misogyny, and the notion that cultural experience and identity are locked into a continual process of construction and deconstruction.

IN THE END I ARRIVE AT THE BEGINNING

In the fifth stanza of his poem "Little Gidding," from *Four Quartets* (1943, p. 39), T. S. Eliot writes

> We shall not cease from exploration
> And the end of all our exploring
> Will be to arrive where we started
> And know the place for the first time.

To continue my struggle of defining my life, and constructing my identity by performing my pedagogy, I once again look to my past. My memories of growing up on the farm and the aesthetic conditions of work and play that I learned from my parents taught me how to use my memory and cultural history to survive the oppressive conditions of school. Just short of nostalgia, my past enables me to understand my relationship to my present cultural circumstances and to imagine my future. By learning to apply who I was and where I came from in school, I was able to understand my relationship to schooled knowledge. I learned to critique what I read in books with the knowledge I brought from my cultural background. Moreover, I was able to create new cultural representations based on my memory and history.

This process of re-presenting the socially and historically determined ideas taught in school allowed me to explore, critique, and know them for

the "first time," that is, from the perspective T. S. Eliot suggests. I found that the same principle applies to teaching, that my exploration of my past was the key to my understanding and creating new pedagogical myths for myself and my students. Thus, in the end I arrive at the beginning with my memories of growing up on the farm, the site where my personal identity, agency, and pedagogy as an artist-teacher first took root.

Working in the dark to pay our raisin debt;
Working in the dark to define our raison d' être;
Working in the dark to raise the dead.

Bibliography

Adorno, T. and Horkheimer, M. (1993). The culture industry: Enlightenment as mass deception. In *Dialectic of Enlightenment* [On-line]. Available: <http://hamp.hampshire.edu/~cmnF93/culture_ind.txt>

Apple, J. (1995). Notes on teaching performance art. *Performing Arts Journal,* May/September, XVII, *(2/3),* 121–125.

Aronowitz, S. and Giroux, H. A. (1993). *Postmodern education: Politics, culture, & social criticism.* Minneapolis: The University of Minnesota.

Artaud, A. (1958). *The theater and its double.* New York: Grove.

Auslander, P. (1992). *Presence and resistance: Postmodernism and cultural politics in contemporary American performance.* Ann Arbor: The University of Michigan.

Auslander, P. (1996). Liveness: Performance and the anxiety of simulation. In E. Diamond (Ed.), *Performance & cultural politics* (pp. 196–213). New York: Routledge.

Austin, J. L. (1962). *How to do things with words.* Cambridge: Harvard University.

Bakhtin, M. M. (1965). *Rabelais and his world.* H. Iswolsky (trans.). Cambridge: MIT.

Bakhtin, M. M. (1981). *The dialogical imagination: Four essays.* M. Holquist (ed.), C. Emerson and M. Holquist (trans.). Austin: University of Texas.

Barba, E. and Savarese, N. (1991). A dictionary of theatre anthropology: The secret art of the performer. London: Routledge.

Barthes, R. (1980). *Writing degree zero.* New York: Hill and Wang.

Battcock, G. and Nickas, R. (1984). *The art of performance: A critical anthology.* New York: E. P. Dutton.

Baudrillard, J. (1984). The precession of simulacra. In B. Wallis (Ed.), *Art after modernism: Rethinking representation* (pp. 253–281). New York: The New Museum of Contemporary Art.

Becker, C. (1991). From tantrums to prayer: Goat Island's can't take Johnny to the funeral. *TDR (The Drama Review), 35* (4), 63–65.

Becker, C. (1994). Herbert Marcuse and the subversive potential of art. In C. Becker (Ed.), *The subversive imagination: Artists, society, and social responsibility* (pp. 113–129). New York: Routledge.

Becker, C. (1995). Survival of the artist in the new political climate. In C. Becker (Ed.), *The artist in society: Rights, roles, and responsibilities* (pp. 56–64). Chicago: New Art Examiner.

Becker, C. (1996). *Zones of contention: Essays on art, institutions, gender, and anxiety.* Albany: The State University of New York.

Berleant, A. (1977, November). *The art of the unseen.* Paper presented at the Postindustrial Culture: Technology and the Public Sphere symposium conducted at the Center for Twentieth Century Studies, The University of Wisconsin-Milwaukee.

Blaum, P. A. (1991). The lonely passion of Charles Garoian. *Ararat, XXXII* (126), 47–51.

Bloom, B. S. (1973). Individual differences in school achievement: A vanishing point? In L. J. Rubin (Ed.), *Facts and feelings in the classroom* (pp. 113–146). New York: Viking.

Boal, A. (1979). *Theatre of the oppressed.* New York: Theatre Communications Group.

Boime, A. (1971). *The academy and French painting in the nineteenth century.* New York: Phaidon.

Bottoms, S. J. (1996). Re-staging Roy: Citizen Cohn and the search for Xanadu. *Theatre Journal, 48* (2), 157–184.

Bourbon, D. (1984). An eccentric body of art. In G. Battcock and R. Nickas (Eds.), *The art of performance: A critical anthology* (pp. 183–193). New York: E. P. Dutton.

Brenson, M. (1995). Where do we go from here? Securing a place for the artist in society. In C. Becker (Ed.), *The artist in society: Rights, roles, and responsibilities* (pp. 66–76). Chicago: New Art Examiner.

Buber, M. (1926). *Rede uber das erzieherische.* Berlin.

Burnham, L. (1997). "Excerpts from 'The D.B.D. Experience: Rachel Rosental's Mind/Body Spa: A Bath for the Soul.'" In M. Roth (Ed.), *Rachel Rosenthal* (pp. 46–50). Baltimore: The Johns Hopkins University.

Butler, J. (1995). Burning acts—injurious speech. In A. Parker and E. K. Sedgwick (Eds.), *Performativity and performance* (pp. 197–227). New York: Routledge.

Cabanne, P. (1971). *Documents of twentieth-century art: Dialogues with Marcel Duchamp.* New York: Viking.

Carlson, M. (1996). *Performance: A critical introduction.* New York: Routledge.

Carr, C. (1993). *On edge: Performance at the end of the twentieth century.* Hanover: University Press of New England.

Cherryholmes, C. H. (1988). *Power and criticism: Poststructural investigations in education.* New York: Teachers College, Columbia University.

Clifford, J. (1988). *The predicament of culture: Twentieth-century ethnography, literature, and art.* Cambridge: Harvard University.

Collins, D. L. and Garoian, C. R. (1994). The Deep Creek School: Technology, ecology and the body as pedagogical alternatives in art education. *The Journal of Social Theory in Art Education, (14)*, 15–34.

Conquergood, D. (1991). Rethinking ethnography: Towards a critical cultural politics. *Communications Monographs, 58* (2), 179–194.

Crease, R. P. (1993). *The play of nature: Experimentation as performance.* Bloomington: Indiana University.

Croce, A. (1994, December/1995, January). Discussing the undiscussable. *The New Yorker, 70* (43), 54–60.

Debord, G. (1995). *The society of the spectacle.* New York: Zone.

Deleuze, G. and Guattari, F. (1977). *Anti-Oedipus.* R. Hurley, M. Seem, and H. R. Lane (trans.). New York: Viking.

Deleuze, G. and Guattari, F. (1987). *A thousand plateaus: Capitalism and schizophrenia.* B. Massumi (trans.). Minneapolis: University of Minnesota.

Dewey, J. (1958). *Art as experience.* New York: Capricorn. (Original work published 1934.)

Dewey, J. (1966). *Democracy and education.* New York: Free Press. (Original work published 1916.)

Diamond, E. (1993). Mimesis, mimicry, and the "true-real." In L. Hart and P. Phelan (Eds.), *Acting out: Feminist performances* (pp. 363–382). Ann Arbor: The University of Michigan.

Diamond, E. (1996). *Introduction.* In E. Diamond (Ed.), *Performance and cultural politics* (pp. 1–12). New York: Routledge.

Dobbs, S. M. (1972). *Paradox and promise: Art education in the public schools.* Unpublished doctoral dissertation, Stanford University, Stanford, California.

Eco, U. (1977). Semiotics of theatrical performance. *TDR (The Drama Review), 21* (1), 107–117.

Eisner, E. W. (1979). *The educational imagination: On the design and evaluation of school programs.* New York: Macmillan.

Eliot, T. S. (1943). *Four quartets.* New York: Harcourt, Brace and Company.

Felman, S. (1987). *Jacques Lacan and the adventure of insight: Psychoanalysis in contemporary culture.* Cambridge: Harvard University.

Felman, S. (1992). Education and crisis, or the vicissitudes of teaching. In S. Felman and D. Laub (Eds.), *Testimony: Crises of witnessing in literature, psychoanalysis, and history* (pp.1–56). New York: Routledge.

Fischer, E. (1963). *The necessity of art: A Marxist approach.* Baltimore: Pelican.

Flavell, J. H. (1963). *The developmental psychology of Jean Piaget.* New York: D. Van Nostrand.

Foster, H. (1985). *Recodings: Art, spectacle, cultural politics.* Port Townsend: Bay Press.

Foucault, M. (1977). *Language, Counter-memory, practice.* Ithaca: Cornell University.

Foucault, M. (1989). Questions of method: An interview with Michel Foucault. In K. Baynes, J. Bohman and T. McCarthy (Eds.), *After philosophy: End of transformation?* (pp. 100–117). Cambridge: Massachusettes Institute of Technology.

Franklin, C. (1994). The roof is on fire: A KRON-NBC Television documentary. Oakland: Chronicle Broadcasting.

Freire, P. (1993). *Pedagogy of the oppressed.* New York: Continuum.

Garoian, C. (1993). Linear perspective and montage: Two dominating paradigms in art education. *The Journal of Social Theory and Art Education, 13,* 57–85.

Garoian, C. R. (1984). Performance art teaching as a new pedagogy. *Dissertation Abstracts International—A 45* (12), p. 3522. (University Microfilms No. AAT8429511).

Garoian, C. R. (1991). Art in crisis: An attack on recent body metaphors. *The Penn State Journal of Contemporary Criticism, 4,* 32–41.

Garoian, C. R. (1992). Art history and the museum in the schools: A model for museum-school partnerships. *Visual Arts Research, 18* (2), 62–73.

Garoian, C. R. (1993). Using cross-disciplinary metaphor to understand art. In J. H. Clarke and A. W. Biddle (Eds.), *Teaching critical thinking: Reports from across the curriculum* (pp. 156–167). Englewood Cliffs: Prentice Hall.

Geertz, C. (1973). *The interpretation of cultures.* New York: Basic Books.

George, D. E. R. (1996). Performance epistemology. *Performance Research: The Temper of the Times, 1* (1), 16–25.

Giroux, H. A. (1993). *Border crossings: Cultural workers and the politics of education.* New York: Routledge.

Giroux, H. A. (1994). *Disturbing pleasures: Learning popular culture.* New York: Routledge.

Giroux, H. A. (1996). *Fugitive Cultures: Race, violence, and youth.* New York: Routledge.

Giroux, H. A. (1995). Borderline artists, cultural workers, and the crisis of democracy. In C. Becker (Ed.), *The artist in society: Rights, roles, and responsibilities* (pp. 4–14). Chicago: New Art Examiner.

Goat Island. (1997). *Schoolbook: Textbook of the 1996 Goat Island summer school in Glasgow.* Chicago: Salsedo.

Goldberg, R. (1979). *Performance: Live art 1909 to the present.* New York: Harry N. Abrams.

Gómez-Peña, G. (1996). *The new world border: Prophecies, poems and loqueras for the end of the century.* San Francisco: City Lights.

Gordon, D. (1981). The aesthetic attitude and the hidden curriculum. *The Journal of Aesthetic Education, 15* (2), 51–63.

Gorsen, P. (1984). The return of existentialism in performance art. In G. Battcock and R. Nickas (Eds.), *The art of performance: A critical anthology* (pp. 135–141). New York: E. P. Dutton.

Goulish, M. (1993, September 22). Performance art and the tradition of rebellion. *The Chronicle of Higher Education, XI* (5), B5.

Greene, M. (1988). *The dialectic of freedom.* New York: Teachers College, Columbia University.

Grotowski, J. (1968). *Towards a poor theatre.* London: Methuen.

Grumet, M. R. (1978). Curriculum as theater: Merely players. *Curriculum Inquiry, 8* (1), 37–64.

Haraway, D. (1985). A manifesto for cyborgs: Science, technology, and socialist feminism in the 1980s. *Socialist Review, 80,* 65–107.

Haraway, D. (1991). *Simians, cyborgs, and women: The reinvention of nature.* London: Free Association.

Herman, E. S. and Chomsky, N. (1988). *Manufacturing consent: The political economy of the mass media.* New York: Pantheon.

Hibbits, B. J. (1996). De-scribing law: Performance in the constitution of legality [On-line]. Available: <http://www.law.pitt.edu/hibbitts/describ.htm>

Huizinga, J. (1950). *Homo ludens.* New York: Beacon.

Illich, I. (1971). *Deschooling society.* New York: Harper and Row.

Jameson, F. (1984, July-August). Postmodernism, or the cultural logic of late capitalism. *The New Left Review: The Impasse of Euro–Socialism, (146),* 53–92.

Jones, A. (1998). *Body art/Performing the subject.* Minneapolis: University of Minnesota.

Kaprow, A. (1966). *Assemblage, environments and happenings.* New York: Harry N. Abrams.

Kaprow, A. (1993a). Nontheatrical performance (1976). In J. Kelley (Ed.), *Essays on the blurring of art and life by Allan Kaprow* (pp. 163–180). Berkeley: University of California.

Kaprow, A. (1995). Excerpts from "assemblages, environments and happenings." In M. R. Sandford (Ed.), *Happenings and other acts* (pp. 235–245). London: Routledge.

Kaprow. A. (1993). Happenings in the New York scene (1961). In J. Kelley (ed.), *Essays on the blurring of art and life* (pp. 15–26). Berkeley: University of California.

Kaprow. A. (1993b). Education of the un-artist, part II (1972). In J. Kelley (Ed.), *Essays on the blurring of art and life by Allan Kaprow* (pp. 110–126). Berkeley: University of California.

Kaprow. A. (1993c). Education of the un-artist, part I (1971). In J. Kelley (Ed.), *Essays on the blurring of art and life by Allan Kaprow* (pp. 97–109). Berkeley: University of California.

Kelley, J. (1995). The body politics of Suzanne Lacy. In N. Felshin (Ed.), *But is it art? The spirit of art as activism* (pp. 221–249). Seattle: Bay Press.

Koestler, A. (1975). *The act of creation.* London: Picador.

Kristeva, J. (1967). Le mot, le dialogue, et le roman. *Critique, 239,* 438–65.

Kruger, B. (1990). Untitled (Your body is a battleground). *Aperture: The Body in Question, (121),* 19.

Kuhn, T. (1970). *The structure of scientific revolutions.* Chicago: University of Chicago.

Lacan, Jacques. (1977). *Écrits: A selection.* A. Sheridan (trans.). New York: W. W. Norton.

Lacy, S. (1980). *Three weeks in May.* Unpublished manuscript, The Studio Watts Workshop, Los Angeles, California.

Lacy, S. (1995). Cultural pilgrimages and metaphoric journeys. In S. Lacy (Ed.), *Mapping the terrain: New genre public art* (pp. 19–47). Seattle: Bay.

Lacy, S. (1995a). Introduction. In S. Lacy (Ed.), *Mapping the terrain: New genre public art* (pp. 19–47). Seattle: Bay.

Lacy, S. (1996, November). Paper presented at the Performance Art, Culture, Pedagogy symposium at Penn State University, University Park, Pennsylvania.

Lakoff, G. and Johnson, M. (1980). *Metaphors we live by.* Chicago: The University of Chicago.

Leder, D. (1990). *The absent body.* Chicago: The University of Chicago.

Leider, P. (March 1978). Stella since 1970. *Art in America, 66,* 120–130.

Lyotard, Jean–François. (1989). The postmodern condition. In K. Baynes, J. Bohman and T. McCarthy (Eds.), *After philosophy: End of transformation?* (pp. 73–94). Cambridge: Massachusettes Institute of Technology.

MacDonald, B. (1996). *Proposal for gallery installation of "dinner with Jocasta."* Unpublished manuscript.

Marcuse, H. (1977). *The aesthetic dimension: Toward a critique of Marxist aesthetics.* Boston: Beacon.

Marsh, A. (1993). *Body and self: Performance art in Australia 1969–92.* South Melbourne: Oxford University.

MCA Publicity postcard. (1997). Chicago: Museum of Contemporary Art.

McCauley, R. (1996). Thoughts on my career. In E. Diamond (Ed.), *Performance and cultural politics* (pp. 265–282). New York: Routledge.

McClaren, P. (1986). *Schooling as a ritual performance: Towards a political economy of educational symbols and gestures.* New York: Routledge.

McEvilley, T. (1983). Art in the dark. *Artforum, XXI* (10), 62–71.

McLaren, P. (1993). *Schooling as a ritual performance: Towards a political economy of educational symbols and gestures.* New York: Routledge.

McMahon, J. (1995). Performance art in education. *Performing arts journal,* May/September, XVII, (2/3), 126–132.

Merleau-Ponty, M. (1968). *The visible and the invisible.* Evanston: Northwestern University.

Meyer, U. (1972). *Conceptual art.* New York: E.P. Dutton.

Minh-ha, T. T. (1990). Documentary is/not a name. *October, 52,* 95–96.

Mouffe, C. (1993). *The return of the political.* London: Verso.

Osborne, H. (1980). Aesthetic implications of conceptual art, happenings, etc. *The British Journal of Aesthetics, 20* (1), 6–22.

Paley, N. (1995). *Finding art's place: Experiments in contemporary education and culture.* New York: Routledge.

Patraka, V. M. (1993). Split Britches in *split britches:* Performing history, vaudeville, and the everyday. In L. Hart and P. Phelan (Eds.), *Acting out: Feminist performances* (pp. 215–224). Ann Arbor: The University of Michigan.

Patraka, V. M. (1996). Spectacles of suffering: Performing presence, absence, and historical memory at U.S. Holocaust museums. In E. Diamond (Ed.), *Performance and cultural politics* (pp. 89–107). New York: Routledge.

Phelan, P. (1993). *Unmarked: The politics of performance.* New York: Routledge.

Piaget, J. (1971). *Genetic epistemology.* New York: W. W. Norton.

Pinar, W. F. (1978). Currere: A case study. In G. Willis (Ed.), *Qualitative evaluation: Concepts and cases in curriculum criticism* (pp. 318–342). Berkeley: McCutchan.

Pinar, W. F. and Grumet, M. R. (1976). *Towards a poor curriculum.* Dubuque: Kendall/Hunt.

Pinar, W. F., Reynolds, W. M., Slattery, P. and Taubman, P. M. (1995). *Understanding curriculum: An introduction to the study of historical and contemporary curriculum discourses.* New York: Peter Lang.

Pratte, R. (1988). *The civic imperative: Examining the need for civic education.* New York: Teachers College, Columbia University.

Ricoeur, P. (1981). *Hermeneutics and the human sciences: Essays on language, action and interpretation.* (J. B. Thompson, Ed. and Trans.). Cambridge: Cambridge University.

Roth, M. (1997. Introduction. In M. Roth (Ed.), *Rachel Rosenthal* (pp. 1–40). Baltimore: The Johns Hopkins University.

Rothenberg, A. (1979). *The emerging goddess: The creative process in art, science, and other fields*. Chicago: The University of Chicago.

Royster, P. M. (1997, February 1–15). Ebonics needed to fully appreciate cultural diversity. *Streetwise (community newspaper, Chicago, IL), (10)*, pp. 7, 9.

Sayre, H. (1989). *The object of performance: The American avant-garde since 1970*. Chicago: The University of Chicago.

Schechner, R. (1982). *The end of humanism: Writings on performance*. New York: Performing Arts Journal.

Schechner, R. (1988). *Performance theory*. New York: Routledge.

Schechner, R. (1993). *The future of ritual: Writings on culture and performance*. London: Routledge.

Schneider, R. (1997). *The explicit body in performance*. New York: Routledge.

Schneider, R. (1993). See the big show. In L. Hart and P. Phelan (Eds.), *Acting out: Feminist performances* (pp. 227–255). Ann Arbor: The University of Michigan.

Seitz, H. (1998). Wer zum teufel ist . . . ?: Von falschspielern und inszenierten wirklichkeiten. *Kunst+Unterricht (223/224)*, 78–80.

Sontag, S. (1969). *Styles of radical will*. New York: Dell.

Sutton–Smith, B. (1979). Epilogue: Play as performance. In B. Sutton-Smith (Ed.), *Play and learning* (pp. 295–322). New York: Gardner.

Taussig, M. (1987). *Shamanism, colonialism, and the wild man: A study in terror and healing*. Chicago: The University of Chicago.

Tsatsos, I. (1991). Talking with Goat Island: An interview with Joan Dickinson, Karen Christopher, Matthew Goulish, Greg McCain, and Tim McCain. *TDR (The Drama Review), 35* (4), 66–74.

Turner, V. (1986). *The anthropology of performance*. New York: Performing Arts Journal.

Ulmer, G. L. (1985). *Applied grammatology: Post(e)-pedagogy from Jacques Derrida to Joseph Beuys*. Baltimore: Johns Hopkins University.

Wertsch, J. V. (1991). *Voices of the mind: A sociocultural approach to mediated action*. Cambridge: Harvard University.

White, J. (1995). A course in performance art. *Performing arts journal*, May/September, XVII, *(2/3)*, 133–136.

Whyte, R. (1993). Robbie McCauley: Speaking history other-wise. In L. Hart and P. Phelan (Eds.), *Acting out: Feminist performances* (pp. 277–293). Ann Arbor: The University of Michigan.

Williams, J. D. (1997, January 19). Ebonics different, not wrong. *Centre Daily Times (State College, Pennsylvania)*, p. 4A.

Wooster, A.-S. (1985). Why don't they tell stories like they used to? *Art Journal (The College Art Association), 45* (3), 204–212.

Zurbrugg, N. (1994). Rachel Rosenthal: Private thoughts of a public performer. *Art and Design: Performance Art Into the 90s, 9 9/10* (38), 36–47.

Zwieg, E. (1997). Art: The best kept secret. *American Book Review* [On–line]. Available: <http://128.138.144.71/abr/zweig.html>

Index

Indexed entries referring to figures have the page numbers in *italics*.